HANDBOOK
OF
MUSEUM TECHNOLOGY

Staff of Research and Education Association

RᴱA
Research and Education Association
505 Eighth Avenue
New York, N. Y. 10018

HANDBOOK OF MUSEUM TECHNOLOGY

Printed in the United States of America

Library of Congress Catalog Number 82-80747

International Standard Book Number 0-87891-540-0

PREFACE

This handbook presents the know-how needed for the day-to-day operations of museums. It provides curatorial standards and serves as a reference for museum workers everywhere. It is also an especially useful book for persons generally interested in museums and for students wishing to pursue a museum career. The museum field is an interesting and rewarding field in which to be involved.

Part I covers guidelines for managing museum collections. Part II details a record system for small museums. Part III discusses the special aspects of curatorship for historic buildings converted to museums. Finally, in Part IV, museum maintenance, the problems of repair, and the procedures for replacement of exhibits are treated in detail.

An especially extensive index is included to aid in the rapid location of information in the handbook.

The information in this handbook was originated and sponsored by the U. S. Department of the Interior and edited by Ralph H. Lewis.

iii

Contents

Part 1 Museum Collections

Part 1 traces guidelines for managing museum collections. While directed particularly to museums in the national parks, it applies almost equally to other museums, especially small ones. Park museums are characteristically small. In them one person often must carry on most of the day-to-day curatorial duties, serve as a museum educator, and advise on the application of sound museum policies. The chapters in Part 1 concern the discharge of a trust on which the reputation of the National Park Service as a safe custodian of the nation's heritage frequently depends. In a real sense all museums hold their collections in trust. The public may rightly judge them by the way museum staff members select, preserve and use the objects in their care. A collection is well managed when the specimens are:
 —chosen purposefully
 —readily available for study
 —properly preserved
 —accompanied by adequately organized information about them
 —used to their potential in the museum's program.
These conditions define the curatorial task.

Museums are a distinctive kind of institution. They have developed in response to certain enduring needs of civilized communities. The characteristics and functions common to all museums fit them to meet these needs effectively. A museum is, according to the definition adopted as a basis for accreditation by the American Association of Museums, ". . . an organized and permanent non-profit institution, essentially educational or aesthetic in purpose, with professional staff, which owns and utilizes tangible objects, cares for them, and exhibits them to the public on some regular schedule." Reflection on each point of this statement will reveal the underlying nature of museums. Another useful definition proposed in 1895 by George Brown Goode also deserves close study. He said a museum is ". . . an institution for the preservation of those objects which best illustrate the phenomena of nature and the works of man, and the utilization of these for the increase of knowledge and for the culture and enlightenment of the people." Museum work is a commitment to public service of a demanding and rewarding sort.

A museum needs a valid purpose to justify its existence, and the public has a right to know what that purpose is. Every museum should therefore

define specific needs in its community that it aims to meet by the exercise of those functions that make it a museum. A basic guideline, which can be adapted to other situations, determines when and why a national park should have a museum: *Museums shall be developed, maintained and operated in areas administered by the National Park Service when they are required for the preservation of original objects important to the parks or are needed in the interpretation of the parks.* By definition a museum has a collection of objects to foster and use. These specimens are important for interpretation, study or documentation. Otherwise they should not be in the collection. Many of them are valuable in terms of money, some are irreplaceable. All of them are subject to deterioration or loss from numerous destructive agencies. So, collections require continual protection and knowledgeable care.

Chapter 1 What to Acquire

Authority for national parks to collect museum objects derives principally from three laws. The Act establishing the National Park Service (1916) does not mention museums, but includes in its statement of purpose both the conservation of natural and historic objects, and their enjoyment. Museums are the special institutions devised by society to collect, preserve, study and interpret such objects when they cannot be safely left in place. The Historic Sites Act of 1935 does state that the Service shall ". . . where deemed desirable establish and maintain museums . . ." in connection with historic or prehistoric sites of national significance. An Act of 1955 to facilitate the management of museum properties by the National Park Service specifies the authority of the Secretary of the Interior to accept donations, purchase museum specimens with donated funds, exchange specimens, accept loans and pay necessary transportation costs involved, and lend specimens. The full text of this law is given in Appendix A. The authority to acquire or decline, and borrow or lend museum objects rests by delegation with park superintendents, limited only in a few cases involving gifts valued above specified amounts. (See Appendix A also for legal restrictions on acquiring specimens involving endangered or threatened species of animals and plants.) This gives superintendents more responsibility in what to acquire or relinquish than many museum directors who must clear accessions with their Boards of Trustees.

Scope of Collections

The National Park Service gives a superintendent permission and encouragement to acquire museum objects by field collecting, gift, loan, exchange or purchase, in accordance with established procedures, *when these objects are clearly significant to the park*. This is his basic guideline. He and his staff have the opportunity and incentive to develop and refine the museum collections to maximum utility and value. The guideline assumes

that park museums will actively collect and preserve those specimens which really contribute to the understanding and interpretation of the parks, and which cannot do so if left where they are. The successful application of this policy requires that the day-to-day decisions on what specimens to acquire and which to reject or eliminate be wise and well-planned. Therefore, each park museum needs a clear definition of the proper scope of its collections. Other museums share this need.

By carefully defining the scope of collections a museum promotes sound growth while guarding against the very real danger of random expansion. The definition sets limits to the collections. It specifies the place, time and subject to which the collections must relate, and also considers the use to which they will be put. The specimens must truly represent or interpret a certain geographical area. For a park museum this is usually the park, but sometimes a larger specific territory is justified. Other museums may set the boundaries of their interest within a county or other political unit, an ecological or physiographic area, or even be worldwide in scope depending on the museum's stated purpose in each case. The specimens must also date from, or specifically relate to, the time span the museum seeks to interpret or preserve. They must clearly pertain to those facets of history or prehistory, or those natural conditions, processes or events which comprise the significant aspects of the museum's field of interest. The collections must reflect the balance of values in this subject field, neither ignoring nor overemphasizing secondary aspects. The collections must relate to the capabilities of the museum for their preservation, and to their potential use for research, documentation and interpretation.

The scope of collections definition also sets goals. Within the limits of pertinence and practicality, the goals call for building up thoroughly representative collections marked by authenticity and quality. In a park museum the collections shall preserve those features of the park which cannot safely be left in place. They shall establish and record information needed in the development, protection and interpretation of the park. They shall serve the genuine study and reference needs of the staff and visitors. They shall represent all the fields necessary to accomplish the purposes of the museum.

The museum should revise the scope of collections definition whenever changed conditions clearly alter needs and purposes. See Appendix B for examples of scope of collection statements developed for three park museums.

Guidelines follow to help formulate and apply a scope of collections statement. They employ the traditional concept of two series of specimens: one for exhibition and the other for study. This is because somewhat different guidelines are used in acquiring objects primarily intended for one or the other function. However, the same specimen often serves both for exhibition and study, either at once or at different times. So the division is not a rigid one.

Exhibit Series

The exhibit specimens comprise those needed to illustrate and interpret the museum's theme by means of display. Throughout the interpretive planning process all who help prepare or review the plans should consider every kind of material object associated with the ideas to be communicated. Some objects will relate so closely to the key aspects or events of the story that they contribute strongly to a better understanding or appreciation. Such specimens in park museums include dinosaur fossils at Dinosaur National Monument, catlinite pipes at Pipestone National Monument, and the Liberty Bell at Independence National Historical Park. Other specimens will help clarify, vitalize, humanize, personalize or symbolize elements of the story. Codfishing and shipbuilding artifacts at Salem Maritime National Historic Site, or personal objects associated with President Washington or members of his cabinet at Federal Hall National Memorial, can add reality and interest to the interpretation.

The decision regarding what specimens will help tell the museum story comes initially in the exhibit plan, or in the furnishing plan for an historic structure. The plan specifies the objects to be displayed, thus creating a "want list". Objects not already in the collection may need to be acquired promptly to meet construction schedules. So the exhibit plan want list may omit some, perhaps many, objects which would help interpret the subject but are not readily available. For these desirable but currently unobtainable specimens, the museum needs a long-range want list. This should be compiled at the time of exhibit planning and used in a continuing acquisition program. Park museums can use a copy of the list in clearing house operations, and should keep it up-to-date (see Clearing House Services, Chapter 6). In preparing the long-range want list, review again all the kinds of objects involved in the story. Be practical still, but this time do not be bound rigidly by the display space presently available, or by the fact that you know where such specimens are.

Every specimen acquired for the exhibit series has an educational or communicative function. It should be the best available example of exactly the right object to accomplish the interpretive purpose. The following guidelines may help in selecting specimens for exhibition.

The object must be what it purports to be; it must be authentic (see Identifying and Authenticating Specimens, Chapter 3). An original object is almost always preferable to a facsimile. The exceptions are when exposure to light or other unavoidable display conditions would harm the original, or when the original is unique or extremely rare and would be better protected or be more useful elsewhere. The Star-Spangled Banner has prime significance at Fort McHenry National Monument, and the Wright Brothers' first plane at Wright Brothers National Memorial, the places where each made unforgettable history. Both are preserved, in the

public interest, at the Smithsonian Institution where professional curators and expert conservators can keep them under observation, and more millions of visitors can see them. In most cases where the original is unavailable, an example of the same kind of object is better than a copy. A specimen actually from the site, or directly associated with the event or person involved in the story, is more desirable than a similar item without such association.

Exhibit specimens should be of high quality in terms of their particular interpretive functions. This requires sound judgment in choosing and applying the criteria appropriate to each situation. A mounted bird, for example, should be of the proper plumage and the taxidermy should be as fine as possible in form, posture and finish. For some situations, a cultural object should be of the finest craftsmanship, for others it should be typical or average. Some exhibits call for specimens to be in new condition. In this case, an object should be just as it came from the maker, without scratches or signs of wear, and with all working parts functional. Sometimes a museum conservator or craftsman can restore a used object to look like new. This is likely to be expensive, so he should be consulted before the specimen is acquired. Often exhibits call for specimens in the condition of everyday use. In such situations, be sure to instruct the staff specialist who cleans and preserves the specimen to restore it so that it reflects the nature of use and degree of maintenance provided by the original user. Occasionally exhibits use specimens in relic condition. The conservator needs to know this fact when he applies necessary preservative treatment. The interpretive value of a museum depends directly on the quality of the specimens it exhibits.

Museums have the opportunity and responsibility to refine the exhibit series. They not only need to search for and acquire the specimens on the want list, but should actively replace existing specimens with better ones.

National Park Service museums do not exhibit live wild mammals or birds in captivity, unless very unusual interpretive circumstances justify an exception to general practice. Fishes and aquatic invertebrates may be exhibited when they are significant to the park story. If interpretation requires the exhibition of other live animals, show them in natural settings rather than cages. Make the confinement devices as inconspicuous as possible.

Study Series

The study series consists of the specimens not on display but required for any of several other purposes. Some specimens need to be gathered and preserved for research. Some provide permanent documentation of the resources in the museum's area of concern or of data used in research.

Some are for reference—to guide administrative decisions, to instruct the interpretive or educational staff and other employees, to assist visiting specialists, and to answer questions from the public. Some form a reserve for future exhibition, for illustrating talks and for other interpretive uses. Measure the value of such a study series by its utility, not by its size. To make it useful the museum must follow an active, planned acquisition program based on the scope of collections definition. Selective, purposeful collecting is required to build up and round out the series, supplemented by the careful elimination or replacement of inappropriate specimens to refine it. A well-balanced collection fitted to the museum's needs will not be achieved by passively acquiring only what happens to be offered or, on the other hand, by promiscuously gathering everything that can be obtained. In a park the superintendent directs the program and the interpretive staff carries it on, with assistance from other park employees and collaborators.

Under some circumstances, study specimens for research or documentation may be preserved and used.to better advantage in another museum. This may be especially true for parks. Research workers may find a city or university museum more accessible, better equipped for study purposes, and with more comparative material in the collections. Take, for example, a park's study series of insects. Hundreds of species live in the park. They form a vital part of the complex biological interrelationships which require preservation. Thus the park needs to know about them, and this knowledge can only come from thorough, well documented collections. However, the staff may need to keep at hand, as specimens for ready reference, only those insects which are conspicuous enough to excite visitor questions or which create management problems. All the rest might be more useful in the entomological collections of a nearby university museum. Obviously, this arrangement would save curatorial time and money for the park. All concerned would benefit whether the specimens were on loan from the park or were collected under permit and belonged to the outside museum. Nonetheless, the park should maintain an active card file showing what and where these materials are.

If a park adopts the idea that specimens collected there but preserved in another museum can actually function as part of its study series, it must use good judgment to decide what belongs at the park and where the rest will serve satisfactorily. The interpreters will know what specimens they want for reference use by the staff and visitors, and resource studies specialists can advise on the collections needed at the park for research and record. All other specimens within the defined scope of the collections might be sufficiently useful to the park if preserved elsewhere. But where? Will they be near enough for the interpreters to consult, and keep an unofficial eye on their maintenance? Does the institution have professional curators and adequate facilities to care for them? Can the park borrow specimens for temporary use or reclaim loaned material readily when

needed? Will the institution supply lists and scientific data concerning spec-
imens from the park? Will scholars find the collections convenient to use?
In most instances the safest choice will be one of more well established
museums relatively near the park. With such considerations in mind, the
superintendent encourages and guides the completion of the study series by
the staff and by specialists from outside the Service operating under collect-
ing permits. He checks to see that these supplementary collections continue
to be preserved and available. He makes sure that the park knows where
these collections are and what they contain.

The national parks comprise three general categories: natural parks
where the primary values are scenic and scientific, historical parks prin-
cipally concerned with human history or prehistory, and recreational parks
which emphasize management of resources for outdoor recreation. The
following specific guidelines for study collections in each type of park have
some relevance to other museums, particularly those concerned with natu-
ral history or history.

1. Natural Areas

The ultimate goal is a collection which will completely represent, by
authoritatively and fully identified catalogued specimens, the plant and
animal life, and the rocks, minerals and fossils, that occur within the park.
Justification for such a natural history collection is that sound research,
accurate interpretation and, in many instances, wise management depend
on it. The collection should aim at completeness, not only taxonomically,
but also in the significant ecological, biological and geological aspects.
Each park determines, on the basis of its present and foreseeable needs,
how much of the total collection should be maintained in the park mu-
seum. Frequently the park will want:

—well prepared study skins and skulls of an adult male, adult female,
and an immature specimen of each species of mammal found in the
park, and similar series of well made study skins of birds, along with
an example of any noticeably different seasonal or ecological variation.
—corresponding representation of the other vertebrate species, preserved
in liquid as a rule.
—good specimens showing the sexual and developmental forms of those
invertebrate species which require interpretation or control.
—specimens forming an inventory of the principal invertebrate families
in the park.
—well mounted herbarium specimens of each species of seed plant. Both
flowers and fruits should be represented, as well as important variations.
—specimens of the ferns, fern allies and conspicuous thallophytes (fungi,
and algae).

—characteristic hand specimens of each rock formation, and additional specimens illustrating any significant geological factors or events.

—samples of any mineral deposits.

—the species of macroscopic fossils found in the park.

Local circumstances will justify variations in this pattern.

It is established policy that all "type specimens" collected in a national park be deposited in the National Museum of Natural History.

Game heads and similar hunting trophies are not proper material for the study series unless they are authentically related to the park, and represent species no longer found there, or have significant historical association with the park.

Historical and anthropological study series in natural areas are limited to those specimens which contribute directly to the preservation, interpretation or management of secondary park values clearly identified in the Master Plan. Within these limitations, follow the guidelines for historical areas.

2. Historical Areas

The goal is to collect and preserve those man-made or natural objects which were significantly associated with the human activities commemorated by the park. These activities may be historic in the usual sense, ethnological or prehistoric. They may involve events, particular persons and ways of life. They comprise the park story and, of course, are basic to the scope of collections definition. Significant association implies that the objects were used in important aspects of the activity, were linked by use or ownership to important participants, or make important contributions to our knowledge of the story.

How do artifacts contribute to historical knowledge? Some specimens provide information not available from written records. While this is true of archeological material in particular, other objects also may reveal new facts. Such specimens are essential documents for research, and as records. Some objects verify statements in the written record. These specimens have value both for recording history and for reference use. Historical objects also increase and deepen our understanding by giving more concrete and detailed meaning to parts of the verbal record. They thus become valuable as reference material for staff and visitors. The study series should contain a good example of each kind of object which meets the tests of significant association. If the object actually used in connection with the park story cannot be obtained, another of the same kind should be substituted.

Search for the specimens that are significantly associated with the park story. Waiting for people to bring items in is too haphazard a method of creating a fine collection. When someone does offer a specimen, however,

determine whether or not it fits the museum's needs. If it represents a significant association, does not duplicate material already in the collection, is in satisfactory condition and can be acquired without restrictions, accept the specimen. If there is any doubt concerning any of these factors, or of the identification or authenticity of the object, decision to accept should be delayed. The owner may be willing to allow the museum to hold it on approval, or may agree to retain the specimen and keep his offer open. The museum can then get expert help to decide whether or not it is worth acquiring. A good rule of thumb in such cases is to accept only objects you would be willing to buy. Sometimes the museum is offered specimens of historic value which are not appropriate to the park. Find out before accepting or rejecting them if another park needs them. If not, the Service has a standing agreement with the Smithsonian Institution to let the appropriate national museum know that the specimens are available. Send this information promptly through channels.

If specimens preserved in the collections of other museums adequately serve the research, documentation or reference needs of the park, examples of the same kinds should not be required in the study series maintained at the park. Make sure, however, that the objects of concern in the other museums are safely kept and properly documented. Do not take this for granted in some local museums. Make sure, also, that the specimens are where the park can benefit from them. In many cases it will be found that historical materials pertinent to the park are not concentrated in a single museum, but scattered in numerous collections. These situations affect the degree to which you can depend on help from outside museums in reducing the requirements of the study series the park maintains. Continual close liaison with the museums concerned is needed.

The historical parks include several groups in which the individual areas commemorate separate aspects of the same general theme. The Civil War battlefields are one example, the Oregon Trail sites another. The parks in such a group can increase the overall value of their study collections by judicious mutual specialization. If one battlefield assembles a definitive series of Civil War swords, another of artillery projectiles, a third of medical and surgical materials, each has a unit of scholarly importance without wasteful competition among the parks for specimens, and without seriously weakening the general study series. Such cooperative specialization could strengthen other museums as well.

Manuscripts and historic photographs are especially important for an historical study series when they clearly relate to the park story. Large collections of manuscripts and photographs, however, require special facilities and staffing for their preservation and proper use. These provisions are beyond the proper functions of the National Park Service. Therefore, extensive manuscript and photographic collections will normally be deposited in archives or libraries outside the park. These, or any other collections

that require facilities the museum cannot presently provide, should not be acquired without consulting the regional director.

The large quantities of artifacts excavated during archeological investigations require special acquisition and storage procedures. The archeologist often keeps all the specimens from the excavation until the completed studies on the project have been published or circulated for review as an official report. He then retains all the specimens for an additional waiting period of 12 to 18 months to allow normal consideration of his work by other professional archeologists, historians or curators. During this time, the archeologist ordinarily holds the collection in his laboratory, but he may deposit it in the museum. If he does the latter, see Exceptions to Standard Procedures, Chapter 8. The museum accessions the whole collection and places it in safekeeping. The outstanding specimens which are obviously of such caliber that they should be in the exhibit or study series are catalogued promptly and filed in the museum collections for extra protection. The rest of the material is held in a temporary uncatalogued status as a field collection waiting to be culled. As soon as possible after the post-report interval, whether the archeologist has retained the collection or deposited it in the museum, an expert or team of experts should sort the specimens into three categories:

a. *Material to be kept as part of the permanent collection.* This comprises the specimens of exhibit quality, specimens of scientific significance including any objects illustrated or specifically referred to in the report, examples typical of bulk material, and specimens needed for comparative purposes. Objects in this group become part of the exhibit or study series in the museum. A park may place them, to the extent desirable, in other designated museums through loan or exchange procedures.

b. *Material saved for possible restudy.* This is largely bulk duplication of common specimens: in historical archeology such items as nails or definitive sections of bottles, and in Amerindian archeology such material as potsherds or definitive stonework specimens. These objects have been studied as far as present techniques or circumstances warrant, but might yield valuable information when archeologists develop new analytical methods or raise fresh questions. The specimens in this group are not unique. The museum has acquired, in the preceding group, one or more catalogued examples of each kind. These duplicate specimens, properly identified by their field numbers, should be packed in sealed containers. The outside of the container should carry a label stating the contents, the archeological site data, and the catalogue numbers of the specimens representing this material in the museum collection. Store the containers in a safe, reasonably accessible place, but not with the museum study series. Enter this group in the museum accession record, if not previously accessioned. Also note on the catalogue form how many duplicates have been saved for each representative specimen, and where stored.

c. *Waste material.* The material that remains has served its purpose in the investigation. The experts can conceive for it no further scholarly or interpretive use. It consists largely of additional duplicates of very common recovered objects. The archeologist disposes of it in a manner that will avoid creating future problems. Amerindian material may be packed in heavy polyethylene bags, for example, and reburied. The archeologist picks a place with similar soil conditions and keeps the material from different excavations separate. He marks the site and records it on the archeological base map. It may be wiser to destroy some excess historical material altogether. If the objects in this group were accessioned as part of the total collection from the archeological project, deaccession them by noting the amount and nature of the discarded material under the original entry. Record the kind, quantity, manner and place of disposal in the accession folder.

In dealing with specimens excavated under an Antiquities Act permit follow the regulations established by law (see Appendix A).

The study series for an historical area may need specimens of the plants and animals involved in restoring and preserving the historic environment, in addition to natural objects related to the park story. The park may also have secondary values in its natural features which require specimens in the collection for reference or record.

3. Recreation Areas

The objective is to acquire and preserve those study specimens actually needed in the management and interpretation of the area. The scope of collections definition must clearly state the local requirements, which may vary considerably from one area to another. In many cases it will recognize two principal functions of the study series. The recreational uses of the land and its resources may necessitate intensive management of the environment in order to preserve the condition desired. If so, specimens of the plant and animal species involved will be needed for research and record. Specialists studying the resources should be consulted on the size and scope of the research collections required. They can also advise on the need for research specimens of the soils or rocks included in the environment. These areas often provide interpretation as a recreational activity. To the extent that interpretation is an important element, the park needs reference collections as a basis for the natural history or historical subject matter presented. The interpretive staff needs study specimens of the conspicuous plants and animals for reference purposes. Beachcombing and other popular recreational activities involving nature study may tend to increase public use of the reference series. If the recreation area includes historic or archeological features, specimens will have to be placed in the study collections for preservation, as well as for study. With a good scope of collections

definition to set the limits, the park may safely adopt the guidelines given above for natural and historical areas. A recreation area, like parks in the other categories, may also consider collections in well established museums outside the park as part of its study series, to the extent that they really function as such.

BIBLIOGRAPHY

Directors and curators of small museums in particular must rely on the literature of museum work for guidance. To develop or maintain competence in deciding questions such as this chapter raises, responsible museum officials will read the professional journals regularly. These include:

Curator, quarterly, American Museum of Natural History, Central Park West at 79th Street, New York 10024.

History News, monthly, American Association for State and Local History, 1400 Eighth Avenue South, Nashville 37203.

Museum, quarterly, United Nations Educational, Scientific and Cultural Organization, 7 Place de Fontenoy, 75700 Paris (U. S. distributor: Unesco Publications Center, P. O. Box 433, New York 10016).

Museum News, monthly, September–June, American Association of Museums, 2233 Wisconsin Avenue, N.W., Washington 20007 (to be bimonthly).

Museums Journal, quarterly, Museums Association, 87 Charlotte Street, London W1P 2BX.

The basic manuals also provide essential background. They include:

Guthe, Carl E. *The Management of Small History Museums*. 2nd ed. Nashville. American Association for State and Local History, 1964.

————. *So You Want a Good Museum?* Washington. American Association of Museums, 1957 (repr. 1973).

MacBeath, George, and S. James Gooding, eds. *Basic Museum Management*. Ottawa. Canadian Museums Association, 1969.

Unesco. *The Organization of Museums: Practical Advice*. Museums and Monuments—IX. Paris. United Nations Educational, Scientific and Cultural Organization, 1960.

The following list of selected books and articles should give readers a solid introduction to developing thought in museology:

Allan, Douglas A., *et al. Administration*. Handbook for Museum Curators A1. London. Museums Association, 1960.

American Association of Museums. "Code of Ethics for Museum Workers," *Museum News*, 52:9 (June 1974), pp. 26–28 (repr. of 1925 code).

Barzun, Jacques. "Museum Piece, 1967," *Museum News*, 46:8 (April 1968), pp. 17–21.

Bazin, Germain. *The Museum Age*. New York. Universe Books, 1967.

Burcaw, G. Ellis. *Introduction to Museum Work*. Nashville. American Association for State and Local History, 1975.

Burns, Ned J. *Field Manual for Museums*. Washington. Government Printing Office, 1941.

Cameron, Duncan F. "The Museum, a Temple or the Forum," *Curator*, XIV: 1 (1971), pp. 11–24.

————, ed. *Are Art Galleries Obsolete?* Toronto. Peter Martin Associates, 1969.

Colbert, Edwin H. "What is a Museum?" *Curator*, IV:2 (1961), pp. 138–146.

Coleman, Laurence Vail. *Manual for Small Museums*. New York. G. P. Putnam's Sons, 1927.

————. *The Museum in America: A Critical Study*. Washington. American Association of Museums, 1939 (repr. Washington. Museum Publications, 1970).

Douglas, R. Alan. "Museum Ethics: Practice and Policy," *Museum News*, 45:5 (January 1967), pp. 18–21.

Elliott, James, *et al. Museums: Their New Audience*. Washington. American Association of Museums, 1972.

Fitzgerald, Marilyn Hicks. *Museum Accreditation: Professional Standards*. Washington. American Association of Museums, 1973.

Fleming, John R. *America's Museums: The Belmont Report*. Washington. American Association of Museums, 1969.

Frese, H. H. *Anthropology and the Public: The Role of Museums*. Leiden, Holland. E. J. Brill, 1960.

Harvey, Emily Dennis, and Bernard Friedberg, eds. *A Museum for the People*. New York. Arno Press (hard cover). Cambridge. Acanthus Press, 1971.

Hellman, Geoffrey. *Bankers, Bones & Beetles: The First Century of the American Museum of Natural History*. Garden City. The Natural History Press, 1968.

Key, Archie F. *Beyond Four Walls: The Origins and Development of Canadian Museums*. Toronto. McClelland and Stewart, 1973.

Low, Theodore L. *The Museum as a Social Instrument*. New York. Metropolitan Museum of Art, 1942.

Neustupny, Jire. "What is Museology?" *Museums Journal*, 71:2 (September 1971), pp. 67–68.

Noble, Joseph Veach. "Museum Manifesto." *Museum News*, 48:8 (April 1970), pp. 17–20.

O'Doherty, Brian. *Museums in Crisis*. New York. George Braziller, 1972.

Outhwaite, Leonard. *Museums and the Future*. New York. Institute of Public Administration, 1967.

Parker, Arthur C. *A Manual for History Museums*. New York. Columbia University Press, 1935.

Parr, Albert E. *Mostly About Museums*. New York. American Museum of Natural History, 1959.

Rainey, Froelich. "The New Museum," *The University Museum Bulletin*, 19:3 (September 1955), pp. 2–53 (University of Pennsylvania).

Richardson, Edgar P. "The Museum in America 1963," *Museum News*, 42:1 (September 1963), pp. 20–28.

Ripley, S. Dillon. *The Sacred Grove. Essays on Museums*. New York. Simon and Schuster, 1969.

Southeastern Museums Conference. "Standards for Museum Practices," *Museum News*, 38:1 (September 1959), pp. 43–47.

Tomkins, Calvin. *Merchants and Masterpieces: The Story of the Metropolitan Museum of Art*. New York. E. P. Dutton & Co., 1970.

Turner, Evan H., *et al. Professional Practices in Art Museums*. New York. Association of Art Museum Directors, 1971 (repr. in *Museum News*, 51:2, October 1972, pp. 15–20).

Washburn, Wilcomb E., *et al.* "Three Schools of Thought," *Museum News*, 40:2 (October 1961), pp. 16–29.

Whitehill, Walter Muir. *Museum of Fine Arts, Boston: A Centennial History.* Cambridge. Harvard University Press, 1970.

———, ed. *A Cabinet of Curiosities: Five Episodes in the Evolution of American Museums.* Charlottesville. University Press of Virginia, 1967.

Wittlin, Alma S. *Museums: In Search of a Usable Future.* Cambridge and London. MIT Press, 1970.

A number of the references cited contain useful bibliographies leading deeper into the literature. Among other sources offering valuable guidance in this direction are:

American Association of Museums. *Index to Publications of the American Association of Museums. Publications.* New series 2. Washington. AAM, 1927.

———. "Index to Special Articles: Volumes 1 to 30," *Museum News*, 30:20 (April 15, 1953), Supplement, 19 pp.

American Museum of Natural History. "Cumulative Index, Volume I–XV," *Curator*, XV:4 (1972), pp. 261–340.

Borhegyi, Stephan F. de, and Elba A. Dodson. *A Bibliography of Museums and Museum Work, 1900–1960.* Publications in Museology 1. Milwaukee. Milwaukee Public Museum, 1960.

———, and Irene A. Hanson. *Bibliography of Museums and Museum Work, 1900–61, Supplementary Volume.* Publications in Museology 2. Milwaukee. Milwaukee Public Museum, 1961.

International Council of Museums, "Bibliography of Basic Museographical Literature," *ICOM News*, 22:2 (June 1969), pp. 29–36.

———. *International Museological Bibliography for the Year 1967* (and succeeding years). Supplements to *ICOM News*. Prague. Office of Museology.

Majewski, Lawrence J. "Every Museum Library Should Have . . . ," *Museum News*, 52:3 (November 1973), pp. 27–30.

Midland Federation of Museums and Art Galleries. *Technical Index to the Museums Journal, 1930–1955.* Nottingham. W. H. Knapp, 1957.

———. *Technical Index to the Museums Journal, 1956–1966.* Nottingham. W. H. Knapp, 1968.

Rath, Frederick L., Jr., and Merrilyn Rogers O'Connell. *Guide to Historic Preservation, Historical Agencies, and Museum Practices: A Selective Bibliography.* Cooperstown. New York State Historical Association, 1970.

Ritterbush, Philip C. *Museums and Media: A Basic Reference Shelf.* Stanford. ERIC Clearinghouse, Stanford University, 1970 (microfiche).

Smith, Ralph Clifton. *A Bibliography of Museums and Museum Work.* Washington. American Association of Museums, 1928.

Stansfield, G. *Sources of Museological Literature.* Information Sheet 9. London. Museums Association, 1971.

In addition, *ICOM News* (International Council of Museums, Maison de l'UNESCO, 1 rue Miollis, 75015 Paris.), *Museum News* and *Museums Journal* regularly review or note new books or pamphlets of museum interest.

The following references apply more specifically to museum accession policies:

American Museum of Natural History. "Science Policy Report," *Curator*, XIV:4 (1971), pp. 235–240.

Bavin, Clark R., and Alan Levitt. "A Hank of Hair and a Bag of Bones," *Museum News*, 52:8 (May 1974), pp. 39–41.

Booton, D. M. "Purpose and Discrimination in Acquisition," *Museums Journal*, 69:3 (December 1969), pp. 110–113.

Cohen, Daniel M., and Roger F. Cressey, eds. "Natural History Collections, Past-Present-Future," *Proceedings of the Biological Society of Washington*, 82 (1969), pp. 559–762.

Faul, Roberta, ed. "Cool Thoughts on a Hot Issue," *Museum News*, 51:9 (May 1973), pp. 21–49, 52:1 (September 1973), pp. 232–235.

Fleming, E. McClung. "Early American Decorative Arts as Social Documents," *Mississippi Valley Historical Review*, XLV:2 (September 1958), pp. 276–284.

Ford, W. K. "Reference Collections in Museums," *Museums Journal*, 60:6 (September 1960), pp. 146–149.

Halls, Zillah, "Costume in the Museum," *Museums Journal*, 67:4 (March 1968), pp. 297–303.

Harrison, Richard. "The Need for a Collecting Policy," *Museums Journal*, 69:3 (December 1969), pp. 113–115.

Harvard University News Office. "Harvard University Approves Policy Governing Acquisition of Art Objects from Foreign Countries," *Curator*, XIV:2 (1971), pp. 83–87.

Hindle, Brooke. "Museum Treatment of Industrialization: History, Problems, Opportunities," *Curator*, XV:3 (1972), pp. 206–219.

Holmes, Martin. *Personalia*. Handbook for Museum Curators C8. London. Museums Association, 1957.

International Council of Museums. "Icom International Committee for Museums of Ethnography," *ICOM News*, 26:1 (Spring 1973), pp. 40–41.

———. "Ethics of Acquisitions," *ICOM News*, 26:2 (Summer 1973), pp. 77–80.

Irwin, Howard S., *et al. America's Systematics Collections: A National Plan*. Lawrence. Association of Systematics Collections, 1973.

Kramer, Eugene F. "Collecting Historical Artifacts: an Aid for Small Museums," American Association for State and Local History Technical Leaflet 6, *History News*, 25:8 (August 1970).

Lindsay, G. Carroll. "Museums and Research in History and Technology," *Curator*, V:3 (1962), pp. 236–244.

Lowther, G. R. "Perspective and Historical Museums," *Museums Journal*, 58:10 (January 1959), pp. 224–228.

Mason, Brian. "Mineralogy and the Museum," *Curator*, V:4 (1962), pp. 387–395.

Mayr, Ernst, and Richard Goodwin. *Biological Materials, Part I. Preserved Materials and Museum Collections*. Publication 399. Washington. National Academy of Sciences–National Research Council, n.d.

Meyer, Karl E. *The Plundered Past*. New York. Atheneum Press, 1973.

Nason, James D., *et al.* "Finders Keepers?" *Museum News*, 51:7 (March 1973), pp. 20–26.

Nicholson, Thomas D. "NYSAM Policy on the Acquisition and Disposition of Collection Materials," *Curator*, 17:1 (1974), pp. 5–9.

Noble, Joseph Veach, *et al.* "Report of the AAM Special Policy Committee," *Museum News*, 49:9 (May 1971), pp. 22–23.

Rodeck, Hugo G. "Private Collections Policy in Institutions," *Curator*, VII:1 (1964), pp. 7–13.

Russell, Loris S. "Problems and Potentials of the History Museum," *Curator*, VI:4 (1963), pp. 341–349.

Squires, Donald F. "Schizophrenia: The Plight of the Natural History Curator," *Museum News*, 48:7 (March 1969), pp. 18–21.

Ullberg, Alan D., and Patricia Ullberg. "A Proposed Curatorial Code of Ethics," *Museum News*, 52:8 (May 1974), pp. 18–22.

Veillard, Jean-Ives. "The Problem of the History Museum from an Experiment in the Musée de Bretagne, Rennes," *Museum*, XXIV:4 (1972), pp. 193–203.

Wald, Palmer B. "In the Public Interest," *Museum News*, 52:9 (June 1974), pp. 30–32.

Zelle, Ann. "Acquisitions: Serving Whose Heritage?" *Museum News*, 49:8 (April 1971), pp. 19–26.

———. "ICOM Ethics of Acquisitions: A Report to the Profession," *Museum News*, 50:8 (April 1972), pp. 31–33.

Chapter 2 How to Acquire

When a museum decides what objects it needs, accession policy should permit and encourage their acquisition. This chapter discusses the several procedures by which specimens are obtained, and suggests safeguards in their application.

Field Collecting

The best method of acquiring museum specimens for scholarly purposes often is field collecting. A qualified staff member or a visiting specialist goes out into the field and gathers the things he needs. With each specimen he obtains the full, exact data that should accompany it. Plants and animals, rocks and minerals, fossils, archeological artifacts both prehistoric and historic, ethnological specimens and historical material still in use or that may be found in abandoned buildings, constitute the principal kinds of specimens obtained by field collecting. The recorded speech of native or oldtime inhabitants, and photographic records of their activities, may also be collected in the field.

To protect the resources entrusted to it, the National Park Service requires that employees, as well as visiting specialists, obtain a permit before collecting specimens in a park. The superintendent issues collecting permits for plants, animals, rocks and minerals in accordance with regulations. Ordinarily he includes rocks containing common invertebrate fossils under these regulations.

The Secretary of the Interior issues permits for collecting archeological specimens and fossils under the Antiquities Act (see Appendix A). This applies to both historical and prehistoric artifacts, but paleontological permits are usually for vertebrate fossils. For most archeological and paleontological field work in the parks, however, the Service specifically assigns fully trained and experienced staff archeologists or paleontologists who, since they are working on approved resource studies projects, do not require additional Secretarial permission. Collecting permits issued by the Service do not obviate the need for permits or licenses required by other agencies.

The permits issued to visiting specialists also help the superintendent guide the development of the study series. Each permit specifies where the collected material will be preserved. The superintendent may request that certain specimens be added to the park museum to fill gaps in the reference collections. He may direct other specimens toward the particular outside museums where they will most effectively supplement the collections held in the park. In issuing permits, the superintendent can also control the quality of the resulting specimens by making sure that the collectors are competent. Field collecting requires specialized technical skills as well as knowledge. The permittee needs to know what to collect and how to collect it. He must know what information to record about the specimen itself, where and when he found it, and significant related factors. He must be able to prepare it skillfully for study and permanent preservation.

The protection of park resources requires that field collectors, as a rule, do not collect particularly rare plants or animals in a park.

Related to field collecting, but random rather than purposive, are casual surface finds and animals killed by automobiles along roads. To deal with these efficiently, a museum needs well publicized procedures that will encourage prompt reporting, and a decision to keep or discard them. Much of the value of such specimens is lost unless you know exactly where and when they were found. Thus, standing instructions should assist the finder to notify the museum without delay. The museum, in turn, should be ready to decide whether or not to save the specimen reported. If it is to be saved, the museum should help the finder arrange for its care and delivery, and give any necessary instructions for its interim preservation. Construction crews that may encounter archeological or paleontological material should be informed on how and why to report it immediately.

Purchasing

Often the best way to get specimens for the exhibit series is to buy them. When you purchase a museum object, you can be sure it is what you want and in the condition you want it. You acquire it without any obligation to the previous owner. For park museums the money to buy specimens usually comes from the appropriated project funds for constructing museum exhibits, or for restoring and refurnishing historic structures. In special circumstances, specimen purchases may be charged to exhibit rehabilitation or visitor services accounts. Cooperating associations and similar organizations of museum or park supporters commonly provide funds to purchase needed objects, thus fulfilling one of their prime functions. Donated funds may come from other sources as well. Sometimes prospective donors can be persuaded to give purchase funds instead of a specimen. The

museum can buy exactly the specimen needed and avoid possible later misunderstandings about the use of the object.

In most instances when buying museum specimens, arrange to obtain an object on approval so an expert check can be made on its authenticity and condition before the purchase is completed. Then, if a park museum decides to acquire it, the procurement officer will issue a regular purchase order. If he finds or anticipates that the seller will have difficulty submitting his bill in proper form, the procurement officer can prepare the bill on blank paper and send it with the purchase order. Then the seller need only sign and return the papers. Occasionally, a small dealer or private collector will balk at even this much red tape. In such cases the procurement officer has, or can obtain, authority to use a standard Purchase Order-Invoice-Voucher. This form, signed in advance by the authorized official, can also be used when making purchases at auction. Any seller not familiar with the museum's purchasing procedures deserves a clear explanation of how and when he will be paid.

In purchasing specimens, there is the problem of making sure that the museum gets its money's worth. *Caveat emptor!* The dealer may ask as much as he can get because specimens often have no firm market price. Such factors as condition, association, collecting fads and his own ability to document the object may greatly affect the asking price. It is up to the museum to determine how much it rightfully should pay. It needs to consider how much knowledgeable collectors are currently paying for comparable material if possible, what it would cost (for example in staff salaries and travel expenses) to search for another similar specimen at a lower price, and what value to allow for condition, association, rarity and perhaps other special factors. Such data are the basis of sound judgment.

The Endangered Species Act of 1973 (87 Stat. 884) and regulations issued under it restrict the acquisition of specimens containing any part of endangered or threatened plant or animal species. An earlier law prohibits purchasing bald or golden eagle specimens or objects containing their feathers, claws and other parts (see Appendix A).

Gifts

Acquiring a needed specimen by gift saves museum funds and often promotes good relations as well. Dangers may counterbalance these obvious advantages, however. It is so much easier to accept an offer than decline it that you may be tempted to take an object the museum does not need. The desire not to disappoint and the fact that it is free may color one's judgment. Does the specimen really fall within the defined scope of the collection? Does the museum have a clear responsibility for its preser-

vation? Will it actually serve a useful purpose? If not, the cumulative costs of its storage and care will waste more money than the object is worth. Does the donor understand how the museum will use and acknowledge his gift? If not, misconceptions may sour his goodwill.

A donation of a museum specimen is a legal transaction. No question regarding conditions of transfer (if any) or ownership of the object should remain. Legal title to the donated object must pass from the donor to the museum just as title to a plot of land must be transferred when it is sold from one person to another. This involves instruments which: (a) state the donor's offer without restriction, (b) accept the offer on behalf of the museum and (c) acknowledge receipt of the object. Gifts for a park museum should be made to the National Park Service rather than to an individual park. The transaction may be documented adequately in most cases with a single letter sent by the museum director or park superintendent and countersigned by the donor, although lawyers for some museums may recommend further proof of title.

A countersigned copy must be kept in the accession file. This letter should contain the following elements:

1. The sincere thanks of the museum for the gift.

2. Acknowledgment that the specimen or collection has been received.

3. Statement of what is given, but with care not to confirm the donor's identification if any doubt exists (e.g. "the cane which your evidence indicates was carried by George Washington" rather than "George Washington's cane").

4. Reminder that the value of the gift is deductible for income tax purposes.

5. Request that the donor sign both copies of the letter and return one in the enclosed self-addressed envelope.

6. Donor's statement with space for signature and date. Park museums use this one: "I hereby release to the National Park Service as an unconditional gift the article(s) listed above." A brief sample letter comprising all these elements follows, but should not be used as a pattern for every occasion:

Mr. George A. Monroe
912 West Main Street
Queenston, MO 63599

Dear Mr. Monroe:

Your generous gift of a Springfield rifle musket, which family tradition reports that your great-grandfather carried in the Battle of Wilson's Creek, has been received. On behalf of the National Park Service I wish to acknowledge and accept it. This gift will be a significant and welcome addition to our museum collections.

In order to complete the gift, you are requested to countersign both copies of this letter on the line marked "donor" below, retain the original for your own records, and return the copy to us. A return self-addressed envelope is enclosed for your convenience.

Gifts to the National Park Service are tax deductible as charitable contributions.

With deep appreciation of your kindness.

Sincerely yours,

Superintendent

I hereby release to the
National Park Service as an
unconditional gift the article
listed above

_____ _____
 Donor Date

Enclosures 2

Your judgment of the individual circumstances will determine any additional explanations that may be desirable. To forestall an embarrassing misunderstanding, for instance, it might be pointed out in the letter that the museum will have other important uses for the specimen beside exhibiting it. Some museums (Edison National Historic Site, for example) enclose with the letter an expert curatorial analysis. This would identify the object, describe its condition upon receipt, and explain its significance in relation to the collection. Whatever form the correspondence takes, it should be characterized by sincerity and warmth.

After the countersigned copy of the acknowledgment is received, it is good practice to send the donor a certificate as further expression of gratitude. Park museums may use either of two certificates (fig. 1). They choose the smaller certificate for ordinary gifts, and reserve the large one for donations of outstanding value or importance.

Sometimes a donor fails to return the countersigned letter. When this happens, go back to him and explain why you must have it on file. If he still fails to provide a document that clearly shows he has transferred ownership to the museum, your only safe recourse is to return the object to him.

Figure 1. Museum donor certificates used by the National Park Service.
a. Small form to acknowledge such donations as a single specimen of moderate value.

United States Department of the Interior
NATIONAL PARK SERVICE

Your valued gift

of

has been received and is gratefully acknowledged.

Respectfully yours,

_____ 19____

To _____

b. Large form for major gifts.

Prospective donors sometimes insist on conditions which limit the use of their gift. Experience has demonstrated that restrictive gifts are so dangerous to sound museum development that they should ordinarily be declined. Rarely, the unique value of a specimen may warrant the acceptance of certain conditions. For instance, an important portrait of General Burgoyne may be worth accepting with the provision that it be retained at Saratoga National Historical Park. On the other hand the same portrait probably should be rejected if the park would be obligated to keep it on exhibition. In considering such an offer, the museum may be sure that the majority of restricted gifts accepted in the past have been regretted afterwards. To reject it courteously, point out that the museum subscribes to the resolution unanimously adopted by the Council of the American Association of Museums in 1945:

> Whereas, museums have commonly received collections through gifts and bequests made with conditions requiring the material to be kept separate, exhibited in one way or another for long terms of years or in perpetuity, or otherwise specially administered; and
>
> Whereas, museums have suffered greatly in their management and work as a result of such restrictions; and
>
> Whereas, limiting terms of gift and bequest are not consonant with the best policies and aims of museums, but tend rather to warp or retard their development and to inhibit change; so be it
>
> Resolved that the American Association of Museums recommend to museums that they accept no gifts or bequests of exhibition material upon which any conditions are attached.

Often the donor can be persuaded to withdraw the condition limiting his offer. He is likely to be reasonable as well as public-spirited. Perhaps he wants his gift kept on display. Point out, for example, that a museum values the specimens in its study series as highly as those on exhibit, cares for them as faithfully, and uses them for fully as important purposes. Explain that a museum forced to stagnate loses the vitality to preserve and use its collections. Recall that, because none of us can foresee the future, the museum needs to be free to use the gift in whatever ways will best serve the public interest. Let the donor see that, in addition to his doing the museum a favor, the museum undertakes a costly obligation to house, preserve and use the specimen. In a sense donor and museum become partners in devoting the gift to public service. If he offers a collection and wants it kept as a unit, show him that the relations among similar specimens are vital to studying and exhibition. Unnatural groupings handicap the museum and curtail the usefulness of the objects.

One condition a donor often wants is his name linked with the specimen on display. Although many museums do this, the National Park Service does not. In a park museum the Service acknowledges its gratitude to all donors by listing them together on a plaque or in a book placed where

visitors may see it. Two practical reasons support this policy. Putting do-nors' names on specimen labels tends to diminish the effectiveness of an exhibit. By lengthening the labels this practice discourages some visitors from reading them. For people who do read the labels, the names divert attention from the idea being interpreted and add little or nothing to an understanding of the object. Use of donors' names on the labels also may create a reaction opposite to the one intended. Some visitors resent the names in the exhibit, regarding them as an expression of status seeking, or at least as an intrusion. This method, therefore, defeats to some extent its purpose of eliciting a grateful feeling toward the donors. A dignified plaque or donors book avoids both objections.

Loans

Museums ordinarily borrow specimens on their own initiative for either of two purposes. One involves a short-term loan, the other a long period. Frequently, a museum needs an object for temporary use. A research proj-ect may require a borrowed specimen for comparison with those in hand. A special exhibition may include borrowed objects. Such brief loans are al-ways for a specific use and a predetermined period. The long-term loan requested by the borrowing museum aims to fill a gap in the exhibit series. The museum hopes to use the borrowed specimen until it can acquire a similar one of its own.

In borrowing a specimen, the museum gives the lender a letter of receipt. This letter expresses appreciation. It also must identify the object clearly, but with special care not to confirm any questionable data of the lender's. It must state definitely the period of the loan. The letter should remind the lender that, while you will assuredly care for his specimen as if it belonged to the museum, responsibility cannot be assumed for any loss or damage. Insurance arrangements, if any, should be mentioned in the letter. The museum retains a copy of the letter of receipt in the accession file. When the borrowed material is returned, record the fact carefully in the permanent accession record. The museum concludes the transaction with a letter again thanking the lender and stating the time and manner of the object's return. It is good practice to enclose a receipt to be signed by the lender and returned in a self-addressed envelope as acknowledgment that he received the material. Retain the signed receipt and a copy of the letter of thanks in the accession file.

Lenders often expect the museum to insure their property while it is in its care. If the owner requires in writing as a condition of a loan to a park museum that the Service carry a specific amount of insurance, government funds may be used for this purpose. Since the National Park Service may not volunteer to insure borrowed objects and may not insure its own collec-

tions, some lenders agree to extend their own existing policies to cover the specimen "wall-to-wall", from the time the specimen leaves their collection until it returns. A park museum may also ask its cooperating association, or some other friend of the park, to pay the cost of insurance under an all-risk, wall-to-wall policy. Other museums will find insurance problems helpfully discussed in references cited at the end of this chapter.

You should encounter few problems with loans in which your museum is the active borrower. Be sure to return or renew them on time. This involves keeping track of any changes in lenders' addresses. Keep a list of expiration dates, perhaps in conjunction with the museum records, and enter the ones for the current year on a calendar. Record both the borrowing and return fully and promptly. Negotiate indefinite loans, and generally all long-term loans, only with other well established museums. Regulations often prevent museums giving, trading or selling their surplus specimens. These institutions can lend an object for permanent use without specifying any date for its return. Good management in some instances leads them to require periodic renewal. In either case, dealing with other museums largely avoids situations in which a lender or his heirs unexpectedly require you to return the object.

Problems occur most frequently with unsolicited loans from individuals. People offer to lend objects to museums for a variety of reasons. When the motive is truly public-spirited, and the specimens will benefit the museum, such a loan may be accepted safely, if both parties clearly understand the conditions and the date of return or renewal. Too often, however, the lender hopes to obtain free storage, personal prestige or increased market value for the object. Avoid these loans because the owner will want his specimen back whenever it suits his personal interests. If there are specimens on indefinite loan from any source except an established museum, take steps to change the status of the material. You may be able to convert the loan to a gift. If not, set a definite expiration or renewal date, or at least get a written agreement that the lender or his heirs will notify the museum a specified number of days before withdrawing the specimens. Make the period long enough to revise the exhibits containing the borrowed objects. Failing such arrangements, return the objects to the lender.

People sometimes bring specimens to the museum for identification, to offer them as a gift or loan, or hoping to sell them. If the employee responsible for receiving and recording them is not immediately available, the visitor may leave the objects with the nearest member of the staff, intending to come back or write a letter. The specimens remain as a loan for which the museum is responsible. To avoid awkward situations, any employee permitted to receive specimens needs to give the visitor a receipt and retain a copy with the material. He must be sure to write down the owner's name and address, and the reasons for bringing and leaving the objects. A prepared form like the example in figure 2 helps record the

proper data. Keep a supply of the forms at information desks or other places where visitors may deposit specimens. The employee accepting custody of the material from the visitor is also responsible for getting the specimens and data to the proper staff member promptly.

Procedures to follow in lending, rather than borrowing, museum specimens are detailed in Chapter 6.

UNITED STATES
DEPARTMENT OF THE INTERIOR
NATIONAL PARK SERVICE
Harpers Ferry National Historical Park

IN REPLY REFER TO:

I have received the following specimens:

Description Condition

_____ _____
Signature and title Date

These specimens belong to:_____
Name

Address

 Phone

Deposited by: _____
Name

Address

 Phone

The specimens are left for: gift, loan, purchase, identification, other _____.

(Fill out in duplicate. Give 1 copy to depositor. Send other copy with specimens to curator or chief of interpretation promptly.)

Figure 2. Receipt for specimens left at a national park museum.

Transfers

In the National Park Service when a park has a museum specimen that would serve the public interest better in another park, it transfers the object. If the museum holding the specimen regards it as surplus, no difficulty arises. Should the two parks disagree on where the specimen would be more useful, a higher echelon arbitrates. As the museum profession matures, such inter-museum transfers may become a matter of ethics.

In transferring a specimen from one museum to another, both museums place a signed copy of the transfer form in their accession file. The receiving museum pays any transportation costs involved. Park museums may locate specimens available for transfer by using clearing house procedures such as those described in Chapter 6. Specimens may be obtained through the clearing house, also, by transfer from other Federal agencies.

The particular danger to avoid in acquiring specimens by transfer is poor judgment. Take objects only because the museum really needs them, not because they are free.

Exchanges

An exchange consists of giving up one or more specimens your museum does not need in return for one or more of equivalent value which it does need. If you adhere to the letter of this definition, exchange provides an excellent means of refining and strengthening the collection. It may provide needed specimens when purchase funds are lacking. It may offer a method by which another museum can furnish you specimens it could not give or sell.

A park superintendent has the authority to make exchanges of museum objects (see Management of Museum Properties Act -c, Appendix A). He documents the final transaction by a letter to the other party of the exchange. The letter clearly identifies the specimens given and received and explains the basis for his judgment that they represent equivalent value. The letter should describe the objects and give their catalogue numbers if any. Signed copies of the letter, along with signed copies of the property transfer form or receipts required by either party, should be placed in the accession files of both incoming and outgoing specimens.

In negotiating exchanges, the superintendent often works through the clearing house. This usually provides a broader choice of objects to acquire because the clearing house is likely to be in contact with more museums, dealers and collectors. It can also help protect him from mistakes in evaluating and authenticating the specimens involved. Such errors constitute the greatest danger in making exchanges. It is not necessary to insist, however,

on an exact dollar-for-dollar deal. Utility of the specimens to the museum enters the equation along with market value, but the exchange is subject to audit.

Referral to the Smithsonian Institution

Whenever a park museum declines an offer of museum specimens, it should notify the clearing house promptly. It reports the kind of objects, who offered them, and the nature of the offer. If no other park museum has need for the objects, the Service informs the Smithsonian Institution. This procedure acquaints the Smithsonian with the availability of specimens which might be desired for one of the national museums. In return, the curators of the national museums refer to the National Park Service sources for specimens useful for park interpretation.

BIBLIOGRAPHY

Field Collecting

As a general introduction see:
Unesco. *Field Manual for Museums.* Museums and Monuments—XII. Paris. UNESCO, 1970.
The highly specialized techniques of field archeology have a large and growing literature beyond the scope of this listing. Start with:
Heizer, Robert F., and John A. Graham. *Guide to Field Methods in Archaeology.* Rev. ed. Palo Alto. National Press, 1967.

Also see:
Clarke, R. Rainbird. *Archaeological Field-Work.* Handbook for Museum Curators C 1 & 2. London. Museums Association, 1958.
Dowman, Elizabeth A. *Conservation in Field Archaeology.* London. Methuen Co. Ltd., 1970.
Harrington, J. C. *Archeology and the Historical Society.* Rev. ed. Nashville. American Association for State and Local History, 1965.

For collecting methods in biology see the bibliography in Chapter 3. Many of the manuals on preparing freshly collected biological specimens include information about collecting as well. The following references concern other aspects of field collecting:
Baum, Willa K. *Oral History for the Local Historical Society.* Nashville. American Association for State and Local History, 1971.
Borhegyi, Stephan F. de. "Curatorial Neglect of Collections," *Museum News,* 43:5 (January 1965), pp. 34–40.

British Museum (Natural History). *Fossils, Minerals, and Rocks.* Instructions for Collectors II. 8th ed. London. Trustees of the British Museum (Natural History), 1962.

Higgs, J. W. Y. *Folk Life Collection and Classification.* Handbook for Museum Curators C 6. London. Museums Association, 1963, pp. 32–38.

Kuhne, Walter G. "Collecting Vertebrate Fossils by the Henkel Process," *Curator,* XIV:3 (1971), pp. 175–179.

Kummel, Bernhard, and David Raup. *Handbook of Paleontological Techniques.* San Francisco. W. H. Freeman and Co., 1965.

Lees, Patricia M. "A Flotation Method of Obtaining Mammal Teeth from Mesozoic Bone-Beds," *Curator,* VII:4 (1964), pp. 300–306.

Madsen, James H., Jr. "Petroglyphs—A Method for 'Collecting'," *Curator,* XV:1 (1972), pp. 62–71.

Miller, George J. "Some New and Improved Methods for Recovering and Preparing Fossils as Developed on the Rancho La Brea Project," *Curator,* XIV:4 (1971), pp. 293–307.

Smithsonian Institution. *A Field Collector's Manual in Natural History.* Publication 3766. Washington. Smithsonian Institution, 1944, pp. 83–118.

Tyrrell, William G. "Tape-Recording Local History," American Association for State and Local History Technical Leaflet 35, *History News,* 21:5 (May 1966).

Williams-Hunt, P. D. R. *An Introduction to the Malayan Aborigines.* Kuala Lumpur. Government Press, 1952 (Appendix C).

Wagstaffe, Reginald, and J. Havelock Fidler, eds. *The Preservation of Natural History Specimens.* II. New York. Philosophical Library. London. H. F. & G. Witherby Ltd., 1968.

Purchasing and Gifts

References in the Chapter 1 bibliography on the ethical aspects of accession policy also pertain to these methods of acquisition. Note particularly *Curator,* XIV:2 (1971), pp. 83–87, and XIV:4 (1971), pp. 232–235; and *Museum News,* 49:8 (April 1971), pp. 19–26, 49:9 (May 1971), pp. 22–23, 50:8 (April 1972), pp. 31–33, 51:2 (October 1972), p. 17, 51:9 (May 1973), pp. 21–49, and 52:1 (September 1973), pp. 46–48. In addition see:

Lee, George J. "On Art Museum Purchases," *Curator,* II:1 (1959), pp. 84–95.

Loans and Insurance

Allen, Carl G., and Huntington T. Block. "Should Museums Form a Buyer's Pool for Insurance?" *Museum News,* 52:6 (March 1974), pp. 32–35.

Block, Huntington T. "Insurance: An Integral Part of Your Security Dollar," *Museum News,* 50:5 (January 1972), pp. 26–29.

———, and John B. Lawton. "Insurance," in Keck, Caroline K., *et al. A Primer on Museum Security.* Cooperstown. New York State Historical Association, 1966, pp. 15–37.

———, and Eleanor S. Quandt. "Insurance in the Conservation Laboratory," *Bulletin of the American Group—The International Institute for Conservation of Historic and Artistic Works,* I:1 and 2 (1961), pp. 5–7, 7–9.

Choudhury, Anil Roy. *Art Museum Documentation and Practical Handling.* Hyderabad. Choudhury & Choudhury, 1963, pp. 56–60, 76–87 and 244–250.

DuBose, Beverly M., Jr. "Insuring Against Loss," American Association for State and Local History Technical Leaflet 50, *History News*, 24:5 (May 1969).

Dudley, Dorothy H., and Irma B. Wilkinson, *et al. Museum Registration Methods.* Rev. ed. Washington. American Association of Museums and Smithsonian Institution, 1968, pp. 83–88, 131–145 and 149–153. Rev. ed. in prep.

Lawton, John B., and Huntington T. Block. "Museum Insurance," *Curator*, IX:4 (1966), pp. 289–297.

Osborn, Elodie C. "Insurance," *Temporary and Travelling Exhibitions.* Museums and Monuments—X. Paris. UNESCO, 1963, pp. 105–109 and 121–123.

Pfeffer, Irving, and Ernest B. Uhr. "The Truth About Art Museum Insurance," *Museum News*, 52:6 (March 1974), pp. 23–31.

Vance, David, "A Proposed Standard Insurance Policy," *Museum News*, 48:1 (September 1969), pp. 21–26.

Sugden, Robert P. *Safeguarding Works of Art: Storage, Packing, Transportation and Insurance.* New York. Metropolitan Museum of Art, 1948, pp. 59–76.

Chapter 3 Preparing Specimens for the Collection

No matter how a specimen is acquired, the museum immediately becomes responsible for its safekeeping. This obligation involves three lines of activity: the accessioning of the specimen as described in Chapter 7, Accession Records; the necessary steps to prepare it for preservation; its continued protection. This chapter concerns the initial preparation that many specimens require. For protective measures see Chapter 4, Caring for a Collection.

When a museum object is obtained that fits one of the following categories, accession it promptly, but do not at once place it in the cabinet or on the shelves set aside for items waiting to be catalogued:

Organic material

Waterlogged specimens

Rapidly deteriorating objects

Freshly collected biological specimens.

Each of these requires special treatment before it is put in the collection.

Organic Material

A specimen composed of, or containing, animal or vegetal matter may harbor an insect infestation. If the object is not treated accordingly, you not only risk its damage or destruction but also may introduce the infestation into the collection where it can spread. Animal products are most vulnerable. They include fur, feathers, wool, silk, leather, rawhide and parchment. Insects may also infest inadequately cleaned horn or bone. Plant materials are subject to attack, too. Herbarium specimens and objects of wood or paper, especially, need treatment, but cotton, linen and other plant products may be infested.

As soon as a specimen in this category is accessioned, take positive measures to eliminate any insects it may contain. When fumigation is possible, make this a routine procedure whether signs of infestation are

detected or not. Set aside the space and equipment necessary to conduct the operation efficiently. The procedure involves two steps. The first consists of holding the specimen in isolation for about two days in an environment a little warmer and more humid than for normal storage. This accelerates insect activity and development making the pests more susceptible to the fumigant. A standard specimen storage cabinet earmarked for this purpose and located outside the study collection room should provide adequate isolation in most instances. Use a damp sponge or hand towel placed inside to raise the relative humidity to about 75%–80%. If the room temperature cannot be set conveniently at 80°–90° F. (26°–32° C.), a 60–75 watt incandescent bulb mounted just above the cabinet top and suitably covered should transmit enough heat through the metal to the interior. Avoid exposing specimens to an environment any damper or warmer than this; enclose a paper hygrometer and a thermometer in the cabinet to check on the condition produced. For specimens too large or too numerous to fit in the standard cabinet use big sheets of polyethylene to isolate them. Spread one sheet on the floor. Lay the specimens on it, but supported out of direct contact with the plastic. Then cover them with another sheet large enough to extend down onto the bottom one all around. Prop it up from the specimens because some insects could chew through it. Seal the enclosure by weighting down the edges of the covering sheet.

The second step, actual fumigation, exposes the specimen to a gas that will kill all the insects present. It requires a tight chamber or other enclosure to maintain a lethal concentration and to prevent the gas from escaping into the surrounding area. At the end of the treatment the situation and equipment must allow for the removal and dispersion of the fumigant without endangering people or other objects in the environment. A chamber operated at normal atmospheric pressure serves for killing infestations on the surface of specimens, but insects can get inside many objects such as wood, upholstered furniture, the filling of mattresses and pillows, and books or stacks of folded documents. Therefore, a chamber which has much of the air pumped out before the fumigant discharges into it provides surer action. The poisonous fumes permeate every available space. Chambers in which the gas can develop pressures above normal also achieve some penetration. Certain fumigants work more efficiently at temperatures above normal room air. Large museums, libraries and archives often have sophisticated equipment for vacuum fumigation. So do hospitals, some warehouses and some pest control operators. A few museums have assembled smaller units that provide some or all of the desirable controls. Figure 3 illustrates one developed at the Harpers Ferry Center. Museums lacking safe fumigating facilities need to have the treatment carried out elsewhere.

Fumigants for use on museum specimens should be selected to have no effect on any of the materials composing the objects and should leave no harmful residue. All fumigants are hazardous chemicals. They are toxic to

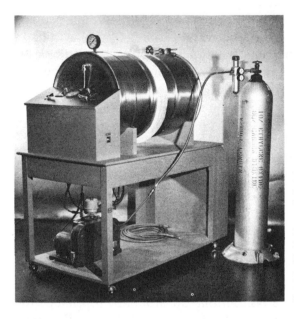

Figure 3. This fumigation tank was designed and assembled by the National Park Service Division of Museum Services. The tank permits fumigation under vacuum, at normal atmospheric pressure, or with moderately elevated pressure; and at room temperature or up to 180° F. (82° C.). The unit includes safety and monitoring devices.

humans and in many cases are flammable or explosive. They represent serious dangers. Consequently the Federal Insecticide, Fungicide and Rodenticide Act as amended (Public Law 92–516) permits the use of only those formulations that have received an Environmental Protection Agency registration number. The law prohibits using these registered products for any purpose or in any manner not specified on the label or in accompanying instructions. The labels and instructions also contain vital precautionary warnings.

Museums have a difficult problem, current at the time of this writing, in selecting a suitable fumigant. No insecticidal gas except paradichlorobenzene, that can be recommended for general use on specimens, was registered for such application. Others which have been in museum use are presently illegal for this reason. To find a solution to this and similar dilemmas an interagency committee has been established to identify the needs for pesticide uses that are minor from a commercial standpoint but nevertheless important. The committee will seek to secure registration of products suitable for these special purposes. When the Environmental Protection Agency does register fumigants for museum use, by all means resume regular fumigation procedures. Become fully acquainted with the hazards involved and post warning signs (fig. 4). Have a safety officer check the operation in detail. Meanwhile follow the first step above by filling the same enclosure for at least two weeks with the fumes produced by 1 pound of paradichlorobenzene crystals for every 100 cubic feet of enclosed space (162 g per m^3). Then subject the specimen to the closest inspection for any sign of live insects because this treatment may not be 100% effective.

DANGER

Fumigation In Progress !

Poisonous and Flammable Gas

KEEP OUT !

Figure 4. Fumigation warning sign.

Wood infected with powder-post beetles or other borers presents a common but specialized problem. If you cannot get the specimen vacuum fumigated, treat it by one of the following methods. You can brush the product carrying Environmental Protection Agency Registration No. 876–100 liberally onto unfinished wood. This is a 2% solution of chlordane in oil. Follow the label directions and precautions carefully. You can also inject into each hole the product having EPA Registration No. 18910–2. Use the pressurized container for this purpose as directed on the label. The insecticide in this case is lindane. The injection method can be used for finished wood and has obvious safety advantages in other situations as well. Museums may write to the Environmental Protection Agency, 401 M Street, S.W., Washington, DC 20460, for the names and addresses of companies that supply these and other registered products.

Waterlogged Specimens

Objects which have lain for many years under water, or in wet soil, often retain their original form to a remarkable degree. However, if the object is of wood, leather or other organic material its solid, well preserved appearance may be deceiving. The internal structure frequently has deteriorated. The component cells maintain their shape because they are full of water. Consequently, as soon as you bring the specimen into the air and the water begins to evaporate, the cell walls start to collapse. The object shrinks. It becomes brittle, or may even disintegrate. Only a few hours of drying can ruin it forever for study or exhibition. Another hidden danger exists if the specimen is of iron and the water is salty. The iron corrodes and its crust of corrosion products becomes permeated with the saline solution. When exposed to air, the dissolved salts act as an electrolyte in decomposing the metal. The destructive action continues as long as moisture from the air reaches the salts.

Therefore, when a waterlogged specimen composed of organic material

or iron is obtained, do two things at once. First, keep it wet using fresh water rather than salt water. If it is too big to immerse, soak it and wrap it in several layers of sodden newsprint, then in thick polyethylene sheeting sealed securely against leakage of water vapor. Second, get expert advice from a conservator about treating it. Park museums should phone the central museum staff. Act promptly because mold may attack the wet object.

For organic specimens, the treatment recommended will probably involve the application of polyethylene glycol. This material comes in a wide range of molecular weights with corresponding differences in properties. The size, nature and condition of the object determine what grade and method of application to use in treating it. Polyethylene glycol 600, for example, is a hygroscopic liquid. Soak as much as possible of it into a specimen of waterlogged wood by immersion or repeated brushing. It replaces the water inside the wood. By continually drawing moisture from the air it keeps the interior of the specimen permanently wet. Another method better suited to some specimens uses polyethylene glycol 4000. Dissolved in alcohol, the material can permeate the specimen. As the solvent evaporates, the polyethylene glycol remains in the cells as a wax-like support. The proper application of polyethylene glycol often requires long periods of time, careful checking of changes in specimen weight and continuous control of other factors. Because of these complexities, and because experimentation with the material continues, it is better to call for advice than to rely on generalized instructions.

Iron recovered after long immersion in salt water is best treated by very carefully controlled electrolysis. This involves the closely regulated flow of an electric current through a conductive solution in which the object is suspended. If large quantities needing treatment preclude such individual attention, the artifacts may require baking at about 1200° F. (650° C.) for a long enough period to drive out all the water. The conservator then applies a waterproof coating to prevent any moisture reaching the salts remaining in the specimen. This usually involves covering the object with a suitable oil, or bituminous, paint. Since the high temperature may alter the metallurgical structure of the specimen, it is an extreme measure to be avoided if possible.

Rapidly Deteriorating Objects

Occasionally other specimens are acquired that need emergency treatment, those deteriorating too fast to wait their turn in the normal schedule of cleaning, repair or restoration and protective processing. This critical condition occurs most frequently when mold attacks a specimen, or when

iron actively rusts. An oil painting which has begun to lose flakes of paint may also need prompt attention.

Mildew growing on a specimen should be killed at once. The mold digests part of the substance on which it grows, leaving the object weakened and often discolored. The spores develop quickly and may spread the infection. In the past museums have fumigated the specimen with thymol, unless oil paint, varnish or thermo-plastics were involved. Thymol fumes tend to soften these substances. Thorough treatment required about two weeks, using a cabinet, box or other container equipped with a 40 watt incandescent lamp. The lamp was mounted on the floor of the container, preferably with the switch outside. A small glass or ceramic dish supported about 2 inches (50 mm) above the lamp contained thymol crystals, allowing 6¼ ounces (177g) for 100 cubic feet (2.8m³) of space (or 1 ounce (28g) for a standard specimen storage cabinet). The specimen was placed on an open rack a foot or so (300 mm) above the dish. The container was closed, the lamp turned on for two hours, then turned off. It was turned on again for the same length of time each day for two weeks. The following day the container was opened and the specimen removed. Heat from the lamp melted the thymol and filled the container with fungicidal gas. Before returning the specimen to the collection, the remains of the mildew were cleaned off with a soft brush. Thymol sometimes irritates the skin and eyes, so users avoided touching it or prolonged contact with the fumes. Note that thymol should be registered as a fungicide for specimens by the Environmental Protection Agency before museums apply it for this purpose. It represents one of the minor uses being referred to the interagency committee at the time of writing.

If a molding specimen cannot be fumigated, take it outdoors to minimize contaminating the collection space. Remove as much of the fungus as possible with a soft brush. Then use a combination of mild heat and moving air to dry the specimen. A hair dryer, or an electric lamp and a fan may serve this purpose. When excess moisture that permitted the mildew to grow has been driven off, be sure to keep the specimen at a relative humidity below 55%. At a higher relative humidity, mold is likely to recur. Most organic materials should be kept in air always at 50%–55% relative humidity. As an alternative to drying and brushing in some cases clean with a fungicide. A quaternary ammonium compound such as benzethonium chloride (for example, Hyamine 1622) in a 1% solution has a mild fungicidal effect. Like thymol this chemical should have an EPA registration before museums use it. To treat painted or varnished wood that has molded wipe it with a sponge or cloth dampened in the solution. Wipe shelves and other surfaces in the study collection room or exhibit room where the mold developed. This treatment may apply to some other specimens for which thymol fumigation is impractical. Record the use of benze-

thonium chloride on any specimen because it may affect subsequent conservation measures. This chemical is very poisonous if swallowed.

When a specimen made of iron or steel is acquired with its finish in good condition, take prompt action to protect it. Do the same for silver, brass and other metals. Fingerprints where you or others have touched the metal start corroding it at once and cannot be removed without damaging the surface. Therefore, *always wear clean cotton gloves when handling clean metal*. Moisture and pollutants from the air may induce rusting or tarnishing where you have not touched the specimen. As soon as such an object is accessioned, wipe it thoroughly with a cloth to remove any finger marks and surface moisture. Then, rub on a temporary protective coating of neutral paste wax, e.g. Simoniz or Butcher's. This should keep the metal finish in its present condition until you are ready to have it cleaned and treated for study or exhibition. If you need to wash an iron object at this stage in order to remove surface dirt, give it a final rinse in a 2% aqueous solution of a complexing reagent such as sodium dihydroxyethylglycine (e.g. Versene Fe-3 Specific) and let it dry in air. This inhibits rusting. Keep the cotton gloves ready to put on whenever you must touch a metal specimen.

Oil paintings, like most specimens, deteriorate slowly. They reach a critical stage when, through age or accident, flakes of paint begin to come loose. A well trained and skillful conservator can do wonders in reattaching loose paint as long as it is still in its original position. Once it flakes off, however, you cannot put it back like pieces of a jigsaw puzzle. The problem is to hold the loose paint in place until the conservator can undertake the restoration of the painting. When an oil painting is accessioned, examine it carefully for evidence of flaking. If there are any signs of it, handle the picture with extra care to avoid loosening or losing any flakes. Lay the painting face up on a table or shelf so gravity will help hold the paint. Then consult a qualified painting conservator. One who is a Fellow of the International Institute for Conservation of Historic and Artistic Works (IIC) has established his or her reputation in the profession and subscribes to its code of ethics. Describe the condition of the painting to the conservator. Park museums phone the central museum staff. If the painting should be faced, the conservator will provide a supply of long fiber tissue paper and dilute starch paste, with the special instructions required.

To face a painting means to cover part or all of the painted surface with a temporary reinforcement. The facing holds the paint firmly in place, but can be removed without damage to the painting at a later stage in restoration. The usual facing process begins with laying the painting face up on the table. Support the canvas by placing under it within the stretcher a smooth block of wood or stack of cardboard cut to size. Cut a piece of tissue into a rectangle an inch or two larger than the area of loose paint. If the tissue does not exceed 6 inches (c. 150mm) it will be easier to handle.

Lay it carefully over the weak area. Hold it gently but firmly in position with one hand. With the other brush the dilute paste over the tissue. Use a good quality, clean paint brush about an inch wide (25mm). Start each stroke from the center and work out in opposite directions—left, right, up and down, in successive strokes. The wet tissue becomes very fragile so try to avoid tearing it. See that the tissue is in contact with the paint at every point leaving no bubbles. Do not try to straighten out any wrinkles by lifting the tissue because the paint would come away with it. If the condition of the painting requires it, you can cover the entire face with rectangles of tissue, overlapping the successive pieces a little at their edges. When the paste dries, the tissue forms a strong support for the loosened paint.

Ship a properly faced painting to the conservator for treatment. See figure 5 for packing instructions.

Freshly Collected Biological Specimens

Ordinarily this kind of specimen is encountered when it is collected personally. The methods of preparing plant and animal specimens for preservation and study tend to follow long established tradition. Technological progress has, as yet, effected little change in the ways of pickling, pressing, skinning or mounting study material. This suggests that you should master the time-tested techniques, but be alert for improved materials and procedures. Because there are specialized methods for many different kinds of biological specimens, it is impractical to repeat full instructions here. Use the notes which follow to supplement the published directions cited for the various groups. As you consult older references, keep in mind that you need to preserve more structural details and more data for present and future research than sufficed in the past. Modify older instructions to save or expose such structures, and record additional significant data.

Specimen Labels

Plant and animal specimens have scientific value *only* if they are accompanied by accurate information. Therefore, fill in the specimen label before you prepare the specimen, as a rule. Later, when you attach the label to the prepared specimen, they become permanently associated. Because the label must be durable, even withstanding prolonged immersion in pickling fluids, both paper and ink must be of high quality.

Include the following information on specimen labels:

Locality —Tell where you collected it. Be precise enough for others to find the place on available maps. Include state, county and elevation.

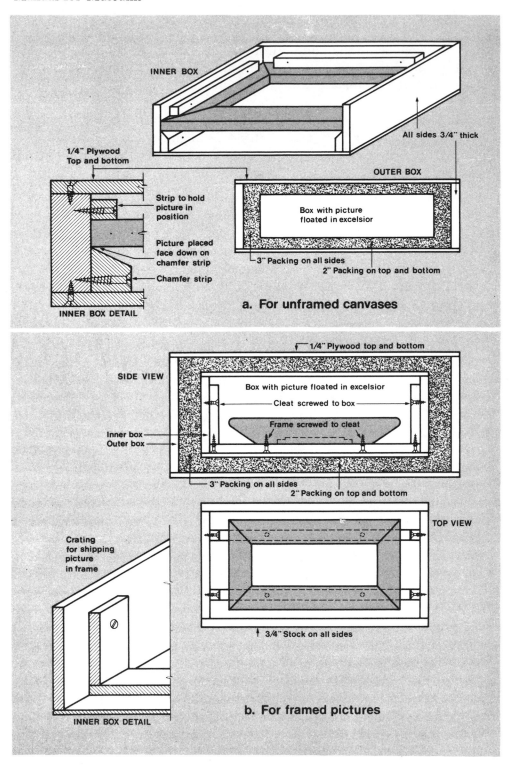

INNER BOX

All sides 3/4" thick

1/4" Plywood
Top and bottom

Strip to hold
picture in
position

Picture placed
face down on
chamfer strip

Chamfer strip

INNER BOX DETAIL

OUTER BOX

Box with picture
floated in excelsior

3" Packing on all sides

2" Packing on top and bottom

a. For unframed canvases

1/4" Plywood top and bottom

SIDE VIEW

Box with picture floated in excelsior

Cleat screwed to box

Frame screwed to cleat

Inner box
Outer box

3" Packing on all sides

2" Packing on top and bottom

TOP VIEW

Crating
for shipping
picture
in frame

3/4" Stock on all sides

b. For framed pictures

INNER BOX DETAIL

Figure 5. The packing of paintings for shipment.

Date —Tell when you collected it. Record month, day and
 year, but abbreviate the name of the month rather than
 using a number.
Collector —Give your name fully enough to avoid confusion. Use
 both initials and your last name at least, or your full
 name as you ordinarily sign it.
Sex —For all vertebrate animals, record the sex unless you
 would have to mutilate the specimen to determine it.
 Use the standard symbols of Mars for male, and Venus
 for female.
Measurements —Record the standard measurements of birds and mam-
 mals because you cannot obtain them accurately from
 study skins. See *Birds* and *Mammals* below for details.
Field number —Enter on the label the number which refers to your
 field notes concerning this specimen.
Catalogue number—When you catalogue the specimen, add this number to
 the label.
Identification —As the specimen is determined, include the scientific
 name on the label.

The form of label, and its attachment to the specimen, vary with differ-
ent groups and preparation methods. These practices are noted in the
sections which follow concerning techniques of preparation.

Field Notes

A specimen label is too small to contain all the important information
that should be linked to the specimen. When you collect and while you
prepare a plant or animal for study, record the collateral data that will
make it useful in a wide range of research. It may be necessary to describe
the collecting locality more exactly because other scientists should be able
to find approximately the same place where the specimen was taken. Ecol-
ogists need to know about the habitat. They ask, for example, that when
fishes are collected you record the clearness and color of the water, its
temperature and the corresponding air temperature, the kinds and abun-
dance of water plants growing there, the character of the bottom and of the
adjacent shore, the distance from shore and the depth at which you col-
lected, the depth of the water at that point, the strength of current, tide
conditions, time of day and method of capture. Make habitat notes in
comparably significant detail for the other kinds of animals or plants col-
lected. Other biologists will depend on your field notes for life history and
behavior data. What did you observe the animal eat or find in its crop or
stomach? What were its feeding habits? At what stage of reproductive
activity was it? What can be told of its age? How much did it weigh? If the

specimen is a plant, how abundant was it? What insects were observed pollinating it? If too large to collect as a whole, how tall was it? The taxonomists need your notes on the structural or other diagnostic features that will be lost in the prepared specimen. For plants, these include color and odor of flowers, sap color and perhaps bark characteristics; for birds, the color of eyes, beaks, and any areas of bare skin; for mammals, the color of eyes, lips and hairless areas, and the number and arrangement of pads on the soles of feet. Specimens preserved in fluid also require color notes.

Naturalists often prefer to enter their field notes in a hard cover pocket notebook with bound pages of relatively permanent paper. Collectors for park museums find some advantages in using a standard Field Service Book, DI-6, for this purpose. It is pocket-sized and has a stiff cover. The paper is 25% rag bond. The pages are bound in but can be removed easily for transfer to the catalogue folder file (see Catalogue Folder File, Chapter 8). Park staffs may also record field notes on their Form 10–257, Natural History Field Observation, but should be sure to assign them field numbers and file them for permanent reference.

Plants

The preparation of plant specimens begins as you collect them. The best procedure for most flowering plants and ferns is to carry a press into the field. Place the specimen in the press directly, arranging it in the newsprint pressing folder in the position in which it will be mounted later. Make field notes for the specimen on the spot, and write the field number which corresponds to these notes on the pressing folder containing the specimen. Be sure the specimen includes all the parts needed for its identification and study—usually root, stem, leaves, flower and, if possible, fruit. All parts should be from the same individual plant, of course. Unless special circumstances preclude it, collect as many specimens as you will need of the same kind of plant at the same place. The minimum ordinarily will be two complete specimens: one for the museum herbarium, and the other to send away for expert identification. Additional specimens may be needed for exchange or to study variation within the population at this particular location. Use the same field number for all the examples of a plant collected at one time and place. If you do not have a plant press with you, collect the specimens into polyethylene bags. Remove them from the bags and put them in the press as soon as you get back to the museum.

At the museum, after a field trip, open the plant press and go over each specimen in its pressing folder. Make sure that the plant is arranged just as it is to be when dry. Turn over a few leaves to show the underside. Adjust the flower parts for good visibility. At this stage, fill in the specimen label except for the identification and the catalogue number. Preferably, type it,

using the same permanent ribbon as for museum catalogue cards (see Supplies for Cataloguing, Chapter 8). Otherwise, print it with pen and permanent, carbon-base ink. Slip the label into the pressing folder with the specimen, and replace the folder in the press with the proper arrangement of blotters and ventilators.

When the specimen is thoroughly dried, mount it on a standard herbarium sheet and paste the label in the lower right corner. Instructions for collecting, preparing and mounting plant specimens are given in the mimeographed *Handbook on Forest Service Plant Collections,* FSH 4083.3, which may be purchased from the Forest Service Division of Administrative Management, Department of Agriculture, Washington, DC. See also *Plants,* Instructions for Collectors 10, 6th edition, London, British Museum (Natural History), 1965; and D.B.O. Savile, *Collection and Care of Botanical Specimens,* A53–1113, Ottawa, Department of Agriculture, 1962. These sources are helpful as well concerning special methods for preserving algae, fungi, lichens, bryophytes and those flowering plants which require different treatment. For additional guidance consult pp. 234–262 in George H.M. Lawrence, *Taxonomy of Vascular Plants,* New York, Macmillan Company, 1951. If you work with aquatic plants, including plankton, see chapters 2, 5 and 18 of E. Yale Dawson, *Marine Botany, An Introduction,* New York, Holt, Rinehart and Winston, 1966. The Department of Botany, U.S. National Museum of Natural History, issues a mimeographed circular, *Basic Rules for Collecting Plants.*

Birds and Mammals

The techniques for converting a bird or mammal into a good study specimen are well established. Following the recognized procedures assures better specimens at lower cost. Even if you are an expert in making study skins, therefore, be sure your museum library contains R. M. Anderson, *Methods of Collecting and Preserving Vertebrate Animals,* Bulletin 69, Biological Series 18, 4th edition, revised, Ottawa, National Museum of Canada, 1965. Review the directions from time to time. If you are not satisfied with the quality of the study skins you make, or with the speed at which you can make good ones, consider additional training, for example by practice under expert guidance at a larger natural science museum. Another useful reference is E. Raymond Hall, *Collecting and Preparing Study Specimens of Vertebrates,* Miscellaneous Publication 30, Lawrence, Museum of Natural History, University of Kansas, 1962. The American Museum of Natural History, the Field Museum of Natural History, the Smithsonian Institution and the British Museum (Natural History) also have published clear, detailed instructions.

When a bird is collected, it is ordinarily made into a study skin. When a small mammal is obtained, prepare it as a study skin and preserve the skull

separately. If the mammal is larger than a raccoon, make a cased skin and keep the cleaned skull as well. Study skins are filled and have reinforcements for the limbs and tail. Cased skins are cleaned and dried on a frame to prevent shrinkage in preparation for later tanning. Rarely it may be desirable to preserve a bird or mammal whole in liquid for special study, or to prepare it as a skeleton. Whatever form the specimen takes, the treatment should protect it from decay or insect attack. The specimen should be suitable for thorough and convenient scientific examination. It should be compact so you can store it economically. Consult the references cited above for special instructions on preparing water birds which require extra degreasing, bigheaded birds such as ducks and some woodpeckers, owls, rabbits, bats, beaver, muskrat, porcupine and flying squirrels. Grease allowed to remain in any skin will eventually ruin it. The decomposing fat makes skin brittle and works through it to discolor the feathers or hair, so thorough removal is essential.

The preparation of bird and mammal skins may involve the use of potentially dangerous substances. Know the dangers and take the necessary precautions. Many workers treat the skins with arsenic as a preservative and insect deterrent. They use commercial white arsenic as a dry powder or mixed with yellow laundry soap and warm water. Arsenic is a stomach poison and skin irritant. Therefore, if it is used, avoid applying it directly with the fingers and keep the powder away from the eyes, nose and mouth. Wash hands thoroughly after use. The arsenical soap is somewhat safer to handle because it is easier to control. Label the container conspicuously as a poison. Better yet, do as some major museums do and avoid using arsenic altogether. One relatively nonpoisonous substitute is borax. Another is composed of 16 parts potassium nitrate mixed with 1 part alum. Both work well as skin preservatives, and you can control insect infestation by other means safer than arsenic. Degrease especially fat skins in a vapor chamber. Use 1, 1, 1–trichloroethane. It vaporizes at c. 160° F. (71° C.). The rising vapor penetrates the skins draped over rods and the extracted grease drips back with the solvent as it condenses. The fumes are moderately toxic and when heated may decompose into highly poisonous compounds.

Before starting to skin the animal, prepare the specimen label. Make the skull label also, if you are working on a mammal. Remember that the label becomes a permanent part of the specimen never to be separated from it. A standard pattern in the content and form will help everyone who studies the collection. For example, while writing always keep the string to the left. Enter on the first line the name of the collector, his field number, and the sex of the animal. Next, record the locality where it was collected. Then add the date and the standard measurements. Always record the measurements in the same sequence and in millimeters. For birds measure: (a) length from tip of bill to tip of longest tail feather with the specimen laid

flat on its back, (b) distance from wing tip to wing tip with wings stretched out full length, (c) weight in grams. For mammals, make the following measurements: (a) total length with the animal laid flat on its back from tip of nose to end of last vertebra in the tail excluding the hairs, (b) length of tail from its base to end of last vertebra in the tail excluding the hairs, (c) length of hind foot with the foot pressed flat from end of heel bone to tip of claw on longest toe, (d) ear length from notch to tip, (e) weight in grams. Later, use the other side of the label to record the scientific name of the animal, the name of the determiner and the museum catalogue number. On the skull tag mark the field number and collector's name. This will be enough to link it to the skin and field data. When the specimen is catalogued, apply the catalogue number directly to the cranium and also to the mandible.

Make the labels as shown in figure 6, 2½ inches long by ⅝ inch wide (c. 64 × 16mm), with two holes drilled in the positions indicated near one end. String 12–13 inches (300–330mm) of No. 30 or No. 40 uncolored linen sewing thread through the holes in the manner illustrated in figure 6, and tie the two strands together with a square knot 1 inch (25mm) from the end of the label. Use high quality paper stock of the kind made for permanent business records. Some museums specify Resistall Linen Ledger, manufactured from 100% new white cotton fibers by the Byron Weston Company, Dalton, Massachusetts. Substance 36 is a good weight. Other museums prefer the heavier Resistall Index Bristol. The special advantage of these papers over all-rag stock is said to be their durability in preserva-

Figure 6. Specimen labels for mammals.
a. Study skin label, front. **b.** Study skin label, back. **c.** Skull label.

tive solutions. Museums can thus use the same paper for labeling various kinds of specimens, including those kept in fluid. (Recent changes in the manufacturing process dictated by industrial hygiene may have affected this particular quality. So keep immersed labels under observation.) Letter the information on the label in India ink, or other permanent carbon-base ink such as Higgins Eternal, using a fine pen. Since it must be legible to all users, print the information you enter on labels.

When you have finished preparing the study skin, tie the specimen label to the crossed legs of a bird, or just above the heel on the right hind leg of a mammal. Fasten it tightly and securely so it can neither slip off nor come untied. Attach the skull label by tying it around the lower jawbone. Do not pull the thread tight as it could break the bone in small species, but be sure the knot is firm. Use a regular specimen label for the skull and snip off the extra paper.

Coldblooded Vertebrates

To obtain good study specimens of fishes, amphibians or reptiles, kill the animals in a manner that leaves the muscles relaxed. Then fix or harden the specimens in positions suitable for study and storage, and finally transfer them to a preserving fluid. The publications by Anderson and Hall, cited for birds and mammals, also contain instructions of expert collectors for preparing the lower vertebrates. Refer to them for details, but since methods vary, the following tabulation may be helpful:

Fishes

1. Killing: drop alive into a solution of 1 part commercial formalin (a 40% aqueous solution of formaldehyde) to 9 parts water.

2. Labeling: use the same kind of specimen label as with bird and mammal study skins, employing high quality paper resistant to fluid preservatives; fill in the data in the same sequence using permanent carbon-base ink, and being sure it is completely dry before immersing the label; attach it securely to the caudal peduncle. (If you are holding several fishes with identical field data for future determination and cataloguing, you may postpone making individual labels until then. Meanwhile, write the data in soft pencil on a slip of strong white paper and place this temporary label in the jar with the specimens.)

3. Fixing: when the fish succumbs, slit the abdomen with a sharp blade about half the length of the body cavity on the right side (unless the specimen is under six inches in length); leave in the formaldehyde solution 3 to 7 days according to size; wash in water, using a little alum and a brush to remove mucus if necessary, then soak 2 to 4 days in several changes of water.

4. Preserving: transfer the specimen to a tightly closed container where it will remain completely immersed in 75% ethyl alcohol; since water and body fluids in the specimen will dilute the alcohol, change over the first few days to attain the correct percentage gradually. This minimizes shrinkage. Alcohol is volatile and flammable, with a flash point close to that of gasoline, so observe fire safety precautions strictly. Its fumes are toxic in concentrations above 2.4 parts per million of air.

Amphibians

1. Killing: drop alive into a solution made by dissolving several crystals of Chloretone (chlorobutanol) in a quart or liter of water, or make a saturated solution and dilute it with four parts of water.

2. Labeling: use the same specimen labels as for other vertebrates; fill in the data in the same sequence using permanent carbon-base ink dried thoroughly before immersion; tie securely but not too tightly around the body just behind the front legs of salamanders, and just in front of the hind legs of frogs and toads, or just below the left knee of the latter. (Labels for tadpoles and salamander larvae can be inserted in the individual vials holding each specimen.)

3. Fixing: remove from the killing solution within an hour; place on a wet paper towel laid in the bottom of a shallow pan, position the specimen for convenient study by straightening the body, extending the legs, spreading the toes and arranging the tail out straight or curved back along the body to prevent breakage; cover with a second towel to hold the parts in place; gently add a solution of 1 part commercial formalin to 12 parts water immersing the specimen; except with quite small species, inject some of the solution into the body cavity and tail with a hypodermic needle, being careful to avoid distending the animal, or slit the abdomen and tail with short incisions to one side of the midline, soon after hardening begins; leave in the formaldehyde about 2 days; wash off the formaldehyde with water.

4. Preserving: immerse in 60% ethyl alcohol, keeping the specimen completely covered by the liquid and maintaining the strength of the alcohol. Remember the flammability of the preserving fluid.

Reptiles

1. Killing: drown in warm water, preferably dissolving a few Chloretone crystals in the water. (For an alternative injection method see Hall, *Collecting and Preparing Study Specimens of Vertebrates,* p. 37).

2. Labeling: use the regular vertebrate specimen labels described above; record the data in the same order, with the same permanent ink, which must be dry before the label goes into the fixing solution; tie not too tightly

around the body of a snake about ¼ to ⅓ of length behind head, or just behind front legs of a small lizard, and tightly to the left hind leg of a turtle or large lizard.

3. Fixing: as soon as the animal dies, transfer to a solution of 1 part commercial formalin to 12 parts water; make sure the fluid penetrates by injecting it into the body cavity, tail and limbs, making an injection every few inches in snakes, and in front of each leg, as well as in the neck, and tail of turtles, or make slits at each point suggested for injection; coil snakes to fit in the jar in which you will store them, arrange the legs of lizards for good visibility and compact storage, spreading the toes and straightening the tail or bending it to lie beside the body, extend the neck as well as the legs and tail of turtles and prop the mouth open; keep in formaldehyde solution 2 days; wash well in water. (For instructions on everting the hemipenis in snakes and lizards see Hall, *Collecting and Preserving Study Specimens of Vertebrates*, p. 38.)

4. Preserving: completely cover with 75% ethyl alcohol maintaining the concentration and level of the fluid, observing fire safety rules.

Insects

While the methods of preparing insects for study are standardized, they vary for large and small ones, those which are hard and soft, scaly, greasy, and so on. Since no single procedure will apply to all the kinds of insects in most collections, consult the published instructions of experts which are merely outlined below. Department of Agriculture Miscellaneous Publication 601, *Collection and Preservation of Insects*, by P. W. Oman and Arthur D. Cushman, describes most of the techniques you will need.

Kill most large insects with a gas. Oman and Cushman tell how to make two kinds of killing bottle, one using cyanide as the lethal gas, and the other employing ethyl acetate. You may be well advised, especially if you collect only occasionally, to use the ethyl acetate because cyanide is potentially very dangerous to humans. Keep several killing bottles of various sizes at hand. Wipe the insides when they become soiled or damp. Place a few strips of toilet paper in each bottle so the captured insects will not damage each other. Reserve one of the larger bottles exclusively for butterflies and moths so the scales that rub off their wings will not spoil other specimens. Insects that are quite small, and a few larger forms including mayflies, stoneflies, termites and ants, should be killed in 75% alcohol (flammable), or in a mixture of 8 parts 95% alcohol, 5 parts distilled water, 1 part glycerin and 1 part glacial acetic acid. The alcohol-glycerin-acetic fluid leaves specimens more flexible and so less liable to break when you handle them. Incidentally, handling insects with forceps rather than fingers, throughout the preparation processes, usually reduces breakage.

Preserve most insect specimens dry, mounted on special pins. You should mount very small species on microscope slides, however. A few soft-bodied forms of intermediate size are best preserved in 75% alcohol or the alcohol-glycerin-acetic mixture in small vials. You may mount specimens from the killing bottle directly on pins unless the bodies contain too much fatty tissue. In the latter case, degrease the specimens before pinning by immersion in xylene until the excess fat has dissolved. Then let them dry on an absorbent pad. Before pinning specimens killed in alcohol, you must degrease them also. First dehydrate them in 100% alcohol, which may require several hours or a day. Next, transfer them to xylene for a similar period; then dry and pin. Consult Oman and Cushman for the details of pinning. To have a good specimen you should use the right size insect pin, insert it at the correct point, and keep the back of the insect at a uniform distance below the pinhead. The specimen should be horizontal when viewed either lengthwise or sidewise. The pin should enter the body near its center of gravity, but where it will not damage or obscure important structures. This point differs among the insect orders, as illustrated by Oman and Cushman. After pinning, spread the wings of butterflies, moths, dragonflies and damselflies, and the left wings of grasshoppers and cicadas. Use the spreading board, as described in Oman and Cushman. To reinforce the fragile bodies of dragonflies and damselflies, run a fine, stiff wire from the head straight through to the tip of the abdomen. For hard-bodied insects, too small to pin but too large for a slide mount, use a triangle cut with a special punch from label stock. Mount the paper point on an insect pin and attach the specimen by the right side of its thorax to the tip with a drop of adhesive. Soft-bodied insects of corresponding size are mounted on very fine headless pins called *minuten nadeln*. These, in turn, are stuck in small rectangular blocks of balsa wood mounted on regular insect pins. For the critical study of some insect groups, dissect out the genitalia or other specialized structures, and mount them on microscope slides.

The specimen labels used for vertebrates are far too big to fit into an insect collection, yet the same kind of information must be associated with each specimen. To do this, use the same high quality, liquid resistant paper and permanent, carbon-base ink. With a crow-quill pen, print the data in as small letters as you can and still keep them legible. The finished label should not exceed about $\frac{1}{4}$ inch in height and $\frac{1}{2}$–$\frac{5}{8}$ inch in width (c. 6–7 × 12–16mm). Give the locality on the first line, the date of collection on the second, and the collector's name and field number on the third. If collecting is consistently in one locality, it pays to have labels printed in 4-point type with the locality, the month, the first two numerals of the year and your name, leaving spaces to letter in the day, the last two numerals of the year, and the field number. Should the locality require more than one line, use a separate label for the collector's name and field number. When the specimen is identified, add another label bearing the scientific name and

the name of the determiner. The first label goes on the pin a little below the specimen. The middle step of a standard pinning block sets it at the preferred height. The long axis of the label parallels that of the specimen with the top of the label to the right. The second label parallels the first, but at the height of the lowest step in the pinning block. If a third label is necessary, place it correspondingly lower on the pin. For specimens preserved in alcohol, use the same kind and size of label and slip it into the vial with the insect. Face the lettering outward so it can be read through the glass. It follows that only one specimen is kept in each vial unless several examples of the same species are collected at the same time and place.

To label microslides, cut the label stock to fit one end of the glass slide, letter the data with permanent ink, and paste the paper securely to the slide. It is a wise precaution to scratch the field number into the slide with a glass writing diamond so the essential data can be traced if the label ever comes loose.

The preservation of other invertebrates requires a variety of methods which may differ with the purpose of the collection and the experience of the curator. The following paragraphs outline some general instructions. For more specialized techniques consult Reginald Wagstaffe and J. Havelock Fidler, *The Preservation of Natural History Specimens*, Volume I, Invertebrates, New York: Philosophical Library, 1955. Do not use this reference for insects, however, because it describes a European system not favored for American collections. See also William K. Emerson and Arnold Ross, "Invertebrate Collections: Trash or Treasure," *Curator*, VIII:4, 1965. Emerson and Ross recommend adding 1 part of glycerin to 19 parts of the alcohol in the final preserving fluid. This gives added protection should the alcohol evaporate faster than anticipated. Do not add glycerin to the preservative fluid for vertebrate specimens because it has a clearing action making tissues more transparent which is undesirable in this case. Handle flammable preservatives with care.

Arachnids

Kill in 75% ethyl alcohol, and preserve in alcohol of the same strength. Use the same high quality, liquid resistant paper for labels. Letter the data with permanent carbon-base ink. Place the label in the vial with the specimen.

Centipedes and Millipedes

Kill and preserve in 75% ethyl alcohol. Letter the labels with permanent carbon-base ink on the regular resistant stock, and insert in the vial with the specimen.

Crustaceans

Use 30%–40% ethyl alcohol as the killing agent. As soon as the animal dies, transfer it to 60% alcohol and leave overnight. Then place it in 70% alcohol for preservation. Make the specimen label with the same resistant paper and permanent ink. If the specimen is collected in the water, record the depth at which you found it, along with the usual data. Keep the label in the vial or jar with the specimen.

Annelids

Before killing earthworms, leave them overnight on moistened soft paper to clear soil particles out of the digestive system. Then kill by immersing in 8%–10% ethyl alcohol. Straighten the worms at this stage, if necessary. Transfer promptly to a solution of 1 part commercial formalin to 10 parts water, for preservation. Leeches require anesthetizing before you kill them. Otherwise they may contract too tightly for study. Use a Chloretone solution as with amphibians, or add a bit of tobacco to the water. When the leech becomes insensitive, wipe off excess mucus and lay it flat on paper toweling dampened with 50% ethyl alcohol. Carefully pour 50% alcohol into the container without dislodging the specimen. Do not quite cover it at first, but after 10 minutes add enough of the alcohol to immerse it. Allow the leech to harden in the 50% alcohol. Then pass it through increasing concentrations up to 85%, which is the strength to use for preserving it. Anesthetize marine worms also with Chloretone solution. Kill in 8%–10% ethyl alcohol and move the specimens into gradually increasing concentrations until you have them in 70%–75% for preservation. Since various kinds of worms are preserved in liquid, use the resistant label stock, record the data in permanent carbon-base ink, and place the label in the container with the specimen.

Mollusks

Ordinarily, living specimens will be collected but only the shells preserved for study. To remove the soft parts from inside the shell, dip the animal into boiling water approximately one minute or until the valves open. By placing the shell in a small net, it can be held in the hot water conveniently. Then clean out the shell using forceps, a hooked needle or wire, and perhaps a knife for cutting the adductor muscle. Finish cleaning the outside of the shell with a brush. Save the operculum, if present, and keep it with the shell. Press bivalves shut again and tie with white string until the hinge stiffens. Let the specimen dry. Some fresh-water mussels have a thin coating on the shell which can be preserved by covering with a fine layer of vaseline or wax. It is not necessary to clean the soft parts from

very small shells that may be too fragile for such treatment. Place these in 70% alcohol for at least a day. Then let them dry slowly. If the outside of the shell is dirty, shake the specimen in a small vial of water with a little sand. You may find it convenient to place a specimen label in the individual specimen tray for each shell. The primary labeling, however, will be the catalogue number marked in India ink on each specimen. Slugs and cephalopods demand a different technique. Drown slugs in a bottle of warm water, brimful and tightly closed. Leave them in the water about a day without disturbing, so the animal will not contract. Transfer to 70% ethyl alcohol for a few days. Change the alcohol as it becomes diluted by body fluids. Then preserve in 80% alcohol. Kill cephalopods in 30%–40% alcohol, adding it slowly at first to narcotize the animal. Transfer to 80% alcohol using plenty of it and changing it about three times because of the volume of water in the animal. Preserve in 80% alcohol. Prepare the specimen label in the usual way for immersion.

Echinoderms

Kill sea urchins and starfish in fresh water. Leave them for a few hours, then transfer to ethyl alcohol starting with 30%–40% and working up to 70% for preservation. Kill brittle stars in 70% alcohol. Change the solution to maintain its strength and preserve in 70% alcohol. Preserve sea cucumbers in 70% alcohol also, but they must be anesthetized to prevent contraction, and special care taken to counteract the large volume of water in their bodies. Place the specimen label, prepared for immersion, in the container with the specimen.

Coelenterates

To kill jellyfish and other coelenterates in a relaxed condition, add formalin to the water, little by little. Preserve in a solution of 1 part commercial formalin to 20 parts water. Insert the label in the container as previously described.

For the continuing care of biological specimens in the collection, see Chapter 4.

The alcohol used to prepare and preserve specimens should approximate the recommended percentages. If it is too weak, the specimens will decay; if too strong, the tissues become hard and brittle. Check the strength of the mixture with an alcohol hydrometer graduated in percentages. The following dilution table may help in preparing the desired strength:

95% alcohol to 85% add 13 volumes of water to 100 of alcohol (v/v).

 80% add 21

 75% add 30

 70% add 39

 60% add 63

 50% add 96

 40% add 144

 30% add 224

 10% add 856

Some workers use isopropyl alcohol as a less expensive substitute for ethyl alcohol, but others have found it an unsatisfactory replacement as a long-term preservative.

Identifying and Authenticating Specimens

The curator's final step in preparing specimens for the collection is to identify them. Little or no use can be made of an object in research or interpretation until you know what it is. Therefore, identify each specimen as completely and accurately as possible. Anyone soon reaches the limits of his own expertness, however. So when personal experience, the available reference books, and opportunities for comparisons have been exhausted, consider the determination of the object as still tentative. Have a specialist in that particular category of objects confirm, refine or correct it.

The procedure for obtaining expert determinations of natural history objects begins with selecting the expert. Choose someone who is an acknowledged authority on the group of specimens concerned. As the next step, write to the specialist and obtain his permission before sending him the specimens for identification. He may welcome the opportunity to be helpful and to study material from your particular area. On the other hand, what he is asked to do requires considerable time and work. Consequently, it is customary in some fields of natural history for the specialist to keep part or all of the material sent to him for determination. That is why two specimens of a plant growing in the same colony should be collected if possible. Press both, mount one for the herbarium, and send the other unmounted to the expert. He sends you the name of the plant, and keeps or discards the specimen. In the case of other natural objects clarify in advance, usually by correspondence, the situation in regard to duplicate specimens. Because the specimens of park museums are ordinarily government property, any duplicates he wishes to keep would be recorded as on indefinite loan. Pack the specimens carefully so the specialist receives them in good condition. Include all the data about each object that will help or

interest him as he studies it. Try to make it as easy as possible for him to repack and return the objects safely. Be sure to record his name as identifier in the catalogue.

Follow the same procedure to obtain expert identification of excavated Indian material. Archeologists rarely ask to retain any of the specimens sent to them, however. If they do find need for a specific duplicate, they presumably will initiate the request for it.

The identification of historical artifacts may be more difficult. It is harder to find people who have won scholarly recognition as authorities on these objects. For park museums most of the historical specimens sooner or later will be sent to the central museum staff for preservative treatment or to be incorporated in an exhibit. At that time the staff can help secure expert identification of the artifacts, if necessary by consulting curators in other museums or similar outside experts. A copy of the catalogue record for each specimen should be sent along with it for amplification or correction if the park desires such assistance. The procedures for historical material apply generally to ethnological specimens as well.

With many historical objects there is the added problem of authentication. The history of a specimen must be verified. Was it really made in this community or by that craftsman? Did it really belong to this person or play a part in that event? Such questions may be crucial in the decision to acquire the object, as well as in making use of it. To answer them satisfactorily requires all the pertinent information that can be gathered. The data must then be weighed and sifted, rigorously applying the rules of evidence as in a court of law. The evidence, the reasoning and the conclusions, should be recorded so they will remain available for review by others in the future. Before acquiring any object of questionable authenticity, accept it on approval. Then submit it for critical examination by experts. If the specimen is already in the collection, evaluate its authenticity along with identifying it. The experts will need all the information about the object that can be supplied. When authentication is needed by a park museum, object and data are referred to the curators on the central staff.

Even after the specimens in the collection have been identified and authenticated by specialists, welcome revisions and refinements by other bona fide experts, and record them in the museum catalogue. Be sure to record the name of the expert too.

BIBLIOGRAPHY

Organic Material

Rice, James W. "Principles of Textile Conservation Science, No. II: Practical Control of Fungi and Bacteria in Fabric Specimens," *Textile Museum Journal*, I:1 (November 1962), pp. 52–55.
————. "Principles of Textile Conservation Science, No. XI: Requirements for Bulk Storage Protection Against Insect Damage," *Textile Museum Journal*, II:4 (December 1969), pp. 31–33.
Yadon, Vernal L. "A Portable Fumigation Chamber for the Small Museum," *Museum News*, 44:5 (January 1966), pp. 38–39.

Waterlogged Specimens

Albright, Alan B. "The Preservation of Small Water-Logged Wood Specimens with Polyethylene Glycol," *Curator*, IX:3 (1966), pp. 228–234.
Ambrose, W. "Freeze-drying of Swamp-degraded Wood," *Conservation of Stone and Wooden Objects*, London. International Institute for Conservation of Historic and Artistic Works, 1970, pp. 53–57.
Christensen, B. Brorson. "Developments in the Treatment of Waterlogged Wood in the National Museum of Denmark During the Years 1962–69," *Conservation of Stone and Wooden Objects*. London. International Institute for Conservation of Historic and Artistic Works, 1970, pp. 27–44.
Eriksen, E., and S. Thegel. *Conservation of Iron Recovered from the Sea*. Royal Danish Arsenal Museum Publication 8. Copenhagen. Nordlunde, 1967.
McKerrell, Hugh, Elisabeth M. Roger and Andre Varsanyi. "The Acetone/Rosin Method for Conservation of Waterlogged Wood," *Studies in Conservation*, 17:3 (August 1972), pp. 111–125.
Muhlethaler, Bruno. *Conservation of Waterlogged Wood and Wet Leather*. Paris. Editions Eyrolles, 1973.
Munnikendam, R. A. "Conservation of Waterlogged Wood using Radiation Polymerization," *Studies in Conservation*, 12:2 (May 1967), pp. 70–75.
Oddy, W. A., and P. C. van Geersdaele. "The Recovery of the Graveney Boat," *Studies in Conservation*, 17:1 (February 1972), pp. 30–38.
Organ, Robert M. "Carbowax and Other Materials in the Treatment of Water-Logged Paleolithic Wood," *Studies in Conservation*, 4:3 (August 1959), pp. 96–103.
————. "Polyethylene Glycols in the Treatment of Waterlogged Wood: Some Precautions," *Studies in Conservation*, 5:4 (November 1960), pp. 161–162.
————. *Design for Scientific Conservation of Antiquities*. Washington. Smithsonian Institution Press, 1968, pp. 14, 136–138, 291–314, 422.
Pearson, C. "The Preservation of Iron Cannon after 200 Years under the Sea," *Studies in Conservation*, 17:3 (August 1972), pp. 91–110.
Rees-Jones, Stephen G. "Some Aspects of Conservation of Iron Objects from the Sea," *Studies in Conservation*, 17:1 (February 1972), pp. 39–43.
Rosenqvist, Anna M. "The Stabilization of Wood Found in the Viking Ship of Oseberg—Part II," *Studies in Conservation*, 4:2 (May 1959), pp. 62–72.

Seborg, Ray M., and Robert B. Inverarity. "Conservation of 200-year-old Water-logged Boats with Polyethylene Glycol," *Studies in Conservation*, 7:4 (November 1962), pp. 111–120.

Smith, James B., Jr., and John P. Ellis. "The Preservation of Under-Water Archeological Specimens in Plastic," *Curator*, VI:1 (1963), pp. 32–36.

Tomashevich, G. N. "The Conservation of Water-Logged Wood," *Problems of Conservation in Museums*, Paris. Editions Eyrolles. London. George Allen & Unwin Ltd., pp. 165–186.

Rapidly Deteriorating Objects

Keck, Caroline K. *How to Take Care of Your Pictures: A Primer of Practical Information*. New York. Doubleday & Co., 1958, pp. 38–40.

Plenderleith, H. J., and A. E. A. Werner. *The Conservation of Antiquities and Works of Art: Treatment, Repair, and Restoration*. 2nd. ed., 2nd printing. London. Oxford University Press, 1971, pp. 59–63.

Unesco. *The Conservation of Cultural Property with Special Reference to Tropical Conditions*. Museums and Monuments—XI. Paris. UNESCO, 1968, pp. 43–52.

For an introductory view of painting conservation, a highly specialized field, see:

Keck, Caroline K. *A Handbook on the Care of Paintings*. New York. Watson-Guptill Publications for the American Association for State and Local History, 1965.

Plenderleith, H. J., and A. E. A. Werner. *op. cit.*, pp. 162–186.

Stout, George L. *The Care of Paintings*. New York. Columbia University Press, 1948.

Unesco. *The Care of Paintings*. Museums and Monuments—II. Paris. UNESCO, 1952.

Freshly Collected Biological Specimens

Anderson, Rudolph M. *Methods of Collecting and Preserving Vertebrate Animals*. Bulletin 69. Biological Series 18. 4th ed. rev. Ottawa. National Museum of Canada, 1965.

Anthony, H. E. *The Capture and Preservation of Small Mammals for Study.* Guide Leaflet 61. 3rd ed. New York. American Museum of Natural History, 1931.

Blake, Emmet R. *Preserving Birds for Study*. Fieldiana: Technique 7. Chicago. Chicago Natural History Museum, 1949.

British Museum (Natural History). *Mammals (Non-marine)*. Instructions for Collectors 1. 6th ed. London. Trustees of the British Museum (Natural History), 1968.

———. *Birds*. Instructions for Collectors 2A. London. Trustees of the British Museum (Natural History), 1970.

———. *Reptiles, Amphibians, and Fish*. Instructions for Collectors 3. London. Trustees of the British Museum (Natural History), 1963.

———. *Insects*. Instructions for Collectors 4A. 4th ed. London. Trustees of the British Museum (Natural History), 1963.

———. *Invertebrate Animals Other than Insects*. Instructions for Collectors 9A. 2nd ed. London. Trustees of the British Museum, 1954.

————. *Plants*. Instructions for Collectors 10. 6th ed. London. Trustees of the British Museum (Natural History), 1965.

————. *Alcohol and Alcoholometers*. Instructions for Collectors 13. 2nd ed. London. Trustees of the British Museum, 1938.

Cantrall, Irving J. *Notes on Collecting and Preserving Orthoptera*. Compendium of Entomological Methods II. Rochester. Ward's Natural Science Establishment, Inc., 1941.

Chapin, James P. *The Preparation of Birds for Study*. Guide Leaflet 58. 2nd ed. New York. American Museum of Natural History, 1929.

Dawson, E. Yale. *Marine Botany: An Introduction*. New York. Holt, Rinehart and Winston, 1966.

Emerson, William K., and Arnold Ross. "Invertebrate Collections: Trash or Treasure?" *Curator*, VIII:4 (1965), pp. 333–346.

Forest Service. *Handbook on Forest Service Plant Collections*. FSH 4083.3. Washington. Division of Administrative Management, Forest Service, United States Department of Agriculture, 1966.

Franks, J. W. *A Guide to Herbarium Practice*. Handbook for Museum Curators E 3. London. Museums Association, 1965.

Gray, Alice. *How to Make and Use Safe Insect-Killing Jars*. Direction Leaflet 1. New York. American Museum of Natural History, n.d.

————. *How to Make and Use Insect Nets*. Direction Leaflet 2. New York. American Museum of Natural History, n.d.

————. *How to Collect Insects and Spiders for Scientific Study*. Direction Leaflet 3. New York. American Museum of Natural History, n.d.

————. *How to Mount and Label Hard-Bodied Insects*. Direction Leaflet 4. New York. American Museum of Natural History, n.d.

————. *How to Make and Use Spreading Boards for Insects*. Direction Leaflet 5. New York. American Museum of Natural History, n.d.

————. *How to Preserve a Collection of Soft-Bodied Insects and Spiders*. Direction Leaflet 6. New York. American Museum of Natural History, n.d.

Hall, E. Raymond. *Collecting and Preparing Study Specimens of Vertebrates*. Miscellaneous Publication 30. Lawrence. University of Kansas, 1962.

Hower, Rolland O. *The Freeze-Dry Preservation of Biological Specimens*. Proceedings of the United States National Museum, Volume 119, no. 3549. Washington. Smithsonian Institution, 1967.

————. "Advances in Freeze-Dry Preservation of Biological Specimens," *Curator*, XIII:2 (1970), pp. 135–152.

Klots, Alexander B. *Directions for Collecting and Preserving Insects*. Rochester. Ward's Natural Science Establishment, Inc., 1932.

Knudsen, Jens W. *Collecting and Preserving Plants and Animals*. New York. Harper & Row, 1972.

Lawrence, George H. M. *Taxonomy of Vascular Plants*. New York. Macmillan Company, 1951, pp. 234–262.

Lucas, Frederic A. *The Preparation of Rough Skeletons*. Guide Leaflet Series 59. New York. American Museum of Natural History, n.d.

Mahoney, R. *Laboratory Techniques in Zoology*. London. Butterworth, 1966.

Oman, P. W., and Arthur D. Cushman. *Collection and Preservation of Insects*. U. S. Department of Agriculture Miscellaneous Publication 601. Washington. Government Printing Office, 1948 (reprinted 1964).

Owen, G., and H. F. Steedman, "Preservation of Molluscs," *Proceedings of the Malacological Society of London*, 33:3 (December 1958), 3 pp.

Ross, H. H. *How to Collect and Preserve Insects*. Circular 39. Urbana. Illinois State Natural History Survey Division, 1966 (8th printing).

Savile, D. B. O. *Collection and Care of Botanical Specimens*. Publication 1113. Ottawa. Research Branch, Canada Department of Agriculture, 1962.

Smithsonian Institution. *A Field Collector's Manual in Natural History*. Publication 3766. Washington. Smithsonian Institution, 1944.

Traver, Jay R. *Collecting Mayflies (Ephemeroptera)*. Compendium of Entomological Methods I. Rochester. Ward's Natural Science Establishment, Inc., 1940.

Wagstaffe, Reginald, and J. Havelock Fidler, eds. *The Preservation of Natural History Specimens*. New York. Philosophical Library and London. H. F. & G. Witherby Ltd., I. Invertebrates, 1955, II. Zoology: vertebrates. Botany. Geology, 1968.

Identifying and Authenticating Specimens

The tentative identification of specimens, especially by the curator in a small museum, frequently depends on comparing them with published descriptions, illustrations and taxonomic keys. These descriptive materials occur in many kinds of publications including popular field guides, AASLH technical leaflets, special interest or professional periodicals, monographs and scholarly catalogues. They are too numerous and varied in scope to permit useful listing here. For biological and geological specimens the appropriate curator in the nearest large public or university museum of natural history can recommend books or separate articles on the kinds of objects from the geographical areas involved. To identify historical artifacts start with the references in:

Rath, Frederick L., Jr., and Merrilyn Rogers O'Connell. *Guide to Historic Preservation, Historical Agencies, and Museum Practices: A Selective Bibliography*. Cooperstown. New York State Historical Association, 1970, pp. 118–184.

Update these by consulting the book review section of *Museums Journal* and *Museum News*. Additional references on aspects of identification or authentication include:

Anthony, Pegaret, and Janet Arnold, *Costume: A General Bibliography*. London. The Costume Society, 1966 (reprinted 1968).

Brown, Lewis S. "Two Small Bronze Horses," *Curator*, XII:4 (1969), pp. 263–292.

Bulletin of APT, quarterly, Association for Preservation Technology, Box 2682, Ottawa.

Costume, annually, Costume Society, Victoria and Albert Museum, S.W. 7, London.

Ekholm, Gordon F. "The Problem of Fakes in Pre-Columbian Art," *Curator*, VII:1 (1964), pp. 19–32.

Furniture History, semi-annually, Furniture History Society, Victoria and Albert Museum, S.W. 7, London.

Guldbeck, Per E. *The Care of Historical Collections: A Conservation Handbook for the Nonspecialist*. Nashville. American Association for State and Local History, 1972, pp. 33–46.

Keck, Caroline K. "Technical Assistance: Where to Find It, What to Expect," *Curator*, VIII:3 (1965), pp. 197–211.

Olsen, Stanley J. "The Archeologist's Problem of Getting Non-artifactual Materials Interpreted," *Curator*, II:4 (1959), pp. 335–338.

Thornton, Peter. "English Furniture Studies Today and Tomorrow," *Museums Journal*, 65:3 (December 1965), pp. 195–203.

Zigrosser, Carl, and Christa M. Gaehde. *A Guide to the Collecting and Care of Original Prints*. New York. Crown Publishers, Inc., 1965.

Chapter 4 Caring for a Collection

Museums gather objects of many kinds. Some of these, such as the Liberty Bell, Washington's inaugural costume and the artifacts of the English settlers at Jamestown, have transcendent importance in themselves. Others are simple everyday objects which reflect aspects of the past. Still others record and verify research. All are alike in requiring constant care to preserve them. Metals corrode; paints, dyes and inks fade; cloth, hides and wood are subject to insect and rodent attack; and many other hazards threaten the survival of museum specimens. None will last forever, but with proper attention you can enable specimens to endure for centuries to come. It is the obligation of a museum to make sure that they receive this care.

Basic Steps

Whoever acts as curator of the collections, regardless of position title, must do four things regularly and without fail:

1. See that each specimen entering the collection is properly prepared for preservation.
2. Place the object in a safe environment.
3. Inspect it periodically.
4. Provide it repeated preservative treatment as necessary.

The first step involves the various procedures discussed in Chapter 3, Preparing Specimens for the Collection. Chapter 3 limits its concern to the kinds of objects needing treatment immediately upon receipt. In addition the collection probably contains artifacts which are not deteriorating rapidly enough to create an emergency. Nevertheless, these specimens ordinarily need cleaning, repair and protective coating or other initial preservative treatment, perhaps including restoration. The best treatment to apply varies with the nature and condition of each object. Choosing the right materials and methods, and knowing just how fast or how far to proceed, requires trained judgment and skill. Specialized knowledge rather than haste is paramount. This is why park museums rely on centralized

treatment by experienced conservators in most cases. The museum informs the regional curator of all untreated artifacts in its care. Depending on the particular situation, directions will be provided for shipping specimens to the central laboratory or to another approved conservation laboratory for treatment, or a conservator will visit the park to work on the objects there, or detailed instructions will be given for treating them locally. Essentially, the treatment involves removing dirt or other deleterious foreign matter from the specimen by methods that do no harm to the object itself. Then, the specific causes of deterioration are removed or counteracted. Broken parts are reattached and weak points strengthened. In some instances, further treatment restores the object to the condition or appearance it had when originally in use.

The standard reference for the care of artifacts is Harold J. Plenderleith and A. E. A. Werner, *The Conservation of Antiquities and Works of Art: Treatment, Repair, and Restoration*, 2nd ed., 2nd printing, London, Oxford University Press, 1971. See also the bibliography on care of collections at the end of this chapter. Whenever possible, however, make use of trained conservators to provide the skills and equipment required. The safest way to find a qualified expert is to consult a Fellow of the International Institute for Conservation of Historic and Artistic Works. Any curator concerned about the care of his collections can apply for associate membership in IIC, and can become a well informed layman in this field by reading the IIC publications. Most conservators in the United States and Canada also belong to the American Institute for Conservation of Historic and Artistic Works. Curators can become associate members of AIC and receive its bulletin.

To execute the second step, placing the specimen in a safe environment, implies protecting it as fully as practicable from the numerous agents of deterioration and destruction. The factors involved and recommended methods are discussed in subsequent sections of this chapter.

Inspection, the third step, is a vital responsibility. Examine every specimen in the collection at regular intervals. The frequency of inspection may vary with the nature of the material and the adequacy of storage facilities. If the collection is carefully filed in cabinets, racks and shelving of proper design and quality, and in a secure room with good control of light, temperature and humidity, inspection can ordinarily be timed as follows:

Geological specimens, ceramic, glass and well treated metal—once a year

Specimens subject to insect attack or mold—every six months

Specimens preserved in liquid—every six months.

When storage conditions are less than ideal, check the objects oftener. Specimens on exhibition also need more frequent examination. In addition to daily inspection of exhibits through the glass, open the cases every three to six months for a closer look at any specimens susceptible to light, mold,

insects or corrosion. The act of inspection consists of searching for evidences of deterioration in each specimen. It is necessary to know what may attack the object and what the agent and its effects look like. See the section on Agents of Deterioration below.

The fourth step becomes essential because several kinds of objects require periodic treatment to assure their continued protection. As soon as the effects wear off, they must be processed again. The following list is not exhaustive but includes the commoner situations needing step 4:

Herbaria—renew continuous fumigant in each cabinet every three to six months depending on the chemical used and how often the cabinet is opened, fumigate with an insecticide registered by EPA for museum use (see Organic Material, Chapter 3) at least once a year.

Insect collections—renew continuous fumigant in each drawer every three to six months, fumigate with an insecticide registered by EPA for museum use if any infestation occurs.

Study skins—renew continuous fumigant in each drawer every three to six months, fumigate with an insecticide registered by EPA for museum use if any infestation occurs.

Specimens preserved in liquid—add enough alcohol of the proper strength every three to six months to keep specimens submerged. Sealing the jar top in place with clear silicone rubber aquarium cement reduces the rate of evaporation.

Metal artifacts—avoid touching the metal with bare hands, e.g., by wearing gloves, and wipe clean after each handling; renew protective covering as needed.

Leather artifacts (except rawhide and buff leather)—remove adherent dust and reapply British Museum leather dressing every year, treat with potassium lactate solution every four years. Some conservators prefer lanolin or a mixture of 40% anhydrous lanolin and 60% neatsfoot oil to the British Museum formula for leather dressing because the latter tends to remain tacky in the warmer climate of most American museums unless applied as thinly as possible. National Park Service conservators overcome the stickiness by applying a final thin coating of a harder microcrystalline wax having a melting point at 160°–180° F. (71°–82° C.).

Leather bookbindings—apply British Museum leather dressing, lanolin or lanolin and neatsfoot oil every year, clean with saddle soap and treat with potassium lactate solution every four years.

Paper—turn pages of exhibited books, even under ultraviolet filters, every month watching also for evidence of fading, embrittlement or mold.

Textiles (especially wool) and artifacts containing hair, feathers, hide or wood—renew continuous fumigant in each drawer and exhibit case every three to six months, clean fabric when necessary.

Adjust the suggested frequency of treatment to fit observed conditions in the museum.

Choose as a continuous fumigant either paradichlorobenzene or dichlorvos (2,2-dichlorovinyl, dimethyl phosphate). Paradichlorobenzene has several advantages. It is both an insecticide and a fungicide. Its EPA registrations adequately cover normal museum use. It is readily available. You can use it with relative safety. On the other hand, it damages some commonly used plastics and may cause some pigments, particularly red-browns, to fade. Many retail stores sell it as a household protection against clothes moths. The white crystals sublime at room temperature changing directly from a solid to a vapor which kills insects and molds. Use enough to develop and maintain an effective concentration of the vapor (1 pound per 100 cubic feet or 162 g per m^3). For a Cornell insect drawer about .07 ounce (2 g) gives this proportion. Common practice would place about a teaspoonful of the crystals in the smallest size pinning tray for each drawer of an insect cabinet and renew the supply as the amount obviously diminished. A standard specimen cabinet requires 3.2 ounces (90 g), an herbarium cabinet 2 ounces (57 g) and an average size exhibit case perhaps ½ pound (227 g). If the crystals do not disappear within a few months, the temperature may be too cool for the gas to evolve at a rate to do much good or the case may be exceptionally well sealed. Avoid prolonged breathing of paradichlorobenzene; heavy doses are harmful. Dichlorvos (e.g. Vapona) protects the collection better from insect attack, but not from mold. It becomes harmful to breathe in concentrations above 1 microgram per liter of air. Being more nearly odorless, it should be used with greater caution. The chemical is impregnated in a resin strip from which it slowly evaporates. The product bearing EPA Registration No. 201–237, and referred to as a military ministrip is the only form legally usable for stored museum materials. Only government agencies may obtain it at present. Since future registrations may make it more widely available to museums, dichlorvos is cited as a possible alternative to paradichlorobenzene.

Protective coatings on metals likely to be encountered in step 4 include waxes and lacquers. Iron and steel specimens often have a covering of wax. The wax forms a barrier through which only small amounts of water vapor and oxygen can pass. It therefore retards rusting. Microcrystalline waxes provide the best protection, but hard paste wax such as Simoniz or Butcher's is also quite effective. First wipe off the old wax with Stoddard solvent. Remove any rust that has formed under the wax. Use a mild abrasive such as jewelers' rubber erasure-like polishers, fine steel wool or 600 grit aluminum oxide or emery paper (e.g. Tri-M-ite). If the object has rusted badly since the previous treatment or is sweating, go back to step 1. Before recoating be sure the specimen is clean and dry. For drying use a warm oven or infrared lamp if the specimen permits, or dip it in acetone (a highly flammable and toxic solvent to be used with caution). Paste wax can be rubbed on with a cloth pad. Apply three coats, letting each dry for about ½ hour before polishing. If the specimen is heat-dried, apply the

first coat while the metal is still warm. Microcrystalline wax needs to be applied as a liquid or specially prepared as a paste. Melt the wax and dip the specimen into it. Let the excess wax drain off. When the remaining wax has set, polish it with a soft cloth. Or mix the microcrystalline wax carefully with dipentene in a double boiler (5 parts wax to 8 parts dipentene). Use an electric hot plate and work in a well ventilated space because the solvent is flammable and toxic. Brush the resulting paste on the specimen, covering the surface completely. After the solvent evaporates, polish the wax with a soft cloth.

Silver, brass, bronze and copper may have a protective coating of lacquer. When tarnishing occurs, remove the old lacquer with acetone using proper safety precautions. Clean the silver, preferably with a chemical dip used quickly and followed by thorough washing, or by placing it in an aluminum pan and immersing it in a 5% solution of washing soda until the tarnish disappears. The latter method requires a careful rinsing in running water. Then polish the object with a soft cloth, being careful not to touch the metal with bare fingers. When the specimen is dry and free of grease, spray it with a tarnish inhibitor and recoat it with clear lacquer. Plastic lacquers in aerosol cans (e.g. Krylon) may be used. To remove the tarnish from brass, bronze or copper before washing, drying and relacquering, use a gentle abrasive such as precipitated chalk or whiting in ammonia (e.g. Noxon). Lead specimens may have a protective coating of wax. If powdery lead carbonate has formed on the object, strip the wax with Stoddard solvent. Remove the corrosion using, if possible, the ion exchange method described on pp. 270–272 of Plenderleith and Werner (*op. cit.*). Then dip the specimen in melted microcrystalline wax, handling it always with rubber-tubing-tipped tongs to avoid touching the metal.

In the periodic cleaning of leather specimens, including bookbindings, remove loose dust with a vacuum cleaner or by brushing. If the object is still grimy and is not rawhide or buff leather, go over it with saddle soap on a damp cloth. Wipe it carefully with a clean, soft cloth and let dry. Whenever you wash leather in this manner, follow with a potassium lactate treatment to restore protective chemicals. Purchase from a library supply company such as Technical Library Service or prepare a solution of potassium lactate (7%) and paranitrophenol (.25%) in distilled water (92.75%). The paranitrophenol acts as a fungicide to prolong the life of the solution. Use a pad of absorbent cotton to apply the liquid, coating the leather completely but not saturating it. Allow the specimen to dry. Then apply one of the recommended leather dressings. Some conservators prefer a mixture of 40% anhydrous lanolin and 60% neatsfoot oil for this purpose. The neatsfoot oil must be free of sulfur compounds, and this is hard to assure even from reliable dealers. National Park Service conservators therefore use laboratory grade anhydrous lanolin alone, obtainable from chemical suppliers. The conservators dilute the lanolin with Stoddard sol-

vent to a good working consistency. Apply this liberally with a cloth or brush, but take pains to protect any paper or cloth parts of the object from contact with the oils. Let the specimen stand for 24 hours. If necessary, apply a second coat and allow a day for it to be absorbed. Then wipe off any excess of the dressing with a soft cloth. Go over it again with a fresh cloth. The other recommended formula, British Museum leather dressing, can be obtained from chemical supply firms. It contains anhydrous lanolin, an oil and wax. It is quite flammable, so observe fire precautions. Apply it lightly and rub it into the leather with your fingers. After two days polish with a soft cloth. If it remains tacky, add a thin layer of microcrystalline wax with a 160°–180° F. melting point (71°–82° C.) rubbed on and polished. In treating leather objects take special care in dressing hinges and other parts that may receive extra wear. Portions of the leather that have begun to powder have deteriorated beyond the point where these methods can help. Specimens in this condition should fall again under step 1.

If fabrics are found to be dusty, vacuum clean or brush them gently when it can be done without endangering the specimen. A moderately weakened textile can sometimes be vacuumed safely by stretching plastic window screen on a wooden frame, laying the specimen on this and covering it with more screen. Textile specimens need to be washed or dry-cleaned when a vacuum fails to remove the dirt. For this they should be reconsidered under step 1. For specimens on exhibition as furnishings in historic houses see Methods and Materials, Chapter 11.

Agents of Deterioration

To protect a collection intelligently and efficiently, you must know the enemy. By understanding what factors endanger specimens and how these factors operate, and by being able to recognize their presence or the conditions that favor them, a museum can combat them successfully. You are almost certain to encounter the following destructive agents, and must be continuously on guard against them.

Humidity

Water vapor in the air, and the liquid water which condenses from it, form a potential hazard to museum specimens. Humidity affects objects in several ways. Too low a relative humidity extracts water from some materials, with resultant damage: paper, parchment and leather become brittle; glue and paste dry out and lose adhesive power; even well-seasoned wood in equilibrium with its normal environment will lose water and may warp. When relative humidity is too high, many materials absorb water. The water enters into degenerative chemical reactions, as in the

corrosion of metals. It also permits the growth of mold which digests components of the specimen, and leaves disfiguring stains. It softens adhesives. Rapid changes in relative humidity cause hygroscopic materials to swell and contract. Wood warps and checks. Oil paintings crack and flake. If the object contains soluble salts, these dissolve, migrate and recrystallize which may cause either chemical or mechanical damage.

When inspecting the collection, watch for the evidence of poor humidity conditions. Mold appears as fuzzy patches growing on any organic material, or as discolored spots on paper. Active corrosion forms encrustations on metal. Paintings sag a little on their stretchers or become too taut. The paint cracks, cups and begins to flake. Wood cracks, bends or twists. Flakes crack off salt impregnated metal. These, however, are signs of damage already well under way. It is better to measure the relative humidity and keep it within safe limits. As discussed below under Climate Control, you should aim at maintaining the relative humidity between 40% and 60% with 55% as the target, except in semi-arid sections where hygroscopic specimens, which absorb moisture from the air, have already achieved equilibrium by gradually adjusting their water content to that of the atmosphere which is at a lower percentage. Museums equipped to maintain separate storerooms at the different levels of humidity ideal for particular kinds of objects will have several target percentages.

Be sure you have protected all specimens from accidental contact with liquid water. If overhead pipes or the roof spring a leak, as they almost surely will someday; if rain should drive through a window broken in a storm or inadvertently left open; if flooding is a possibility; have you already provided a safe barrier between the potential source of water and the collection?

Temperature

High temperature above 70° F. (21° C.) permit molds to grow if the relative humidity is also high, and may speed up the life cycles of harmful insects. Low temperature by itself does little or no damage to museum specimens. Fluctuating temperatures, however, can be doubly destructive. Matter tends to expand and contract as temperature rises and falls. When a specimen incorporates two or more substances that respond to temperature changes at different rates, dangerous strains can develop. Repeated freezing and thawing may also do much damage to specimens having high water content. A secondary effect of temperature variation is more often serious. When temperature drops in a closed space, relative humidity rises, and vice versa. To hold relative humidity within safe limits you ordinarily must control the temperature as well. Try to keep it between 60° and 75° F. (16° and 24° C.).

In caring for the collection keep watch of temperatures along with

humidity. Be alert for the danger signals. When conditions are too warm, look for mold on organic materials, especially in dark and poorly ventilated places. If the temperature varies much beyond the recommended range, check composite artifacts to see if the bond between materials is loosening. Such specimens may include paintings, objects made of two or more kinds of metal, or wood and metal combinations. However, if relative humidity should fall below 45% in an area where sensitive materials such as paintings or furniture are stored or exhibited, try to raise it by lowering the temperature. A 10° F. (6° C.) fall in temperature can result in a rise of about 20% in relative humidity.

Light

The radiant energy of light absorbed by molecules of a specimen may cause chemical changes that seriously damage the object. Organic materials are most vulnerable, but even such seemingly inert substances as some ceramics and glasses are affected. One familiar result is the fading of colors. Less apparent is the weakening of fibers. Silk, for example, may lose half its strength from less than a month of exposure to sunlight. Both wave length and amount of light (as determined by the duration of exposure) influence the processes of degeneration. The shorter wave lengths, especially in the ultraviolet range, possess the greatest photochemical activity, but the visible spectrum also causes deterioration which increases with the amount of light and the duration of exposure.

In checking the collection, make sure that organic materials not on display are stored in darkness. Watch susceptible specimens on exhibition for any signs of fading or of threads breaking. More important, use filters to screen out the ultraviolet components of sunlight or fluorescent light, limit the amount of illumination to 15 footcandles (150 lux) or less in exhibits containing vulnerable specimens such as documents, textiles, watercolors or biological specimens and keep the exhibit area dark when it is closed to the public. See Garry Thomson, *Conservation and Museum Lighting*, London, Museums Association, 1974.

Dust

Composed largely of minute mineral particles, dust is an abrasive. When water condenses around the particles, some of them become active chemical agents attacking the specimens directly. Dust disfigures specimens by soiling the surface, and its removal involves washing, wiping or shaking, which accelerate wear and tear and increase the risk of physical damage. Nearly all types of objects suffer to some extent if allowed to gather dust.

Again, prevention is better than treatment. Keep most specimens in dust-tight storage or exhibit cases. Provide dust covers of flame-proofed un-

bleached muslin or polyethylene for objects stored on shelves or otherwise exposed in storage. If plastic covers are used, be sure to allow enough ventilation to avoid condensation. Check for accumulated dust, perhaps with some form of "white-glove inspection". Clean specimens by approved methods before they get too dirty.

Chemical Air Pollution

Industrial fumes, motor vehicles exhausts and domestic heating by-products contaminate the air with numerous chemical compounds. These include, or combine to produce, sulfuric acid and other strongly corrosive or oxidizing agents. Some of the pollutants attract water and so facilitate harmful chemical reaction. Near the coast the air contains chloride salts and other compounds. They are often highly corrosive. Inside closed exhibit cases the air may be polluted by organic acids from inadequately seasoned wood or by sulfur-containing solvents liberated from unsuitable paints, textiles used for display backgrounds or foam rubber gaskets. These pollutants can cause silver to tarnish, bright copper to discolor, lead to become coated with a white powdery encrustation and leaded bronze to grow crystals. Salts already present in porous specimens may dissolve in condensed water, migrate outwards, crystallize and redissolve with changes in humidity. Upon crystallization, the salts develop severe pressures within the object. Thus, air pollution exposes many kinds of museum objects to chemical and physical damage. Metals, stone and many organic materials suffer attack, fabrics and leather especially.

Watch for rust or flaking in iron specimens, corrosive encrustation on copper or lead and their alloys, heavy tarnishing of silver. Observe stone objects for signs of flaking or crumbling. Look for evidence of rotting in textiles, or of leather becoming brittle. If you have no convenient way of determining the amount and kinds of air pollution in the museum, be vigilant to detect its effect on specimens (but see fig. 14). In urban areas, and elsewhere if conditions are bad, steps should be taken to clean and filter the air as well as treating the specimens. Avoid using materials that release harmful vapors in the construction of exhibit cases or storage equipment. These include oak unless seasoned and thoroughly sealed with paint, other inadequately seasoned woods, paints containing lithopone, unpainted hardboard, acidic papers and plastics containing certain plasticizers.

Mold

If the collection provides organic material to grow on and the humidity exceeds 65% with a temperature 70° F. (21° C.) or above, mold (also called mildew) can be expected. Mold spores are so fine, light and numer-

ous that they occur practically everywhere. It has been estimated that molds have destroyed more specimens than any other agency. Since the myoolium (tho uouolly unooon throudliko growing und fovoding purt) uotu ally dissolves and absorbs components of the specimens, it causes more than superficial damage. Look for velvety patches or small areas of discoloration. See Rapidly Deteriorating Objects, Chapter 3 for emergency treatment. Particularly avoid a warm, damp environment for specimens.

Insects

Some of the destructive species of insects, almost certainly, will get into the collection sooner or later. The damage they do can be rapid and irrevocable. Therefore, insect infestation is one of the real emergency situations encountered in curatorial work. Insects attack, in some degree, all specimens composed of organic materials. They eat the sizing on paper, the glue in bindings and the paper itself. They devour cloth, hair, feathers. They bore tunnels in wood. The insects wreaking havoc with your collection may be larvae or adults, small or large, conspicuous or hidden. The most common invaders include dermestid beetles, powder-post beetles, clothes moths, silverfish and cockroaches.

To recognize infestation by the common insect pests, look for the following signs:

Dermestids

The carpet beetle and related species that attack a wide variety of museum specimens are destructive as larvae. The adults are small, about $1/8$–$3/16$ inch long (3–5mm) and inconspicuous. The larvae are elongate-oval or tapering and $1/4$–$1/2$ inch (6–13mm) long (fig. 7), characterized by prominent reddish, brown or black bristles. The first evidence may be a cast larval skin, visible on the white background of the specimen tray or the case floor. A fine dark powder may collect below the point where a dermestid is feeding. In insect collections this dust gathers at the foot of the pin while the larva devours the body of the specimen. Infestation may be detected through visible damage to an object such as holes in woolen textiles, loose hair or pile, and wings or legs falling off mounted insects.

Powder-post beetles

Several species of wood-boring beetles attack the wooden parts of museum specimens. The larvae do the damage, but you do not see them, and rarely see the adults. Evidences of a powder-post infestation are the small round or oval holes some species leave at the surface (fig. 8), and the fine light powder that may accumulate below such openings, or that can be shaken or tapped out of them.

Figure 9a

Figure 9b

Figure 7 Figure 8

Figure 7. Dermestid larvae, *Anthrenus* sp. Courtesy, U.S. Department of Agriculture, Bureau of Entomology and Plant Quarantine.

Figure 8. Wood infested with powder-post beetles.

Figure 9. Clothes moths, *Tinea pellionella*. Courtesy, U.S. Department of Agriculture, Bureau of Entomology and Plant Quarantine.
a. Adults and larvae.
b. Larval cases.

Figure 10

Figure 11

Figure 12a

Figure 12b

Figure 10. Silverfish, *Lepisma saccharina*. Courtesy, U.S. Department of Agriculture, Bureau of Entomology and Plant Quarantine.

Figure 11. Envelope damaged by silverfish. Courtesy, U.S. Department of Agriculture, Bureau of Entomology and Plant Quarantine.

Figure 12. Cockroaches, *Blatta orientalis*.
a. Adult. Courtesy, U.S. Department of Agriculture, Bureau of Entomology and Plant Quarantine.
b. Egg case.

Clothes moths

You probably recognize and kill on sight the adult moth with its narrow, buff-colored wings spreading about ½ inch (13mm). The larvae do the actual feeding on hair, fur, wool, feathers or other animal fibers. They are white grubs, about ½ inch long (13mm), with dark heads. They spin a light-colored web or case covering their bodies, and you may observe these before seeing the insect itself (fig. 9). Moth holes and other damage caused by their feeding may be all too evident unless you detect the infestation early.

Silverfish

These wingless insects which may be up to ½ inch long (13mm) have a tapering shape and three prominent caudal "bristles" (fig. 10). Their bodies are covered with gray scales. At all stages of development they may be destructive to paper specimens, bookbindings, rayon textiles and starch in cloth. Most often their presence is detected by seeing a silverfish when a light is turned on, a book opened or a specimen lifted. By closer inspection, you can tell where size or paste has been eaten from the surface of paper. In extreme cases the insects may have removed the entire surface including any printing or lettering on it. This can be disastrous with specimen labels as well as specimens (fig. 11).

Cockroaches

All five species that infest buildings are relatively broad, oval, flat, brownish insects. They vary in size according to age and species, from barely visible to 2 inches long (50mm). They eat many things, but are especially destructive to bookbindings, any paper having paste on it, mounted insects and some textiles. Roaches tend to feed at night and are most often seen when a light is turned on. Look for them in dark crevices and other hiding places during your inspections. Also watch for the characteristic egg cases (fig. 12). Evidence of their feeding on paper specimens may resemble the work of silverfish.

To treat an insect infestation fumigate the affected specimens as described under Organic Material, Chapter 3. Seal and fumigate with paradichlorobenzene any specimen storage cabinets involved. Additional preventive measures include keeping paradichlorobenzene crystals or dichlorvos strips with all organic specimens, the use of insect-tight storage cabinets and rigorously good housekeeping. If infestations become frequent, have a professional exterminator treat the entire building by fumigation or the application of residual insecticides sprayed or blown into the spaces where the pests lurk. The exterminator should not apply any material directly to museum specimens.

Rodents

Mice, rats, squirrels and other small rodents that sometimes infest buildings may attack museum collections. Because they can destroy numerous specimens in a single night, their incursions call for emergency measures. These animals may eat some kinds of organic specimens, and use others for nest building. Prehistoric fiber sandals, for example, provide fine nesting material. So do textile specimens and paper, including specimen labels.

Watch closely for droppings, for signs of gnawing on vulnerable objects and for the rodents themselves. Proper specimen storage cabinets, herbarium and insect cabinets, and most exhibit cases are designed to be rodent-proof. Use traps or an EPA registered poison with prescribed safeguards to eliminate infestations in the building.

Fire

Few museum specimens would survive a major fire, at least without severe damage. Metal cabinets and shelving for specimen storage reduce the amount of combustible material but transmit heat readily, and therefore afford little protection. That also is why you need to keep the original copy of the museum catalogue in a vault or wherever it will receive maximum fire protection.

When inspecting collections, make sure that flammable materials do not accumulate near the specimens. Do not let paints, solvents, packing materials, lumber and cleaning materials be stored in the same room with the objects. If small quantities of flammables are at hand for frequent use, place them in special containers approved for fire protection. Stress good housekeeping in the museum. Eliminate extension cords and any other makeshift electric wiring. Work out with a fire protection expert the number, kinds and proper location of fire extinguishers and who should be trained to use them. Decide what specimens, if any, are so rare and valuable that they should be evacuated from the building in case of fire. Mark their location clearly, and work out a plan of action with the local fire-fighting organization. Study and apply the information contained in the National Fire Protection Association publication, *Recommended Practice for Protecting Museum Collections from Fire* (NFPA No. 911) and in Appendix G.

Humans

Careless handling, malicious destruction and theft constitute the principal human hazards to the collection. Broken, bent, scratched, dented, soiled or corroded specimens may result from careless handling. When objects are dropped, piled together or leaned against something improperly, damage may occur. Even nominally clean fingers leave a print of oil and

moist salts that can corrode metal. The dangers of handling are greatest while you are transporting specimens within or outside the museum. Malicious damage tends to be unpredictable, but thieves usually steal objects they hope to sell. Weapons, jewelry, small paintings and things associated with famous names are most tempting.

In guarding against human destructiveness, do not curtail the legitimate uses of the collection. By keeping a specimen in its individual chipboard tray you can handle it more safely, seldom touching the object itself and protecting it from accidental contact with other specimens in the same drawer. Other types of properly designed specimen storage equipment also help to minimize careless handling. They should eliminate the need to pile objects together or lean them against one another. Strictly observe rules for transporting specimens in the museum. For example, carry only one object in your hands at a time. Keep one hand under the specimen. Do not lift a specimen by protruding parts that might prove fragile. Place the object in a padded tray for moving from room to room. If more than one are put in the tray, use adequate padding to keep them from touching one another. General rules for handling some kinds are given in Frieda Kay Fall, *Art Objects: Their Care and Preservation*, La Jolla, Laurence McGilvery, 1973; and in Robert P. Sugden, *Care and Handling of Art Objects*, New York, Metropolitan Museum of Art, 1946. They can be readily adapted to other types of specimens.

When specimens are shipped, pack them with special care. Ordinarily this involves wrapping the specimen itself in white tissue paper fastened snugly with masking tape (but being sure the tape does not come into contact with the object), then surrounding the wrapped specimen with corrugated board securely taped, then carefully wrapping the package in kraft paper, and sealing it with tape. Pack the wrapped object in a box or tin can suitably padded with shock absorbing material so that it "floats" with adequate protection on all sides. If several specimens are shipped together, float each one in its individual carton or can as described above and then carefully pack several of these into a strong wooden shipping box or larger can with adequate padding. Never, on the other hand, pack heavy objects in the same shipping box with light or fragile ones. Whenever specimens are packed for shipment, assume that the package will receive rough handling en route despite precautionary markings. Figure 5 illustrates ways to pack oil paintings for shipment, but especially valuable objects need to be kept in a controlled environment en route (see Nathan Stolow, *Controlled Environment for Works of Art in Transit*, London, Butterworths, 1966). Caroline K. Keck, *Safeguarding your Collection in Travel*, Nashville, American Association for State and Local History, 1970, may also help.

The materials used to pack specimens for shipment are selected to protect them from physical damage in transit. Corrugated board, wrapping paper,

tape, padding and crating lumber may well have an acid content or other properties that will harm objects left in contact with them. So unpack specimens promptly on receipt, perhaps leaving the inner wrappings on for a day or two to slow down the rate at which the objects take up or lose moisture in their new environment.

National Park Service museums, like other museums, have experienced thefts. The thieves have included an expert who removed a valuable specimen from a case and left a cheap replica in its place, a disgruntled former employee seeking revenge, a kleptomaniac, roving juvenile gangs, and unscrupulous visitors pocketing souvenirs. The range of incidents emphasizes the necessity for appropriate measures. The security of the collection depends first and last upon personnel. Someone obviously must become aware of an act of theft or vandalism. Someone must prevent the offense or restore the loss and, if possible, apprehend the offender. Many museums lack the manpower to keep a continuous watch on the collections, but much can be done to extend the effectiveness of the existing staff. Measures to consider include protective operating procedures, detection devices and alarms. Good judgment is necessary to determine what special protection, if any, a collection warrants. The costs of security, which include staff time, equipment installation and service charges, must be weighed against (1) the monetary value of the specimens; (2) their scientific, historical or interpretive importance; (3) the possibilities of replacement; and (4) the reputation of the museum as a safe custodian of valuable property. In cases where the money value of a specimen or collection predominates, the costs of special protection over a 10-year period probably should not exceed the replacement cost. The amount which may properly be spent to protect a collection of primarily intangible value requires an administrative decision in each case. The curator should recommend the best protection he can justify and request funds to implement it.

No staff or budget should prove too small to maintain the following standard procedures if the collection contains tempting material that would be difficult or expensive to replace:

1. In writing, assign specific responsibility for the security of the collections to one staff member. Give him authority and responsibility to deputize and train another reliable staff member to perform the security functions when he is not on duty.

2. Have him provide a thorough check of the building at closing time each day. He should make sure that all exhibit specimens are in their proper places, no one has tampered with case or specimen fastenings, the study collection area has been closed and locked, the original copy of the museum catalogue is locked in a fire-resistant safe, all unauthorized persons are out of the building, all doors and windows are securely locked, and night lights are on.

3. Have him check the exhibits at opening time to be sure all specimens are in place.

4. Give him adequate control over keys, after-hours entry and access to study collections, remembering that these are for use.

5. In accordance with an operating plan worked out in advance, have him establish and maintain contact with the police who will be called in when trouble occurs.

6. Be sure the museum catalogue contains all the detailed information needed to identify and establish ownership of a stolen object if it is recovered.

7. Report any loss to the proper staff and police authorities immediately.

Some other preventive measures give additional low-cost but valuable protection. Would-be thieves and vandals avoid well-lighted, plainly visible areas. Good exterior lighting, especially at points of possible entry, helps deter these people. Night lights in the lobby and hallways make it more likely that someone may observe an intruder (but specimens which light tends to deteriorate should not be subject to illumination at night). Landscape planting and building design can eliminate, or at least minimize, potential hiding places near doors and windows. Gates or chains can prevent driving a get-away vehicle conveniently close to the building.

Devices can be installed in the building to detect the presence or activity of an intruder. In effect they extend the eyes and ears of the staff concerned with protection. During open hours they can warn the attendant at the information desk or the security officer that someone has opened an emergency exit, has entered a restricted area or is tampering with an important exhibit. When the museum is closed, these devices can signal the opening of a door or window, the movement of a person inside the building or the touching of a specimen. They vary so widely in technical nature, cost and suitability to a particular situation, that a museum needs expert advice in making a wise choice. Invite several reputable companies to study the problem and submit proposals for selection.

The detection device transmits its message to the person responsible. Unless he receives it and acts promptly, the equipment is practically useless. The continuous availability of a receiver—that is, a living person—and the speed and effectiveness of his response are, therefore, key factors in designing or selecting a system. A traditional burglar alarm using a loud bell or horn on the outside of the building to alert anyone who happens to be within earshot is of dubious value. The primary receiver should be the museum's protection staff, the responsible police headquarters or a central station operated by the company installing the system. The device should send its message when it detects intrusion, but also if a malfunction occurs or someone tampers with it. Otherwise it might be out of order at the crucial moment. All detection and alarm equipment requires regular expert maintenance and periodic testing.

Detection Equipment

The types of detection equipment available include the following:

Devices to Detect Unauthorized Entry or Exit

1. Door and Window Switches. Opening the door or window makes or breaks a built-in electrical contact which transmits a signal. This type provides a relatively simple, inexpensive, reliable but strictly limited form of detection.

2. Window Tape Circuits. A band of conductive tape glued to the inside of the glass and connected to suitable terminals sets up an electrical circuit around each window. If the tape is broken by removal or breakage of the glass, the interruption of the current triggers a signal. Many store windows have this protection. The tape is plainly visible, so an intruder knows what to expect. Being obvious, the tape is esthetically objectionable in many museum situations.

Devices to Detect Movement of Intruders Inside the Museum

1. Pressure Switch Pads. A thin plastic sandwich contains convex strips of metal connected by fine wires. The plastic pad is hidden under carpeting or floor mats. When an intruder steps on it, his weight flattens the curved metal and makes an electrical contact. The current carries the signal. The pads may be located inside points of entry, close to vulnerable exhibits or throughout the museum. The pads are sturdy and moderate in price.

2. Sound Detectors. Sensitive microphones concealed at strategic points in the museum react to even slight increases in the sound level by signaling the principal receiver. He may then turn up the volume to determine what caused the noise.

3. Ultrasonic Detectors. A centrally located device fills a room with high frequency sound waves inaudible to most people. Any movement in the area which interferes with the wave pattern activates a signal. This type has been installed in some museums, so the waves may be completely harmless to specimens although annoying or intolerable to some sensitive ears.

4. Photoelectric Cells. Two kinds of detection systems depend on the response of a photoelectric cell to changes in illumination. One uses beams of light focused on a cell. By arranging the light beams so that anyone moving from a point of entry to a vulnerable exhibit would cross a beam, an intruder would interrupt the light causing the cell to send its warning signal. A disadvantage of this method is the difficult of hiding the equipment so a thief will not be aware of the beams and perhaps avoid them. The

second type uses a photoelectric cell as in a light meter to detect any changes in the overall illumination of an area. At night a match or flashlight will induce a signal; in daylight a passing shadow can activate the cell.

5. Closed-Circuit TV. A number of large museums use TV cameras mounted to scan the exhibit rooms so one man at a console can maintain a watch over a wide area. This system is primarily for daytime use and has the added disadvantage that the cameras must be at least partially exposed to view and might give visitors an uncomfortable feeling of being watched.

Devices to Detect Attempts on Individual Exhibits

1. Pressure Switches. Electrical switches including small versions of the switch pads described above can be mounted beneath or behind specimens. The weight of the object or its pressure as mounted holds the switch open or closed. A slight decrease in the pressure caused by someone trying to lift or move the object activates the switch sending a signal.

2. Vibration Detectors. A relatively small electronic device can be attached to the back of some specimens and to the base or mounts of others. Any attempt to move the object causes enough vibration to set off the device which transmits the warning signal.

3. Capacitators. Devices which create an electrostatic field within a case or around a specimen provide an "electronic fence". Anyone reaching into the protected area upsets the balance of the system which signals the change even before the specimen is touched.

For more detailed information consult André F. Noblecourt, "The Protection of Museums Against Theft," *Museum*, XVII:4 (1964), pp. 184–196, 211–232 and other references on museum security cited at the end of this chapter.

The planning and installation of security measures against theft and vandalism should be correlated closely with fire protection. Dovetailing the day-to-day procedures and the detection systems for security and fire protection should increase the efficiency and economy of both.

Some museums have experienced disasters caused by human violence, storms, fire or flood. Military action has ravaged many museums. A tornado heavily damaged the Kansas State Historical Society Museum and a hurricane devastated the Jefferson Davis Shrine in Biloxi, MS. The Corning Museum of Glass suffered a destructive flood. The list of fire-damaged museums is long. Consider these risks seriously. Planning ahead can reduce losses greatly. Measures may include keeping a copy of the museum catalogue in a safe repository elsewhere, stockpiling materials that would be needed to give emergency protection or aid salvage in the damaged structure, training the staff for disaster duties and organizing procedures.

Climate Control

By keeping museum specimens in a suitable environment, you prolong their existence and minimize the preservative treatment they need. Materials differ in their optimum humidity and temperature requirements. The working comfort of the people who use the specimens must also be considered, but is less critical than the welfare of specimens which could suffer irreparable harm. Taking the variables into account, it has been determined that the best attainable conditions for most museum collections comprise the following:

Relative humidity	40%–60%
Temperature	60°–75°F. (16°–24°C.)
Light	15 footcandles or less, free of ultraviolet (150 lux)
Air	freed of as much dust and chemical pollution as is practicable.

Museums should try to maintain this climate in the exhibit and study collection rooms the year round. Special circumstances admit a few exceptions, however. In semi-arid sections of the Southwest, for example, specimens have adjusted their water content in balance with a lower range of moisture in the air. Museums in such dry areas may find it better to hold the relative humidity as near 40% as feasible. Some park museums necessarily close during the winter, often becoming buried in snow. The continuous cold protects objects from insects and mildew and the snow denies access to some other destructive agents, but humidity conditions may become detrimental, especially during thaws. A careful inspection with this in mind, made when the museum is reactivated, may indicate future protective measures. Fortunate museums that are far from industrial plants, traffic congestion and sources of blowing dust, need not worry about purifying the air.

The first step in climate control is to measure the temperature and relative humidity of the air surrounding the objects in the collections, and the amount of light that reaches them. The instruments used to determine the relative humidity will also indicate the temperature. At least two kinds are needed. As the basic instrument, use a battery operated aspirated psychrometer (fig. 13a). This compact piece of equipment has a small electric fan driven by flashlight batteries. The fan draws a uniform stream of air over the wet bulb and dry bulb thermometers. As long as the wick is clean, closely fitted to the thermometer bulb and never handled with the fingers or eposed to blowing dust, distilled or deionized water is used in the reservoir, and adequate battery power is maintained, the psychrometer will provide accurate readings. Employ it to take periodic measurements of relative humidity and temperature in the rooms as a whole, and in confined

a. Aspirated psychrometer

b. Hygrothermograph

Figure 13. Instruments for measuring relative humidity and temperature in museums.

d. Dial hygrometer

c. Sling psychrometer

e. Paper hygrometer

spaces where poor air circulation may create different conditions. Use it also to calibrate the second instrument. The psychrometer does not permit you to measure effectively the relative humidity inside exhibit cases and specimen storage cabinets where most objects are kept. For these situations a hygrothermograph that will measure relative humidity and temperature continuously for as long as a week, and record them by inked lines on a chart is needed (fig. 13b). Set the hygrothermograph inside and close the case. It will operate long enough to record the atmospheric conditions as they settle down to normal after the opening and closing. The recording instrument depends on a hair or synthetic fiber element that expands and contracts as it absorbs or releases moisture. The element, however, tends to accommodate to prevailing conditions so must be calibrated every few weeks by comparing the reading with that of the psychrometer and making any adjustments required. If the collections contain important or valuable objects susceptible to damage by too much or too little moisture, measure conditions continually. Do so especially if the local climate imposes severe humidity conditions. Museums that face less critical climatic situations should make occasional checks at different seasons to be sure that relative humidity percentages really are not dangerous. Less expensive instruments can be substituted, with some loss of convenience and accuracy. You can use a sling psychrometer in place of the aspirator (fig. 13c), and a dial type hair hygrometer which does not record, but can be read at regular intervals (fig. 13d). A dial thermometer is often part of the same instrument. Paper hygrometers having dyed patches that change color at different percentages of relative humidity provide another convenient check (fig. 13e).

To determine the amount of light striking the specimens use a light meter. The ones intended for photographers give exposure readings so get a meter which registers directly the footcandles or lux of incident light, for example GE Type 213 or others designed for measuring incident rather than reflected light. (On a camera meter set at ASA100 and f4 the reading $\frac{1}{4}$ second approximates 15 footcandles or 150 lux.) To obtain a measurement hold the meter close to the specimen without shading it and follow the manufacturer's instructions. Check the calibration periodically. If no daylight enters the room, one set of readings should suffice until new lighting fixtures are introduced. When natural light reaches the objects, a series of measurements are needed to reveal the range produced by daily and seasonal cycles, and by changing weather. Be sure that the light fixtures and all transmitting or reflecting surfaces are clean, and that any fluorescent tubes are relatively fresh when taking readings. A monitoring instrument for measuring the proportion of ultraviolet in museum light has been developed, but is necessarily expensive (see Garry Thomson, ed. *1967 London Conference on Museum Climatology*, rev. ed., London, IIC, 1968, pp. 151–172).

A device for measuring the amount of some common air pollutants in museums is available (fig. 14). You can also obtain impregnated paper strips which change color in the presence of sulfur dioxide. Use one of these means, if possible. Also watch for situations in the neighborhood that might produce dangerous concentrations, and observe closely for sooty deposits and other signs of air contamination.

The control of relative humidity in the museum may involve three approaches, singly or perhaps in combination: condition the air and circulate it through the museum; simply add water vapor to the air at one time and extract it at another to counteract seasonal and day-to-day weather changes; or buffer the humidity fluctuations that normally occur. The choice should depend on such factors as the importance and susceptibility of the objects being protected, as well as on cost. Air-conditioning, if it is designed and operated in the interest of the specimens, provides the fullest and most effective control. A good system should be able to hold both temperature and relative humidity continuously within the safe limits defined above. A problem occurs in freezing weather, however, because water vapor condenses on the cold surface of windows and exterior walls even when the overall relative humidity of the inside air is far below the desirable minimum. Condensation occurs on surfaces cooled to 35° F. (2° C.), for example, when the air-conditioning system is delivering air at relative humidities of 30%–35% and 70° F. (21° C.). The resulting liquid water damages or disfigures woodwork and structural members. Thus, in a climate with cold winters, an air-conditioned museum must be particularly well insulated and have double glazed windows in order to allow proper humidity levels. It may also be desirable to use a vapor-barrier paint on the inner face of exterior walls so water from the moist air in the building will not get in and freeze. Another difficulty arises if the equipment is turned off

Figure 14. Testing kit for pollutant gases in the air. The device measures amounts of sulfur dioxide, nitrogen dioxide, hydrogen sulfide, carbon monoxide and carbon dioxide in parts per million.

at night to save money. In the visitor center of one humid park this practice not only permitted the relative humidity to climb too high overnight but caused wide, rapid fluctuations each morning as the system resumed operation. Humidifying equipment tends to give trouble unless supplied with water nearly free of dissolved minerals.

If air-conditioning is impractical, use humidifying and dehumidifying appliances in the museum rooms to raise and lower the relative humidity before it exceeds safe percentages. In temperate climates, this usually means operating the dehumidifier in summer when humid weather prevails outside, and turning on the humidifier in winter to overcome the drying effect of central heating. In both situations, control the equipment with humidistats that will turn them on and off in response to significant changes in the relative humidity of the room air. You will also need to keep a hygrothermograph in operation, or a dial hygrometer under observation as a check on the actual conditions the appliances create. If a dial hygrometer, which is cheaper, is used, be sure to calibrate it regularly also (see above). Portable dehumidifiers designed for household use serve the purpose adequately if fitted with humidistats. Some extract water by refrigeration. Others use silica gel and reactivate it automatically. In selecting a humidifier, choose one that supplies water vapor by evaporation. Avoid for museum use the kinds which create aerosol dispersions of water in the air because they also may spread chemical impurities contained in the water unless the water supply can be deionized economically. Units for home use that combine dehumidification by refrigeration and humidification by evaporation, both under humidistat control, work well, but must be switched manually from one operation to the other. Evaporative humidifiers fall off rapidly in effectiveness as the relative humidity of the air rises about 35% so extra units will be needed if 50% is actually to be achieved.

Small room dehumidifiers can be used to dry the air in individual exhibit cases displaying valuable objects. This has worked well in the highly humid and salt-laden atmosphere of some Atlantic coastal forts, for example, where exposed metal specimens would visibly corrode overnight. In such critical circumstances, a spare machine should always be at hand in case of mechanical failure. Silica gel will serve the same purpose if a sufficient quantity is exposed to the air inside the case and reactivated as often as necessary. Silica gel is reactivated by heating it at about 400° F. (204° C.) for several hours. By including a small amount of the gel treated with a humidity sensitive blue dye it is easy to tell by the color (which turns pink) when it needs baking. If you use indicator gel, limit the reactivating temperature to about 300° F. (150° C.). Higher temperatures blacken it irreversibly. Both the dehumidifying appliance and the silica gel method require specially designed exhibit cases to contain but conceal the drying agent.

When objects which require controlled humidity are kept in tight exhibit

or study collection cases, buffering may suffice. Buffering depends on the fact that a hygroscopic substance readily exchanges water vapor with the air around it until its moisture content is in balance with the relative humidity of the air. In this state the substance gives off or takes in moisture whenever the relative humidity falls or rises. It thus tends to hold the relative humidity close to the point of equilibrium. Therefore, if you can condition such hygroscopic material to air at 55% relative humidity and enclose enough of it in the case with the specimens, it will keep the case air near the optimum percentage. For precise control you would need special laboratory equipment to condition the buffer, since it must be held under just the right atmospheric environment for several days. As an exception, a particular silica gel such as Fisher S–699, when available, can be wetted directly in order to introduce the required water. Follow the directions given by R. M. Organ (*Museum News*, 51:3 (November 1972) p. 5). To calculate accurately the amount of buffer needed to compensate for changes in ambient temperature would require data on the hygroscopic characteristics of the material. In less critical situations, take advantage of the buffering effect without such precision. Silica gel is an excellent buffer. Wood, cellulose fiber boards, newsprint, and cotton or linen cloth have similar hygroscopic properties at a lower level of efficiency. These materials placed in a case tend to reduce the magnitude of relative humidity changes. Use them particularly to supplement other control methods and to protect specimens in shipment. Since wood, fiber board, and newsprint may contain acids, the cloth offers a safer substitute for silica gel. Fresh wood shavings, for example, can lead to corrosion in lead alloys and newsprint can cause paper specimens to become brittle. To give some idea of effective quantities, one successful installation reported in Technical Supplement 11, *Museum News*, 44:6 (February 1966), used about 4 pounds of conditioned silica gel to every 3 cubic feet of air in the case (23 kg to 1 m^3). Care was taken to expose the gel as fully as possible to the case air.

Temperature control in an air-conditioned museum should give few problems. Be sure, of course, that the system operates continuously to maintain the stable environment needed for the specimens. If the museum is not air-conditioned, there may be more difficulty with temperature in summer than in winter. Most central heating systems should permit, in the cold months, room temperatures above 60° F. (16° C.) and well below 75° F. (24° C.) overnight and on weekends, as well as during working hours. In summer you may have to depend on the judicious manipulation of shades and ventilation to hold to a minimum periods when the temperature in the museum exceeds 75° F. (24° C.). Shutting out as much as possible of daytime heat, and letting in cooler night air, help the situation some. Exhibit lighting should, of course, be outside the cases. Even so, check to be sure that sufficient air and glass separate the light sources from the specimens to prevent heating of the objects.

Control of light in a museum should protect the specimens from ultraviolet radiation and from too much exposure to the visible spectrum. Although the danger of ultraviolet could be eliminated by depending entirely on incandescent lamps for illumination, most museums choose to cope with it for practical and esthetic reasons. (Note that low voltage incandescents and quartz-halide or other high efficiency incandescent lamps of high color-temperature may generate a little ultraviolet.) Museums usually want a token amount of daylight, not to light the exhibits but to keep in touch with the outdoors. The light contains much ultraviolet, but adds to visitor comfort and pleasure. Many museums also prefer fluorescent lamps because they generate less heat and cost less to operate. On the other hand, they emit ultraviolet wave lengths. As a first step in control, minimize the amount of ultraviolet coming from these two sources. Let no direct sunlight reach a specimen. Use curtains, Venetian blinds, baffles, overhangs, plantings, or other means to moderate the amount of daylight entering the rooms containing specimens, without cutting off a view or at least a sense of the outdoors. If daylight is used to illuminate exhibits, be sure it is first reflected and scattered from a wall or ceiling painted with zinc oxide or titanium white. When a fluorescent tube burns out in a park museum, it is replaced with a standard warm white lamp. White fluorescent tubes come in at least seven color variations: white, soft white, warm white, deluxe warm white, cool white, deluxe cool white, and daylight. Tests have indicated that the standard warm white lamps normally release substantially less ultraviolet than the others. Diffusing louvres or screens also help to lessen the intensity of ultraviolet reaching the objects.

A second step should be taken when an exhibit contains an important specimen liable to photochemical damage. It should be shielded from all ultraviolet radiation. The best method presently available filters out all wave lengths of radiant energy below visible light by a chemical formulation in clear plastic, (e.g. Plexiglas UF-3). To filter out the ultraviolet components of all light reaching the object, cover it with a box made of this highly transparent, almost colorless material. If there are several specimens in the case to protect, and daylight is not involved, slip sleeves of the plastic filter over the fluorescent tubes. Sheets of the filter material could be used to cover windows or case tops, although it is hard to keep clean without scratching. Plexiglas UF-3 has a slight color. For specimens in which this would be objectionable use Plexiglas UF-1. It is colorless and filters out almost all of the ultraviolet. Comparable protection can be obtained from some other films and tube sleeves having the same light transmittance characteristics. The effective life of available ultraviolet absorbing materials is uncertain. So check the filters for ultaviolet transmittance or replace them periodically. Checking requires the use of a special ultraviolet meter.

To protect specimens from an excess of visible light, control the amount

striking them. Limit the level of illumination and also its duration. Measures for reducing the quantity of daylight in your museum are noted above. If the light meter still shows more than 15 footcandles (150 lux) reaching vulnerable objects, an exhibits specialist should collaborate on the necessary changes in number, voltage or distance of the light sources to retain the proper display effect. Paper and ink may suffer particularly from exposure to light. Therefore, cover any valuable document on exhibition with a clear yellow filter such as Plexiglas 2208. This cuts out the light waves at the lower end of the visible band without affecting legibility. The remaining light, however, can still energize photochemical deterioration, so turn the pages of a book at least once a month. A single page document should not ordinarily remain on exhibition. Show it on special occasions and substitute a photocopy (identified as such) for everyday viewing. It is also good practice to install a dense filter or opaque cover over especially susceptible objects and let visitors lift it to examine the specimens. As another way to minimize the time of exposure, provide a means for visitors to switch on the case lights while using the exhibit. Consider some of these measures for watercolors and textiles, which are vulnerable to photochemical action.

Air pollution presents another problem in climate control. If the museum is air-conditioned, reasonable control can be achieved with care and testing. The right kind of dry filter can remove 90% or more of the solid particles. Avoid electrostatic filters for museum use because they tend to add ozone to the air. Ozone is a strong oxidizing agent. The water spray that washes and humidifies the air in the system takes out some of the remaining solids and some of the gases. By making the water alkaline it will remove more of the dangerous sulfur dioxide. Activated charcoal in the system also eliminates some gaseous pollutants, but must be regenerated periodically. Some museums without air-conditioning have reduced dust in study collection storerooms by installing good quality dry filters in the doors and any other air intake points. Another good practice is to dust mop the collection storeroom floors gently the first thing each morning after the dust has settled overnight.

Study Collection Space

Good management of a museum collection requires space for the preparation, storage and study of specimens. Each of these functions calls for specialized facilities. You cannot provide them all satisfactorily in a single room. They share, however, the need to be together because each involves

the same objects and the same people. It is equally important to locate the facilities close to the offices of staff members who must work on the collection between other pressing duties, and who should oversee it when outsiders use the specimens.

Specimen preparation involves fumigating, cleaning and mounting. It often produces strong, unpleasant odors as well as dust and waste matter. It needs effective ventilation. It also requires lighting for close handwork. In this space a staff member in the natural sciences, for example, makes study skins, dries and mounts plants, pins insects or trims rock specimens. An archeologist washes sherds, restores pottery or removes corrosion from excavated metal. A curator of history cleans or treats a variety of artifacts. The minimum equipment includes a fumigating chamber, a well lighted work table, a laboratory sink with drainboards, hot and cold water, adequate electrical outlets and proper cabinets for the varied instruments and the supplies which often include moderate quantities of flammable liquids and poisons. The nature of the collection will dictate what other, more specialized equipment you need. Although the disagreeable by-products must be isolated, visitors find it fascinating and instructive to observe specimen preparation in progress. In instances where the work goes on much of the time, this interest may justify a viewing window from the exhibit room or other public space.

The storage of specimens imposes different requirements. In this space, especially, relative humidity and temperature need to be controlled; light must be excluded from vulnerable specimens; objects should be protected from insects, rodents and airborne pollution; fire needs to be guarded against; and access must be limited. The next section of this chapter describes the kinds of specimen storage equipment park museums use. To calculate how much space should be reserved for this function, estimate the number of cabinets and length of shelving needed to file the present collection in a systematic and convenient manner and to provide for its planned growth. Allow aisles 4 feet wide between rows of cases for safe handling of drawers and large objects.

Using the collection in research demands room to spread out specimens for comparison, to examine them closely, measure them, describe them and draw or photograph them. Such work needs good light. The space should also be well ventilated because some of the objects will reek with preservatives. Equip it with study tables at which to examine specimens critically using microscopes or whatever other optical or measuring instruments are required, and to record the results. Study tables are needed for as many staff members and visiting specialists as are likely to use the collection at the same time. Provide enough counter or tabletop space, in addition, to lay out several drawers from specimen cabinets. Museum records will probably be kept here in the study area, except for the original catalogue that belongs in the vault. Ready access to a sink is desirable.

Specimen Storage Equipment

Park museums keep study specimens in the cabinets, shelf units or boxes detailed below. Service-wide adoption of this equipment has had several advantages. Every park obtains types that have been thoroughly tested and proved effective and convenient, adds compatible units as the collection grows, and swaps surplus units or parts with other parks. Familiarity with the equipment carries over when staff members move from one park to another. Standardization permits quantity buying with some savings in cost.

Standard Specimen Cabinet (figs. 15, 16)

This tightly closing steel case practically excludes insects, rodents, light, dust and room air. Therefore it is used for most museum objects including study skins, geological specimens, archeological and ethnological materials and historical artifacts. On the other hand for insect collections, herbaria, zoological specimens preserved in liquid, framed pictures and documents, as well as outsized objects, park museums use the cabinets or shelf units described for these below. The standard cabinet is 29 inches wide × $31\frac{15}{16}$ inches deep × $36\frac{7}{8}$ inches high (736 × 810 × 937mm). The flat top provides a convenient, counter-height working surface, but cases may be stacked two or even three high as the collection grows. The gasketed front fastens with pressure catches or a locking mechanism to assure tight sealing, and lifts free to provide easy access. Refrigerator type gaskets, e.g. of butyl rubber, may retain a closer seal than the usual ones of

Figure 15. Standard specimen storage cabinet showing two types of doors. Both doors lift off. Those on the left are also hinged.

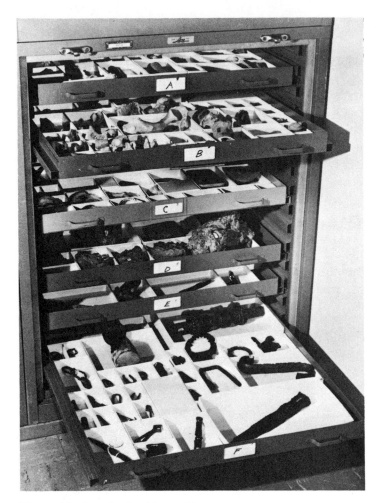

Figure 16. Standard cabinet with trays.

polyurethane foam, but all require replacement in time. The cabinet has runners spaced 2 inches (50mm) apart to accommodate 16 shallow drawers. By using fewer drawers you can space them to take taller or thicker objects. Most parks find it satisfactory to order only 10 drawers per case. Each drawer will support at least 50 pounds (22.5 kg) of specimens, and will fit any case made to the standard specifications.

A case of similar construction but twice as wide would accommodate hides of larger mammals or some of the bigger artifacts and still fit well into a range or stack of the standard-size cabinets (fig. 17).

In using the standard cabinet, curators do not as a rule place specimens directly in the metal drawer. They put each object in an individual chipboard tray and set the tray in the drawer. The tray protects the specimen from rolling and bumping other objects as the drawer is slid in and out. It minimizes specimen handling, makes arrangement more orderly and re-

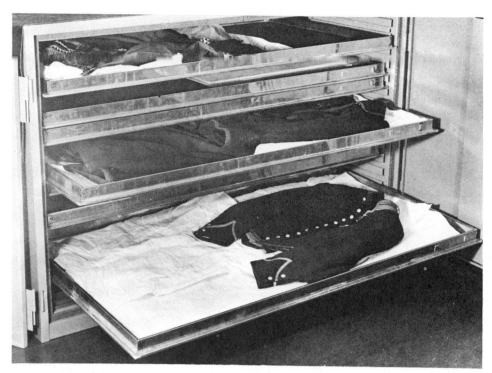

Figure 17. Double-size specimen cabinet.

arrangement easier. Each tray is lined with glazed, non-acid paper as a further protection. Trays come in six sizes:

1. 11.7 × 14.5 × 1.5 inches (296 × 368 × 38mm)
2. 11.7 × 7.25 × 1.5 inches (296 × 184 × 38mm)
3. 5.85 × 7.25 × 1 inch (148 × 184 × 25mm)
4. 5.85 × 3.625 × 1 inch (148 × 92 × 25mm)
5. 2.925 × 3.625 × 1 inch (74 × 92 × 25mm)
6. 2.925 × 1.8 × 1 inch (74 × 46 × 25mm).

A drawer holds from four to 128 trays depending on the combination of sizes that suits the purpose. The trays should fit fairly snugly from side to side but allow space from front to back for inserting wooden blocks to carry group labels. When space in a drawer is left for later acquisitions, the voids can be filled with empty trays turned upside down. This keeps the ones containing specimens from sliding when you move the drawer.

Particularly in humid regions it is good practice to set the cabinets on wood strips to allow air circulation between the case bottom and the floor. Near the coast at least, it is also wise to wax such steel furniture as added protection against rust. A steel cabinet does not protect its contents from fire because heat transmitted through the metal will ignite flammable materials inside.

Insect Cabinet (figs. 18, 19)

The cabinet itself provides a steel enclosure for 12 standard Cornell type insect drawers. It resembles the standard specimen cabinet in construction and affords essentially the same protection from destructive agents exclusive of fire. It is $23\frac{3}{16}$ inches wide × 20 inches deep × $42\frac{3}{4}$ inches high (589 × 508 × 1086mm). The top can be used as a work surface or the cases may be stacked. The gasket-sealed front forms a removable door. Many entomologists prefer the National Museum type insect drawers and cabinet. This system of storage works in a similar manner but the components differ a little in dimensions.

The Cornell drawer is of wood construction with a removable glass cover. The glass is held in a wooden frame fitted tightly over a flange on all four sides of the drawer and held firmly in place by four brass hooks. The drawer holds unit trays of chipboard having a special pinning bottom and a glazed paper facing. These come in three sizes:

1. $4\frac{3}{8}$ × $7\frac{9}{32}$ × $1\frac{5}{8}$ inches (111 × 184 × 41mm)
2. $4\frac{3}{8}$ × $3\frac{21}{32}$ × $1\frac{5}{8}$ inches (111 × 92 × 41mm)
3. $4\frac{3}{8}$ × $1\frac{13}{16}$ × $1\frac{5}{8}$ inches (111 × 46 × 41mm).

From eight to 32 trays fill the drawer, leaving space for label blocks. All the specimens of one species are pinned in a single tray. For exceptionally large insects the drawer may have its own pinning bottom instead. In this case a drawer ordinarily contains the specimens of a single species only.

The value of the case depends particularly on the tight construction of the drawers and the close fit of their covers which should prevent such pests as dermestids from reaching the specimens. So the sides are joined at the corners with multiple mortise and tenon or dovetail joints, the $\frac{1}{8}$-inch (3mm) tempered hardboard bottom is fitted and glued into a groove on all four sides and the top has a polyurethane foam gasket as well as fitting snugly over a rabbet all around.

Herbarium Cabinet (fig. 20)

This corresponds to the standard specimen cabinet in general construction and protective features. Instead of drawers, however, it contains 12 fixed steel compartments to hold pressed plant specimens. The case is $29\frac{5}{32}$ inches wide × $18\frac{25}{32}$ inches deep × 40 inches high (740 × 477 × 1016mm). It is counter-height and may be stacked. The door is gasketed and removable. Each compartment is $12\frac{5}{8}$ inches wide × $17\frac{1}{2}$ inches deep × $5\frac{7}{8}$ inches high (320 × 445 × 150mm). It will hold up to 80 standard herbarium sheets in genus covers, giving the cabinet a capacity of over 900 specimens. The compartment partitions allow air circulation within the case for fumigating.

Figure 18. Insect cabinet.

Figure 19. Construction details of a Cornell type drawer made to National Park Service specifications.

Figure 20.
Herbarium cabinet.

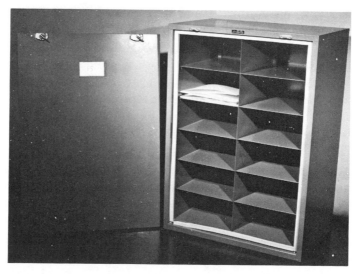

Utility Cabinet

A common steel storage cabinet, 36 inches wide × 18 inches deep × 78 inches high (914 × 457 × 1981mm), with six adjustable shelves, provides a convenient and economical unit for several categories of specimens. Park museums use it for the jars holding reptiles, amphibians, fishes or invertebrates preserved in liquid. These need protection from light but do not require a highly dust-tight, insect-proof cabinet. If the jars tend to move on the shelves because of vibrations from outside, a strip of self-adhesive polyurethane foam along the front edge should prevent displaced jars from tipping off when the cabinet is opened; or cover the shelves with sheets of the somewhat more durable ethafoam. This cabinet can give some added protection to manuscripts filed in the small document boxes described below. Twenty-four to 63 can be stored per cabinet. To store long firearms out of sight and under lock, remove the shelves from one of these cabinets and build into it a wooden gun rack (fig. 21). The rack is designed so no part of a weapon touches the metal of the cabinet. One cabinet holds eight guns. Similarly, a wooden rack can be built to hold up to nine swords (fig. 22). The rack supports each sword by its hilt allowing the blade to hang free. A hook beside each provides a place to hang its scabbard. A leather scabbard, in particular, should not remain on the blade because it tends to absorb moisture and hasten corrosion, but it is important to keep a sword and its scabbard associated. Two sword racks fit into each cabinet. This cabinet with the shelves removed and a coat rod added can be used to hang costumes and uniforms if they are hung in echelon and not crowded. These specimens must be further protected from dust and insects, however. If the room is adequately air-conditioned, this can be done by sealing the specimens in polyethylene or polyester bags containing a 1-inch (25mm) strip of dichlorvos impregnated resin. Unless temperature and relative humidity are controlled, moisture may condense inside sealed bags. Under such circumstances, use muslin dust covers, and replenish the fumigant in the cabinet more frequently. Hangers should be specially padded and fitted to give shoulders, and preferably waist, broad support (see illustration on p. 71, Dorothy H. Dudley and Irma B. Wilkinson, *et al., Museum Registration Methods*, Washington, American Association of Museums and Smithsonian Institution, 1968). For a preferred method of storing most costume specimens see below (Document Boxes). A cabinet without shelves can also be used to store some other textile specimens. The fabric can be rolled in acid-free tissue paper on a cardboard cylinder several inches in diameter or laid over two adjacent cylinders with its ends hanging free. Cover the cardboard with Permalife or other acid-neutralizing paper stuck on with BEVA adhesive or acrylic pressure-sensitive double-faced tape. A wooden rod slipped through the cylinder can rest on notched members at the sides of the cabinet held in place by the shelf supports (fig. 23). Muslin should

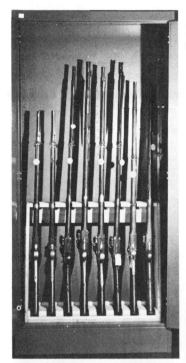

Figure 21. Gun rack.
a. In utility cabinet.

b. Construction details.

b. Construction details.

Figure 22. Sword rack.
a. In utility cabinet.

Figure 23. Textile storage in utility cabinet.

cover the specimen to keep out dust. Suspend large rugs, flags or other flat textiles too wide for the cabinet in the same manner with cylinders and poles. Being more exposed they require especially vigilant care.

Steel Shelving

Objects too big or heavy for a standard specimen cabinet may be placed on shelves. This method of storage provides no special protection from the agents of deterioration. It economizes space, however, promotes orderliness and reduces the necessary handling of the specimens. For general storage of oversized specimens plain skeleton shelving perhaps offers greatest flexibility. Park museums ordinarily use units 36 inches wide × 24 inches or 36 inches deep (914 × 610 or 914mm). These are available in different heights; e.g., 6 feet 3 inches (1905mm) with 7 shelves, 7 feet 3 inches (2210mm) with 8 shelves, 8 feet 3 inches (2515mm) with 9 shelves and 9 feet 3 inches (2819mm) with 10 shelves. Too high shelves would introduce handling risks, of course. Some situations call for back and ends on the shelves.

To protect specimens on open shelves from dust, cover them with unbleached muslin. Be sure to flameproof the cloth before using it. To do this saturate the cloth in a solution of 10 ounces of borax and 4 ounces of boric acid to 1 gallon of hot water (70g borax and 30g boric acid to 1 liter). Squeeze out the excess lightly, but aim to let as much of the salts as possible dry into the fabric. Wash the dust covers before they collect too much dirt, and renew the flameproofing. Cloth is better than plastic sheeting for this purpose because it avoids the danger of moisture condensation which might occur if trapped air were chilled.

Picture Racks (fig. 24)

The safest way to store framed pictures is to hang them on a metal mesh panel. It permits free circulation of air around the paintings so both face and back respond to the same atmospheric conditions, and it reduces the danger to frames and glass. Allow room behind the screen, or mount it at right angles to the wall so you can hang pictures on both sides of it. Park museums are advised to use flattened expanded aluminum panels or preferably welded square-mesh wire panels, and to replace the screw eyes on the backs of the frames with hooked brass mirror plates which can be screwed securely to the frame and hung directly on the storage screen. This avoids loose hooks which could puncture a canvas or fall between canvas and stretcher. If the collection is large enough to require several panels, obtain screens designed for this purpose and mounted with overhead tracks about 18 inches apart. They can be installed in compact space and rolled out individually.

a. Racks.

b. Hook.

Figure 24. Storage rack for framed pictures.

Print Boxes (fig. 25)

To protect unframed prints, maps, drawings or watercolors, store them in special containers called print or solander boxes. These boxes are constructed of light wood covered with fabric and lined with an acid-free glazed paper, or preferably acid-neutralizing paper to prevent accumulation of acid vapors from the wood. A flange at the top and metal clasps keep the container reasonably dust-tight and light-proof. The hinged back lies flat when opened to permit safer, easier handling of the individual prints stacked inside. In some cases, the front drops similarly. Print boxes come in at least five standard sizes. Each of these provides an inside depth of about 2½ inches (64mm) to held 12–24 matted pictures. The other dimensions accommodate the following mat sizes: 11 × 14 inches (280 × 355mm), 14¼ × 19¼ inches (360 × 490mm), 16 × 22 inches (405 × 560mm), 19 × 24 inches (480 × 610mm), and 22 × 28 inches (560 × 710mm). Larger sizes for mats up to 36 × 42 inches (915 × 1065mm) are available on special order. For added protection, park museums store the standard size print boxes in the drawers of standard specimen cabinets. Bigger ones are laid flat on shelves.

Before placing valuable prints, maps and similar specimens in a print box have them mounted in standard window mats. A window mat consists of two sheets of acid-free mat board composed of 100% rag fiber. The specimen is mounted on the back sheet with two paper hinges at the upper edge allowing an ample border of the backing sheet all around. The second sheet is the same size as the back one and is fastened to it with a hinge along the upper edge. It has an opening cut in it slightly smaller than the specimen so it overlaps the latter a little on all sides. Lay a sheet of acid-free transparent paper directly over the specimen between the mat sheets to protect the face of the object in storage. Glassine paper is often acid. "Matt reflex" paper (e.g., Promatco) has tested acid-free. All the specimens in one print box should have mats of approximately the same size and of a proper size for the box to minimize slipping. Store less valuable specimens of this type in print boxes or flat document storage boxes without mats, but place each picture or map in an individual folder of acid-free buffered paper (e.g., Permalife). Make the folder larger than the specimen and close to the inside dimensions of the box. For fuller instructions see Anne F. Clapp, *Curatorial Care of Works of Art on Paper*, 2nd rev. ed., Oberlin, Intermuseum Conservation Association, 1974, pp. 58–62, 67–68, 95.

Map File Cabinet

The collection may contain historic maps, prints or similar specimens too large for even an outsized print box. Park museums store these in steel map cabinets. These are five-drawer units with separate base and top. Two,

Figure 25. Print box.

three or even four of the drawer units will stack one above another with a single base and top. Two units of drawers, with a base and top, make a convenient combination.

A map cabinet affords less protection from dust and insects than a print box. Therefore, do not use it in preference to the print boxes when the size of a specimen permits a choice. All maps and prints stored in map cabinets should be matted, or enclosed in individual folders of acid-free buffered paper. If these large drawers are used to store textile specimens in order to avoid folding the fabric, place each specimen in a folder of acid-free tissue paper, and remember to take extra precautions against insect attack.

Document Boxes (fig. 26)

Protective containers for manuscripts and other documents come in two conventional sizes: legal 15¼ inches long × 10¼ inches wide (387 × 260mm), or letter 12¼ inches long × 10¼ inches wide (310 × 260mm), and either 2½ or 5 inches deep (63 or 127mm). Each box holds up to 50 or 100 documents, unfolded and enclosed in individual acid-free paper folders (e.g. Permalife). The box is made of acid-free kraft paperboard. It has a hinged overlapping cover, but does not close tightly enough to exclude insects or be rated dust-tight. Park museums have used similar boxes made of kraft paperboard lined inside and out with aluminum foil. The aluminum reflects heat so efficiently that these light containers protect their contents from fire if the exposure is not prolonged. Unfortunately foil-covered boxes are available only if ordered in lots of 10,000 or more. As suggested above, the document boxes may be stored in utility cabinets or, of course, on open shelves. Place the boxes so the documents lie flat rather than standing on edge.

Figure 26. Document boxes.

Flat storage boxes made of the same acid-free stock and with plain, removable covers provide good containers for documents larger than legal size and, as noted above, for unmatted prints or maps. Available sizes include $17\frac{1}{4} \times 11\frac{1}{2} \times 3\frac{1}{2}$ inches ($438 \times 291 \times 89$mm) and $20 \times 16 \times 3\frac{1}{2}$ inches ($508 \times 406 \times 89$mm). The buffered folders for individual specimens should approximate the box dimensions to prevent sliding. Keep these boxes in standard specimen cabinets or on steel shelving. If on open shelves inspect the contents more frequently for dust, mold or insect infestation. Use these boxes for account books, scrapbooks, and other bound volumes that should lie horizontal in storage, or fabricate boxes of acid-free buffered board to fit each volume as shown in Anne F. Clapp, *op. cit.*, p. 92.

Larger boxes made to order of acid-free corrugated board in sizes up to 60 inches long \times 28 inches wide \times 6 inches deep ($1524 \times 711 \times 153$mm) offer practical containers for storing costumes flat and unfolded. This puts aged fibers under the least possible strain. Lay the garment in acid-free tissue paper and use the tissue paper also to form pads in sleeves or wherever else the threads might bend sharply. Enclose paradichlorobenzene (but not if patent leather or shellacked surfaces are present) or dichlorvos in the box. Wrap the box in kraft paper and seal the wrapping seams with tape. Mark the date of sealing on the wrapper to show when the fumigant needs renewal. Then lay the box flat on steel shelving.

Central Repositories

Park museums regularly maintain their own basic study collections. Experience fully justifies this standard practice. Specimens, as a rule, serve the park better on site, and park staffs generally care for them well. However, when a park has no space in which specimens can be safely kept, or has no staff member qualified to take care of them, the collection needs to be protected elsewhere. This is a temporary arrangement pending development of adequate facilities and staffing at the park. Archeological projects often result in large collections which must be held for an extended period before being culled. The volume of specimens may exceed available study and storage space at the park. Central repositories provide a temporary home for collections in such circumstances.

The National Park Service presently operates five central repositories for museum collections: at the Arizona Archeological Center, the Chaco Center, the Midwest Archeological Center, the Southeast Archeological Center and the Harpers Ferry Center museum clearing house. The primary function of the first four centers is archeological research. They necessarily maintain their own study collections continually used by the staff and visiting scholars. The fifth is general and Service-wide in scope, but primarily concerned with interim storage, reassignment and disposal of specimens. When one of these centers is asked to take temporary custody of a collection, part or all of which should someday return to the park, the specimens do not ordinarily go into dead storage. The staff at the center provides as complete curatorial service as circumstances permit. Specimens may be stabilized, cleaned, restored if they warrant it, identified, catalogued, photographed and described or illustrated in scientific publications. They will be used as working components of the center's research collection as long as they remain at the repository. The park receives the three copies of any catalogue records made for specimens to be returned, and the center may retain a duplicate copy.

BIBLIOGRAPHY

Whoever has responsibility for the care of collections can turn for help to a large and rapidly growing literature. Most curators will find it worthwhile to keep at hand:

Thomson, Garry, ed. *Control of the Museum Environment: A Basic Summary.* London. International Institute for Conservation of Historic and Artistic Works, 1967.

Curators in charge of artifacts should be conversant with:

Plenderleith, H. J., and A. E. A. Werner. *The Conservation of Antiquities and Works of Art: Treatment, Repair, and Restoration.* 2nd ed., 2nd printing. London. Oxford University Press, 1971.

The following aids provide good access to the specialized literature on object conservation:

Art and Archaeology Technical Abstracts, semi-annually, Institute of Fine Arts, New York University, for the International Institute for Conservation of Historic and Artistic Works, 1 East 78th Street, New York 10021 or IIC, 608 Grand Buildings, Trafalgar Square, London WC2N 5HN.

IIC Abstracts, Abstracts of the Technical Literature on Archaeology and the Fine Arts, semi-annually 1955–1965 when succeeded by AATA, International Institute for Conservation of Historic and Artistic Works, London.

Gettens, Rutherford J., and Bertha M. Usilton, comps. *Abstracts of Technical Studies in Art and Archaeology 1943–1952.* Freer Gallery of Art Occasional Papers, 2:2, Smithsonian Publication 4176. Washington. Smithsonian Institution, 1955.

Thomson, Garry, ed. *Cumulative Index: Studies in Conservation, Volumes 1–12, 1952–1967.* London. International Institute for Conservation of Historic and Artistic Works, 1969.

Usilton, Bertha M., comp. *Subject Index to Technical Studies in the Field of the Fine Arts.* Pittsburgh. Tamworth Press, 1964.

Professional journals concerned with the scientific conservation of artifacts include:

Bulletin of the American Institute for Conservation of Historic and Artistic Works (formerly *Bulletin of the American Group—IIC*), semi-annually, Conservation Center, Institute of Fine Arts, New York University, 1 East 78th Street, New York 10021.

Studies in Conservation, quarterly, International Institute for Conservation of Historic and Artistic Works, 608 Grand Buildings, Trafalgar Square, London WC2N 5HN.

Technical Studies in the Field of the Fine Arts. Fogg Art Museum, Harvard University, Cambridge, 1932–1942.

The IIC also organizes international conferences to help conservators and curators keep abreast of current research and practice. It has published the papers presented at each, either as preprints or as edited records of the proceedings. These include:

Thomson, Garry, ed. *Recent Advances in Conservation.* Contributions to the IIC Rome Conference, 1961. London. Butterworths, 1963.

IIC, ed. *1964 Delft Conference on the Conservation of Textiles.* Collected Preprints. 2nd ed. London. International Institute for Conservation of Historic and Artistic Works, 1965.

Thomson, Garry, ed. *Contributions to the London Conference on Museum Climatology, 18–23 September 1967.* Rev. ed. London. International Institute for Conservation of Historic and Artistic Works, 1968.

IIC, ed. *Preprints of the Contributions to the New York Conference on Conservation of Stone and Wooden Objects, 7–13 June 1970.* London. International Institute for Conservation of Historic and Artistic Works, 1970.

IIC, ed. *Conservation of Paintings and the Graphic Arts.* Preprints of Contribu-

tions to the Lisbon Congress 1972, 9–14 October 1972, London. International Institute for Conservation of Historic and Artistic Works, 1972.

Most of the references which follow address themselves to curators rather than conservators:

Basic Steps

Clapp, Anne F. *Curatorial Care of Works of Art on Paper*. 2nd rev. ed. Oberlin. Intermuseum Laboratory, 1974.

Colbert, Edwin H. "Old Bones, and What to Do About Them," *Curator*, VIII:4 (1965), pp. 302–318.

Coremans, Paul. "The Museum Laboratory," *The Organization of Museums: Practical Advice*. Museums and Monuments—IX. Paris. UNESCO, 1960, pp. 93–118.

Cunha, George Martin and Dorothy Grant Cunha. *Conservation of Library Materials*, I, 2nd ed., II. Metuchen. Scarecrow Press, 1971, 1972.

Daifuku, Hiroshi. "Collections: Their Care and Storage," *The Organization of Museums: Practical Advice*. Museums and Monuments—IX. Paris. UNESCO, 1960, pp. 119–125.

Dolloff, Francis W., and Roy L. Perkinson. *How to Care for Works of Art on Paper*. Boston. Museum of Fine Arts, 1971.

Dowman, Elizabeth A. *Conservation in Field Archaeology*. London. Methuen Co. Ltd., 1970.

Drost, William E. "Caring for Clocks," American Association for State and Local History Technical Leaflet 47, *History News*, 23:9 (September 1968).

Emerson, William K., and Arnold Ross. "Invertebrate Collections, Trash or Treasure?" *Curator*, VIII:4 (1965), pp. 333–346.

Fales, Mrs. Dean A., Jr. "The Care of Antique Silver," American Association for State and Local History Technical Leaflet 40, *History News*, 22:2 (February 1967).

Giffen, Jane C. "Care of Textiles and Costumes: Cleaning and Storage Techniques," American Association for State and Local History Technical Leaflet 2, *History News*, 25:12 (December 1970).

Glover, Jean M. *Textiles: Their Care and Protection in Museums*. Information Sheet 18. London. Museums Association, 1973.

Greathouse, Glenn A., and Carl J. Wessel, eds. *Deterioration of Materials: Causes and Preventive Techniques*. National Research Council, Prevention of Deterioration Center. New York. Reinhold Publishing Co., 1954.

Guldbeck, Per E. "Leather: Its Understanding and Care," American Association for State and Local History Technical Leaflet 1, *History News*, 24:4 (April 1969).

———. *The Care of Historical Collections: A Conservation Handbook for the Nonspecialist*. Nashville. American Association for State and Local History, 1972.

Harding, E. G. *The Mounting of Prints and Drawings*. Information Sheet 12. London. Museums Association, 1972.

Horton, Carolyn. *Cleaning and Preserving Bindings and Related Materials*. 2nd ed. rev. Conservation of Library Materials, LTP Publication 16. Chicago. Library Technology Program, American Library Association, 1969.

Kane, Lucile M. *A Guide to the Care and Administration of Manuscripts*. 2nd ed. Nashville. American Association for State and Local History, 1966, pp. 41–49.

Klapthor, Margaret Brown. *Laundering Fragile Cotton and Linen Fabrics*. Washington. National Trust for Historic Preservation, 1961.

Keck, Sheldon. "A Little Training is a Dangerous Thing," *Museum News*, 52:4 (December 1973), pp. 40–42.

Leene, Jentina E., ed. *Textile Conservation*. Washington. Smithsonian Institution Press, 1972.

LeGear, Clara E. *Maps: Their Care, Repair and Preservation in Libraries*. Rev. ed. Washington. Map Division, Library of Congress, 1956.

Malinowski, Kazimierz, ed. *Conservation of Metal Antiquities*. Warsaw. Scientific Publications Foreign Cooperation Center of the Central Institute for Scientific, Technical and Economic Information, 1969.

McHugh, Maureen Collins. *How to Wet-Clean Undyed Cotton and Linen*. Information Leaflet 478. Washington. Textile Laboratory, Museum of History and Technology, Smithsonian Institution, 1967. Rev. ed. in prep.

Merrill, William. "Wood Deterioration: Causes, Detection and Prevention," American Association for State and Local History Technical Leaflet 77, *History News*, 29:8 (August 1974).

Minogue, Adelaide E. *The Repair and Preservation of Records*. Bulletins of the National Archives 5. Washington. Government Printing Office, 1943.

Organ, Robert M. *Design for Scientific Conservation of Antiquities*. Washington. Smithsonian Institution Press. London. Butterworths, 1968.

Ostroff, Eugene. "Conserving and Restoring Photographic Collections," *Museum News*, 52:8 (May 1974), pp. 42–45.

Peterson, Harold L. *Bibliography on the Preservation of Museum Specimens*. Washington. National Trust for Historic Preservation, 1961. Rev. ed. in prep.

———. "Conservation of Metals," American Association for State and Local History Technical Leaflet 10, rev. ed., *History News*, 23:2 (February 1968).

Santen, Vernon, and Howard Crocker. "Historical Society Records: Guidelines for a Protection Program," American Association for State and Local History Technical Leaflet 18, *History News*, 27:9 (September 1972).

Smith, C. Lavett. "Maintaining Inactive Fish Collections," *Curator*, VIII:3 (1965), pp. 248–255.

Thomson, Garry. "Planning the Preservation of Our Cultural Heritage," *Museum*, XXV:1, 2 (1973), pp. 15–25.

Tribolet, Harold W. "Rare Book & Paper Techniques," American Association for State and Local History Technical Leaflet 13, rev. ed., *History News*, 25:3 (March 1970).

Unesco. *The Conservation of Cultural Property with Special Reference to Tropical Conditions*. Museums and Monuments—XI. Paris. UNESCO, 1968.

Van Gelder, Richard G. "Another Man's Poison," *Curator*, VIII:1 (1964), pp. 55–71.

Waterer, John W. *A Guide to the Conservation and Restoration of Objects Made Wholly or in Part of Leather*. London. G. Bell & Sons, 1972.

Werner, A. E. A. "The Care of Glass in Museums," Technical Supplement 13, *Museum News*, 44:10 (June 1966), pp. 45–49.

Wilson, William K., and James L. Gear. *Care of Books, Documents, Prints and Films.* National Bureau of Standards Consumer Information Series 5. Washington. Government Printing Office, 1971.

Winger, Howard W., and Richard Daniel Smith, eds. *Deterioration and Preservation of Library Materials.* Chicago. University of Chicago Press, 1970.

Zigrosser, Carl, and Christa M. Gaehde. *A Guide to the Collection and Care of Original Prints.* New York. Crown Publishers, Inc., 1965, pp. 99–117.

Zwiefel, Richard G. "Guidelines for the Care of a Herpetological Collection," *Curator,* IX:1 (1966), pp. 24–35.

Agents of Deterioration and Climate Control

References on organisms attacking museum specimens include:

Deschiens, Robert, and Christine Coste. "The Protection of Works of Art in Carved Wood from the Attacks of Wood-eating Insects," *Museum,* X:1 (1957), pp. 55–59.

United States Department of Agriculture. *How to Prevent and Remove Mildew: home methods.* Home and Garden Bulletin 68. Rev. ed. Washington. Government Printing Office, 1971.

———. *Protecting Woolens against Clothes Moths and Carpet Beetles.* Home and Garden Bulletin 113. Rev. ed. Washington. Government Printing Office, 1971.

———. *Silverfish and Firebrats.* Leaflet 412. Rev. ed. Washington. Government Printing Office, 1974.

———. *Cockroaches: How to Control Them.* Leaflet 430. Rev. ed. Washington. Government Printing Office, 1971.

———. *Controlling Wood-Destroying Beetles in Buildings and Furniture.* Leaflet 558. Rev. ed. Washington. Government Printing Office, 1973.

For information on the effects of light see:

Brommelle, N. S. "Museum Lighting. Part 3: Aspects of the Effect of Light on Deterioration," *Museums Journal,* 62:1 (June 1962), pp. 337–346.

———. "Museum Lighting. Part 4: Viewing the Object," *Museums Journal,* 62:3 (December 1962), pp. 178–186.

———. "The Planning of Museums and Art Galleries: Technical Services. Air Conditioning and Lighting from the Point of View of Conservation. Museum Lighting," *Museums Journal,* 63:1 and 2 (June–September 1963), pp. 32–42.

Cooper, B. S. "Fluorescent Lighting in Museums," *Museums Journal,* 53:11 (February 1954), pp. 279–290.

Feller, Robert L. "Control of Deteriorating Effects of Light upon Museum Objects," *Museum,* XVII:2 (1964), pp. 72–98.

———. "The Deteriorating Effect of Light on Museum Objects: Principles of Photochemistry, The Effect on Varnishes and Paint Vehicles and on Paper," Technical Supplement 3, *Museum News,* 42:10 (June 1964).

———. "Control of Deteriorating Effects of Light on Museum Objects: Heating Effects of Illumination by Incandescent Lamps," *Museum News,* 46:9 (May 1968), pp. 39–47.

Genard, J. "Extreme Ultra-violet Radiation from Tubular Fluorescent Lamps and its Effect on Museum Lighting," *Museum,* V:1 (1952), pp. 53–58.

Hanlan, J. F. "The Effect of Electronic Photographic Lamps on the Material of Works of Art," *Museum News*, 48:10 (June 1970), pp. 33–41.

Lusk, Carroll B. "Museum Lighting III," *Museum News*, 49:6 (February 1971), pp. 18–22.

Stolow, Nathan. "The Action of Environment on Museum Objects, Part II: Light," *Curator*, IX:4 (1966), pp. 298–306.

Thomson, Garry. "Visible and Ultraviolet Radiation," *Museums Journal*, 57:2 (May 1957), pp. 27–52.

————. *Conservation and Museum Lighting.* Information Sheet 6. London. Museums Association, 1974.

The following sources concern fire protection, security and safe handling:

Bostick, William A. "What Is the State of Museum Security?" *Museum News*, 46:5 (January 1968), pp. 13–19.

Chapman, Joseph M. "Stepping Up Security," *Museum News*, 44:3 (November 1965), pp. 18–21.

————. "Fire," *Museum News*, 50:5 (January 1972), pp. 32–35.

Fall, Frieda Kay. *Art Objects, Their Care and Preservation: A Handbook for Museums and Collectors.* LaJolla. Laurence McGilvery, 1973.

Faul, Roberta, ed. "Your Security Questions Answered," *Museum News*, 50:5 (January 1972), pp. 22–25.

Francis, Frank. "The Planning of Museums and Art Galleries: Security," *Museums Journal*, 63:1, 2 (June–September 1963), pp. 28–32.

Gossin, Francis. "A Security Chief Comments on Guards," *Museum News*, 50:5 (January 1972), pp. 30–31.

Grossman, Albert J. "Television: Museum Watchdog," *Museum News*, 44:3 (November 1965), pp. 22–24.

Howard, Richard Foster. *Museum Security.* Publications, new series 18. Washington. American Association of Museums, 1958.

Keck, Caroline K., *Safeguarding your Collection in Travel.* Nashville. American Association for State and Local History, 1970.

————, et al. *A Primer on Museum Security.* Cooperstown. New York State Historical Association, 1966.

McQuarie, Robert J. "Security," *Museum News*, 49:7 (March 1971), pp. 25–27.

Michaels, A. J. "Security and the Museum," *Museum News*, 43:3 (November 1964), pp. 11–16.

National Fire Protection Association. *Recommended Practice for the Protection of Museum Collections from Fire.* NFPA 911. Rev. ed. Boston. NFPA, 1974.

Noblecourt, André F. "The Protection of Museums Against Theft," *Museum*, XVII:4 (1964), pp. 184–196, 211–232.

Pakalik, Michael J. "Security and Protection in a Museum," *Curator*, I:4 (1958), pp. 89–93.

Probst, Tom. "Electronic Eyes and Ears on Guard," *Museum News*, 44:3 (November 1965), pp. 11–17.

————. "Fire Detection/Fire Protection," *Museum News*, 44:9 (May 1966), pp. 11–17.

Sugden, Robert P. *Care and Handling of Art Objects.* New York. Metropolitan Museum of Art, 1946.

Weldon, Stephen. "Winterthur: Security at a Decorative Arts Museum," *Museum News*, 50:5 (January 1972), pp. 36–37.

Windeler, Peter. "Fire: Endangers the Past—for the Future," *Museums Journal*, 70:2 (September 1970), pp. 69–71.

Air-conditioning in museums and exhibit cases is discussed in:
Amdur, Elias J. "Humidity Control-Isolated Area Plan," Technical Supplement 6, Part II, *Museum News*, 43:4 (December 1964), pp. 58–60.
Beecher, Reginald. "Apparatus for Keeping a Showcase Free from Dust: An Experiment at the Victoria and Albert Museum," *Museums Journal*, 70:2 (September 1970), pp. 69–71.
Buck, Richard D. "A Specification for Museum Airconditioning," Technical Supplement 6, Part I, *Museum News*, 43:4 (December 1964), pp. 53–57.
Cameron, Duncan. "Environmental Control: A Theoretical Solution," *Museum News*, 46:9 (May 1968), pp. 17–21.
Douglas, R. Alan. "A Commonsense Approach to Environmental Control," *Curator*, XV:2 (1972), pp. 139–144.
Harvey, John. "Air-conditioning for Museums," *Museums Journal*, 73:1 (June 1973), pp. 11–16.
Nelson, Elmer R. "Do We Understand Museum Air Conditioning?" *Curator*, XI:2 (1968), pp. 127–136.
Oddy, W. A. "An Unsuspected Danger in Display," *Museums Journal*, 73:1 (June 1973), pp. 27–28.
Plenderleith, H. J., and P. Philippot. "Climatology and Conservation in Museums," *Museum*, XIII:4 (1960), pp. 242–289.
Stolow, Nathan. "Fundamental Case Design for Humidity Sensitive Museum Collections," Technical Supplement 11, *Museum News*, 44:6 (February 1966), pp. 45–52.
———. "The Action of Environment on Museum Objects, Part I: Humidity, Temperature, Atmospheric Pollution," *Curator*, IX:3 (1966), pp. 175–185.
Werner, A. E. A. "Heating and Ventilation," *Museums Journal*, 57:7 (October 1957), pp. 159–166.

Study Collection Space and Specimen Storage Equipment

Anon. "Solving Storage Problems," *Museum News*, 41:4 (December 1962), pp. 24–29.
Arnold, Janet. *A Handbook of Costume*. London. Macmillan, 1973.
Bartlett, John, and Norman Reid. "The Planning of Museums and Art Galleries: Storage and Study Collections," *Museums Journal*, 63:1, 2 (June–September 1963), pp. 62–73.
Borhegyi, Stephan F. de. "Organization of Archaeological Museum Store-Rooms," *Museum*, V:4 (1952), pp. 256–260.
Brawne, Michael. *The New Museum: Architecture and Display*. New York. Frederick A. Praeger, 1965, pp. 192–195.
Buck, Anne. *Costume*. Handbook for Museum Curators D 3. London. Museums Association, 1958, pp. 9–20.
Buechner, Thomas S. "The Open Study-Storage Gallery," *Museum News*, 40:9 (May 1962), pp. 34–37.
Colbert, Edwin H. "Inexpensive Racks for the Storage of Large Specimens," *Curator*, IV:4 (1961), pp. 368–370.
Cox, Trenchard. *Pictures*. Handbook for Museum Curators D 1 & 2. London. Museums Association, 1956, pp. 23–25.

Cranstone, B. A. L. *Ethnography*. Handbook for Museum Curators C 4. London. Museums Association, 1958, pp. 30–40.

Dunn, Walter S., Jr. "Storing Your Collections: Problems and Solutions," American Association for State and Local History Technical Leaflet 5, rev. ed., *History News*, 25:6 (June 1970).

Fikioris, Margaret A. "A Model for Textile Storage," *Museum News*, 52:3 (November 1973), pp. 34–41.

Franks, J. W. *A Guide to Herbarium Practice*. Handbook for Museum Curators E 3. London. Museums Association, 1965, pp. 7–10.

Gowers, Harold J. "A Storage Fitting for Arrows," *Museums Journal*, 58:1 (April 1958), pp. 13–14.

Harrison, Raymond O. *The Technical Requirements of Small Museums*. Technical Paper 1. Ottawa. Canadian Museums Association, 1969.

Harvey, Virginia I. "Space and Textiles," *Museum News*, 42:3 (November 1963), pp. 28–33.

Hayes, P. A. "Storage Racks for Service Swords," *Museums Journal*, 71:1 (June 1971), pp. 29–30.

Hughes, Olga. "Storage on a Shoestring," *Museum News*, 51:3 (November 1972), pp. 37–38.

Lanier, Mildred B. "Storage Facilities at Colonial Williamsburg," *Museum News*, 45:6 (February 1967), pp. 31–33.

Organ, Robert M. "The Safe Storage of Unstable Glass," *Museums Journal*, 56:11 (February 1957), pp. 265–272.

Pinckheard, John, and Edward Pyddoke. "A System of Standard Storage," *Museums Journal*, 60:11 (February 1961), pp. 281–284.

Reynolds, Barrie. "Some Ideas on the Storage of Ethnographic Material," *Museums Journal*, 62:2 (September 1962), pp. 102–109.

Saltonstall, David. "The Brooklyn Museum Library of Paintings," *Curator*, X:3 (1967), pp. 248–252.

Stansfield, G. *The Storage of Museum Collections*. Information Sheet 10, 2nd ed. rev. London. Museums Association, 1974.

Steel, C. A. B. "A System for the Storage of Mounted Birds," *Museums Journal*, 70:1 (June 1970), pp. 10–12.

Sugden, Robert P. *Safeguarding Works of Art: Storage, Packing, Transportation and Insurance*. New York. Metropolitan Museum of Art, 1948, pp. 11–33.

Waddell, Gene. "Museum Storage," *Museum News*, 49:5 (January 1971), pp. 14–20.

Central Repositories

Owen, David. "Care of Type Specimens," *Museums Journal*, 63:4 (March 1964), pp. 288–291.

Swinton, W. E. *Type Specimens in Botany and Zoology: Recommendations for their Conservation in Natural History and General Museums*. Paris. International Council of Museums, 1955.

Chapter 5 Using Museum Collections

All the curatorial tasks detailed in the preceding chapters culminate in the utilization of the collections. You acquire, prepare and preserve specimens for people to use. The skill, patience and money invested in these objects is justified by the use they receive. On the other hand, do not expect that people will necessarily use the collections immediately or automatically. In fact, the most important utilization may come 50, 100 or 1,000 years hence. Then some of the specimens gathered and preserved with such care will be rare indeed, and scholars will have new questions the collection can help to answer. Meanwhile the present uses of the collection are important too, but they need to be encouraged and developed by active effort. The following discussion suggests how.

Exhibition

One of the most important and characteristic ways in which museums employ specimens is to exhibit them. People learn from exhibited objects. At the simplest level, seeing an object makes actual the words we apply to it. The word symbols with which we think and communicate acquire fuller, more accurate meaning. Visitors can be told that the battle began with a bursting shell from a 30-pounder Parrott rifle, but what can these words convey to people who have never seen this kind of cannon and shell (fig. 27)? If other senses could be involved as well—letting visitors touch the cannon barrel, feel the rifling, heft the shell, smell powder smoke or hear the blast, the words would become still more meaningful. Rarely, however, is a specimen exhibited just to give concrete meaning to its name. Displayed in context, the object helps communicate ideas. You add to its interpretive power in various ways. It is exhibited in a manner that shows how it works or how people used it (fig. 28). It is placed with similar objects to invite comparisons (fig. 29). It is grouped with the other things that normally accompany it (fig. 30). Combined with labels, the object becomes evidence supporting a conclusion (fig. 31), a symbol for a more abstract idea (fig. 32) or a link with some person or event (figs. 33, 34).

Figure 28

Figure 27

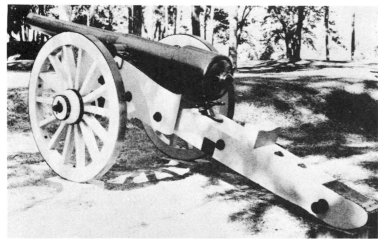

Figure 29 **Figure 30** **Figure 32**

Figure 27. Parrott Rifle, 30-pounder, Fort McAllister, Ga. One of these heavy cannon fired the opening shot at the first battle of Manassas. Its barrel is 11 feet long (3.36m).

Figure 28. Surveying the U.S.-Mexico boundary, Chamizal National Memorial, an exhibit of instruments illustrating their use.

Figure 29. A rock fault exhibit, Pinnacles National Monument. It invites comparison between two groups of rocks collected from opposite sides of the San Andreas Fault as proof of lateral movement along the fault.

Figure 30. Participation exhibit, Rock Creek Nature Center, National Capital Parks West.– West. Objects exhibited as evidence—feathers on the ground—provide clues to an owl in the neighborhood.

Figure 34

Figure 31 **Figure 33**

Figure 31. Museum exhibits, Custer Battlefield National Monument. Objects related to one another in their original use gain added meaning when exhibited together.

Figure 32. Museum exhibit, Fort Caroline National Memorial. A carved ivory madonna and child and a 16th-century edition of Calvin's *Institutes* symbolize divergent religious convictions.

Figure 33. Pistol used in the assassination of President Lincoln, Lincoln Museum, National Capital Parks–West. This specimen is exhibited to bring visitors into closer touch with a tragic event.

Figure 34. General Custer's buckskin suit, Custer Battlefield National Monument. Objects associated with historic individuals give viewers a stronger sense of historical events.

In addition to helping people understand, specimens on exhibition give enjoyment. Some have esthetically satisfying or exciting form and color (fig. 35). The strangeness of others stimulates pleasurable feelings of curiosity. Visitors take comfort in familiar objects. A few specimens evoke stronger emotions (fig. 36).

In developing the use of the collections, therefore, explore fully the opportunities to exhibit specimens. Besides the regular "permanent" exhibits, consider the possibilities extending in at least two other directions. Special exhibitions are an important auxiliary technique. Characteristically short-term, they highlight seasonal changes, mark an anniversary, emphasize timely aspects of the museum's theme, elaborate on a collateral interest, display recent acquisitions or encourage appropriate donations. Such

Figure 35. Basketry exhibited for aesthetic values, Indian Arts Museum, Colter Bay Visitor Center, Grand Teton National Park.

exhibitions take time and money, but are justified when they give greater depth and breadth to the interpretive program, increase community interest and generate favorable publicity. If displayed too long, these exhibitions lose much of their value. So schedule each one to last about a month. By following it promptly with another special exhibition you can establish a rotation of fresh, timely, significant displays using to good advantage specimens from the study collections and objects borrowed for the occasion.

The museum is not the only place to install special exhibitions. Often stores, banks, schools, clubs or other institutions in the vicinity welcome them. Even though such a special exhibition is temporary, adopt techniques and standards of presentation that will communicate with the visitor and evoke desirable response. A poorly designed or crudely executed display would not be worth the effort. Since other museums arrange special shows, extend the use of your collection by lending them specimens for this purpose when asked. Exercise good judgment in deciding when the hazards to an important object outweigh the potential benefits of exhibiting it away from the museum.

Figure 36. The Liberty Bell, Independence National Historical Park. It stirs the emotions of young and old.

The use of objects can also be extended by developing ways to bring visitors into closer contact with them. To many of us the phrase "exhibit specimen" connotes something visible—in a case—behind glass. Important as this is, it is only one exhibit technique, and it utilizes only the visual sense. The effectiveness of an exhibit can be enhanced, often to a dramatic degree, by bringing into play as many as possible of the four remaining senses: touch, hearing, smell and taste. Achieve multiple use of the senses, for example, by letting visitors manipulate the specimen in the original manner. Grinding, and then tasting, corn meal from a mano and metate, writing with a quill pen or slate pencil, donning articles of clothing or armor, and taking readings with old navigation instruments, have been included in exhibits by imaginative interpreters. If such use might shorten the life of a historic object, substitute a reproduction and tell why. Many other ways of letting visitors handle some exhibit specimens safely and instructively can be devised (fig. 37). Introduce appropriate odors in the refurnished kitchen, the granary, the stable or the shop. Audio devices may contribute the proper sounds for a specimen whether it is a rattlesnake or a backsmith's hammer. Going beyond exhibits, use specimens to illustrate a talk or guided trip, passing sturdy objects around to be handled and examined or merely holding them up and explaining them.

Figure 37. Beaver exhibit, Moraine Park Museum, Rocky Mountain National Park. The exhibit invites visitors to gain a better understanding of the beaver by the touching and feeling of specimens that can be replaced when they wear out.

You go a step further when the specimen is demonstrated. How the object works and what it accomplishes is shown. The visitor sees, hears and sometimes smells what goes on. Often he can try his hand, and he has the opportunity to talk with the knowledgeable demonstrator (fig. 38). This may be the best way to interpret a complex specimen, or a group of related objects like the tools of a trade. Many craft operations, however, are too rapid for the eye to follow, so need supplementary visual explana-

tion. Demonstrations may be operating continuously or may be scheduled periodically. They may be conducted in the museum, on site or at a specially prepared location. Good curators have concluded on the basis of experience that as a rule demonstrations should employ reproduced objects to save originals from inevitable wear and tear. An increasing number of museums have adopted this as their policy.

Figure 38. Learning how a specimen was used, Old Sturbridge Village. A visiting student in the Museum shells corn with a reproduced flail like originals seen in exhibits

This manual does not discuss exhibit planning and preparation in any detail, although exhibits comprise a vital aspect of museum work. In the National Park Service, as is true of many museums, full-time planners, designers, artists and craftsmen perform this work. Curators provide the specimens and the expert knowledge about the subject matter. Then they verify the absolute accuracy of the presentation. Quality standards dictate such specialization. Public tastes and styles in design also change at a fairly rapid rate. New materials continually become available to preparators. It takes specialists to keep up to date. Nevertheless many curators in small museums must create their own exhibits. They too can set high standards and achieve results that serve their public well.

Curators who shoulder the task of producing exhibits with little or no specialized assistance can help themselves in several ways. The references cited at the end of the chapter will answer many questions on theory and practice. So will exhibits observed in other museums. Many curators carry a notebook or tape recorder and sketch pad or camera whenever visiting museums. By keeping analytical notes on whatever aspects of exhibits seem to work well or obviously fail, they build a stockpile of ideas and acquire a vocabulary of exhibit methods. In addition the following may offer some useful guidelines:

—Specimens form the core of almost every exhibit. They are what visitors come to see. Nevertheless, it is what the objects communicate to the visitors that counts. In planning an exhibit the curator must decide what the specimens should accomplish. Will he use them to attract attention, stimulate a particular line of thought, transmit specific information, demonstrate a conclusion, arouse intended feelings or produce a combination of such effects? It follows that each exhibit needs to start with a clearly defined purpose. In national park museums defining objectives ordinarily precedes the selection of specimens. Decide what the exhibit should communicate before asking what do we have to exhibit.

—Museums have earned a considerable degree of public trust because people can generally rely on what they see in the exhibits. It follows that the planning of each exhibit should include a determination to make what it communicates as nearly true and as completely unbiased as possible. The evidence presented in the exhibit should enable the visitor to validate for himself whatever statement it makes.

—Visitors are individuals. They bring to an exhibit a wide range of sizes and ages, background information, personal interests, conceptual skills and sensitivities. They cannot all react to the exhibit in the same way. Being free agents they will respond in individual ways by choice as well. It follows that the more thoroughly the curator understands the visitors to his museum the better he can aim the exhibit to target their needs. What he knows about the public will affect both the purpose and methods of dis-

play. By observing visitors, listening to them and perhaps questioning them he learns to create exhibits relevant to their points of view.

—Museum exhibits ordinarily occupy exhibit cases. There are good reasons why. A properly designed and well constructed case protects the specimens from dust, insects, rapid changes in relative humidity, ultraviolet radiation, handling and theft. A case that does all this tends to cost accordingly. On the other hand, cases do deny visitors the close contact with objects often desirable. Some specimens do not need full protection. It follows that the curator should use cases selectively, insisting on them where really needed, dispensing with them where permissible and taking active measures to compensate for the greater risks when he displays objects in the open. When a curator must fabricate exhibit cases in the museum, he should bear in mind the following considerations. Every joint must be as tight as possible if the case is to exclude much dust or deter insect attack. Gaskets of strips of felt poisoned with an insecticide or of plastic foam can help make a case tight. As a rule no exhibit case should have lighting units inside the space enclosing the specimens. Unless the lights are outside and adequately ventilated, the heat they generate will nullify efforts to dustproof the case or will harm the case contents. Case lights should allow quick replacement of burned out lamps. Generally cases that open from the front make exhibit installation and maintenance easier than ones with back or side access. They also make it easier to replace fumigants or humidity buffers. Build cases to be as unobtrusive as possible. Visitors should hardly notice their presence while absorbing their contents.

—Specimens on exhibition usually require some kind of mounting. The curator must fasten them to a background, rest them on a support or perhaps suspend them in mid air. This aspect of exhibit preparation demands special care for two reasons. The safety and integrity of the objects usually means that no adhesive will be applied to them, no holes drilled into them and no pins, nails or screws pushed through them. The welfare of the specimen dominates mounting decisions. Because it is continually under critical inspection by visitors, the method of mounting should be inconspicuous or very neatly executed.

—Few visitors know how to "read" objects. This is a skill for which training is scarcely ever available. Viewers need help, particularly if you want an object to say something specific. For this reason most good exhibits include various supplementary aids: pictures, maps, models and especially labels. Their role is to bridge the communication gap between the voiceless specimen and the visitor. It follows that these elements require careful selection or design to fit them for specific purposes. A map, for example, may relate an object to a place. Is the map simple enough for visitors to understand? Does it really show where the place is in relation to places they know? Does it introduce problems of orientation or scale? Is it detailed enough to answer the geographical questions the exhibit is likely to

raise? Would a reproduction of a map contemporary with the object add more meaning than one drawn just for the exhibit? The choice of pictures raises similar questions. A picture that shows the use or setting of a specimen as seen through the eyes of an artist of the same period has more validity than one drawn for the exhibit. An explanation of some special feature of construction or function may call for a sketch or diagram made to illustrate this one point. A photograph may provide more convincing evidence than an artist's impression. Models involve questions of accuracy, clarity and scale. Each supporting element of the exhibit merits careful thought.

—To write a good label stretches the verbal skill of any curator. Visitors with the best of intentions find it hard to read exhibit labels. It is physically tiring to read while standing, especially when the varying heights and distances require holding one's head at unaccustomed angles and changing focus frequently. Age and bifocals compound the difficulty. There are mental obstacles too. Other elements in the exhibit compete for attention. Other visitors distract. It follows that labels need to be as readable and as legible as possible. Readability ranks first. A good label must say significant things in ways that capture attention and interest. It should also be short. The factors that discourage label reading increase with every added line. Some museums feel that any label longer than 25 words needs special justification. The inclusion of a donor's name ordinarily weakens a label. Strive to make every label accurate, clear, interesting and brief.

—A well-written label next needs production in a highly legible form. This involves questions of size, spacing, letter design and color. If a museum can afford to have a skillful and sensitive printer handset and print its labels, it can achieve the finest in legibility. For the curator who must make his own, several practical alternatives enable him to produce labels of acceptable quality. The results will depend largely on his patience. He can use a typewriter with carbon ribbon to make a clear, sharp-lined copy. This can be enlarged photographically to legible size. He can buy sheets of letters printed on clear plastic with a pressure-sensitive adhesive on the back. With these he can set up the label one letter at a time. He can also buy individual letters die cut from cardboard or cork and letters cast in various plastic materials; or he can cut or cast them himself. These find use in titles particularly. Templates and special pens used by draftsmen permit him to letter by hand in an acceptable manner. Using stencils and an electrical tool he can rout the words into wood, plastic or sheet aluminum. He can produce labels by the silkscreen process, either cutting the stencil by hand from carefully traced letters or making it photographically. Most of these alternatives give him scope to use big or bold letters for headings and key ideas, and suggest less emphasis by smaller or lighter type. Such methods offer the curator no easy answer, but leave little excuse for poor legibility.

—The curator working without a staff of artists and craftsmen need not aspire to sophisticated design or complex construction. He should set standards of clearly defined exhibit purposes linked to well understood community needs, of specimens thoughtfully selected and safely and sympathetically installed, of logical arrangement, of neatly finished workmanship, of first-class maintenance. Then he should take time to observe the exhibit in use, identify its weak points and devise ways to improve them.

Reference

Specimens not on exhibition comprise the study series. As the term implies, the objects are used by studying them. Most frequently they are turned to for specific, detailed information as to a reference book. The objects provide authoritative answers. Curators and interpreters depend on the collections to supply or verify many of the facts they present in reports, publications, talks and guided tours. This is particularly the case with naturalists and archeologists who must rely on data furnished by correctly identified specimens.

Seasonal interpreters in parks, younger museum docents and volunteers often use the study series even more than the senior, full-time staff. It may be their most dependable training aid. From the specimens they learn to recognize the rocks, fossils, plants and animals they will encounter and interpret. As they find unfamiliar species in their guided trips, the collections help identify the forms quickly and accurately. The specimens may also give details of a localized character the interpreters could not get from books. When these staff members give talks or make other verbal interpretive contacts, they can speak reliably and with confidence about the kinds of objects they have examined and handled in the collections.

Wise decisions in the management and protection of a park or other environmental unit often depend on the correct identification of the plants, animals, rocks or other features involved. Thus the people who recommend measures, and those who carry them out, should use the study series to check their determinations and to make sure they can recognize the specific forms in the field. When the decisions involve historical restoration, the use of the collections may be equally vital.

Visitors also use the study series. Many want to know the name of an unfamiliar animal or plant they have seen. The collections not only provide a prompt, authoritative answer, but also may stimulate further interest. Some visitors seek more specialized help because their vocation or avocation touches a facet of the museum's field of interest. The amateur botanist or the gun collector, for example, may want to dig deeper, looking at all the pertinent specimens and checking data on the catalogue cards. People

awakened to the environmental crisis can obtain many insights as well as helpful data from study specimens. More visitors will use the study series to good advantage if properly controlled access is easy. Let people know what the collections contain and invite them to examine the specimens in which they are interested. In addition to learning from these particular specimens, visitors enjoy getting behind the scenes. They see and appreciate the solid factual basis underlying what the museum says and does.

Sometimes a collection in the study series has enough significance or general interest to warrant installing it in "visible storage". It then supplements the exhibit series, assuming of course, that it is in accordance with the defined purposes of the museum. The Fuller gun collection at Chattanooga-Chickamauga National Military Park is used in this way (fig. 39). Visible storage implies protection and accessibility for study along with attractive but usually compact display.

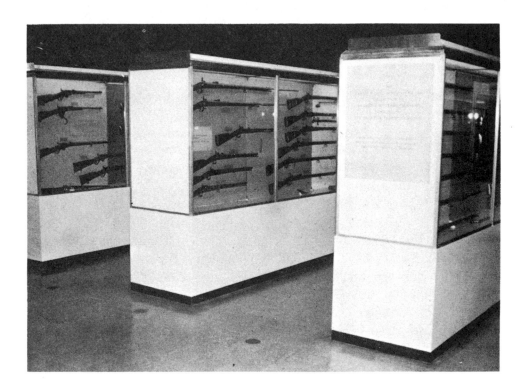

Research

The collections serve research needs in several ways. Accurately identified specimens form the datum plane for essential ecological and some archeological studies. Intensive analysis of the specimens themselves may comprise valuable contributions to knowledge—descriptions of new spe-

cies, revised classifications or datings, for example. Broader studies use specimens as part of the evidence leading to fresh conclusions, like the discovery of the source of North Devon pottery in the Jamestown collection at Colonial National Historical Park. Often, as in the case of archeological projects, the research creates the collection. To develop the research use of the collections, first be sure to gather objects worth studying, to preserve them properly for study and to record full data about them. Then take steps to let scholars know what resources the collections contain. Curators generally recognize their responsibility to have scholarly catalogues of their collections compiled and published, although other duties too frequently delay these projects. The annotated inventory of its archeological collections in the Southwest compiled by the National Park Service is an excellent example of an intermediate measure. An entry from this inventory comprises Appendix C. This kind of information about the collections should get into the hands of professors and graduate students at appropriate universities. Another step of increasing importance involves the storage of full information about the specimens in computerized data banks. Practical techniques for accomplishing this on an intermuseum, international basis should become available soon (see bibliography at the end of the chapter).

Documentation

A specimen which has been used in research acquires value as a document because other scholars can verify the results only by re-examining the original evidence. While this does not mean that every specimen studied in the course of a research project must be kept permanently, you need to recognize and respect the documentary importance of those specimens which were significant in the study. Similarly, the objects which support statements which a museum communicates to the public have documentary functions. While documentation is a relatively passive use of the collections, it justifies the continued preservation of many specimens.

BIBLIOGRAPHY

Exhibition

The professional literature abounds with articles and books on exhibits and also on the related educational uses of museum collections. To help develop personal standards of exhibit quality study the published illustrations and descriptions of newly installed displays. Almost every issue of the Unesco

quarterly, *Museum*, contains photographs or floorplans and explanations that reveal current exhibit practice. In addition see, for example:

Aloi, Roberto. *Musei: Architettura-Tecnica*. Milan. Hoepli, 1962.

Bergmann, Eugene. "Exhibits That Flow," *Curator*, XIV:4 (1971), pp. 278–286.

Bliss, Dorothy E. "Creating a Conceptual Teaching Hall on the Invertebrates," *Curator*, XIV:4 (1971), pp. 241–263.

Connor, Patricia, and Kenneth Pearson. "The Birth of the Fishbourne Roman Palace Museum," *Museums Journal*, 68:3 (December 1968), pp. 115–117.

Mantel, Linda Habas. "Presenting Physiological Concepts in a Museum Exhibit," *Curator*, XIV:4 (1971), pp. 264–277.

Merrifield, Ralph. "The Fishbourne Museum," *Museums Journal*, 68:3 (December 1968), pp. 118–120.

Mollo, Boris. "New Regimental Museums," *Museums Journal*, 74:1 (June 1974), pp. 12–14.

Nicholson, Thomas D. "The Hall of Man in Africa at the American Museum of Natural History," *Curator*, XVI:1 (1973), pp. 5–24.

Parker, Harley W. "New Hall of Fossil Invertebrates, Royal Ontario Museum," *Curator*, X:4 (1967), pp. 284–296.

Plath, Helmuth. "The Historical Museum on the Hohen Ufer," *Museums Journal*, 67:3 (December 1967), pp. 219–227.

Quimby, Ian M. G. "The Specialized Museum: A Case Study," Part I, *Museum News*, 44:6 (February 1966), pp. 34–36; Part II, 44:7 (March 1966), pp. 28–32.

Taylor, Frank A. "The Museum of History and Technology: The Smithsonian's Newest," *Museum News*, 42:10 (June 1964), pp. 11–18.

Tynan, A. M., and M. P. McLauclin, "Popular Geology, A New Approach to an Old Problem," *Curator*, VII:1 (1964), pp. 39–50.

Vermeule, Cornelius, and Mrs. Penelope Truitt. "The Galleries of Early Greek Art at the Museum of Fine Arts, Boston," *Curator*, XI:3 (1968), pp. 211–217.

For discussion of the theory of museum exhibits see:

Bayer, Herbert. "Aspects of Design of Exhibitions and Museums," *Curator*, IV:3 (1961), pp. 257–287.

Beneker, Katharine. "Exhibits—Firing Platforms for the Imagination," *Curator*, I:4 (1958), pp. 76–81.

Borhegyi, Stephan F. de. "Visual Communication in the Science Museum," *Curator*, VI:1 (1963), pp. 45–57.

Cameron, Duncan F. "A Viewpoint: The Museum as a Communications System and Implications for Museum Education," *Curator*, XI:1 (1968), pp. 30–40.

Conway, William G. "How to Exhibit a Bullfrog: A Bed-Time Story for Zoo Men," *Curator*, XI:4 (1968), pp. 310–318.

Gabus, Jean. "Aesthetic Principles and General Planning of Educational Exhibitions," *Museum*, XVIII:1, 2 (1965), pp. 2–31, 82–97.

Gilborn, Craig. "Words and Machines: The Denial of Experience," *Museum News*, 47:1 (September 1968), pp. 25–29.

Gill, Edmund D. "Search for New Ideas on Museum Exhibits," *Curator*, X:4 (1967), pp. 275–278.

Hale, John. "Museums and the Teaching of History," *Museum*, XXI:1 (1968), pp. 67–72.

Hofmann, Helmut, and Leonard G. Johnson. "Translating Inert to Living Knowledge," *Curator*, V:2 (1962), pp. 120–127.

Knez, Eugene I., and A. Gilbert Wright. "The Museum as a Communications System: An Assessment of Cameron's Viewpoint," *Curator*, XIII:3 (1970), pp. 204–212.

Larrabee, Eric, ed. *Museums and Education*. Washington. Smithsonian Institution Press, 1968.

McLuhan, Marshall, *et al. Exploration of the Ways, Means and Values of Museum Communication with the Viewing Public: A Seminar with Marshall McLuhan, Harley Parker, and Jacques Barzun*. New York. Museum of the City of New York, 1969.

Neal, Arminta. "Function of Display: Regional Museums," *Curator*, VIII:3 (1965), pp. 228–234.

Noble, Joseph Veach. "More than a Mirror to the Past," *Curator*, XVI:3 (1973), pp. 271–275.

Parr, Albert Eide. "Some Basic Problems of Visual Education by Means of Exhibits," *Curator*, V:1 (1962), pp. 36–44.

Screven, Chandler G. "The Museum as a Responsive Learning Environment," *Museum News*, 47:10 (June 1969), pp. 7–10.

———. "Instructional Design," *Museum News*, 52:5 (January/February 1974), pp. 67–75.

Shapiro, Harry L. "Some Observations on the Function of a Scientific Exhibit," *Curator*, IV:3 (1961), pp. 226–230.

Shettel, Harris H. "Exhibits: Art Form or Educational Medium?" *Museum News*, 52:1 (September 1973), pp. 32–41.

Swauger, James L. "Topless Girl Guides or We have a Crying Need to be Old-Fashioned," *Curator*, XII:4 (1969), pp. 307–318.

Warhurst, Alan. "The Planning of Museums and Art Galleries: Display Problems," *Museums Journal*, 63:1 and 2 (June—September 1963), pp. 42–53.

Weiss, Robert S., and Serge Boutourline, Jr. "The Communication Value of Exhibits," *Museum News*, 42:3 (November 1963), pp. 23–27.

Wilson, Kenneth M. "A Philosophy of Museum Exhibition," *Museum News*, 42:2 (October 1967), pp. 13–19.

Wittlin, Alma S. "Hazards of Communication by Exhibits," *Curator*, XIV:2 (1971), pp. 138–150.

Sources of advice on exhibit preparation include:

Beazley, Elisabeth. *The Countryside on View: A Handbook on Countryside Centres, Field Museums, and Historic Buildings Open to the Public*. London. Constable & Company Ltd., 1971, pp. 72–115, 195–201.

Belcher, M., K. Heathcote and G. Stansfield. *Silk-screen Printing*. Information Sheet 16. London. Museums Association, 1973.

Bloch, Milton J. "Improvised Exhibit Design for the Small Budget," *Museum News*, 47:1 (September 1968), pp. 21–24.

———. "Labels, Legends, and Legibility," *Museum News*, 47:3 (November 1968), pp. 13–17.

———. "Lighting," *Museum News*, 47:5 (January 1969), pp. 20–29 (sic).

———. "A Case of Boredom," *Museum News*, 47:9 (May 1969), pp. 21–24.

Bowditch, George. "Preparing Exhibits: Case and Prop Design," American Association for State and Local History Technical Leaflet 12, *History News*, 26:6 (June 1971).

———. "Preparing Your Exhibits: Case Arrangement and Design," American

Association for State and Local History Technical Leaflet 56, *History News*, 26:2 (February 1971).

————, and Holman J. Swinney. "Preparing Your Exhibits: Methods, Materials, and Bibliography," American Association for State and Local History Technical Leaflet 4, *History News*, 24:9 (October 1969).

Brommelle, N. S. "Museum Lighting Part 1: Colour Rendering," *Museums Journal*, 61:3 (December 1961), pp. 169–176.

————. "Museum Lighting Part 4: Viewing the Object," *Museums Journal*, 62:3 (December 1962), pp. 178–186.

Conaway, Mary Ellen. "Exhibit Labeling: Another Alternative," *Curator*, XV:2 (1972), pp. 161–166.

Cordingly, David. *Methods of Lettering for Museums.* Information Sheet 15. London. Museums Association, 1972.

Denyer, Edward F. "Silk Screen Printing and Museum Exhibits," *Curator*, VII:3 (1964), pp. 185–195.

Freeman, Joan E., and H. Charles Fritzemeier. "Preparing Your Exhibits: Figures for Miniature Dioramas," American Association for State and Local History Technical Leaflet 20, *History News*, 27:7 (July 1972).

Harris, J. B. "Museum Lighting Part 2: Artificial Lighting and Museum Display," *Museums Journal*, 61:4 (March 1962), pp. 259–267.

Jones, William K. "Preparing Exhibits: The Use of Plexiglas," American Association for State and Local History Technical Leaflet 49, *History News*, 24:2 (February 1969).

Kelly, Richard. "Museum Lighting. Part III," *Museum News*, 37:3 (May 1959), pp. 16–19.

Lusk, Carroll B. "Museum Lighting," *Museum News*, 49:3 (November 1970), pp. 20–23.

————. "Museum Lighting II," *Museum News*, 49:4 (December 1970), pp. 25–29.

————. "Museum Lighting III," *Museum News*, 49:6 (February 1971), pp. 18–22.

McCandless, Stanley. "Museum Lighting. Part I," *Museum News*, 37:1 (March 1959), pp. 8–11.

————. "Museum Lighting. Part II," *Museum News*, 37:2 (April 1959), pp. 8–11.

Neal, Arminta. *Help! for the Small Museum: A Handbook of Exhibit Ideas and Methods.* Boulder. Pruett Press, 1969.

————. "Gallery and Case Exhibit Design," American Association for State and Local History Technical Leaflet 52, *History News*, 24:8 (August 1969), reprinted from *Curator*, VI:1 (1963), pp. 77–95.

————. "Legible Labels: Hand-lettering," American Association for State and Local History Technical Leaflet 22, rev. ed., *History News*, 26:7 (July 1971).

————. "Legible Labels: Three-dimensional Letters," American Association for State and Local History Technical Leaflet 23, rev. ed. *History News*, 19:10 (May 1964), revised 1971.

North, F. J. *Museum Labels.* Handbook for Museum Curators B 3. London. Museums Association, 1957.

Riviere, Georges Henri, and Herman F. E. Visser. "Museum Showcases," *Museum*, XIII:1 (1960), pp. 1–55.

Weiner, George. "Why Johnny Can't Read Labels," *Curator*, VI:2 (1963), pp. 143–156.

Williams, Luther A. "Labels: Writing, Design, and Preparation," *Curator*, III:1 (1960), pp. 26–42.

Wilson, Don W., and Dennis Medina, "Exhibit Labels; A Consideration of Content," American Association for State and Local History Technical Leaflet 60, *History News*, 27:4 (April 1972).

Behavioral studies of museum visitors aim on one hand to define the museum audience and on the other to measure and improve exhibit effectiveness. For access to this important field see:

Elliott, Pamala, and Ross J. Loomis. *Studies of Visitor Behavior In Museums and Exhibitions*. Washington. Smithsonian Institution, 1975.

Loomis, Ross J. "Please Not Another Visitor Survey," *Museum News*, 52:2 (October 1973), pp. 21–26.

As a sampling of the literature on the educational or interpretive uses of collections see:

Bay, Ann. *Museum Programs for Young People: Case Studies*. Washington. Smithsonian Institution, 1973.

Cart, Germaine, Molly Harrison and Charles Russell. *Museums and Young People*. Paris. International Council of Museums, 1952.

Cheetham, Francis W., ed. *Museum School Services*. London. Museums Association, 1967.

Frese, H. H. *Anthropology and the Public: The Role of Museums*. Leiden. E. J. Brill, 1960, pp. 73–96, 160–193.

Gibbs-Smith, Charles H. *The Arrangement and Organization of Lectures*. Information Sheet 8. London. Museums Association, 1974.

Harrison, Molly. *Museum Adventure*. London. University of London Press, 1950.

———. *Learning Out of School*. London. Educational Supply Association, Ltd., 1954.

———. *Changing Museums: Their Use and Misuse*. London. Longmans, Green and Co., Ltd., 1967.

———. *Museums and Galleries*. London. Routledge & Kegan Paul Ltd., 1973.

ICOM. *Museums' Annual: Education, Cultural Action*. Paris. International Council of Museums, 1969. (Original title: *Annals—Museums, Education, Cultural Action*).

Larrabee, Eric, ed. *op. cit.*

Long, Mrs. M., *et al. Pterodactyls and Old Lace: Museums in Education*. London. Evans Brothers Ltd and Methuen Educational Ltd. New York, Citation Press, Scholastic Magazines Inc. for Schools Council, 1972.

Low, Theodore L. *The Museum as a Social Instrument*. New York. Metropolitan Museum of Art, 1942.

———. "The Museum as a Social Instrument: Twenty Years After," *Museum News*, 40:5 (January 1962), pp. 28–30.

Oliver, Ruth Norton, ed. *Museums and the Environment: A Handbook for Education*. New York. Arkville Press for the American Association of Museums, 1971.

Ramsey, Grace Fisher. *Educational Work in Museums of the United States*. New York. H. W. Wilson Co., 1938.

Tilden, Freeman. *Interpreting Our Heritage: Principles and Practices for Visitor Services in Parks, Museums and Historic Places*. Rev. ed. Chapel Hill. University of North Carolina Press, 1967.

Unesco. *Museums, Imagination and Education.* Museums and Monuments—XV. Paris. UNESCO, 1973.

Winstanley, Barbara R. *School-Loan Services.* Handbook for Museum Curators G 4. London. Museums Association, 1959.

————. *Children and Museums.* Oxford. Basil Blackwell & Mott, Ltd., 1967.

Zetterberg, Hans L. *Museums and Adult Education.* London. Evelyn, Adams & Mackay for the International Council of Museums, 1968. Clifton. Augustus M. Kelly, 1969.

Reference

Peters, James A. "The Time-shared Computer as an Adjunct to Museum Exhibits," *Museums Journal,* 72:4 (March 1973), pp. 143–145.

Young, Rachel M. R. *Museum Enquiries.* Information Sheet 11. London. Museums Association, 1972.

Research and Documentation

Chavis, John. "The Artifact and the Study of History," *Curator,* VII:2 (1964), pp. 156–162.

Chernela, Janet. "In Praise of the Scratch: The Importance of Aboriginal Abrasion on Museum Ceramic Ware," *Curator,* XII:3 (1969), pp. 174–179.

Cohen, Daniel M., and Roger F. Cressey, eds. "Natural History Collections, Past–Present–Future," *Proceedings of the Biological Society of Washington,* 82 (1969), pp. 559–762.

Fleming, E. McClung. "Early American Decorative Arts as Social Documents," *Mississippi Valley Historical Review,* 45:2 (September 1958), pp. 276–284.

————. "The Period Room as a Curatorial Publication," *Museum News,* 50:10 (June 1972), pp. 39–43.

————. "Artifact Study: A Proposed Model," *Winterthur Portfolio 9.* Charlottesville. University Press of Virginia for the Henry Francis du Pont Winterthur Museum, 1974, pp. 153–173.

Gilborn, Craig. "Pop Pedagogy," *Museum News,* 47:4 (December 1968), pp. 12–18.

Hale, Richard W., Jr. "Methods of Research for the Amateur Historian," American Association for State and Local History Technical Leaflet 21, rev. ed., *History News,* 24:9 (September 1969).

Hubbell, Theodore H., *et al.* comps. and eds. *America's Systematics Collections: A National Plan.* Lawrence. Association of Systematics Collections, 1973.

Jenkins, J. Geraint. "The Collection of Ethnological Material," *Museums Journal,* 74:1 (June 1974), pp. 7–11.

Johnels, Alf G. "The Museum as a Monitoring Instrument: Role of Natural History Museums," *Museum,* XXV:1/2 (1973), pp. 54–58.

Mayr, Ernst, and Richard Goodwin. *Biological Materials, Part I. Preserved Materials and Museum Collections.* Publication 399. Washington. National Academy of Science–National Research Council, n.d.

Mori, John L., and Joycelyn I. Mori. "Revising Our Conceptions of Museum Research," *Curator,* XV:3 (1972), pp. 189–199.

Neustupny, Jire. *Museum and Research.* Prague. Office of Museum and Regional Work of the National Museum, 1968.

Parr, Albert Eide. "Systematics and Museums," *Curator*, I:2 (1958), pp. 13–16.

———. "The Right to Do Research," *Curator*, I:3 (1958), pp. 70–73.

———. "The Functions of Museums: Research Centers or Show Places," *Curator*, VI:1 (1963), pp. 20–31.

Peters, James A., and Bruce B. Collette. "The Role of Time-share Computing in Museum Research," *Curator*, XI:1 (1958), pp. 65–75.

Smith, Albert C., *et al.* "The Role of the Research Museum in Science," *Curator*, III:4 (1960), pp. 311–360.

The accessibility of the information embodied in museum collections has much to do with the use of the collections in research. A growing literature concerns the storage and retrieval of these data by computers. See, for example:

Anon. *Computers and Their Potential Applications in Museums.* New York. Arno Press, 1968.

Ball, Laurel. "Recording Agricultural Collections," *Museums Journal*, 72:2 (September 1972), pp. 55–57.

Chenhall, Robert G. "Sharing the Wealth," *Museum News*, 51:8 (April 1973), pp. 21–23.

———. *Museum Cataloging in the Computer Age.* Nashville. American Association for State and Local History, 1975.

Cutbill, J. L., ed. *Data Processing in Biology and Geology.* Proceedings of a Symposium, Cambridge, England. New York. Academic Press, 1971.

———. *Computer Filing Systems for Museums and Research.* London. Museums Association, 1973.

Dudley, Dorothy H., and Irma B. Wilkinson, *et al. Museum Registration Methods.* Rev. ed. Washington. American Association of Museums and Smithsonian Institution, 1968, pp. 283–290. Rev. ed. in prep.

Elisseeff, Vadime, *et al.* "Museums and Computers," *Museum*, XXIII:1 (1970/71), pp. 1–62.

Lewis, Geoffrey D. "Obtaining Information from Museum Collections and Thoughts on a National Museum Index," *Museums Journal*, 65:1 (June 1965), pp. 12–22.

———. "IRGMA (Information Retrieval Group of the Museums Association)," *Museums Journal*, 69:3 (December 1969), p. 142, 70:3 (December 1970), p. 134, 71:3 (December 1971), p. 129, 72:3 (December 1972), p. 116, 73:3 (December 1973), p. 128.

———, *et al.* "Information Retrieval for Museums. Report of a Colloquium Held at the City Museum, Sheffield in April 1967," *Museums Journal*, 67:2 (September 1967), pp. 88–120.

———, ed. *Draft Proposals for an Interdisciplinary Museum Cataloguing System.* London. Museums Association, 1969.

Manning, Raymond B. "A Computer-Generated Catalog of Types: A By-Product of Data Processing in Museums," *Curator*, XII:2 (1969), pp. 134–138.

Peters, James A. "The Computer and the Collection-at-Large," *Curator*, XIII:4 (1970), pp. 263–266.

Rensberger, John M., and William B. N. Barry. "An Automated System for Retrieval of Museum Data," *Curator*, X:4 (1967), pp. 297–317.

Ricciardelli, Alex F. "A Census of Ethnological Collections in U.S. Museums," *Museum News*, 46:1 (September 1967), pp. 11–14.

————. "A Model for Inventorying Ethnological Collections," *Curator*, X:4 (1967), pp. 330–336.

Roads, C. H. "Data Recording, Retrieval and Presentation in the Imperial War Museum," *Museums Journal*, 67:4 (March 1968), pp. 277–283.

Squires, Donald F. "Data Processing and Museum Collections: A Problem for the Present," *Curator*, IX:3 (1966), pp. 216–227.

————. "An Information Storage and Retrieval System for Biological and Geological Data," *Curator*, XIII:1 (1970), pp. 43–62.

Vance, David. "Museum Computer Network: The Second Phase," *Museum News*, 48:9 (May 1970), pp. 15–20.

————. "Museum Computer Network: The Third Phase," *Museum News*, 51:8 (April 1973), pp. 24–27.

Van Gelder, Richard G., and Sydney Anderson. "An Information Retrieval System for Collections of Mammals," *Curator*, X:1 (1967), pp. 32–42.

Chapter 6 Disposal of Specimens

When any museum specimen ceases to have value, keeping it in the collection wastes space, staff time and money. Good management requires its disposal. Deciding which objects to get rid of and how best to dispose of them are demanding parts of a curator's job. Museums have lost important and valuable specimens because someone incorrectly judged them to be useless or surplus. Such mistakes are irrevocable. They do double damage by undermining a museum's reputation. In considering disposal, therefore, make sure first that you really know what the object is. Then determine beyond reasonable doubt that it has no further use in the museum. In reaching a decision, review all the ways in which specimens serve the public interest, present and future (see Chapter 5, Using Museum Collections). Do not discard an object simply because it is in poor condition, for example, or because it is not of current interest. Proper restoration or repair can often return it to usefulness. Interests and tastes change continually. Accept the responsibility of specimen disposal although it involves risks. It is an essential step in refining collections.

Another factor will play a larger part in disposal policy as museums mature in their outlook. Curators will ask not only, "Is this specimen useful?", but, "Where will it be most useful?". This approach will lead to truly rational collections.

Methods

To dispose of a specimen you may perhaps sell it, exchange it, give it away, lend it or destroy it. Choosing the best method in each case calls for good judgment. All the permissible ways should be considered. Often you

cannot use one or another because of institutional restrictions or conditions accepted when the object was acquired. Specimens owned by a national park museum, for example, become Federal property. The park cannot sell them nor give them away, even by returning a gift to the original donor. The means of disposal have various advantages and may well be considered in this order:

1. Transfer to another museum. When a specimen not needed in one museum is transferred to another where it is useful, both museums benefit. Such free movement of specimens on the basis of need often does more good than trying to negotiate value-for-value exchanges. This is the common practice among park museums.

2. Exchange with another museum. In an exchange both museums receive objects of generally comparable value. The objects achieve increased usefulness and remain available to the public. National park museums consider exchanges with the Smithsonian Institution first because the objects continue to be Federal assets while getting better use. Exchanges between museums such as these can become a continuing process. Specimens moving in one direction then become the basis for some future movement in the other. This makes negotiations easier and less time-consuming.

3. Exchange with dealers or collectors. Bartering inappropriate specimens for others that the museum does need can be beneficial, but be sure that you know at least as much about the identity, authenticity and value of the specimens on both sides of the deal as does the other party.

4. Sale to dealers or collectors. When this is permissible, a museum can dispose of unwanted material to obtain funds with which to purchase specimens it can use to good advantage.

5. Gift to responsible public or private institutions, organizations or agencies. Specimens which are neither usable in the museum nor of interest to other museums, dealers or collectors who could offer something in exchange, may sometimes be put to good use by a local museum or school, for example. Do not use this or the following method as easy ways to get rid of objects of such poor quality that they have questionable educational value.

6. Long-term loan to responsible public or private institutions, organizations or agencies. If an object has lost its usefulness to the museum but must be retained as museum property, it can ordinarily be loaned. Find a borrower who can take care of it and use it.

7. Destruction. A few objects having no scientific, historical, esthetic or educational value may remain. These should be destroyed, not just thrown out where someone might retrieve them. In park museums this requires that they be surveyed for disposal through surplus property channels.

The disposal of specimens should be properly documented (see below, Lending Museum Specimens, and Deaccessioning, Chapter 7).

Clearing House Services

National park museums have access to services which help in effective specimen disposal. Other museums familiar with these clearing house operations may benefit from the exchanges or loans negotiated. The clearing house is a procedure to refine all park collections by concerted action to eliminate inappropriate specimens, fill gaps and reassign objects to their places of greatest usefulness. It provides an efficient channel for negotiating advantageous transfers, exchanges and long-term loans to free the collection of unneeded specimens. It helps replace some of them with objects the museum really needs. Throughout the process it protects the public interest.

Park museums participate in the clearing house as follows:

1. They send the regional curator a duplicate catalogue card for each specimen in the park collections which seems to be inappropriate or surplus to the needs of the park. They also send the immediate and long-range want list of exhibit specimens, along with a list of objects needed to round out and strengthen the study series. They describe clearly the items on the want lists. If help is needed in determining what is lacking, surplus or not pertinent, they request the regional director to assign qualified specialists to compile or review the selections.

2. The regional curator compares the wants and unwanted specimens with those of all other parks in the region. He sends each park's want list to the other regions and to the Harpers Ferry Center clearing house for checking with their files of unneeded specimens. When the regional curator finds that a park has a specimen available which seems to fit another park's need, he sends a description of the object. If the specimen is what the second park wants, it is shipped directly and the regional curator is notified so the lists will be current.

3. When the want list contains specimens not available from the parks, the regional curator tries to locate the needed objects in other museums, private collections or dealers' stocks. He then negotiates an equitable exchange, if possible, using the surplus specimens offered or even those available from other parks. When a good deal has been arranged, the regional curator notifies the park or parks involved. If acceptable, the specimens are sent directly to the institution or individual offering the exchange. The transaction is reported to the regional curator so the lists remain up-to-date.

4. The regional curator locates museums, schools or similar institutions that can make good use of the unneeded specimens which are also unsuitable for exchange. He arranges a long-term loan. If acceptable, the specimens go directly from the park to the borrowing institution with notification to the regional curator.

5. It takes time and patience to negotiate productive transfers, exchanges or loans. If the regional curator fails to develop a satisfactory

disposition of an unneeded specimen in due time, he ordinarily will recommend, by memorandum, that the park's Board of Survey declare the specimen surplus government property to be sold or destroyed under General Services Administration rules. His memorandum releases the specimen from the clearing house operation. To assure timely disposal the date when the specimen was referred to the clearing house is noted on the working (blue) copy of the catalogue card. Then action can be requested if it remains too long.

In the clearing house procedure there are two additional responsibilities. Park staffs notify the regional curator of any promising leads they have for transfers, exchanges or loans. Such contacts complement the broader reach of the regional curator or Harpers Ferry Center curators (see also the Center's clearing house facilities, Central Repositories, Chapter 4). In some instances the park superintendent or interpreter may be asked to carry out the negotiations because he knows the people involved, or is conveniently close to them. Also, the park must document the actual transactions involving its collection. See Chapter 2 for recording transfers and exchanges. Instructions on loans follow. The Board of Survey report documents its action. The park notes the manner and date of all disposals on the museum catalogue form and in the accession records.

If there is a specimen which has deteriorated to a condition of obvious worthlessness, the park bypasses the clearing house and refers it directly to the accountable property officer. Other occasions may be found when it is possible for the park to act directly in arranging a transfer, exchange or loan to better advantage than through the clearing house. If so, it keeps the regional curator informed.

Lending Museum Specimens

Long-Term Loans

This course of action accomplishes two ends. It converts a presently useless specimen, or series of specimens, into a useful one. In the process, it saves the space and care the material required in the museum. On the other hand, lending does not relieve you of all responsibility for the objects. They remain in the museum records as part of the collection for which you are curatorially accountable. Therefore, select carefully the institution to which to lend, and make sure it understands the nature and conditions of the loan.

The minimum condition is that the borrower return the specimens whenever the institution is no longer willing or able to care for them. If the objects have little intrinsic value or can be readily replaced, this may be

enough. The obligation then consists of knowing that the borrowing institution is still in existence. With more valuable specimens, a definite period should be set at the end of which the borrower requests renewal of the loan for a corresponding length of time. The best period between renewals varies with the importance of the specimens and the character of the institution involved, but ordinarily should not exceed five years. For particularly valuable items, inspect them between renewals, and in exceptional instances ask the borrower to insure them. When a specimen on long-term loan wears out or deteriorates beyond repair, have it destroyed. Park museums refer it to the accountable property officer.

To document a long-term loan, send the borrower a letter stating what is being lent, how and when the agreement may be renewed and that the material is to be returned if the borrower can no longer take care of it. Park museums enclose with the letter two copies of Standard Form 10–127, Loan of Specimens (fig. 40). They fill in part of the form first, request the borrower to fill in additional parts and ask him to return one copy as a receipt. They file a copy of the letter and the loan form in the accession folder.

Short-Term Loans

Although not a means of disposal, brief loans require similar procedures. If the museum contains important specimens, other museums or scholars may wish to borrow them for special exhibition or study. Such uses increase the value of the specimens to the public. Requests, therefore, should be granted to lend objects unless they are unlikely to withstand the risks involved. Consider the nature and condition of the specimen. It may be too fragile to lend, or it may need preservative treatment first to strengthen and restore it. Also consider the capability and experience of the borrower. Will the specimen be handled and protected by experts? Weigh the possibilities of damage or loss against the significance of the special use proposed. If the loan is justified, specify mutually satisfactory conditions. These include the period of the loan, which is always definite and short (usually less than six months). Require that the borrower insure the specimen under an all-risk, wall-to-wall policy if the value of the object warrants it. Sometimes it is desirable to specify packing and shipping requirements, or special protective measures while the specimen is in storage or on display.

Document a short-term loan with a letter to the borrower clearly defining the conditions. Park museums again enclose two copies of SF 10–127, one of which the borrower returns as a receipt. They make sure the condition report is complete and accurate for the outgoing specimen. When the specimen is returned, they complete the loan form with equal care. They file the correspondence and loan form in the accession folder. Both the loan and return of the specimen should be entered on the catalogue card.

IN REPLY REFER TO:

UNITED STATES
DEPARTMENT OF THE INTERIOR
NATIONAL PARK SERVICE

Lafayette National Memorial
(Park)

October 9, 1974
(Date)

Dear

 We are lending you the items described below for the purpose of special exhibition commemorating Lafayette_____ for the period of two months (October 15 - December 15, 1974)

 You are responsible for all items in the list. The utmost caution must be exercised in their use. They should be returned in the same condition they were lent.

Will O Hack
(Signature)

Superintendent
(Title)

NO.	OBJECT	VALUE
746	Oil portrait of Lafayette by Prudhomme	$7,500.00
1091	Silver mounted dress sword	
		1,925.00
1092	Scabbard for sword 1091	

(Condition reports on back of this sheet must be filled in)

Signature and title of borrower	Name of organization, etc.	Date of receipt
Marvin E. Fox Director	Academy Memorial Museum	October 12, 1974

Form 10-127 (6/59) / LOAN OF SPECIMENS

a. Obverse.

Figure 40. Form accompanying loaned specimens.

TO BE FILLED IN BY LENDER ONLY

Date loan is to be returned: *(If known)* December 15, 1974

(Examine and describe each specimen carefully, describe any damage or weakened condition on condition.)

 746 Painting cleaned and relined in 1962. Old crackle visible, but no loose
 paint. Gesso chipped on left side of frame molding 2 inches from bottom,
 but the break has been gilded. Follow unpacking and packing instructions
 carefully.

1091-2 Sword complete and sound. Leather scabbard broken 9 inches from tip,
 repaired and reinforced by inside sleeve. Handle only with cotton gloves.

Signature and title of lender	Date
Harry C. Smith Museum Curator	October 9, 1974

TO BE FILLED IN BY THE BORROWER ONLY

Condition of specimens on receipt. *(Photograph and report promptly any damage found in shipment.)*

 746 Painting okay. Fragment of gesso 1/2" long missing just above old
 break. Broken piece not found. (Reported to W. O. Hack by letter
 9/12/74.)

1091-2 As described above.

Signature and title of borrower	Date
David E. Warther Registrar	October 12, 1974

TO BE FILLED IN UPON RETURN OF LOAN

Condition of specimens on return. *(Examine each object carefully. Describe any new damage. Record new damage by photograph.)*

 746 Painting in satisfactory condition. Frame damage as reported, but
 fresh break had been touched up with gilt paint.

1091-2 Light tarnish on hilt, no permanent damage.

Signature and title of person receiving return of loan	Date
Harry C. Smith Museum Curator	December 18, 1974

b. Reverse.

BIBLIOGRAPHY

Methods

Begemann, Egbert H. "The Price is Never Right," *Museum News*, 51:9 (May 1973), pp. 32–35.

Hoving, Thomas P. F. "A Policy Statement from the Met," *Museum News*, 51:9 (May 1973), pp. 43–45.

Jacob, John. "The Sale or Disposal of Museum Objects: The Principles Involved, and an Account of Some Cases in Point," *Museums Journal*, 71:3 (December 1971), pp. 112–115.

Mitchell, Wallace. "When You Run Out of Money . . . Sell," *Museum News*, 51:9 (May 1973), pp. 36–39.

Montias, J. Michael. "Are Museums Betraying the Public's Trust?" *Museum News*, 51:9 (May 1973), pp. 25–31.

Naumer, Helmuth J., and Aubyn Kendall. "Acquisitions and Old Lace," *Museum News*, 51:9 (May 1973), pp. 40–42.

Nicholson, Thomas D. "NYSAM Policy on the Acquisition and Disposition of Collection Materials," *Curator*, 17:1 (1974), pp. 5–9.

Snowman, A. Kenneth. "The Sale or Disposal of Museum Objects: A Dealer's View," *Museums Journal*, 71:3 (December 1971), p. 116.

Wald, Palmer B. "In the Public Interest," *Museum News*, 52:9 (June 1974), pp. 30–32.

Lending Museum Specimens

Cannon-Brookes, Peter. "The Loan of Works of Art for Exhibition," *Museums Journal*, 71:3 (December 1971), pp. 105–107.

Dudley, Dorothy H., and Irma B. Wilkinson, *et al. Museum Registration Methods*. Rev. ed. Washington. American Association of Museums and Smithsonian Institution, 1968, pp. 83–88. Rev. ed. in prep.

Hatt, Robert T., and George L. Stout. "Standard Procedure for Intermuseum Loans," *Museum News*, 27:18 (March 15, 1950), pp. 7–8.

International Council of Museums. "Icom Guidelines for Loans," *ICOM News*, 27:3/4 (1974), pp. 78–79.

Shapiro, Harry L. "Borrowing and Lending," *Curator*, III:3 (1960), pp. 197–203.

Part 2 Museum Records

Introduction

Curators know from experience that a specimen has little or no value to a museum without accompanying information. For each object the essential facts are *what* it is, *how* and *from whom* it was acquired, *when* it was acquired and *where* it is. These comprise the bare minimum; the more data associated with an object, the more useful it is likely to be. Finding out and writing down this information fully, accurately and in a way that will always relate it to the specimen form one of the most important duties of a curator.

While museum record systems vary in detail, they consist of two elements. One, the Accession Record, registers each transaction by which specimens are acquired. The other, called the Catalogue, provides an individual entry for each specimen. Some museums combine the two parts to a degree, but the National Park Service has adopted a standard procedure which keeps them separate. Doing so makes the pattern simpler because it distinguishes clearly between the two functions. It promotes accuracy, at least for the first 100,000 specimens in the collection, by requiring shorter, less complicated numbers. Part II details a record system for small museums as it is applied in the national parks.

Chapter 7 Accession Records

A museum always needs to know the essential details of transactions whereby it has obtained specimens. It therefore keeps a record of this information in as durable a manner as it can. Park museums use a bound volume for this purpose so loose pages will not be lost. The paper is of highest quality, all-rag ledger stock which should last for centuries. Entries are written in carbon-base ink that resists fading. To insure that important facts will not be omitted, printed column headings serve as reminders of the data required. Two secondary records supplement the bound register— an Accession File and a Source of Accession File. These useful compilations need not employ such exceptionally long-lasting paper and ink because they could be largely reconstituted from the book entries.

Accession Book

As each lot of specimens arrives at the museum, enter immediately in the accession book as much of the required information as is available. Fill in the remainder of the entry when the specimens are catalogued or their status changes. The complete record consists of seven columns:

Accession number An accession is all the specimens received from one source at one time. A barnful of miscellaneous artifacts bequeathed to the museum by a former resident is one accession. The fragment of a cannon shell found by a road crew and turned in yesterday is another, while a piece of the same shell they find and turn in today is a third. An accession may contain one object or many, but there can be only one source and one time of arrival. Any exception to this rule seriously weakens the record system. Number the accessions in sequence starting with 1 and progressing indefinitely in unbroken succession. Because accessions are recorded and assigned numbers in the order of arrival, the book automatically becomes a chronological list of the transactions. Enter the number of the accession in the first column and attach the same number temporarily to the objects received (see below).

Date received Record the month, day and year the delivery occurs. This is when the accession actually comes into the museum. By making the entry the same day, you assure accuracy on this point. Avoid any abbreviations of the date that might be confusing. An abbreviation adopted internationally for medical data would use, for example: 9 SEP 74.

Description While this must be brief, tell enough to distinguish the material received. State the number of specimens, if possible (see fig. 41 for examples).

Received from Enter the full name and address of donor, lender, vendor or other source from whom the accession came. Since you will depend on this for future contacts, be sure to record the proper title of address (e.g. Mr., Miss, Col.) and include the zip code.

How acquired State whether the accession is a gift, bequest, purchase, transfer, exchange, term loan or indefinite loan. If it results from field collecting by a staff member as part of his official duties, enter it as a field collection. Otherwise record a field collection as a gift from the individual or organization carrying on the project.

Remarks Use this column to note any unusual facts concerning the transaction, particularly deaccessioning actions (e.g. return of borrowed material, transfers or exchanges, loss or destruction), but also the termination date of loans received and the fact that certain objects are in the museum on approval or for identification.

Catalogue numbers When you catalogue the objects in the accession, go back and enter the catalogue numbers in the last column. If the accession contains too many items for the space allowed, place a list of the numbers in the accession file and note here, "see acc. file." The numbers in this column provide an important link between the two sets of museum records.

Accession File

All accessions should have an accession folder. This is a regular correspondence file folder clearly marked with the accession's number in a carbon-base ink and filed in numerical order in a standard file cabinet. All correspondence (original incoming and duplicate outgoing) and other documents relating to the accession including letters of acknowledgment, conditions of gift, loan or exchange agreement, return receipt, transcript of will, deed of gift, a copy of the bill of lading and invoice, report of damaged condition and any other material relating to that particular trans-

action should be placed in the accession folder (see Chapter 2, especially Gifts and Loans). Until the specimens in an accession are catalogued, keep in the folder field notes and other research data which will later be put in a catalogue file. If documents required for accounting purposes must be retained in the finance office make copies for the accession folder.

Park museums need not send incoming correspondence pertaining to the acquisition of museum specimens to central files, but must notify the officer in charge of general files that the correspondence has been retained in the museum records.

Source of Accession File

This simple reference aid, a handy file of the sources from which the museum has acquired specimens, saves a museum much time and often embarrassment as well. When a donor revisits the museum, for example, you can quickly locate whatever he has given in the past. Merely set up a file of plain 5 × 8-inch (127 × 203mm) cards. On each type the name and address of a source from which the museum has gotten specimens, i.e. copy the entries in the *Received from* column of the accession book onto separate cards. File them alphabetically. Place the accession number on the card below the name and address. Then when a later accession comes from a source for which you already have a card, add its accession number to the card. A glance at the card will tell what accession book entries to check. There you will find the catalogue numbers which will lead you directly to the specimens involved. Park museums regularly maintain one of these files (fig. 42).

Tagging and Storing Accessions

An accurate accession record is of little use if the objects to which it refers cannot be identified or located. Therefore, tag new accessions temporarily with their number until they are catalogued, and place them in space specifically allotted to accessions that have not been catalogued. Set aside a section of specimen storage equipment for this purpose. One drawer in a specimen cabinet may be enough, for example, depending on the amount of new material generally received. Use the designated space for no other purpose and mark it *Accession storage.*

Write the accession number on a tag and fasten it temporarily to each specimen in the lot. Circular, metal-rimmed stock tags or small cardboard price tags with loops of string attached make convenient ones. They can be tied to most objects. Avoid taping the numbers on because the adhesive can damage specimens.

Accession Number	Date Received	Description
01	Jan. 8, 1974	Oil painting by Thomas Smith, "Lookout Point"
02	Jan. 15, 1974	15 Geological specimens – 10 minerals and 5 Devonian fossils.
03	Feb. 10, 1974	Navajo rug, 5'x9', for "Navajo Crafts" exhibition
04	Feb 12, 1974	126 Archeological specimens, Hohokam Sites
05	Mar. 28, 1974	King snake found dead by visitor on Boyles Yoki Trail, 2 miles below Fossil Fern Quarry.
06	Apr. 3, 1974	Flower specimen, Saguaro Cactus
07	Apr. 10, 1974	3 Rock specimens from May Creek
08	Apr. 15, 1974	Gila aggregata plants, pressed, from Ocho Mt.
09	Apr. 30, 1974	Studebaker automobile, 1910, once owned by Jim Jay
10	May 2, 1974	Blue-bellied lizard, alive, 20 Mile Point, May 2, 1974.
11	May 8, 1974	Sioux war bonnet, purchased 1910 at Minot, N.D.
12	May 9, 1974	2 Hopi baskets from Yoca Pueblo.
13	May 9, 1974	Autographed letter signed by Nathaniel Greene, to General Hand dated Philadelphia, March 7, 1778.
14	May 20, 1974	U.S. Sergeant's uniform, c. 1890, blouse and trousers.
15	July 12, 1974	Springfield rifle, M 1863, with bayonet
16	Aug 16, 1974	Badge, order of Purple Heart, awarded Sgt. William Black, 1783.
17	Aug 20, 1974	Cup and saucer, complete, found at Old Fort James Site
18	Sept 4, 1974	Recruiting poster, World War I
19	Sept 17, 1974	3-Boxes of pottery sherds

Figure 41. Sample page from an accession book.

Received From	How Acquired	Remarks	Catalogue Number
Mr. Roger G. Cobbet 15 Sycamore Street Elmira, N.Y. 14904	Gift	Security Transfer Co., New York City.	1
Ward's Natural Science Establishment, Inc. 3000 Ridge Road, East Rochester, N.Y. 14622.	Purchase	acquired for Visitor Center exhibits by Harpers Ferry Center	2-16
Museum of Northern Arizona Flagstaff, Az 86001	Temporary Loan.	Returned June 6, 1974.	
Arizona Archeological Center Tucson, Az. 85717.	Transfer	See accession file.	
Mr. John L. McKee 246 Center Street Logan, UT 84321.	Field Collection		195
Desert Botanical Garden Tucson, Az 85704	Gift	For wild flower exhibit. Discarded April 18, 1974.	
Roy S. Sayre, Dept of Geology, University of Arizona. Tucson, Az 85721.	Gift		197, 198, 199
Mr. Robert A. Small Seasonal Naturalist, Park Staff	Gift	See accession file	
Estate of Mrs. Alice C. Farnsworth 7 Canton Drive Los Angeles, Ca 90032.	Bequest	For display in carriage House	196
Mr. James R. Wright Seasonal ranger, Park staff	Field Collection		207
Mrs. Mary J. Frye 101 Main Street Fargo, ND 58849.	Gift	Transferred to Custer Battlefield Sept. 10, 1974. See Cat. No. 51	208
Mr. Joseph Kim P.O. Box 14 Yuma, Az 85364	Exchange		216, 217.
Mr. Spencer A. Riley 18 Grove Street San Francisco, Ca 94102	Gift	Held for Regional Curator, Mid-Atlantic Region.	
Mr. E. Wright Brown Willow Farms, Willis Tx 77378.	Gift		210, 211
Richard A. Short 2 Wicker Street Hartford, Ct 06118.	Purchase	Funds donated by Southwest Monuments Association.	212
Mr. Alfred M. Black 54 Sandusky Street Flagstaff, Az 86001	Gift	Transferred to Colonial N.H.P. Oct 1, 1974.	206
Mr. Harry G. Saunders Equipment operator,	Field Collection		306, 307
Mr. Willard S. Watson 340 Mill Street Chicago, Il. 60608	Gift	For "Indian Citizens" exhibit.	215
Found by Crew restoring foundation of Commanding Officer's house, summer 1974	Field Collection	See accession file.	

Figure 42. Source of accession file.

A box containing many objects which cannot be unpacked immediately may need only one label or the number might be marked directly on the box with an indelible crayon. However, it is wise to unpack accessions as soon as possible, both to note the condition of the objects upon arrival and to prevent acidic or other harmful packing materials remaining in contact with them.

Deaccessioning

Specimens permanently removed from the collection are deaccessioned or cancelled. The object may be withdrawn because of deterioration, transfer to another area, exchange, loss or the return of a loan. Note the disposition of the object in the accession book under *Remarks* and on the source card. Any correspondence or receipts referring to the withdrawal should be placed in the accession file folder. If the object has been catalogued, mark the disposition on the catalogue forms and on the catalogue file folder. Do not remove the catalogue forms or the catalogue folder from their places. Park museums will also require a Board of Survey Report or Transfer of Property form in accordance with the property accounting regulations of the Service.

Installing a New System

Small museums have sometimes accumulated collections without setting up a proper system of museum records. In this situation start an accession book without further delay. First search the correspondence files and any other available sources of information to find out when and how objects have been acquired. Enter in the new accession book in chronological order all past accessions for which you can establish dates. Then record in the book each accession of which you know the source but not the date of receipt, giving it the next available accession number. In the *Date received* column for each of these state that it came in prior to the day you started the book. After these assign the next number to the remainder of the existing collection, comprising the objects for which you can discover neither where they came from nor when the museum got them. Then enter the first new acquisition and proceed to maintain complete accession records in regular form. If you later find the source of some object or objects lumped in the remainder entry, record this accession under the next free number regardless of chronology in order to preserve the information in usable form.

BIBLIOGRAPHY

Some museums use a combined accession and catalogue number described or illustrated in several of the references listed. This complex number has advantages, but also disadvantages because of which national park museums retain separate numbers for the two kinds of essential records.

Borhegyi, Stephan F. de. "Curatorial Neglect of Collections," *Museum News*, 43:5 (January 1965), pp. 34–40.

———, and Alice Marriott. "Proposals for a Standardized Museum Accessioning and Classification System," *Curator*, I:2 (1958), pp. 77–86.

Choudhury, Anil Roy. *Art Museum Documentation and Practical Handling.* Hyderabad. Choudhury & Choudhury, 1963, pp. 127–150.

Dudley, Dorothy H., and Irma B. Wilkinson, *et al. Museum Registration Methods.* Rev. ed. Washington. American Association of Museums and Smithsonian Institution, 1968, pp. 17–22, 35, 207–221. Rev. ed. in prep.

Freundlich, A. L. "Museum Registration by Computer," *Museum News*, 44:6 (February 1966), pp. 18–20.

Graham, John M., II. "A Method of Museum Registration," Technical Supplement 2, *Museum News*, 42:8 (April 1964).

Guthe, Carl E. "Documenting Collections: Museum Registration & Records," American Association for State and Local History Technical Leaflet 11, *History News*, 18:9 (July 1967), rev. ed. 1970.

Sturtevant, William C. "Ethnological Collections and Curatorial Records," *Museum News*, 44:7 (March 1966), pp. 16–19.

Chapter 8 Museum Catalogue

The Catalogue records all significant facts regarding the physical appearance and history of every object accepted for addition to the permanent collection. It may well be the museum's most important possession because so much of the value of all the specimens depends on it. Therefore the Catalogue is made fully as durable as the Accession Book. In addition every precaution is taken to protect the original from fire or other dangers. Good cataloguing demands knowledge of the objects, clear and logical thinking, orderliness and accuracy.

Museum Catalogue Form

Park museums use a specially designed catalogue form. It is supplied in triplicate so that necessary copies may be typed in a single operation. It consists of two paper copies (white and blue), designed to be filed in post binders, and a third card-copy for index filing. The *original*, of white permanent record paper and typed with permanent ink, is filed numerically (the most recent number on top) in a post binder. It constitutes the prime record of each specimen in the museum's permanent collection. Keep it separate from the other museum records in a vault with high fire resistance. The *blue* copy, of good bond paper typed with Grade A, extra quality hard or medium finish carbon paper, is also filed numerically in a post binder. This provides the working reference to the museum's permanent collection. The record of the last object catalogued is always on top as the book is opened. In this way the last catalogue number assigned to an object and the approximate number of specimens in the collection may be seen at a glance. The *index copy*, a white card typed with the same quality carbon paper, is placed in a card file according to classification. It forms an index to the collection, as essential as a subject catalogue to a library. The third copy may be duplicated as many times as necessary for cross references in the classified file.

Information recorded on the catalogue form comes in part from the accession book and accession file. More of the data, however, must result from careful study of the object and research involving it. This takes time, but initiate the cataloguing of specimens as soon as possible after receiving them. They cannot become useful until you do. Set high standards of accuracy and thoroughness. Select the nomenclature recognized by students of each kind of object and use it consistently, but be sure others will understand it (see Appendix E and e.g. the chapter on Terminology of the Sword in Harold L. Peterson, *The American Sword, 1775–1945*, rev. ed., Philadelphia, Ray Riling Arms Book Co., 1965). Slipshod cataloguing not only makes inadequate and inefficient museum records, but may also cause needless confusion in later years. The catalogue form contains the headings listed below to suggest what information to record (fig. 43).

Figure 43. Sample catalogue form.

Classification The categories entered here represent as nearly as possible the groups in which anyone using the collection is most likely to search for and study the specimens. The same categories appear in the catalogue card file and the study collection storage. Chapter 9, which describes the system of classification park museums use, illustrates how difficult it is to define groups that will meet the widely different needs of scholars. List the larger category first then progressively smaller ones as needed.

Area Park museums fill in the name of the park.

Catalogue number Start the catalogue with number 1 and progress in numerical order indefinitely. Assign the next available number to each object as it is studied and catalogued. (To check the last number used refer to the post binder containing the blue copies of the catalogue form, which should be at hand where the cataloguer is working.) Affix the number permanently to the specimen. Its sole purpose is to distinguish that particular object. It should imply nothing about the kind of object and no letters, decimals or fractions should be used. This number bears no relation to the accession number but is cross-referenced to it by entry in the last column of the accession book. Objects in pairs or sets such as identical chairs, a portfolio of prints, a pair of candlesticks or a cup and saucer receive separate numbers. Note the catalogue numbers of the related objects in the description on the catalogue form. Treat component parts of specimens, such as teapot and cover, as one and apply the same number to each part. The skin, skull and skeleton of one mammal specimen receive the same number as do the bones of a single skeleton. In instances where component parts are of themselves complete specimens, however, give each a separate catalogue number (e.g. a sword and scabbard or the hat, blouse and trousers of a uniform). Note the numbers of the other parts in the description of each.

Accession number Copy the accession number on the catalogue form to complete the cross-reference to the record of acquisition.

Object Enter the name of the object, a single specific identification (e.g. *Microtus pennsylvanicus,* meadow mouse, skin and skull; or pistol, flintlock). Avoid repeating a term already used in the classification entry, or using the name over again in the description. While there is as yet no standard list of object names for historical artifacts, set a consistent policy within the museum. Do not use "bedspread" one time and "coverlet" the next, or call one specimen "pants" and another "trousers." When in doubt, cross-reference.

Locality Record the place of origin of the object—precisely where a natural history specimen was collected, the site and level at which an archeological artifact was recovered, or the country and political subdivision or region where an historic or artistic object was made. The meadow mouse locality would correspond to the data on the specimen label (see Freshly Collected Biological Specimens, Chapter 3), while the pistol might be from Birmingham, England, for example. For an archeological specimen the entry would clearly indicate the location of the excavation as well as the exact position within it. Note that the locality of primary interest differs in different disciplines. If the cataloguer knows where an archeological specimen was made, he will record it in the description.

Description This is the heart of the catalogue. It comprises both a physical description of the object and a record of its history. The former often includes a verbal description supplemented with sketches on the catalogue form and photographs in the catalogue file, a careful report of markings, detailed measurements and a statement on its condition. Describe adequately two sets of characteristics—those that are significant in studying the category of objects to which it belongs and those that distinguish this specimen from all others like it. The first set is for students and varies considerably from one kind of object to another. The second should enable you to prove beyond question that the object recovered by the police is the one someone stole from your museum. For the scholarly description the best guidance comes at present from studying published catalogues of important collections and standard books concerning the type of object involved. These sources will indicate what details are significant and illustrate the accepted terminology. See also Geraldine Bruckner, "A Standard Terminology for Describing Objects in a Museum of Anthropology," in Dudley and Wilkinson, *Museum Registration Methods*. Descriptions of biological specimens usually require the sex, stage of life cycle and any exceptional aspects. In describing an artifact identify the materials of which it is made, if you can be sure, or tell their characteristics (e.g. a highly polished, dark green stone too hard to scratch with a knife). Give the shape, color and details of decoration.

In recording marks on the specimen copy any field number, previous owner's catalogue number or old labels attached to it. Indicate any maker's marks, proof marks, hallmarks, serial numbers or other special markings and note their location. In a paper specimen describe, sketch or trace the watermark. Transcribe any signature or date and tell where it is located on the specimen. Copy any inscription, dedicatory or otherwise, and translate it into English if necessary (noting the translator's name in the catalogue). Also describe and locate any accidental marks such as chips or scratches that will help identify this specific object. Rubbings of important marks should be filed in the catalogue folder.

Record the standard measurements. These vary with different kinds of objects (see e.g. Freshly Collected Biological Specimens, Chapter 3 above and Chapter 4 in Dudley and Wilkinson, *Museum Registration Methods*). Use millimeters and inches as a rule, so the data will be equally useful to you and to the expanding metric world. Be accurate to 1 millimeter or $\frac{1}{16}$th inch in measuring specimens other than very small ones. For these an accuracy to 0.5% has been recommended. When the measurement does not fall exactly on the millimeter or $\frac{1}{16}$th–inch mark, record the next larger. For most artifacts give the height first, then width or diameter and depth. Irregular shaped objects require more dimensions. Record all measurements in a consistent sequence. If part of an object is missing, specify that the measurements given are incomplete and estimate what the

full dimensions of the complete specimen would be. Weigh as well as measure those specimens which are too small or too nearly like others of the same kind to distinguish by dimensions alone. Aim for the same degree of accuracy in weighing as in measuring, 0.5%.

In describing the condition of the specimen state whether it is good, fair or bad (but for firearms use the standard terms of the National Rifle Association, see Appendix D). Record in detail missing parts, chips, scratches, tears, repairs, alterations and any other evidence of damage or deterioration.

The history of the specimen to be recorded in the catalogue includes such information as who made it and when, who owned or used it from the time of its production until it entered the museum, its association with particular people or events, when and where it has been exhibited, its preservative treatment. Document the statements on the catalogue form or refer to documentation in the catalogue file, which may also contain fuller details on the object's history. For natural history specimens the history may be adequately recorded in the field notes filed in the catalogue folder. Indicate this on the form, although significant ecological data may also be noted here.

See Appendix E for examples of catalogue descriptions for several common types of specimens.

Date received Give the same date as in the accession book. It is convenient to have this information repeated here.

Received from Copy the full name and address of donor, vendor or collector from the accession book. If the collector is on the staff, include his title. If the specimen is from a special expedition, archeological project or other named enterprise, include the name (e.g. George A. Smith, Park Archeologist, 1956 Excavation of Bluefield Site).

How acquired From the accession book indicate whether the object is a gift, bequest, purchase, transfer, exchange or field collection.

Value Whenever possible record the purchase price or appraised value of a specimen which has actual monetary value. If the information is not available for such specimens, the cataloguer in a park museum must assign a reasonable monetary value for accountability purposes to each object (other than loans) which would be worth $100 or more. Knowing the value of a specimen is often useful and sometimes very important, particularly when a museum insures its collections or when a loss occurs. For park museums, recording the value places the specimen under financial control

which broadens and underlines responsibility for its protection. Museums as a rule maintain a strict policy of not appraising objects except for their own internal use. While a donor is entitled to claim the value of his gift to the museum as a tax deduction to the full legal extent, the proper amount is a matter between him and the Internal Revenue Service in which the museum should not get involved. Giving appraisals could subject the museum or the curator to court actions in other situations as well. For park museum purposes most scientific specimens do not need to be valued, but some can be put under fiscal control by being designated of exceptional scientific importance. Thus a prehistoric vessel can receive this added protection without the risk of encouraging pot hunters who think in terms of marketing such objects.

Present location Write *in pencil* the room, case, cabinet and drawer or shelf where the specimen is exhibited or stored. Revise this entry whenever the specimen is moved.

Determined by Enter the name of the expert who has made an authoritative identification of the specimen and the date it was identified. If the cataloguer makes the identification, leave the space blank. The specific name determined by the expert is entered under *Object*. If there are successive determinations with changes or refinements in the identification, the details can be filed in the catalogue folder and a reference noted on the catalogue form.

Cataloguer The individual who fills out the catalogue form should enter his name and the date the object is catalogued. If the curator makes out the form in rough draft for someone else to type, his name rather than the name of the typist is entered.

Disposal When an object is removed from the collection by loan, transfer, exchange, loss, accidental destruction or by other means, the transaction should be documented in accordance with established procedures. The catalogue forms remain in place, the manner and date of disposal are entered and, if desired, a line may be drawn across the forms. The catalogue number is not used again.

The space marked off in the upper right corner of the National Park Service catalogue form is for convenience in locating particular specimens. One museum, for example, might place a red check here on the forms for all specimens which have a catalogue folder, and a green check for those which have photographs or which have been illustrated in publications. Also, cards for specimens having monetary value can be marked in this space so they can be spotted for accounting purposes.

Catalogue Folder File

Some specimens will require a catalogue folder. This is a regular correspondence folder clearly marked with the specimen's catalogue number in a carbon-base ink and filed in numerical order in a standard file cabinet. The catalogue folder acts as a supplement to the catalogue form. All research information and correspondence relating to the specimen including bibliographies, photographs marked with negative numbers, field notes, working notes, exhibition information, conservators' reports and other reports based on a study of the object or referring to it are placed in the catalogue folder.

Naturally, many specimens will not need a folder, and by the same token a specimen that did not require a folder originally may need one at a later date to save all useful information as it accumulates.

Some museums file the photographs of a specimen in the catalogue folder. This is recommended, especially when detailed study photographs are involved. When a small record photograph of each specimen is used, it may be glued to the back of the third copy of the catalogue form. Because mounting adhesives may deteriorate and harm the catalogue card, park museums more often attach the photograph to a separate card (e.g. the National Park Service print file card, Form 10–30), marked with the catalogue number in the upper right corner and filed directly behind the catalogue form in the classified card file (fig. 44).

Figure 44. Print file card.

Inventory or Location File

Park museums use a 5 × 8-inch (127 × 203 mm), salmon-colored card copy of the standard catalogue form to provide an auxiliary record. It fills the frequent need for an inventory or location index. This can be especially useful for furnished historic structure museums to provide a record of furnishings by room. It is often helpful to keep the location file in the house. Also, where collections are large or housed in several buildings, a central file which shows the specimens in each particular location is a convenience, particularly at inventory time.

Local requirements will dictate the amount of information recorded on this supplemental form. Some museums transfer all the catalogue data, others need only the number, object name, accession information and location.

Numbering Specimens

Each object in the museum's permanent collection has its own individual catalogue number. This number must be legible, unobtrusive, permanent. It should not alter or deface the specimen. It should be easy to find, but must not interfere with the study or display of the object. As a rule, the number should be placed in the same location on all objects of the same class. Applying it calls for manual skill, forethought and consistency.

There are two commonly recommended methods of numbering most museum specimens. The one used is optional, depending on which proves easier to handle. You may letter the number in India ink on an oblong of white lacquer. Paint directly on the specimen a neat oblong of flat drying, white brushing lacquer, just large enough to hold the number. Allow it to dry. When the lacquer is set, write the number on the oblong in India ink with a fine steel pen. With a crow-quill pen and practice you can make a perfectly readable number on the edge of a coin or on a surgical needle, for example. On white china or glass, a clear lacquer may be used instead of the white.

The other method of numbering is to paint the number directly on the specimen with a brush. If the material is porous such as wood, first apply a thin layer of shellac to the surface to prevent absorption of the paint. Artists' oils and a number 2 sable brush should be used to paint the number. On small objects, requiring very small numerals, reduce the brush to 3 or 4 hairs. Use the best quality of professional artists' oil paints available from art supply stores.

Cadmium red is the preferred color, but on objects where red does not stand out use titanium white or ivory black. Thin slightly with turpentine. If quick drying is necessary add a drop of drier. On smooth surfaces such as glass or china use lacquer thinner instead of turpentine, with a drop of

raw linseed oil and varnish added to the oil paint so it will adhere to the surface and dry harder.

Whichever method you use to apply the number, i.e., with ink or paint, cover it finally with a thin protective coating. This is easy to do with one stroke of a brush, but for best results wait a day so the numbers are dry. Over the ink use clear white shellac, and clear lacquer on the paint. With a minimum of care these numbers should last indefinitely unless removed with alcohol (solvent for shellac or oil paint) and acetone (solvent for lacquer). As extra protection during cleaning, place wax temporarily over the number.

Use either of these methods for numbering specimens composed of ceramic, glass, leather, metal, stone or wood. Park museums locate the numbers on such objects as follows:

Armor On the inside of each principal or readily separable element, but on a small zinc or aluminum tag wired to chain mail.

Ceramic objects On a concave portion of the underside not touching the surface on which the object rests.

Coins On the edge, if possible.

Firearms On the inside of the trigger guard or on the breech of the barrel opposite the lock.

Furniture On the front face of the rear leg at the viewer's right, close to the rail, or for heavy pieces close to the rear edge of the side on the viewer's right near the base.

Glass On a concave portion of the underside as for ceramics, but with extra care to place it inconspicuously and execute it neatly.

Metal obects On a concave portion of the base as with ceramics and glass, close to the junction with the handle on tools or on a protected and inconspicuous position.

Oil paintings On the reverse side at the lower right corner (viewer's right) of both stretcher and frame; if the picture is heavy repeating the number on the side of the frame at the lower right corner.

Sculpture Low on the right (viewer's) rear of the base.

Swords On the reverse side of the blade just below the counterguard, and in the same relative position on the scabbard.

Specimens too small to be numbered (e.g. common pins or small glass beads) should each be placed in a vial with the catalogue number either on the vial itself or on an all-rag card slipped inside it.

Textile specimens require a different method of numbering. Letter the catalogue number in India ink on a small oblong of linen tape. Then sew the tape to the specimen. If the fabric is fragile, such as lace, attach the tape with a small loop of thread. Locate the number on the object inconspicuously and consistently as follows:

Clothing On the inside of neckband (centered at back) or waistband (end).

Draperies On the reverse side at the lower right corner (viewer's right).

Rugs On the reverse side at the lower right and preferably also at the diagonally opposite corner.

Paper must also be numbered in a different way because the ink or paint would deface the specimen or alter it. Write the number on the object in pencil, using a medium grade between HB and 2H. Do not use an indelible pencil. Place the numbers as follows:

Books On the inside of both covers at the lower corner near the hinge, also in the corresponding position on the reverse of the title page and on any loose pages.

Documents On the reverse at the lower right corner.

Prints On the reverse at the lower right corner, and in the same location on the mat or mount.

Watercolors On the reverse at the lower right corner, and similarly on the mat or mount.

Natural history specimens are numbered according to well established procedures. See Freshly Collected Biological Specimens, Chapter 3, for details regarding most plant and animal specimens. In general the number is recorded in India ink or typed with permanent ribbon on the specimen label. In addition number skulls on the cranium and mandible, other parts of skeletons on the shaft of each bone and on the container, and tanned mammal skins on the tanned side, using India ink in each case and protecting it with a stroke of clear white shellac. Use the lacquer oblong or the brushed number on rocks, minerals and fossils. Pick a smooth spot, if possible, that will not interfere with the study or exhibition of the object. Mark microscopic fossils and thin sections on the lower right corner of their glass slides.

Exceptions to Standard Procedures

Park museums recognize the need for a few exceptions to the rules, but keep these to a minimum. Books which are preserved and used primarily as historical objects or for exhibition are accessioned and catalogued as museum specimens. Other books in park collections, intended for reading and reference, are considered library material. In the same way manuscripts for exhibition or for historical documentation of other specimens in the collection or used as evidence in support of the museum's subject area become museum objects to be accessioned or catalogued. Manuscripts preserved as active research collections should be part of the library rather than the museum. Parks with relatively few manuscripts and without fully developed library records, however, may catalogue all of them as museum specimens to achieve better control. The same criteria should apply to photographs and other documentary materials. Thus photographic prints and negatives preserved primarily for their historical value should be accessioned and catalogued as part of the museum collection rather than as part of the regular photographic files of the park.

Replicas of museum objects for exhibition are accessioned and catalogued as museum specimens but display panels and dioramas or other display art produced in connection with museum exhibits are not. Neither are the reproductions used for "living history" demonstrations.

Cannon and carriages exhibited outdoors which are not incorporated in the design of a monument or marker, are accessioned and catalogued as museum specimens. This includes cannon replicas and cannon tubes mounted on pedestals.

Insect collections are usually not catalogued. No individual specimen number is assigned. All data are recorded on small labels attached to the pin below the specimen and the series of specimens representing each species is pinned in a separate tray. The arrangement of the trays in accordance with the accepted classification makes separate indexing unnecessary. However, in parks having small insect collections, regular cataloguing procedures may be followed if desired. The data labels should be attached to the pin as usual, but with the catalogue number added and the regular forms made out.

Herbarium collections in some institutions are not catalogued on the grounds that the individual sheet labels form a satisfactory catalogue. This does not provide for the safekeeping of the permanent record. If an uncatalogued herbarium sheet is lost or destroyed, the record of the specimen is lost with it. With these considerations in mind it is recommended that in parks plant specimens be catalogued as part of the museum collections. Exceptions must be justified.

Archeological collections also present special problems. When specimens are excavated, the archeologist usually assigns them field numbers or

site designations in accordance with established professional practices. These numbers serve various scholarly purposes and are quite separate from the museum accession and catalogue numbers which become associated with a specimen after it enters a museum collection. A park museum accessions an archeological collection immediately upon receiving it from the archeologist. If the archeologist has already culled the collection, he should supply for the accession file folder a statement of what has been eliminated and the means of disposal. If the collection has not yet been culled, the museum holds it in "field collection status," i.e., will postpone cataloguing the specimens until an expert has culled it. At the time of culling he will provide information for the accession file on what he has eliminated and how. "Field collection status" is a temporary arrangement which the museum will terminate as soon as possible. The practice favored by some archeologists of keeping "open" accession numbers weakens the value of, and complicates the use of the accession record for normal museum purposes. Therefore, open accession numbers should not be used. The culling of collections before they are turned over to the museum removes in part the utility of open numbers. Specimens should be accessioned as soon after field work as practicable, of course.

Catalogue the archeological specimens in the standard way with a simple number for each specimen, except for large series of type sherds and similar type series of, for example, projectile points, pipe stems or nails. In these instances each representative specimen of a type series receives the same catalogue number. The description on the card will note how many comparison specimens are in the series. This procedure involves the dangerous practice of assigning the same catalogue number to more than one specimen. It is permissible only with groups of archeological specimens collected at one place and time, that is, having identical data as well as identical temporal and cultural affinities and no significant differences. When a specimen in such a series is found to be significantly different from the others, it should be recatalogued as a separate item. In the central repositories holding collections from more than one park, the staff may use distinguishing marks on specimens to designate the different collections when necessary to avoid serious confusion while specimens are being used in comparative studies. These marks are not part of the catalogue number, but are archeologists' markings like the site numbers. Similarly, in a few parks which contain many individual ruins spanning a long period of time, major archeological investigations may require the specimens to be accessioned as excavation proceeds. The accession number in these instances may also serve as part of the archeologists' study marking on the specimen because it identifies the site where the specimen was found. This practice should be closely limited and approved in advance.

An indefinite loan calls for another exception. Technically it is not a permanent part of the museum collection. Actually the museum has long-

term custody and responsibility. For this reason park museums catalogue an indefinite loan as carefully and completely as if it belonged to the museum. The catalogue number is applied to the borrowed object, but with special care to avoid any harm to it if the number later has to be removed. A loan, regardless of its value, is not included in the property accountability records. If an indefinite loan is returned, the museum deaccessions it and records the action as with any other object removed from the collection.

Report to Finance Office

Park museums safeguard specimens under financial control (which must include all those, other than loans, having monetary value of a certain amount or more, presently $100) by submitting receiving reports to the finance office. The report indicates the catalogue number and value of each controlled object as it enters the collection. The property officer with the curator's help obtains the information required for this report from the museum accession book and catalogue. When an object under financial control is removed from a collection, a more detailed report goes to the finance office on the proper accounting form.

A physical inventory of the controlled specimens must be taken at least once a year. The inventory goes to the finance office for reconciling to the accountability records.

Supplies for Cataloguing

Using the right materials makes the job of cataloguing easier and the results better. Park museums have found the following supplies effective for numbering specimens and typing the standard forms. In numbering they use India ink or professional quality artists' oil paints (e.g. Grumbacher, Winsor & Newton Ltd. or Permanent Pigments) in the smallest size tubes. As a white lacquer they select an automotive grade, refrigerator white. Clear lacquer is automotive grade, water white, or acrylic. The shellac is clear white, not orange. Steel pens of the crow-quill type work well for numbering in ink. To number with paint they choose a professional quality lettering brush, sable, number 2 size (e.g. Delta or Grumbacher). For making the lacquer oblong or applying the protective coat over the number artists' brushes of the same quality, sable, number 3 size are fine, although small bottles with applicator brush tops such as used for typewriter correction fluid or nail polish can be satisfactory and convenient. Any small, tightly capped jars serve to hold the supplies of alcohol, acetone and turpentine needed to clean the brushes.

The ink used in most typewriter ribbons fades on prolonged exposure to light. Park museums consequently use single color, black record ribbons that meet Federal Specification DDD–R–311F. To obtain carbon copies somewhat resistant to smearing they use a hard or medium finish, grade A, extra quality carbon paper as defined in Federal Specification UU–P–158d.

The quality of the catalogue in form and content, as the museum's most vital record, measures the capacity of the curator and the standard of excellence the institution can claim. As he catalogues, a good curator appreciates that, to quote Stendhal, all the pleasure and the truth are in the details.

BIBLIOGRAPHY

Blundell, John D. "Go Metric Now," *Museums Journal*, 70:2 (September 1970), pp. 61–62.

Borhegyi, Stephan F. de. "Curatorial Neglect of Collections," *Museum News*, 43:5 (January 1965), pp. 34–40.

Bowditch, George. "Cataloging Photographs: A Procedure for Small Museums," American Association for State and Local History Technical Leaflet 57, *History News*, 26:1 (November 1971).

Choudhury, Anil Roy. *Art Museum Documentation and Practical Handling.* Hyderabad. Choudhury & Choudhury, 1963, pp. 127–146, 151–244.

Conran, G. L. "The Valuation of Museum Objects," *Museums Journal*, 56:8 (November 1956), pp. 187–190.

Connor, Seymour V. "A System of Manuscript Appraisal," American Association for State and Local History Technical Leaflet 41, *History News*, 22:5 (May 1967).

Cox, Janson L. "Photographing Historical Collections: Equipment, Methods, and Bibliography," American Association for State and Local History Technical Leaflet 63, *History News*, 28:5 (May 1973).

Dudley, Dorothy H., and Irma B. Wilkinson, *et al. Museum Registration Methods*. Rev. ed. Washington. American Association of Museums and Smithsonian Institution, 1968, pp. 17–62, 154–201, 207–217, 222, 224–239. Rev. ed. in prep.

Graham, John M., II. "A Method of Museum Registration," Technical Supplement 2, *Museum News*, 42:8 (April 1964).

Hurst, Richard M. "Putting a Collection on Film," *Curator*, XIII:3 (1970), pp. 199–203.

Levitt, I. M. "Inching Toward the Metric System," *Museum News*, 49:4 (December 1970), pp. 30–31.

Macdonald, Robert R. "Toward a More Accessible Collection: Cataloguing at the Mercer Museum," *Museum News*, 48:6 (February 1969), pp. 22–26.

Oddon, Yvonne. "The Documentation of Collections in General Museums," *ICOM News*, 23:3 (September 1970), pp. 55–60.

Schneider, Mary Jane. *Cataloguing and Care of Collections for Small Museums.* Columbia. Museum of Anthropology, University of Missouri, 1971.

Sturtevant, William C. "Ethnological Collections and Curatorial Records," *Museum News*, 44:7 (March 1966), pp. 16–19.

Whiting, Alfred F. "Catalogues: Damn 'Em—An Inter-museum Office Memo," *Curator*, IX:1 (1966), pp. 85–87.

See also the references on computerized museum data retrieval in the bibliography following Chapter 5. For assistance in cataloguing historical artifacts see particularly:

Rath, Frederick L., Jr., and Merrilyn Rogers O'Connell. *Guide to Historic Preservation, Historical Agencies, and Museum Practices: A Selective Bibliography.* Cooperstown. New York State Historical Association, 1970, pp. 114–184.

Also see other references under Identifying and Authenticating Specimens in the bibliography following Chapter 3 and:

Darbee, Herbert C. "A Glossary of Old Lamps and Lighting Devices," American Association for State and Local History Technical Leaflet 30, *History News*, 20:8 (August 1965).

Eaches, Albert R. "Scales and Weighing Devices: An Aid to Identification," American Association for State and Local History Technical Leaflet 59, *History News*, 27:3 (March 1972).

Emery, Irene. *The Primary Structures of Fabrics: An Illustrated Classification.* Washington. Textile Museum, 1967.

Frangiamore, Catherine L. "Rescuing Historic Wallpaper: Identification, Preservation, Restoration," American Association for State and Local History Technical Leaflet 73, *History News*, 29:4 (April 1974).

Hodgkinson, Ralph. "Tools of the Woodworker: Axes, Adzes, and Hatchets," American Association for State and Local History Technical Leaflet 28, *History News*, 20:5 (May 1965).

Nelson, Lee H. "Nail Chronology as an Aid to Dating Old Buildings," American Association for State and Local History Technical Leaflet 48, *History News*, 24:11 (November 1968).

Peterson, Harold L. *The American Sword 1775–1945.* Rev. ed. Philadelphia. Ray Riling Arms Book Co., 1965.

Rempel, John L. "Tools of the Woodworker: Hand Planes," American Association for State and Local History Technical Leaflet 24, rev. ed., *History News*, 26:9 (September 1971).

Russell, Loris S. *A Heritage of Light.* Toronto. University of Toronto Press, 1968.

Watkins, C. Malcolm. "Artificial Lighting in America, 1830–1860," *Annual Report of the Smithsonian Institution for 1951*, Washington. Government Printing Office, 1952, pp. 385–407.

Welsh, Peter C. *Woodworking Tools.* Contributions from the Museum of History and Technology 51. Washington. Government Printing Office, 1966.

Chapter 9 Classification

Although museum workers have not yet agreed on a universal system for classifying specimens, park museums have adopted a classification scheme. It makes the information contained in their collections more accessible for reference and research. It helps in the management of individual collections and usefully links the resources of the widely separated museums. The classification provides the basis for filing the third copy of the catalogue form. Specimens in the study collections are filed according to the same system as far as is practicable.

Classification depends on identification. A museum classifies its collection at the outset as completely as knowledge of the specimens permits. Then, as it actively accumulates expert determinations, it assigns the objects to progressively smaller categories. A few specimens probably will not quite fit the system, but good judgment and cross-references help solve these problems.

Each object in a park collection fits one of the following general categories: Botany, Zoology, Geology, Archeology, Ethnology or History. These form the major divisions of the catalogue card file. A museum may allot separate drawers for each division represented in the collection or mark the divisions with index tab cards. In using the numerous subordinate categories described below the card file is subdivided with index tab cards only to the extent practicable and useful. As a rule of thumb, groups of less than 25–30 cards probably need no further breakdown. To assist in refiling cards after use, as many of the larger index tab card categories applicable to each specimen as needed may be entered in the space marked *Classification* on the catalogue card along with those specified in the directions which follow. The additional entries may be in pencil in the righthand portion of the space. It is important to avoid introducing other categories as substitutes for those adopted. The instructions as given to park museums for classifying collections under each major category follow.

Botany

In the space marked *Classification* on the catalogue form type the scientific name of the order. Add the common name of the order if desired. Type on the next line the scientific name of the family. Add the common name of the family if desired. In some orders, particularly of lower plants, it may not be practical to use family designations. The scientific binomial of the species is entered in the space marked *Object*, and the common name may be added here also.

Prepare index tab cards for the divisions, classes, orders and families represented in the collection. File the catalogue cards in taxonomic order as far as families (or orders where families are not used) according to the standard arrangement as given in the National Research Council *Handbook of Biological Data*, Appendix II. Taxonomic Classification: Plants, Philadelphia, W. B. Saunders Company, 1956. Below the family (or order) file the cards alphabetically by genus and by species within each genus.

Special plant materials that need to be referred to separately in addition to, or rarely outside, the taxonomic series may have duplicate cards or cross-reference cards filed under their own index tab cards, arranged alphabetically at the end of the botanical section. Such materials might include pollen, galls, polished wood samples or pathological forms, for example.

Zoology

In the space marked *Classification* on the catalogue form type the scientific name of the order. Add the common name of the order if desired. Type on the next line the scientific name of the family. Add the common name of the family if desired. In some orders it may not be practical to use family designations. The scientific binomial of the species is entered in the space marked *Object*, and the common name may be added here also.

Prepare index tab cards for the phyla, classes, orders and families represented in the collection. File the catalogue cards in taxonomic sequence as far as orders according to the standard arrangement as given in the National Research Council *Handbook of Biological Data*, Appendix I. Taxonomic Classification: Animals, Philadelphia, W. B. Saunders, 1956. Below the order file the cards as follows:

Invertebrates

In most groups arrange families in alphabetical sequence, then file genera alphabetically under family and species alphabetically under genus. Parks having significant collections of mollusks should file the cards and

arrange the specimens in the taxonomic order used in R. Tucker Abbott, *American Seashells*, New York, Van Nostrand Reinhold Company, 1954. Insect collections should be arranged in the sequence of families used by the *Zoological Record*, London, the Zoological Society of London. Below families arrange the genera and species taxonomically when advice from a specialist in the group is available. Pending this, arrange genera alphabetically under family and species alphabetically under genus.

Fishes

File families according to *A List of Common and Scientific Names of Fishes from the United States and Canada*, 3rd ed., Washington, American Fisheries Society, 1970. File genera alphabetically under family and species alphabetically under genus.

Amphibians and Reptiles

File families, genera and species in the taxonomic sequence in Karl P. Schmidt, *A Checklist of North American Amphibians and Reptiles,* 6th ed., Chicago, American Society of Ichthyologists and Herpetologists, 1953.

Birds

File families, genera and species in the taxonomic sequence of the American Ornithologists' Union, *Check-List of North American Birds*, 5th ed., 2nd printing, Baltimore, Port City Press, 1961.

Mammals

File families, genera and species in the taxonomic sequence used by Gerrit S. Miller, Jr. and Remington Kellogg, *List of North American Recent Mammals*, United States National Museum Bulletin 205, Washington, Government Printing Office, 1955.

Special animal materials that will need to be referred to separately in addition to, or rarely outside, the taxonomic series may have duplicate cards filed under their own index tab cards arranged alphabetically at the end of the zoological section. Such materials might include nests, eggs, dried feces, stomach contents or feathers.

Geology

Use index tab cards to divide the collection into minerals, rocks and fossils:

Minerals

In the space marked *Classification* on the catalogue form type the appropriate major group name as used in the Dana system. These groups are:

Native Elements
Sulfides
Sulfosalts
Oxides
Oxygen Salts
Silicates.

The name of the mineral is entered in the space marked *Object*. Use an index tab card for each of the above mineral groups represented in the collection. File them in the sequence given above. Within each group file the catalogue cards alphabetically by the specific name of the mineral. If the mineral collection is of special scientific value, the catalogue cards should be filed in the sequence of Dana numbers rather than alphabetically. This sequence is contained in James Dwight Dana, *et al., System of Mineralogy*, 7th ed., vol. 1 1944, vol. 2 1951, vol. 3 1962. Additional volumes remain to be published, but a loose-leaf listing projected by the Smithsonian Institution may make the classification more accessible. When the Dana number is used, it should be entered in parentheses after the specific name in the space marked *Object* to avoid any confusion with catalogue numbers. Museums wishing to file small mineral collections alphabetically may find helpful Michael Fleischer, *Glossary of Mineral Species*, Bowie, Mineralogical Record, 1971. Specimens containing more than one mineral will require cross-reference cards.

Rocks

In the space marked *Classification* on the catalogue form type the name of the major group to which the specimen belongs:

Igneous and Metamorphic
Sedimentary.

If the specimen is sedimentary rock, type on the next line the name of the stratigraphic formation. The specific name of the rock is entered in the space marked *Object*. Use an index tab card for each of the two major groups. For the sedimentary series use index tab cards for formations also. Arrange the formation tab cards in stratigraphic order starting with the oldest. Igneous and metamorphic specimens may be cross-referenced to the formation when this would be helpful. File the catalogue cards alphabetically by specific names.

Fossils

These specimens are studied from two distinct points of view, those of the geologist and the biologist. The classification is correspondingly complicated to serve both needs. In the space marked *Classification* on the catalogue form type the name of the stratigraphic formation. Type on the next line the scientific name of the taxonomic class. Add the common name if desired. On the third line type the scientific name of the order if known, adding the common name if you desire. If the family name is known, it may be typed on the fourth line, or the name of the class may be omitted on the second line and the order and family used as the second and third entries. The scientific binomial, if it is known, the generic name alone or the lowest known taxonomic category is entered in the space marked *Object*.

Prepare index tab cards for the formations and for either classes and orders, orders and families or all three categories. Arrange the formation tab cards in stratigraphic sequence starting with the oldest. If convenient, group them under tab cards for the geologic periods involved. Under the formations arrange the taxonomic tab cards in taxonomic order using the standard classifications approved for botanical and zoological specimens as far as they go. File the catalogue cards alphabetically by families under the order, if necessary, by genera under the family and by species under the genus as far as identification permits.

Archeology

Use this category for excavated specimens and similar specimens collected in archeological field surveys, and preserved to study and interpret non-European cultures. In the space marked *Classification* on the catalogue form type the name of the material of which the specimen is made, for example, stone or metal. Classify biological or geological specimens in these same categories if the primary source and value of the specimens are archeological. The kinds of material are listed in the outline classification given below. Specimens manufactured from more than one raw material are classified under the material having the greatest representation in the specimen unless this is a residual category such as Other Plant Materials. Do not type further subdivisions in the *Classification* space on the catalogue cards. The cultural uses or technology of materials vary so much that standardization of categories at this time, at least, would not serve a useful purpose. If the quantities and kinds of objects are numerous enough to require further subdivision, all collections in the same cultural area use uniform subheadings. Enter the subheading on the catalogue card in pencil.

Prepare index tab cards for the four major material categories listed in the outline classification below and for the kinds of material represented in the collection. If the collection is large enough to need it, make index tab cards also for the subdivisions adopted for the cultural area. Arrange the index tab cards as follows, with the necessary subdivision tab cards following the appropriate material category card:

Mineral
 Stone
 Clay
 Metal
 Glass
Vegetal
 Wood
 Fiber
 Other Plant Materials
Animal
 Shell
 Bone
 Antler
 Hide
 Hair
 Other Animal Materials
Human Remains
 Inhumations
 Cremations
 Other Human Remains.

File the catalogue cards numerically under the proper index tab cards.

European trade goods from excavated American Indian sites should be classified as archeological material under the above system if the specimens are studied as part of the archeological collection. They may be cross-referenced to the history section of the classified catalogue card file in as much detail as desired.

Ethnology

Use this category for material originally obtained from living cultural groups of non-European origin and preserved to study or interpret their life. Ethnologists are interested particularly in the functional aspects of the cultures, so the classification is based on activities. In the space marked *Classification* on the catalogue form type the function or activity with which the specimen is associated. Use the activity categories listed below.

If the use of the object is unknown, it ordinarily may be grouped in the last category, considering it as an example of manufacturing activity. For objects in this final, catchall group type on the second line of the space marked *Classification* the name of the material of which the specimen is made. The list of material given below is the same as that used for archeological collections. If any of the other activity categories contain enough objects to require subdividing, enter the kind of object on the second line in pencil. No breakdowns are given because collections vary. Be sure to use standard terminology.

Prepare index tab cards with the names of the tribes which used the objects. Parks on the Continent use the tribal names as given in John R. Swanton, *The Indian Tribes of North America*, Bureau of American Ethnology, Bulletin 145, Washington, Government Printing Office, 1953. Prepare index tab cards for the activity categories represented in the collection. As necessary, also prepare index tab cards for the kinds of objects included under an activity group. Use these latter only sufficiently to make the card file workable. Arrange the tribal index cards alphabetically. Under each tribe arrange the activity index cards in the sequence given below. Arrange the index cards for kinds of objects alphabetically under the activity except for those under Arts and Industries which should follow the sequence given below:

Tribe
 Hunting and Fishing
 Agriculture and Plant Gathering
 Food Preparation
 Foods
 Medicine and Narcotics
 Shelter and Furniture
 Clothing and Personal Adornment
 Games and Pastimes
 Warfare and Weapons
 Council and Government
 Ceremony and Religion
 Mortuary Customs
 Transportation
 Arts and Industries
 Stone
 Clay
 Metal
 Glass
 Wood
 Vegetable Fibers
 Other Plant Materials

Shell
Bone
Antler
Hair
Other Animal Materials.

File the catalogue cards in the sequence of the catalogue numbers under the proper index tab cards.

If the ethnological collection contains important groups of objects which need to be consulted under other categories, handle it by cross-referencing. Cards for baskets that are scattered through the card file by function, for example, can be cross-referenced to Arts and Industries, Vegetable Fibers, where they may be examined as a group. If the composition and use of the collection clearly warrant it, the cards may be filed under the Arts and Industries subdivision and cross-referenced to the history section of the catalogue card file.

History

Use this category for specimens preserved to study or interpret American history. Historical objects are so varied and so often unique in one way or another, and they are studied from so many points of view, that it is perhaps impossible to devise a classification that will serve all needs equally well. The problem is simplified somewhat for park museums because most are specialized in keeping with the significance of the park. By dividing the classification into three main areas: military, social-political and economic-industrial, a park museum can concentrate much of its classifying work in one of these areas. A frontier fort, for example, would use military categories for most of its collection, but social-political for the furnishings of the married officers' quarters. Use index tab cards to divide the file if more than one of these main areas is represented in the collection, unless you need to use only one or two subdivisions from another area (e.g., documentary material in a military collection). Carry the history breakdown only as far as the collection requires for effective use:

Military

In the space marked *Classification* on the catalogue form type the major category in which the specimen belongs. These five categories are listed below. On the second line type the proper subordinate category as given in the list which follows. Firearms require a third breakdown. Type this on the third line. In some collections Other Equipment may need subdividing also, but entries should be in pencil. Prepare index tab cards for as many of the categories as are represented in the collection. Arrange them as follows:

Weapons
 Firearms
 Heavy Ordnance
 Small Arms
 Ammunition
 Edged Weapons
Equipment
 Accoutrements
 Aircraft Equipment
 Artillery Equipment
 Barracks Equipment
 Cavalry Equipment
 Camp Equipment
 Medical Equipment
 Nautical Equipment
 Other Equipment
Uniforms
 Apparel
 Insignia
Flags
Awards and Decorations.

File the catalogue cards in numerical order under the proper index tab card. If you have a large number of small arms, use additional index tab cards to group the catalogue cards under hand guns and shoulder arms, for example, and then under the ignition system. It is not necessary to enter these subheadings on the catalogue card under *Classification*, but you may do so in pencil if convenient. Similarly edged weapons may be subdivided into swords, bayonets, knives and hafted weapons if necessary for ready reference, and heavy ordnance or ammunition can be subdivided appropriately. In organizing the military collection place gun carriages, limbers and caissons with heavy ordnance. Under accoutrements include equipment carried on the person. Some large collections may find tab cards useful to separate army material from that of navy or other service branch.

Social-Political

In the space marked *Classification* on the catalogue form, type the major category into which the specimen best fits. You probably will find that most of the collection belongs in a few of the large groups outlined below, but that you will need several of the other categories for odds and ends. On the second line type the secondary category which applies to the specimen. Some types of furnishings require a third subdivision as listed below. Prepare index tab cards for the categories in which the museum has speci-

mens. The notations in parenthesis are to help interpret the various classes. Do not transcribe these notes to the catalogue cards or index tab cards. Arrange the index cards as follows:

Architecture
 Building Materials (e.g. bricks, plaster, nails)
 Architectural Details (e.g. moldings, mantels, hardware)
Furniture (e.g. household, office, public building)
 Bedsteads
 Chairs
 Chests and Chests of Drawers
 Cupboards, Sideboards and Wardrobes
 Desks and Bookcases
 Kitchen Specialities (e.g. dough troughs, dry sinks, flour bins)
 Mirrors
 Racks (e.g. hat racks, towel racks, music racks)
 Screens
 Settees, Sofas and Daybeds
 Stools and Benches
 Tables and Stands
 Washstands, Commodes and Bathtubs
 Whatnots and Shelves
 Furniture Hardware
Furnishings (e.g. household, office, public building)
 Ceramics
 Earthenware
 Stoneware
 Porcelain
 Glassware
 Metalware
 Brass, Bronze and Copper
 Iron
 Pewter
 Silver
 Tin
 Other Metalware
 Woodenware
 Textiles
 Bedclothes
 Curtains and Draperies
 Floor Coverings
 Other Textiles (e.g. cushions, tablecloths, lace doilies)
 Cleaning Devices (e.g. brooms, mops, washing machines)
 Heating Devices (e.g. stoves, foot warmers, fireplace equipment)

Lighting Devices (e.g. lamps, matches, light bulbs)
Household Instruments (e.g. clocks, thermometers, scales)
Sewing, Spinning and Weaving Implements
Miscellaneous Furnishings
 Bed Accessories (e.g. springs, mattresses, bed jacks)
 Boxes and Holders
 Bric-a-Brac
 Curtain Fixtures, Shades and Blinds
 Household Tools
 Trunks and Carrying Cases
 Writing Accessories
 Other Furnishings
Personal Adornment
 Clothing
 Accessories (e.g. belts and buckles, buttons, handbags, handkerchiefs, jewelry, watches)
 Grooming Devices (e.g. combs, hairbrushes, toothbrushes)
 Physical Aids (e.g. eyeglasses, hearing aids, canes)
 Smoking and Snuff Accessories
Recreation Devices
 Musical Instruments
 Sports and Games
 Toys
 Other Pastimes
Educational Devices (e.g. writing slates and tablets, alphabetical and counting devices, globes)
Religious Objects
Money and Stamps
Patriotic, Political and Fraternal Objects
 Badges and Insignia
 Flags
 Law Enforcement Equipment
 Medals
 Souvenirs and Trophies
Fine Arts
 Drawings
 Paintings
 Picture Frames
 Prints
 Sculpture
 Silhouettes
Documentary Material
 Books and Periodicals

> Broadsides and Posters
> Manuscripts
> Manuscript Books
> Maps and Charts
> Newspapers and Clippings
> Plans and Drawings
> Printed Documents (e.g. certificates, diplomas, envelopes, receipts)
> Sheet Music
> Photographs
> Negatives
> Positives (e.g. ambrotypes, daguerreotypes, tintypes, paper prints)
> Transportation
> Vehicles
> Riding Equipment
> Accessories (e.g. currycombs, lap robes, tire pumps).

If the number of specimens under any secondary or tertiary category requires further subdivision (e.g. Vehicles into Automobiles, Boats, Carriages, Wagons), add the final subdivision in pencil on the catalogue card and insert corresponding index tab cards arranged alphabetically. Entitle these smaller categories using terms clearly defined in standard reference works.

File the catalogue cards numerically under the proper index card except as noted below. The secondary categories are largely by function. In furnishings, most specimens will go in the secondary categories by material. Objects made of several materials may need to be classified in the functional divisions, for example a tin and wood foot warmer under heating devices. Where you find a choice of categories, cross-reference if desirable. If the museum has a large collection of ceramics, you may need to subdivide it with index tab cards for the country of manufacture, arranged alphabetically. In a few instances typological subdivisions under country may be required. In the fine arts section index tab cards for the artists' names filed alphabetically may be helpful. Classify books, when the number involved warrants it, alphabetically by author and under the author alphabetically by title. In similar circumstances file the cards for manuscripts and manuscript books by writer. If numerous, classify maps alphabetically by title or geographical areas, newspapers by year and then by title, clippings by subject, plans by subject or title and photographs by subject. In all categories when more than one card is filed under the same name, the sequence of catalogue numbers may be followed.

This social-political classification contains an inherent weakness because it mixes criteria of function and material. From a pragmatic standpoint it works reasonably well for small collections, particularly with a sensible use of cross-referencing. When a more nearly ideal system becomes standard,

the changeover need involve little more than a simple refiling of cards and specimens.

Economic-Industrial

In the space marked *Classification* on the catalogue form type the kind of business, craft, profession or trade in which the object was used. On the second line type the category of object as listed below. If your collection requires additional subdivisions, use any that appear under appropriate headings in the social-political section (e.g. Other Equipment may need to borrow categories from Furniture or Furnishings) and type the name on the third line. If you need third level categories not available from the social-political list, insert them in pencil. Prepare index tab cards for the businesses, crafts, trades and professions represented in the collection. Arrange them alphabetically. No list is proposed but examples are agriculture, blacksmithing, fishing, gunmaking, spinning and weaving, whaling. Collections at an industrial park may need to use crafts within the industry as major or special secondary categories. Prepare index cards for the following and arrange them in order under each of the main index cards that requires them:

Raw Materials
Tools or Instruments
Machines
Transportation
Advertising Devices
Other Equipment
Products
Books
Documentary Material
Photographs.

Make tab cards for any tertiary categories and arrange them alphabetically in turn.

File the catalogue card in numerical sequence under the proper index tab card. Business records should be classified under Documentary Material in the social-political section, if a museum has both kinds, in order to facilitate finding all documents in the collection. Then cross-reference the business papers to Economic–Industrial, Documentary Material, and file by type of record and date or other logical arrangement if helpful.

BIBLIOGRAPHY

Museums throughout the national parks arrange their natural science collections and accompanying records in accordance with systematic classifications that have received wide acceptance. The published listings presently followed are:

Abbott, R. Tucker. *American Seashells.* New York. Van Nostrand Reinhold Company, 1954.

American Ornithologists' Union. *Check-List of North American Birds.* 5th ed. 2nd printing with minor corrections. Baltimore. Port City Press, 1961. Rev. ed. in prep.

Bailey, Reeve M., *et al. A List of Common and Scientific Names of Fishes from the United States and Canada.* 3rd ed. Special Publication 6. Washington. American Fisheries Society, 1970.

Dana, James D., *et al. System of Mineralogy.* 7th ed. 3 vols. to date. New York. John Wiley & Sons, 1944, 1951, 1962.

Miller, Gerrit S., and Remington Kellogg. *List of North American Recent Mammals.* United States National Museum Bulletin 205. Washington. Government Printing Office, 1955.

National Research Council. *Handbook of Biological Data.* Philadelphia. W. B. Saunders Company, 1956.

Schmidt, Karl P. *A Checklist of North American Amphibians and Reptiles.* 6th ed. Chicago. American Society of Ichthyologists and Herpetologists, 1953.

Zoological Record, annually, Zoological Society of London, Regent's Park, London NW1 4RY.

To achieve similar common practice in ethnological collections park museums regularly use the tribal names from:

Swanton, John R. *The Indian Tribes of North America.* Bureau of American Ethnology Bulletin 145. Washington. Government Printing Office, 1953.

For discussions of classification and alternative systems, particularly in regard to cultural objects see:

Borhegyi, Stephan F. de., and Alice Marriott. "Proposals for a Standardized Museum Accessioning and Classification System," *Curator,* I:2 (1958), pp. 77–86.

British Ethnography Committee. *Suggestions Concerning Classification, Storage, and Labelling of Objects Illustrating English Life and Traditions.* London. Royal Anthropological Institute, 1950.

Coleman, Laurence Vail. *Manual for Small Museums.* New York. G. P. Putnam's Sons, 1927, pp. 151–156.

Cuisenier, Jean. "Feasibility of Using a Data-processing System in the Musée des Arts et Traditions Populaires, Paris," *Museum,* XXIII:1 (1970/71), pp. 33–36.

Dudley, Dorthy H., and Irma B. Wilkinson, *et al. Museum Registration Methods.* Rev. ed. Washington. American Association of Museums and Smithsonian Institution, 1968, pp. 154–163, 202–206. Rev. ed. in prep.

Emery, Irene. *The Primary Structures of Fabrics: An Illustrated Classification.* Washington. Textile Museum, 1967.

Higgs, J. W. Y. *Folk Life Collection and Classification.* Handbook for Museum Curators C 6. London. Museums Association, 1963, pp. 39–50.

Mitchell, C. M. *Applied Science and Technology before the Industrial Revolution.* Handbook for Museums Curators E 7. London. Museums Association, 1961.

Murdock, George P., *et al. Outline of Cultural Materials.* New Haven. Human Relations Area Files Press, 1969.

Part 3 Furnished Historic Structure Museums

Introduction

An historic building authentically furnished and exhibited becomes a museum. This is so because it assembles and preserves objects, provides opportunity for object-centered research and interprets through contact with the real things it contains. These are the functions that characterize museums. A furnished historic structure, however, requires some policies, procedures and techniques differing from normal museum practice. Part 3 concerns these special aspects of curatorship.

The peculiar requirements of furnished historic structure museums stem largely from two factors, one theoretical and the second purely practical. This kind of museum undertakes to recreate the environment of some historic person, event or period. An environment is a complex whole. Emphasis upon it rather than on individual specimens and simpler concepts affects development, operation and use at every turn. On the practical side the buildings these museums occupy were originally designed for other purposes, for example, as a residence. Any museum that takes over a building secondhand has serious problems in adapting the space. When the structure is itself a specimen, the historic partitions, doors, stairways, windows and other elements must remain or be restored as part of the setting. The preservation and display of objects and the handling of streams of visitors (sometimes a multitude of people) under these relatively inflexible conditions demand adjustments which are seldom easy.

Standards of accuracy and care in restoration, refurnishing, maintenance and interpretation should be equally high for every historic building that finds its best use in being furnished for exhibition regardless of its original importance. The sod house or slave cabin demands as much authenticity and as fine curatorship as does Independence Hall or Arlington House.

The terms applied to this kind of museum have caused some confusion. "Historic house museum" is the name in common use, but it raises questions because people ordinarily picture a house as a residence. They hesitate to consider a blacksmith shop, a country store, a chemical laboratory or a fort as an historic house. To make clear that such museums may

preserve and interpret the setting for any sort of occupancy, this manual adopts the more inclusive name, *furnished historic structure museum*. In some instances it refers to a single building such as Theodore Roosevelt's Maltese Cross Ranch cabin. In other cases the museum comprises a group of buildings having an essential unity in organization and interpretation. Such a group may be a house and its dependencies like the Adams Home with its adjacent library and carriage house. It may also be a larger organic group, for example Hopewell Village, Fort Laramie or the Pioneer Yosemite History Center. If, however, a park contains two or more furnished historic structures that are separate interpretive entities, each is considered a museum. The Schuyler House and Neilson House at Saratoga National Historical Park are examples. Sometimes explanatory exhibits help interpret the furnished structure. These are ordinarily and much preferably housed in a separate building designed for the purpose, but are considered a part of the museum. Thus Arlington House is a furnished historic structure museum with supplementary exhibits in a nearby building. The historic structures involved are usually original, but may be reconstructions; are usually on their original sites, but may have been moved.

Chapter 10 Development

Criteria for Deciding to Furnish

Furnishing an historic building for exhibition costs more than most other possible uses of the structure and presents greater problems. The decision to furnish it is therefore a critical one. The project should warrant an affirmative answer to each of the following questions:

1. Will the building with its furnishings preserve an important primary or secondary historical resource?

2. Is furnishing the best way to communicate the meaning of this structure? In the case of a national park this criterion includes the relevance of the meaning to the park's interpretive objectives or themes.

3. Can the building be furnished accurately?

4. Can visitors see and enjoy the furnished space under practical operating conditions?

Ask these questions at each successive planning stage in the preservation of the structure.

Apply the criteria, for example, to the Neilson House at Saratoga (fig. 45). Unfurnished, this little farmhouse on Bemis Heights would be simply a landmark of the battlefield. Furnished as makeshift quarters for the generals who occupied it while the army was there, it preserves the setting for a particularly significant detail of the battle story. Therefore, furnishing it fulfills the first criterion. Benedict Arnold's unhappy relationship with fellow officers, the relationship's dramatic expression in the battle and its sorry aftermath at West Point involve complex and subtle ideas. The furnished quarters he shared with other generals at Saratoga do not tell the story singlehanded, but recreating this environment calls attention to the situation which underlay events, stimulates interest in it, adds reality and fills in a background. Visitors viewing the furnished rooms experience a variety of impressions and feelings linked to the subject. Thus furnishing the house in this instance adds an appropriate form of supplementary interpretation contributing importantly to visitor understanding. We can give a qualified "yes," at least, to the second questions. In this example the furnishing can be relatively accurate as required by question 3, although

Figure 45. Neilson House, Saratoga National Historical Park. At least one and perhaps three generals of the Revolutionary Army were quartered in this modest farmhouse. Benedict Arnold's wounded pride festered in this environment.

existing records do not give a completely exact picture. There is an inventory of the possessions left by Neilson's son, and a hundred inventories of other upper Hudson Valley families in the 1770's yield supporting data. We know much about the field equipment carried by Revolutionary generals and their staffs. Considering the fourth question, the Neilson House is so small that visitors can see enough from the front door and windows without having to enter. Its exhibition presents much simpler problems than usual and is practical. The decision to furnish it meets all four criteria and is justified.

Similarly Robert Harper's house, the oldest building in Harpers Ferry, clearly meets the first test. Furnishing does help to communicate its meaning in an especially important way. As an 18th-century building associated with the town's founder it has little relevance to the site's main significance. Furnished as the home of a known tenant in 1859–1860 the house typifies characteristic aspects of the community when it flashed into prominence with John Brown's Raid. Reasonably accurate furnishing again is possible thanks to knowledge of the occupant's social and economic position, in-

tense search of local documents and considerable archeological evidence. Broad porches, outside stairways and the easy visibility of rooms from a few central points make exhibiting and surveillance convenient.

Check List of Procedures

The development of a furnished historic structure in a national park normally progresses through ten stages:

1. List of Classified Structures. The superintendent first proposes the use of the building in the field report which recommends its inclusion and classification in the list according to its apparent historical or architectural significance. This guides future planning for its development and use.

2. Master Plan. The park Master Plan confirms the building's significance as an historical resource and fits it into the preservation and interpretation activities designed to accomplish the area objectives.

3. Interpretive Prospectus. This intensive study of the interpretive needs and possibilities of the park results in a firm decision that furnishing for exhibition is or is not the best use of the building. The prospectus selects the general methods for achieving the interpretive objective and supplies preliminary cost estimates.

4. Development/Study Package Proposal (Standard Form 10–238). Following approval of the Master Plan and Prospectus the superintendent submits a request for the needed research and development so funds may be programmed.

5. Historic Structures Report. It records in detail the historical, archeological and architectural data essential to the preservation of the building. This report clarifies and justifies the need for funds to prepare detailed plans and carry out development, and may generate a revision of the development/study proposal. It supplies information furnishing planners will use.

6. Construction Drawings. The restoration architect and landscape architect prepare the detailed construction drawings and specifications for work on the fabric of the building and its setting. These plans interrelate with the Furnishing Plan at many points.

7. Planning Directive. The planning specialists prepare a tactical scheme for the intensive work ahead so it can proceed efficiently.

8. Historic Furnishings Report. It presents first a thorough study of the evidence. Then on the basis of these data and conclusions it specifies the furnishings and their arrangement. This report should follow promptly approval of the Historic Structures Report.

9. Implementation of Furnishings Report. Approval of the Historic Furnishings Report starts a series of curatorial activities involving the acquisition, preparation and installation of the furnishings, quality control

and the training of staff in interpretive maintenance and operation.

10. Confirmation. In carrying out the plan contained in the approved Historic Furnishings Report some modifications may become necessary. If so, the plan is amended following installation to show the furnishings as they actually are. For minor changes an addendum may suffice. The document then continues in force as the control for maintaining historical accuracy. Furnishings thereafter should be rearranged or replaced only in accordance with approved changes in the plan.

The first six steps comprise park management documents largely beyond the scope of this manual. The seventh and eighth are described in detail below under What the Furnishing Plan Contains.

Cooperative Responsibilities

Wise development of a furnished historic structure requires cooperation among an array of specialists. For a park these technicians normally include the park interpreter, a curator with expert knowledge of furnishings, a restoration architect, a landscape architect, an archeologist, a research historian and an interpretive planner. While none of them may work on the project from beginning to end, the need to share their knowledge across specialty lines occurs at every stage. The sustained, intimate collaboration needed comes through careful scheduling of assignments and mutual determination to keep one another adequately informed.

In preparing the Interpretive Prospectus the park interpreter and the interpretive planners who work with him make the definitive recommendation to furnish and exhibit a building. They can hardly reach a fully considered decision without consulting a furnishings curator and the restoration architect. Will furnishing and exhibition create conditions that help or hinder the structure's preservation? Can the needed furniture be obtained at an acceptable cost? Will furnishings be likely to communicate the desired interpretive message? Such key questions and others demand specialized knowledge the architect and curator can contribute.

The Historic Structures Report calls for advice from most of the experts. The architect, landscape architect, archeologist, resource studies historian and curator can each best estimate the work in his specialty needed on the project and its probable cost. Together they provide the data for a realistic project construction proposal and define the research needs. The furnishings curator may also know from experience the difficulties often accompanying a cooperative agreement with some other organization involving acquisition of furnishings, operation of the museum or other aspects and can suggest ways to avoid them.

The architecture section of the Historic Structures Report offers an occasion for especially useful cooperation. The restoration architect should

invite the historian and the furnishings curator to participate in examining the structure for evidence of original furnishings before removing any parts of the building fabric. He needs their advice in planning and specifying interior finishes, wiring, lighting and climate control. They and a safety expert should advise on fire detection and control and other special safety or security measures. The archeologist should consult with the architect, historian and curator before excavation and obtain their participation, if possible, in examining evidence as he uncovers it. The landscape architect should get from the archeologist, historian and curator whatever can be learned about original plantings, paths and outdoor furniture. He should discuss with the historians and the curator the interpretive effects that the restored historic landscape setting aims to achieve.

The combined and cooperative effort culminates in the Historic Furnishings Report. The park interpreter, a resource studies (i.e., research) historian and a furnishings curator usually join in its preparation. They need to maintain close contact among themselves and with the architect restoring the building. The architect and curator should coordinate their work step by step because many of the decisions each makes affect the other's plans. One determines the paint color, for example, while the other selects wallpaper. One is concerned about window framing and the other with curtain fixtures that must fasten to it. Both must help reconcile the practical requirements of heating and wiring to the historic furniture arrangement so modern outlets do not interfere with accurate placement of furnishings. The historian's research, which results in the first part of the report, and the curator's studies, which follow it to develop the second part, should both be scheduled before or during the time the architect is preparing specifications for the restoration work. In defining the special protective and maintenance provisions required the curator needs to involve the architect and to consult the protection and maintenance staffs who will be responsible for the museum when it opens.

Collaboration should continue in carrying out the plan. The project needs the expert help of the furnishings curator at several points. The curator often is in the best position to find and acquire the pieces specified. His knowledge of sources and values can save time and avoid mistakes. It is desirable that he work closely with the museum staff in installing the furnishings to be sure the intent of the plan is achieved. He also can give valuable assistance in training the staff to assure that maintenance and operation of the furnished structure will contribute to its interpretation as well as its preservation. The museum should also call on this curatorial specialist and on conservators for help in cleaning, repairing or restoring furnishings that need it before being exhibited. When the furnished structure opens to the public, cooperation takes the form of a critical inspection. Experts check the accuracy with which the historic environment has been recreated and the apparent effectiveness of its interpretation. Museums not

having such expertise on call should seek qualified consultants through a state or professional historical agency.

The Furnishing Plan

A furnished historic structure museum, like other museums, requires an exhibit plan. Called a furnishing plan in this instance, it determines what furnishings to display and how to arrange them. It guides their acquisition and installation. It controls maintenance and replacements or other changes in the furnishings to protect the quality and integrity of the museum. To produce a good plan requires thorough research, an enlightened understanding of the life which the furnishings should reflect and considerable interpretive insight. It therefore usually calls for a team effort.

The National Park Service has outlined a procedure for developing this essential plan in three coordinated steps, each succeeding one dependent on those before. Proper development of any furnished historic structure museum may require something comparable.

Who Prepares the Furnishing Plan

According to this procedure the Denver Service Center initiates the plan by preparing a Planning Directive in collaboration with the park superintendent, his interpretive staff and the Branch of Reference Services, Harpers Ferry Center. Next a research historian under the supervision of the Denver Service Center produces Part I of an Historic Furnishings Report. Then a curator with expert knowledge of furnishings draws up Part II of this report under direction of the Branch of Reference Services, Harpers Ferry Center. The steps may be summarized:

Document	Prepared by
Planning Directive	Denver Service Center with park
Definition of interpretive objectives	and Harpers Ferry Center
Operating plan	
Historic Furnishings Report, Part I:	
Historical Data	Research historian, Denver
Analysis of historic occupancy	Service Center
Evidence of original furnishings	
Historic Furnishings Report, Part II:	
Furnishing Plan	Furnishings curator, Harpers
Description of recommended furnishings	Ferry Center
with cost estimates, floor plans and	
elevations	
Special installation, maintenance and	
protection recommendations.	

If a park has a qualified historian or furnishings curator, either or both parts of the Historic Furnishings Report may be prepared by the park, but this is rarely the case. When circumstances permit, the historian who worked on the history section of the Historic Structures Report should get the Furnishings Report, Part I, assignment because the two studies dovetail. The Branch of Reference Services at the Harpers Ferry Center, which has special responsibility for Part II and its execution, ordinarily arranges to assign a curator who specializes in furnishings, or find a furnishings specialist, trained preferably in a museum, to prepare this section under contract.

When Is the Furnishing Plan Prepared

Preparation of the Planning Directive and Historic Furnishings Report which comprise the furnishing plan follow as soon as possible after approval of the Interpretive Prospectus and the Historic Structures Report. Three reasons make prompt action advisable. First, the architect of the restoration needs information from the Furnishings Report before he can satisfactorily complete structural work on the building. The report tells him what the furnishings and their proper display require in regard to lighting, floor and wall finishes, protective devices, humidity controls and perhaps other features. Second, the furnishings curator and the historian should have an opportunity before and during restoration to study the building fabric with the restoration architect to find any surviving evidence of original furnishings or their placement such as carpet tacks, picture hangers, shelf outlines or patterns of floor wear. Third, the work required to assemble, restore and install the furnishings takes so much time that it can cause an embarrassing delay in opening the restored structure. To make sure that funds are available when needed for preparing the furnishing plan as well as for implementing it, the estimated cost of preparing the Furnishings Report and the acquisition of furnishings should be included in the development proposal (SF10–238) which follows the Interpretive Prospectus.

What Does the Furnishing Plan Contain

Each section of the plan provides information needed to carry out a furnishing project successfully. The Planning Directive includes:

Definition of interpretive objectives

Although the Master Plan and the Interpretive Prospectus set goals for the project, the furnishing plan needs to focus on the specific objectives more precisely. What facts, insights, feelings and impressions should the refurnished structure communicate to visitors? Some installations interpret

the everyday life of average people. Others illumine the character of an individual or the spirit of a family. Still others recapture the setting of a single event. The Moore House at Yorktown, for example, is an upper middle class 18th century plantation home, but its interpretive objective is not to illustrate plantation life or the Moores. Here for a few tense hours in 1781 a group of officers, controlling their inner feelings of bitterness or elation and punctiliously observing military etiquette, hammered out the terms of surrender. The furnishings as arranged to serve the conferees should give visitors a sense of the reality of this event and help them understand its nature.

Operating plan

To assure the practicality of refurnishing proposals the Planning Directive spells out how the structure will be used. It charts the path visitors will follow. It indicates open hours and how visitors will be directed or conducted. It tells how many interpreters or guards will be on duty and where they will be stationed. It also considers the staff and mechanical provisions necessary for maintaining the building and its contents, and protecting them as well as visitors from special hazards.

The Historic Furnishings Report, Part I: Historical Data, contains:

Analysis of historic occupancy

The research historian must determine who occupied the structure within the specific time limits set by the interpretive objectives. He must discover and evaluate what they did there. In this section he provides a documented account of all the people involved. It is important to learn as much as possible about their ages at the time, their habits, tastes, interests and activities. Their economic and social status will influence the furnishings as well. The account should include the life that went on in the building to the extent that records permit. Illustrate this section with a set of floor plans identifying each room.

Evidence of original furnishings

The aim of the plan is to refurnish the structure as nearly exactly as it was at the chosen time as possible. The more information obtained on the original furnishings, the less remains for conjecture. This section of the plan assembles all the available evidence of original furnishings. Such historical sources as receipts, bills of sale, inventories taken to settle an estate or a bankruptcy, insurance records, wills, deeds of gift, tax records, auction records, letters, family papers, travelers' accounts, military records, photo-

graphs and other pictures may contain useful data. They should be searched as fully as conditions permit. Sometimes similar records for other structures comparable in time and place can supply valuable supplementary information. Appendix F suggests resources and techniques found useful in such research. This section should record the present or last known location of any furnishings supposed to be original along with pictures, if available, and documentary or traditional evidence on their history. The information will help in searching for original pieces or in identifying objects offered as such by descendants or later purchasers.

The Historic Furnishings Report, Part II: Furnishing Plan, comprises:

Description of recommended furnishings

This is the core of the Furnishing Plan. It comprises a complete descriptive inventory of the building's proposed contents. For each room in turn the furnishings specialist explains the relationship of the furnishings to the personalities, activities, interests or other ideas they should communicate to visitors. He then lists and describes each item of furnishing. He bases his recommendations on the evidence in Part I, on additional research to clarify confusing or incomplete contemporary records and on his thorough knowledge of the culture of the period. He selects the actual, original furnishings whenever possible, of course. Where these are not available, he describes the specific type of object to acquire. Ordinarily, for example, the list should call for something as specific as "a sack back Windsor chair of the type made in Philadelphia by Francis Trumble in the 1770's" rather than for just "a Windsor chair." Photographs or sketches, with color notes, should supplement verbal descriptions. When neither originals nor period pieces of equivalent type are obtainable, even after thorough searching, the plan may have to specify reproductions. A few circumstances justify their use. The furnishings specialist will not make recommendations on the basis of modern standards of taste, but will reflect period practices. He will resist the temptation to select furnishings of better quality or design than the evidence supports. The lists should include the furnishings for porches and grounds if they are part of the restoration.

The descriptive list for each room should be accompanied by a floor plan and an elevation of each wall showing where the furnishings are to be placed (fig. 46).

For each item in the list the specialist includes the estimated cost of acquiring it, and of restoring it if necessary. He also notes probable sources from which to acquire it. In large projects he may wish to compile a supplementary want list of all furnishings as a reference aid in searching for many items in numerous sources.

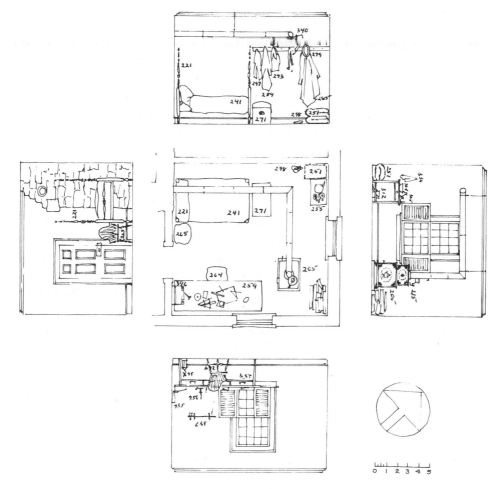

Figure 46. The Great Hall, Grand Portage National Monument. Floor plan and elevations of bedchamber 4 from the furnishing plan showing placement of furnishings.

Special installation, maintenance and protection recommendations

In this section the furnishings curator should describe the provisions necessary for the safe and effective display of the recommended furnishings. If the rooms or furnishings require labeling, the plan should specify the form, location and wording of the labels. If room barriers will be needed, the plan should suggest their location, height and general form. If certain accessories within reach will need inconspicuous fastenings, this should be indicated. If delicate wallpapers, drapes or carpets require protective covers at vulnerable points, these should be identified. Should the importance of the furnishings call for special protection from temperature

and humidity changes, sunlight, air pollution, infestation, fire or theft, the plan must at least make the specific problems clear and may recommend solutions. Lighting needs also should be considered both for viewing the furnishings and for visitor safety. As a general policy, wiring of lighting fixtures that were originally non-electric is not recommended. The placement of furnishings for convenience in protecting or displaying them rather than for historic accuracy should be guarded against. The plan should recommend a maintenance schedule, point out any training the maintenance staff will need in advance, and include a realistic estimate of the annual maintenance and operating costs.

Some historic structures become museums with the original furnishings more or less intact. The Historic Furnishings Report for such a building should be prepared along the same lines. Part I would present the documentation, written and pictorial, on the furnishings that are missing as well as those still in the structure. Part II would record the existing furnishings and their arrangement by photographs and lists, recommend additions or deletions and cover problems of maintenance and protection.

Some structures have been refurnished in past years without a plan. For these the Planning Directive and Part I of the Historic Furnishings Report should now be prepared as though the structures were unfurnished. Part II would then be based on the historical requirements, utilizing existing furnishings where appropriate and recommending whatever changes are necessary.

Who Approves the Furnishing Plan

The director of the region approves the Historic Furnishings Report, Part II, when thorough review assures him of its adequacy. Before being recommended to him, it is critically reviewed by restoration architects, historians, curators and interpretive planners. The regional director may have members of his technical staff review it thoroughly at this stage. The manager, Harpers Ferry Center, has it revised as necessary. When the regional director approves Part II, the Harpers Ferry Center distributes copies to the offices concerned.

Who Carries Out the Furnishing Plan

The superintendent is usually responsible for execution of the approved Furnishing Report, Part II, and for keeping the refurnished structure in conformity with it. He calls on the services of various specialists. The

furnishings curator and the restoration architect, for example, may need to collaborate on the room barriers, with the architect designing them to fit the general specifications of the plan, then having them built and installed. Both specialists may need to cooperate with engineers to assure that necessary protective devices are unobtrusive as well as effective. Exhibits specialists should produce any labels required.

Where area staff are not qualified to acquire the needed furnishings, the Branch of Reference Services assists. Funds for acquisition and preservation treatment of furnishings are normally alloted to the unit actually doing the work.

The Continuing Role of the Furnishing Plan

The Historic Furnishings Report, Part II, as originally approved may not describe the finished product exactly. At the time of approval most of the objects specified still have to be found and acquired. What the curator actually obtains may vary somewhat from the ideal specimens envisaged in the plan. During installation some desirable shifts in placement may become apparent. Any major variance from the plan requires prior approval, of course, but the accumulation of small legitimate changes creates another need. After the initial installation the report continues in force as the established reference point for maintaining the historical accuracy of the re-created environment. The museum must stay in conformance with the plan in order to prevent a slow erosion of integrity that would result if changes to fit convenience or individual tastes were allowed. Consequently, as soon as the furnishings have been installed and inspected, the curator should amend or revise the description of furnishings in the report, and other sections if necessary, so the plan corresponds to the actual situation. Part II should identify fully the furnishing materials such as wallpaper, draperies, upholstery fabric and floor coverings which must be replaced from time to time. Samples of these should also be kept in the catalogue file folder. To achieve the same end for all painted surfaces in the exhibited portions of the structure, the plan should include precise definitions of the paint standards. Then whenever repainting becomes necessary, the work will remain faithful to the chosen historic finishes.

At the same time the revised or amended plan should make clear what aspects of the existing installation are still incomplete or unsatisfactory, and should specify remaining needs. The acquisition of historic furnishings tends to be a slow process. The museum may well open to the public with a few gaps still to be filled and with some pieces selected as the best available at the moment but not exactly what is desired. The continuing plan which guards against undesirable changes must not hinder improvements.

Implementing the Furnishing Plan

Acquisition

From the curatorial standpoint the first step in carrying out a furnishing plan is to acquire the furnishings it specifies. Use an expert, for two reasons. First, whoever searches for the needed pieces and initiates their acquisition usually must deal to some extent in the antiques market or with the interior decoration trade. People who sell historic furnishings on a commercial basis naturally operate with objectives and standards different from those of a museum. These divergences create pitfalls for the inexperienced. The museum buyer should evaluate the material at least as knowledgeably as the dealer in regard to both historical authenticity and cost. Second, the study of historic furnishings is becoming more precise and detailed. Scholars are learning to recognize more and more accurately the individual differences that characterize makers and localities. They are defining the areas and time spans of particular types. A familiarity with styles and periods no longer suffices. Knowledge in this field is growing rapidly and casual students cannot keep abreast. In a park the superintendent should try to retain the services of the furnishings curator who worked on the plan because he or she already knows the plan and the structure as well as having specialized knowledge of the furnishings involved. When this is impractical, the superintendent locates someone with suitable museum experience, usually through the Branch of Reference Services.

The curator should acquire the furnishings needed by means of gift, purchase, transfer, exchange or loan (see Chapter 2 for instructions). Note especially the importance of avoiding restrictions on the use or disposal of specimens. The museum should be completely free, within the dictates of the approved plan, to move or dispose of any furnishing item and replace it with a more appropriate one. No piece should stand in the way of future changes to improve the presentation. The only likely exception which might justify the acceptance of some limitation on disposal is furniture that was unquestionably in the building at the time to which it is being restored.

The historical data section of the furnishing plan (i.e., Part I, Historic Furnishings Report) provides the curator with a good start on his search for original items. If the furnishings that actually were in the structure at the historic time exist, he should, as a rule, make every effort to get them back. Anything else is a substitute. When such pieces come on the market, their association with the historic person or event usually increases the price. Logically, the amount of increase should be proportional to the fame of the person or event. The significance of the part played by the object in question also should influence the amount. The pen used to sign the document gains more in proportionate value from the event than does a painting hanging on the wall nearby. The curator must decide whether or not the increase in price is reasonable. If it is too much, he needs to question

the seller's appraisal and negotiate a fair price. When he accepts the valuation, he may have to justify it to his procurement officer. Common sense and a comparison with associative values other museums and collectors have accepted are the best available guides. Original furnishings in private hands, particularly of descendants, involve other problems. Often the curator has to persuade the owner to part with a cherished possession. In good conscience he can appeal to the public interest, but he should also communicate his enthusiasm, his sense of the significance of the completed project. The curator should be prepared to complete the deal on the spot. To reach agreement and then come back later to finish the transaction almost inevitably permits second thoughts to complicate the matter. The owner's conception of the object's value, either in terms of his desire to keep it or of its price, goes up. If he expects to buy the piece, the curator should have the money in hand. A park museum curator may do this by using either imprest funds or cash obtained from his cooperating association.

When the original furnishings are not available, the best alternative is usually to acquire furnishings made and used at the same period under comparable circumstances. The curator hunts for and selects items that are as nearly like the originals as he can find. They lack the full emotional impact of the actual association pieces, but they have historic authenticity and an important intangible value as having been part of life at the time. Much of the quality of the finished installation depends on his knowledge and discrimination in choosing what will truly recapture the essential characteristics of the original setting. He faces three principal temptations, each of which leads to lower standards. One is to accept furnishings as gifts because they are free or will promote good public relations even though he could find more suitable items. The second is to select pieces that are of finer quality or in better taste than the historic structure actually contained. The third is to acquire furniture because it is available and might be useful later, accumulating a stock in advance of known specific needs. Experience has demonstrated that such pieces seldom represent the best possible selection when a time finally comes to use them. In searching for furnishings that will really correspond as closely as possible to the originals the curator should comb the vicinity, write or visit antique dealers and watch for auctions. He will find it helpful to enlist the interest of other curators, local museums and private collectors. It may pay to broadcast his requirements through notices in appropriate publications. Unless he knows the material thoroughly and examines the pieces carefully in advance, he should acquire them on approval pending expert identification and authentication. Most dealers will send specimens on this basis except at auctions. Buying at auction requires assurance through prior examination or reliable documentation that the object is what is wanted, although a responsible auctioneer may redeem an item he had unknowingly misrepresented. An auction oper-

ates under strict rules about bidding, payment and delivery. These may or may not be spelled out in the sale catalogue. If the curator lacks experience or the scene of the auction is too far away, he sometimes can arrange to have an expert bid for him either as a favor or on commission. The bidder needs to know the maximum amount he can offer. At some auctions the curator may send in a bid by mail indicating the top price he is willing to pay. If the bidding at the sale does not reach this figure, he obtains the item at a figure somewhat above the next highest bid.

The use of reproductions rather than period pieces is justified in a few circumstances, for example:

—when the original piece of furniture is well known but unobtainable. This may occur when another museum has the original on exhibition and cannot or will not return it.

—when the situation demands more identical pieces of a set than can be found. The Congress Hall chairs at Independence National Historical Park illustrate this case. Not nearly enough of the original chairs have survived to equip the House and Senate chambers.

—when the historic structure itself requires a peculiar shape or particular size that cannot be matched. The curved desks for the lower house in Congress Hall had to fit a given space exactly.

—when the item is perishable and must be replaced periodically. The most frequently reproduced furnishings are draperies and upholstery fabrics that deteriorate from exposure to light, floor coverings that wear out in use and wall coverings that resist transfer and reinstallation.

—when the building itself is a total reconstruction. Genuine antique furnishings in a building that is a modern replica of the original structure introduce two possible interpretive hazards. The old furnishings may carry too much relative impact, calling attention to themselves more than to the ideas they should communicate. They also make it harder to avoid conveying a false impression that the building is an old one too. Museum ethics require that visitors be told in an effective manner the true nature of reproductions.

—when the item will be used by staff or visitors in "living history" programs. "Living history" or demonstrations almost inevitably wear out most objects they employ. No museum should contribute to the destruction of objects, even ordinary or plentiful ones, that it wants people to respect.

In general reproductions are likely to be as costly as period pieces. Sometimes, however, a manufacturer will donate a reproduction in return for permission to market copies. A park museum cannot grant an exclusive right to anyone to copy its specimens, but if permission to sell additional copies is given, the superintendent should emphasize the importance of accurate reproduction and truthful advertising. All reproductions should be clearly and permanently marked, on the bottom or in some other inconspicuous place, so they cannot be mistaken for originals. In most instances

the reproductions used in a furnished historic structure museum should be exact copies of the originals. But when the original is unknown, the curator may be justified in using a period reproduction that is on the market already rather than selecting a period piece for costly copying. This decision rquires good judgment. It usually involves textiles or wallpaper.

The money to acquire furnishings often comes from the construction funds for restoring the building. This is normally the case in a park. The request for restoration financing therefore should be checked, and revised if necessary, to make sure it fully reflects the cost estimates in the furnishing plan (Furnishings Report, Part II). In requesting the funds consider the time factor also. Searching out old furniture is a slow task. Pieces that fit the plan are likely to be scarce and scattered. They may come on the market only occasionally. It often takes years to acquire everything needed to complete the furnishings. To avoid embarrassing delays in opening the museum, intensify the search. Let the curator concentrate on it and do the necessary traveling. Under these circumstances most furnished historic structures can be ready to open one to three years after approval of the plan. Some gaps will remain, but they can be filled as opportunity permits. The funds should be programmed in stages, if necessary, to avoid the disadvantage of carrying over unexpended project balances year after year. The initial restoration program, for example, may include part of the money for furnishings. The rest can be added as a completion item the year after the main project closes. If loose ends of furnishing remain too long to keep the second account open, provision for continuing occasional purchases should be made. In parks, cooperating associations and private donors may also help provide money for furnishings. To minimize the total expense by doing the job efficiently keep in mind that the cost of a piece of furniture includes not only its purchase price and transportation to the museum, but also the curator's salary and travel costs while searching for it and the conservator's salary and materials to clean or restore it. Consider these factors in comparing prices.

Study and Recording

Curatorial responsibility in implementing the Furnishing Plan goes beyond acquisition. A park interpreter needs the curator's expert help in accessioning and cataloguing the furnishings as they are acquired. The details of the transactions by which they are obtained should be entered in the accession book immediately, of course. Prompt and thorough cataloguing is also important. The unavoidable exposure of exhibited furnishings makes them liable to loss from theft, accidental breakage or deterioration. Recovery, accurate repair and replacement depend on detailed information in the catalogue. Photographs which reveal the individual characteristics of a piece, rubbings or other adequate records of marks and labels and de-

scriptions of other features peculiar to the specimen have special value.

The curator can also make a vital contribution to the quality of interpretation provided through the furnished structure. He should record his specialized analyses of individual items of furnishing and file them permanently in the catalogue folders. He chose the pieces because they illustrate particularly well some aspect of the life or event being interpreted. He should explain the relation between the specimen and the idea so guides or attendants will understand and communicate it. The curator should discover and record as much as he can about the furnishings—who made them, when, where, how, the materials and their sources, designs and their history, marketing and so on. This factual information lays a solid basis for future research and also serves the special interests of antiques-oriented visitors. His appraisal as a connoisseur has interpretive value too. His informed judgment of the furnishings in terms of period standards of taste and craftsmanship should be added to the catalogue folder file.

The study and recording of the furnishings take time. Cost estimates should provide for it.

Treatment

Old furnishings more often than not need cleaning, repair or restoration before being exhibited. The museum staff can obtain valuable help at this stage also from the expert knowledge of the furnishings curator. The curator should analyze the condition of each piece. He should recommend the kind and extent of treatment. If the work can be done by museum employees or craftsmen in the vicinity, he may supervise it from the technical standpoint and inspect the results. For more complex treatment he will know whether to use the conservators in a central laboratory such as the National Park Service and some museum consortiums have, obtain the assistance of another museum or locate a qualified, reliable private shop. In any event the curator should insist on the observance of two principles. First, preserve as much as possible of the original object. If a wooden part has deteriorated, impregnate it, reinforce it or patch it. Replace it only as a last resort. Clean and restore the old finish rather than removing it and starting fresh. Retain original upholstery on an important association piece as long as its appearance can be tolerated. Get expert advice on mending or backing frayed areas and splits. Perhaps the worst-worn spots can be concealed by laying an appropriate object over them. If reupholstering becomes necessary, use the original stuffing and backing or replace them with the same kind. As the second principle, restore each item as nearly as possible to the appearance it had during the historic occasion or period. In most instances the furnishings at the time they were in use were in good, serviceable condition neither brand new nor antique looking. It takes skill and good judgment to restore furnishings so the wear and decay of the intervening years do not show too

plainly without diminishing the integrity of the specimens in the process. The curator needs a clear understanding of the desired result in order to specify and check the work, He should make sure that detailed treatment reports go into the catalogue folders.

The methods used to clean, repair and restore furnishings vary with the materials, and to some extent with their condition. Each piece tends to present a unique problem. The curator selects techniques in consultation with the craftsman who will perform the work. One treatment, however, can be prescribed. Most furnishings contain wood, textiles or other organic matter which may invite insect attack. All such pieces should be fumigated, under vacuum if possible (see Organic Material, Chapter 3). Do this before the furnishings are placed in the historic structure. If pieces already on exhibition need repair or restoration, maintain the same standards of expert treatment.

Installation

Although the furnishing plan specifies the arrangement of the furnishings for each room, the curator should help install them if possible. Numerous last-minute questions need expert checking. Will sunlight fall directly on a vulnerable piece? Is any furniture too close to a heating vent? Will small objects be easier to reach or more tempting than anticipated? If so, can they be made secure in an acceptable manner? Above all will the room with furniture in place have the visual effect intended, particularly when seen from the visitors' viewing positions? Some adjustments probably will be found desirable. The curator should make them, weighing all the factors involved and being sure to record all changes in the furnishing plan.

Installation need not wait until every object listed in the plan has been acquired. As soon as enough furnishings are on hand to embody the ideas the museum should interpret, public interest may warrant opening it. In this event, however, do not relax the search for the remaining items. Visitors will get an incomplete and correspondingly unsatisfactory impression until everything is in place.

Quality Control

The larger question of the integrity of the installation requires prompt attention. In opening to the public the museum vouches for the essential accuracy of the furnishings and their arrangement. It says, in effect, that they truly represent the time, place, people and ideas being interpreted. Whoever acquires and installs the furniture becomes too closely involved in decisions to evaluate the results impartially. Therefore, in a park the chief interpreter has responsibility for making a critical examination of the museum as soon as possible after it opens. He should ordinarily call in advis-

ors to supplement his own knowledge, or he may delegate the appraisal to a qualified curator. He checks four aspects in particular:

1. Is each item of furnishing correct for the period, locality, form, function and taste or quality specified in the plan?

2. Does the ensemble truthfully recreate the physical environment of the people and their activities it undertakes to show?

3. Are provisions for the exhibition, protection and preservation of the furnishings adequate and appropriate?

4. Does the interpretive experience in total and in detail seem to communicate the intended understandings?

The evaluator reports his findings and recommendations to the superintendent for whatever action may be required.

Staff Instruction

To be successful the furnished rooms of an historic structure must strongly suggest the imminent presence of the historic occupants. While the curator creates this lived-in atmosphere, the staff members working in and about the building have a large part in preserving it. Such an atmosphere is very easily destroyed by the attitude or activity of an interpreter or guard. The maintenance staff can sustain it or ruin it unintentionally in some instances, for example, by being too tidy. The curator should therefore give the staff a clear, sympathetic understanding of the nature and purpose of this intangible atmosphere and the elements which help communicate it. The following chapter concerns other areas in which the staff should be trained.

BIBLIOGRAPHY

Published information on developing furnished historic structure museums must be gleaned mostly from the larger literature of historic preservation. The following references contain pertinent material:

Alexander, Edward P. "Artistic and Historical Period Rooms," *Curator*, VII:4 (1964), pp. 263–281.

———. "A Fourth Dimension for History Museums," *Curator*, XI:4 (1968), pp. 263–289.

Allan, Douglas A. "Folk Museums at Home and Abroad," *Proceedings of the Scottish Anthropological & Folklore Society*, V:3, pp. 90–120.

Coleman, Laurence Vail. *Historic House Museums*. Washington. American Association of Museums, 1933. (Repr. Detroit. Gale Research Co., 1972).

Hosmer, Charles B., Jr. *Presence of the Past: A History of the Preservation Movement in the United States before Williamsburg*. New York. G. P. Putnam's Sons, 1965, pp. 260–272.

Little, Nina Fletcher. "Historic Houses: An Approach to Furnishing," American Association for State and Local History Technical Leaflet 17, rev. ed., *History News*, 25:2 (February 1970).

National Trust for Historic Preservation. *Criteria for Evaluating Historic Sites and Buildings*. National Trust Publications 3. Washington. 1956.

———. *Historic Preservation for Tomorrow: Revised Principles & Guidelines for Historic Preservation in the United States*. Williamsburg. National Trust for Historic Preservation and Colonial Williamsburg, 1967, pp. 27–29.

Rasmussen, Holger. *Dansk Folkemuseum & Frilands Museet: History & Activities*. Copenhagen. National Museum of Denmark, 1966.

Rath, Frederick L., Jr., *et al. Primer for Preservation: A Handbook for Historic-House Keeping*. Historic-House Keeping Series #1. Washington. National Trust for Historic Preservation, n.d.

———, and Merrilyn Rogers O'Connell. *Guide to Historic Preservation, Historical Agencies, and Museum Practices: A Selective Bibliography*. Cooperstown. New York State Historical Association, 1970, pp. 23–27, 29–31, 49–59.

Seminar on Preservation and Restoration, Williamsburg, Virginia, 1963. *Historic Preservation Today*. Charlottesville. University Press of Virginia, 1966, pp. 201–224.

Stewart, John J. "Historic Landscapes & Gardens: Procedures for Restoration," American Association for State and Local History Technical Leaflet 80, *History News*, 29:11 (November 1974).

United States Conference of Mayors, Special Committee on Historic Preservation. *With Heritage So Rich*. New York. Random House, 1966.

Many books and articles concern historic furnishings. See:

Peterson, Harold L. *Americans at Home: From the Colonists to the Late Victorians*; *A Pictorial Source Book of American Domestic Interiors with an Appendix on Inns and Taverns*. New York. Charles Scribner's Sons, 1971.

Rath, Frederick L., Jr., and Merrilyn Rogers O'Connell. *op. cit.*, pp. 114–184.

Chapter 11 Housekeeping

Keeping a furnished historic structure clean ranks in importance with protecting and interpreting it. Every museum has the basic obligation to preserve the specimens in its collection. In this kind of museum the building and furnishings are the collection. This makes careful housekeeping a necessity. Otherwise accumulating dirt will hasten deterioration by its abrasive and chemical action. Pollutant gases in the air will build up acid concentrations or oxidants attacking such materials as textiles, metals, leather, paper and even stone. Insects and mold will find more favorable conditions for breeding and feeding. (See Agents of Deterioration, Chapter 4.) Were added justification for thorough housekeeping necessary, concern for appearance and sanitation would provide it. An uncleaned museum soon offends and misinforms visitors. It becomes an unhealthy place to work in and to visit. Everything in a furnished structure museum requires periodic cleaning, not only the floors and furnishings but also the walls, ceilings, wood trim, windows and other historic surfaces of the building. This chapter suggests methods and precautions to consider in setting and applying historic housekeeping standards.

Two precautions should influence every step in the cleaning operations. Remember first that many of the actions and processes involved are potentially harmful to furnishings or the structure itself. Rubbing, scrubbing, pulling, bending, wetting, drying and the use of various cleansing agents might readily accelerate wear, cause breakage, lead to chemical damage or augment other hazards. Historic housekeeping, therefore, demands the choice of methods that are safe as well as effective. It also calls for skill and extraordinary care in their application. Second, remember that well-intentioned cleaning can go too far. It can falsify the visual impression of historic living conditions. Housekeepers must share the curator's sensitive understanding of the degree of cleanliness and neatness in which the original occupants would have felt at home. Both the precautions noted here underline the interdependence of housekeeping, protection and interpretation. The organization of the work should reflect these relationships.

Organization

Supervision

In other kinds of museums housekeeping is a function of the maintenance staff, while the curators take care of the collections. Maintenance and collection care overlap to only a limited extent, for example in the cleaning of exhibits (see Chapter 15). Normal cleaning in furnished historic structures, on the other hand, directly affects the historic collections. The responsibilities of maintenance staff and curators overlap critically. Ordinarily the maintenance department selects, trains, schedules, equips, supplies and supervises cleaning personnel. Its objective is to keep the museum satisfactorily clean as efficiently as possible. Curators approach the cleaning of furnished historic rooms from a different point of view. They consider first the nature and condition of these valued artifacts. They try to determine what cleaning materials and methods will contribute most to the preservation of the individual objects. They watch closely for additional signs of deterioration that would make changes in cleaning practice advisable. They also are concerned about the interpretive effects. If the housekeepers had to take their orders from both maintenance supervisors and curators, chaos might result. Good management requires clear definition of the lines of authority. Good housekeeping needs the contributions of both specialist areas. The solution lies in assigning direct control to one while assuring that the other provides technical support. National parks having furnished structure museums sometimes place the historic housekeeper under the chief of maintenance. The curator, or the interpreter bearing the curatorial responsibility, then has the clear duty to give the chief of maintenance practical technical advice on how and how often each historic furnishing or structural element should be cleaned from the standpoint of preservation and interpretation. The curator must also keep close watch over the effects of cleaning, informing maintenance when methods or frequency seem harmful. The chief of maintenance has a reciprocal obligation to consult the curator and take his advice or work out acceptable alternatives. Because of these considerations parks having especially valuable or numerous historic furnishings often find it better to assign direct supervision to the curator. Local circumstances may favor other ways of sharing responsibility, but close cooperation and open communication between the maintenance and curatorial staffs should result.

Whoever supervises historic housekeeping has a serious responsibility. The supervisor must keep close watch over the condition of the building fabric and furnishings, and the integrity of the historic setting. In addition he or she must check on the quality of cleaning, the efficiency with which it is accomplished, the care of equipment and the practice of safety. To do this properly requires a good working knowledge of the standards set, the methods prescribed, the tools employed and the materials used in cleaning.

In many public buildings established practice calls for the immediate supervisor to observe every cleaner at least once each working day and to inspect in detail at least one completed cleaning assignment daily. This enables the supervisor to guide, instruct, correct or commend cleaners on all phases of their work as well as to evaluate the finished product. Someone at a higher level of authority then makes an inspection of the state of housekeeping throughout the building at regular intervals, perhaps every month or two months. Furnished historic structures also need thorough, systematic, knowledgeable supervision of their cleaning operations.

Staffing

Persons who do the actual housekeeping will handle historic objects at almost every turn. These objects are often historically important, costly, fragile, rare or irreplaceable. They vary widely in nature and condition. Historic housekeepers should therefore be thoroughly reliable individuals. They need a well developed sense of responsibility. They require the capability to understand and follow a considerable volume of specific instructions. Their manual skills should particularly include gentleness and dexterity. To treat the furnishings roughly or clumsily would be intolerable. While housekeeping traditionally has been work in which women excelled, men also have the requisite skills. Often a man and woman working together provide an effective staff. Historic housekeepers are not ordinary janitors or charwomen, although some persons experienced in such work can become excellent ones under proper training and supervision. Neither are they equivalent to old-time domestic servants for whom present appearance outweighed permanent preservation of the things they kept clean. They are public servants entrusted with helping preserve part of the people's heritage. Furnished structure museums must recruit and train people qualified for this task.

A few museums successfully combine housekeeping with other duties. Guides, for example, may do the daily cleaning before the doors open for tours. Costumed attendants may dust and sweep as they carry on informal interpretation and surveillance of visitors. Multiple duties call for correspondingly versatile, talented and motivated employees selected and trained for the full range of their responsibilities. The housekeeping by itself makes demands that should not be minimized in such combined assignments.

How many historic housekeepers a museum ought to have obviously depends on the amount of work necessary to maintain the desired standard of care. The size of the building affects the workload. So do the number, kinds and condition of the furnishings. Other variable factors include weather, surrounding sources of dust and polluted air and the rate of visitation. Each museum needs to measure its own staffing requirements. A

logical way to do so starts with a systematic survey of the entire building. Go through it room by room with floor plans and tape measure in hand. Record every housekeeping task. The table under Scheduling below suggests the kinds to include. Show the area of such surfaces as floor, walls or rugs to be cleaned and the number of such items as dishes, books or chairs in each job unit. If properly done, the resulting list will be long and detailed. To make it more manageable group the rooms according to the level of cleaning required, for example: exhibited rooms, public access areas where visitor traffic aggravates cleaning problems, space used primarily by staff including storage and utility rooms, and unused spaces as in attics or outbuildings which still need periodic cleaning. Next consolidate the comparable jobs for all the rooms in each category to give the total area of exhibited rugs or exposed floor, or the number of leather-bound books. For each task in the condensed list estimate the amount of time it should take and how often it should be done. Multiply the man-hours for each by the number of times it will be performed in a year. Then add the results to obtain the total man-hours per year required for housekeeping. Since a full-time employee works about 2,000 man-hours a year, the proper size of the housekeeping staff can be easily calculated. As a rough check National Park Service experience indicates that a typical furnished historic house needs housekeeping at a rate of about one man-year for 8,000 square feet of floor space (743m²) or one man-hour per year for every four square feet (.372m²).

Two additional factors affect the workload calculations. Allow for the time every housekeeper needs each day to take care of equipment and supplies. Mops and dust cloths must be washed, dried and put away carefully. Tools such as vacuum cleaners and the various kinds of brushes require frequent cleaning and proper storage. Flammable supplies should be removed from the historic building or safely stored with special care. Also, some housekeeping tasks involving expensive equipment, uncommon skills or hazardous operations may be assigned to outside specialists. Examples include the dry cleaning or laundering of certain textiles, the cleaning of paintings and perhaps window washing. Omit these jobs from the manpower tabulation, but select carefully the experts entrusted with them. Choose among contractors who have had actual experience both in working on historic buildings or museum objects and in applying methods approved by museum conservators. Check on the quality of their previous work. Write detailed specifications and provide for knowledgeable inspections.

In deciding how long each unit of work should take and how frequently to have it done, base estimates on personal observation, staff experience and that of other furnished structure museums. Supplemental help may be found in manuals developed for large scale cleaning operations and in the tabulation in the following paragraph on scheduling. Cleaning manuals

usually apply to office buildings, hospitals, hotels or other situations where the furnishings and finishes permit the work to proceed at a faster pace. So the figures they cite on the amount of each type of cleaning that can be done in a given time and the frequencies they recommend rarely fit museum needs exactly.

Scheduling

Historic housekeeping should follow a schedule. Otherwise some cleaning tasks may be crowded out or forgotten. If the schedule allots each job unit adequate time at the proper intervals, both supervisor and housekeeper will know what needs to be accomplished during every working day of the entire year. The man-hour estimates and frequencies compiled in the staffing survey provide the data for schedule making. The list which follows may be a useful check. It represents fairly common or desirable practices, but the curator should fit frequencies more precisely to the museum's own collection and environment.

Table of representative frequencies of housekeeping tasks:

Daily

Exhibited Rooms
1. Dust all woodwork, ledges, moldings, mantels, louvers, radiators, air grilles and additional horizontal room surfaces within reach from the floor; all fixtures within reach; all furniture except fabrics; all exposed furnishings except fabrics, paintings and carved, molded or gilded picture frames.
2. Dust mop exposed and linoleum or oilcloth covered floors.

Public Access Areas
1. Empty and clean trash receptacles, sand urns and ash trays.
2. Clean floor surfaces over which visitors walk including door mats, runners, carpets, exposed floors and stairs—vacuuming, wet mopping, scrubbing or dust mopping as the kind of surface requires; remove gum or tar and spot clean carpets.
3. Dust as in exhibited rooms.
4. Damp wipe and dry polished metal, glass and plastic surfaces to remove fingerprints and other spots.
5. Damp wipe with disinfectant such surfaces extensively handled by visitors as the top rails of room barriers, stair rails, entrance and exit door handles, audio guiding devices.
6. Spot clean walls or furniture smudged by visitor contacts.
7. Clean and service public toilets.

Staff, Storage and Utility Areas
1. Empty and clean waste baskets and ash trays.
2. Dust staff rooms as in exhibited rooms except for working materials on desks.
3. Damp wipe and dry polished metal, glass or plastic fixtures.
4. Spot clean walls and office furniture.
5. Dust mop exposed floors, sweep carpets.
6. Clean and service staff toilets and any sinks or cooking equipment.

Weekly

Exhibited Rooms
1. Dust furnishings in cupboards, cabinets, closets, drawers.
2. Vacuum fabric floor coverings, upholstery, drapes, bed hangings, bedspreads and tablecloths or other exposed textiles (original fabrics may well require much gentler care); blinds or shades; tops of door and window frames and other high ledges in reach from the floor; light fixtures.

Public Access Areas
1. Vacuum fabrics, blinds, high ledges and light fixtures as in exhibited rooms.
2. Buff waxed floors.
3. Clean and polish door hardware or other bright metal fixtures and fittings unless originals, when corrosion inhibitor plus hard lacquer should be applied as needed—perhaps annually.

Staff, Storage and Utility Areas
1. Vacuum carpets, drapes, upholstery, dust covers, blinds, high ledges within reach, light fixtures.
2. In storage and utility rooms dust all horizontal room surfaces within reach from the floor, furniture, storage cabinets and shelves, equipment.

Biweekly

Exhibited Rooms
1. Burn candles and oil lamps briefly to remove traces of dust.

Public Access Areas
1. Burn dust from exhibited candle and lamp wicks.

Monthly

Exhibited Rooms
1. Damp wipe and dry mirrors, glass panels in furniture and picture glass.

 2. Blow dust from carved or molded picture frames.

 3. Clean plastic ultraviolet filters and similar plastic surfaces.

 4. Vacuum walls or wipe with clean dust cloth.

Public Access Areas

 1. Clean mirrors, furniture glass and picture glass as in exhibited rooms.

 2. Clean plastic filters and protective plastic coverings.

 3. Vacuum walls.

Staff, Storage and Utility Areas

 1. Buff waxed floors in staff rooms.

 2. Wet mop floor in utility rooms, and in storerooms if appropriate.

 3. Spot clean carpets in staff rooms.

Quarterly

Exhibited Rooms

 1. Wash windows (but semiannually if original fabrics must be taken down).

 2. Wash light fixtures.

Public Access Areas

 1. Wash windows.

 2. Wash light fixtures.

 3. Wax and buff floors requiring it.

Staff, Storage and Utility Areas

 1. Wash windows.

 2. Wash light fixtures.

 3. Vacuum walls.

 4. Dust or vacuum high pipes, ceiling fixtures and other features requiring ladders.

 5. Clean or replace filters in heating and ventilating equipment.

 6. Renew pesticides in stored organic materials.

Unused Spaces

 1. Wash windows.

Semiannually

Exhibited Rooms

 1. Vacuum or dust ceilings and other high areas requiring ladders.

 2. Clean walls and ceilings around radiators and air grilles.

Public Access Areas

 1. Vacuum ceilings and other high places as in exhibited rooms.

 2. Wash non-historic wall coverings.

 3. Strip, wax and buff waxed floors.

 4. Dry-clean non-historic carpets (some may need it much more often).

Staff, Storage and Utility Areas
1. Vacuum ceilings.
2. Clean walls and ceilings around radiators and air grilles.

Annually

Exhibited Rooms
1. Clean rugs, drapes, bed hangings, bedspreads, exposed clothing and other textiles not suitable for wet washing (but check first with the conservator, who may advise less frequent cleaning).
2. Launder window curtains, bed linens, table linen and other loose fabric coverings on furniture (but check first with the conservator).
3. Remove tarnish from silver, brass, copper and pewter objects and treat with inhibitor (oftener if necessary).
4. Wash ceramics, glass and marble furnishings, using special techniques for historic marble.
5. Wash Venetian blinds.
6. Clean floors thoroughly—wet mopping, stripping and waxing or other treatment appropriate to the kind of flooring.

Public Access Areas
1. Clean modern drapes and renew flame retardant.
2. Launder window curtains and renew flame retardant.
3. Wash or clean furnishings as in exhibited rooms.
4. Wash Venetian blinds.

Staff, Storage and Utility Areas
1. Clean modern drapes and renew flame retardant.
2. Wash window curtains and dust covers, renewing flame retardant.
3. Wash Venetian blinds.
4. Clean floors thoroughly in staff and storage rooms—wet mopping or stripping and waxing as appropriate.

Unused Spaces
1. Vacuum floors, walls and ceilings.
2. Wash light fixtures.

Biennially

Exhibited Rooms
1. Treat leather in bookbindings, upholstery, harness, trunks and other objects.
2. Clean and wax woodwork of furniture and room paneling except where painted, oil finished or raw wood.
3. Clean historic wall coverings.

Public Access Areas
1. Clean and wax historic woodwork as in exhibited rooms.
2. Clean historic wall coverings.

Staff, Storage and Utility Areas
1. Treat leather as in exhibited rooms.
2. Clean and wax woodwork of stored and office furniture as in exhibited rooms.

Equipment

A housekeeper needs proper tools in order to clean thoroughly and efficiently. The tools require good care. The following annotated list adapts recommendations from the cleaning practices of large public and commercial buildings:

Bags

To minimize the spreading of dust and save many steps housekeepers may carry plastic bags into which they empty wastebaskets and dustpans. The bags, closed with a wire tie, hold the trash and dirt until removed from the premises or transferred to metal cans or bins with tight covers. Polyethylene bags large enough to fit a 32-gallon (120-liter) can are convenient. Some national park museums use ones $38\frac{1}{2}$ inches long \times $19\frac{1}{2}$ inches \times $14\frac{1}{2}$ inches (c. $1 \times .5 \times .4$ m). If the plastic is at least .002 inch (.05 mm) thick, the bags are strong enough to wipe out and reuse. In case trash must remain bagged overnight or longer in or near the historic building, use polyethylene bags of the fire-retardant type. As another fire precaution never empty smokers' refuse from ashtrays or sand urns into the trash bags. A small tin can makes a safer receptacle for collecting and removing it.

Brooms

Traditional upright brooms and push brooms tend to raise and scatter dust. Replace them with dust mops and vacuum cleaners, at least indoors. On the other hand a hearth broom, like an ordinary upright broom but on a smaller scale, makes a handy tool for sweeping piles of dirt or bits of litter into a dustpan without continual stooping. A whisk broom also finds occasional use in loosening and removing dirt from crevices. Both should be made of the best quality broom corn fiber or of nylon. Brush or comb loose dirt from these brooms after each day's use. When they become soiled, wash them in warm water with soap or detergent, then rinse. Hang them up to dry so any remaining water drains out and the weight does not rest on

the fibers. Store them in the same manner when not in use. Discard them when they start to shed.

Brushes

Historic housekeepers find several kinds of brushes helpful. Articles of furnishing too delicate to dust with a cloth may permit gentle brushing. For this purpose use a camel hair lens or negative brush about 1 inch (25.4 mm) wide with inch-long bristles. Tufted upholstery, some pottery and a few other furnishings may call for a slightly larger and stiffer dusting brush. Select an inexpensive artists' paint brush, No. 14 broad. A conventional radiator brush with narrow body and long horsehair bristles can pull dirt from awkward recesses to within reach of a dust mop or vacuum cleaner. A scrub brush shaped well for grasping and with tapered ends helps in cleaning stubborn dirt or old wax from the corners and edges of floors or stairs. It also loosens patches of dried mud on carpets or other surfaces. Select one with nylon bristles an inch or a little more (c. 25–30 mm) in length. If rubber or plastic runners along traffic routes become muddy, they may need to be taken outside to be hosed and scrubbed. In this case a long-handled deck or floor scrubbing brush with bristles of palmetto or other coarse plant fiber may be useful. To remove lint and loose dirt from the bristles of housekeeping brushes and brooms use a hairbrush with stiff nylon bristles as well as a comb. Wash brushes when they become soiled, using warm water and soap or detergent. Hang them to dry after rinsing and when not in use so the bristles remain straight.

Carpet sweeper

If carpet runners cover much of the traffic route, they may require frequent cleaning to remove grit and obvious dirt. A non-electric household carpet sweeper can do this quickly between more thorough treatments. It can also be used with care on historic rugs. After each day's use empty the catch pan, clean lint from the brushes, wipe the outside clean and put the sweeper away carefully in its assigned place. In situations where soiled spots on the runners become an everyday problem, select a carpet sweeper that can also shampoo rugs with "dry" foam. After using it for this purpose rinse the brushes and sponges, empty the shampoo reservoir and wipe off the entire sweeper before returning it to storage.

Chamois

In washing windows and perhaps other glass surfaces a soft, oil-tanned sheepskin chamois may replace a wiping cloth. Wash it well after use and hang it spread out to dry.

Cloths

Dust cloths should pick up dust rather than push it off one surface onto another or into the air. For this reason cloths intended for the purpose are better than rags. A good dust cloth should be of soft cotton fabric and should have all edges hemmed or selvage. It should be big enough to permit folding so the housekeeper will have several fresh surfaces. One a yard or a meter square folded to a convenient 9 inches (or 250 mm) pad gives 32 clean sides in turn. When a dust cloth has been properly treated with a specially formulated mineral oil emulsion, it picks up dust much more efficiently. On the other hand it smears some surfaces and leaves a possibly harmful residue on others. Use a treated cloth to dust finished wood, metal and other hard surfaces unlikely to absorb oil. Do not use one on glass, which it smudges, or on marble, paper and other porous materials. Dust these with an untreated cloth. Both treated and untreated dust cloths require frequent laundering. This removes the emulsion from the former, so retreatment is necessary. While housekeepers can buy the oil emulsion in either liquid or aerosol form from hardware stores or janitorial supply houses and apply it themselves, it is hard to get just the right amount into the cloth. Consequently it is generally wiser to rent the treated cloths, returning soiled ones for washing and processing. In either case be sure the treating mixture has an Underwriters' Laboratories fire hazard rating between 0 and 20 and that tests have shown that cloths treated with this material are not subject to spontaneous combustion. Even so, keep all treated cloths in self-closing metal safety cans before and after use. For damp wiping or for drying damp-wiped furnishings and fixtures select a highly absorbent, soft cotton cloth, for example with waffle weave. Wiping cloths should be of a convenient size with hemmed or selvage edges. These also need laundering often. If the museum has plastic ultraviolet filters on windows or lights, or protective plastic coverings over fragile materials within reach of visitors, cloths impregnated with an antistatic solution make it easier to clean them (see Detergents under Methods and Materials below; nonionic detergents have antistatic properties).

Comb

A hair comb, preferably of metal and with long teeth, helps in cleaning lint from the housekeeper's brushes and brooms.

Dustpans

A janitorial style dustpan teams with the hearth broom in gathering up sweepings and litter with less physical exertion. It has an upright handle like the broom so it can be manipulated without stooping. The hooded

metal body swings back when lifted, holding the dirt without spilling. For close work around historic furniture an ordinary household dustpan made of rubber or flexible plastic helps prevent scratches. Wipe dustpans clean after use and hang them to protect the edge.

Floor polisher

Museums that have only a small area of waxed floors to maintain usually can rent a floor polishing machine or strip, wax and buff the floor by hand. When the amount of work justifies owning a polisher, one of the household models should be adequate for most furnished historic structures. These polishers usually operate two 6-inch (c. 150 mm) brushes. The machine should have interchangeable sets of brushes and pads designed respectively for stripping old wax, scrubbing and buffing. Some polishers have two- or three-speed motors to drive the brushes at different rates for the separate processes. Some also have reservoirs and additional brushes for shampooing rugs. This feature is desirable only if the museum has carpet runners on traffic routes or considerable modern carpeting in staff areas. In using a floor polisher be sure the switch is off before plugging in the cord. Have the machine in position and a firm grip on the handle before switching on the motor. When the job is finished, remove the brushes and pads used, wash them in warm water with soap or detergent, rinse thoroughly, shake out the remaining water and hang up to dry. Then wipe all dirt from the machine and cord, wind the cord loosely and secure it in place and return the polisher to its assigned storage.

Gloves

Historic housekeepers usually need two kinds of work gloves. To avoid leaving fingerprints that will etch themselves into metal objects, thin cotton gloves must be worn whenever metal in any item of historic furnishing is touched. Thin gloves assure a firmer grip. White ones show dirt quickly to tell when they need laundering. National park museums use a kind manufactured for photographic darkroom use or ones supplied to undertakers. To protect housekeepers' hands from disinfectants and strong cleansers rubber gloves should be worn, as when cleaning toilet fixtures. Wash the rubber gloves in warm water with soap or detergent after each use. The cotton gloves can be washed as needed several times before being discarded.

Ladders

Numerous cleaning operations involve surfaces, fixtures or furnishings out of reach from the floor. For these tasks the housekeeper usually needs to work from a step ladder. If the ladder is too short, it tempts one to climb

higher than the second step from the top, which risks a bad fall. If the ladder is too long, moving it and setting it up increases the risk of damage to the historic furnishings. A job that can be done more safely by two people, such as taking down heavy drapes, requires two ladders of the proper length. These considerations call for providing as many step ladders of different sizes as will best fit the specific tasks. All the step ladders should meet safety standards (see Safe Practices in Housekeeping, Chapter 12). Wipe them clean before and after use and be sure to check that all braces and brackets are solidly attached. Any straight ladders needed for window washing or other cleaning on the outside of the building should also conform to safety standards in construction and be the right length for the job.

Mops

The best tool for the daily sweeping of bare floors is a dust or sweep mop. Select one with a handle about five feet (1.5m) long attached to a mophead holder by a universal joint. The mophead should be either of two types. One consists of cotton duck formed into a pocket to fit over and fasten to a metal frame. The lower surface of the mophead bears short tufts of cotton yarn in an arrangement designed for efficient dust collecting. The frame is about 5 inches (130mm) wide and comes in a range of lengths to suit the extent and openness of the area to be swept. The second type is a loose sleeve of cotton osnaburg (a coarse, heavy cloth) that slips over a special brushhead. The brushhead, a wood form with short bristles to grip the cloth as it moves along the floor, is also about 5 inches wide and of various lengths. For most historic structures the dust mop frame or brushhead probably should be between one and two feet (300–600mm) long. Both kinds of mophead contain the same dust-absorbent mineral oil emulsion as treated dust cloths. Like the dust cloths, the mopheads can be obtained on a rental basis and returned for laundering and retreatment. As dust accumulates on the mop during use, shake it outside the building and remove additional dirt with a vacuum cleaner. When the mophead becomes soiled beyond such cleaning, have it laundered and processed. Store all treated mopheads in self-closing metal safety cans when not in use. For floors that require wet mopping choose good quality string mops, for example with strands of eight-ply cotton yarn about 30 inches (750 mm) long, attached by a spring lever clip to a 60-inch (1.5 mm) handle. Use one mop for initial cleaning and a fresh one for rinsing and drying the floor. After use rinse the mops in clear water, wring them, fluff out the strands and hang head up to dry. When they become dirty, follow the same steps after washing them in warm water with soap or detergent.

Pails

Several cleaning tasks require the use of warm water with soap, detergent or other cleaning agent in it. These jobs need clear rinsing water as well, and so call for two pails. One-piece molded polyethylene pails are lighter and easier to keep clean than metal ones, and are less liable to mar furniture on accidental contact. Select nine- or 10-quart (8–10-liter) sizes with bail handles. Those having graduations molded in the side help when cleaning solutions should be mixed to the right proportions. Wet mopping demands three pails, but larger ones strong enough to support the mop wringer. Galvanized metal mop buckets of 16-quart (15-liter) capacity with bail handles and attached casters should serve the mopping and rinsing needs of many furnished structure museums. The casters may add more weight than advantage if only small areas need mopping. All housekeeping pails should be rinsed thoroughly after use, wiped clean inside and out, then stored where they will not become dented or pressed out of shape.

Putty knife

This is the tool generally used to scrape off gum, tar or similar deposits that have stuck to the floor. Use it for this purpose only, not to pry open cans or tighten loose screws. Keep it clean and dry.

Sink

Housekeeping requires a convenient source of hot and cold water, an easy way to fill and empty pails and a suitable fixture in which to wash brushes, cloths, mops and sponges. Bearing in mind the structural integrity of the historic building the restoration architect should provide the sink or sinks best adapted to the needs of the housekeeper that will not be disruptive to the building fabric. He may select a janitorial sink, a mop basin, a laundry tub, a kitchen sink or some combination of these. Wipe or scrub the sink clean at the end of the day.

Sponges

Coarse-textured cellulose sponges of convenient size to hold in the hand work better than cloths for many damp wiping, spotting and surface washing tasks. Obtain the sponges in at least three different colors, reserving each color for a particular kind of job. One common practice assigns green sponges for general use, confines yellow ones to wiping toilet seats and the outside surfaces of toilet bowls and urinals, and employs pink ones to clean

toilet partitions and adjacent walls. Wash all sponges after use in warm water with soap or detergent, rinse in clear water, squeeze and store where they will dry.

Squeegee

A common window washing technique employs a squeegee to wipe the glass dry. It should have a rubber blade firmly held in a brass frame. The frame should include a centrally placed socket to hold a pole for reaching high windows, but also to provide a convenient handle for close work. Select a blade length to suit the size of the panes. Wet the edge of the blade before starting the first stroke. Keep it wiped clean. Store it so no weight rests on the rubber.

Syringe

Even a lens brush can dislodge bits of carved wood or gilded gesso from old picture frames. To dust them use a two-ounce (56 ml) rubber ear syringe. Squeezing the bulb creates a small blast of air for blowing off the loose dust.

Toilet bowl swab

For cleaning the inside of toilet bowls, urinals and sanitary napkin receptacles with necessarily strong solutions a chemically resistant swab has some advantages over the traditional toilet brush. The swab of polyester yarn should have a sliding protective cup on the handle. Wash the swab well after using it, rinse, shake out and hang up to dry.

Vacuum cleaner

This important cleaning tool should be relatively light and compact for safe maneuvering among easily damaged furnishings. It should facilitate cleaning under beds or other large pieces of furniture without moving or marring them. It should have attachments for working on bare floors, walls, carpets, drapes and upholstery, and for reaching into corners and crevices. A household model of the canister type probably fits the needs of most furnished historic structures better than either an upright or an industrial one. If the furnishings include fragile textiles, the amount of suction must be regulated. The control provided by a hole in the wand covered or uncovered with a rotating sleeve is insufficient. Have an electrician install a motor speed control on the cleaner. Whenever operating the vacuum cleaner make sure the switch is off before connecting the cord. Empty the dust bag after each day's use. Clean the bag thoroughly with a vacuum

or brush about once a week. Clean the brushes and other attachments after using them. Before putting the machine away wipe it and the cord clean and coil the cord loosely. Report any needed adjustments or repairs promptly.

Wax applicator

If the museum needs a floor polishing machine, it can also use a special tool for spreading fresh wax evenly over the floor. This applicator usually has a handle about 4½ feet (1372 mm) long. The block holds a replaceable pad of lamb's wool. After using the applicator take off the pad, wash it thoroughly in a solution that will remove the wax, rinse and shake out, then replace it on the block and hang in storage where the pad will dry.

Wringer

Wet mops require frequent, controlled and often thorough wringing as the work progresses. Wringers for this purpose fit onto the rim of the mop bucket. Cleaners who do much mopping prefer one having a gear and rack mechanism to exert a downward squeeze. Select a wringer of this type to fit the size of mops and buckets being used. Keep it clean by rinsing and wiping after each mopping session.

This equipment list implies the need for space in which to store and take care of the housekeeping tools and supplies. The space should be large enough to permit orderly storage. It requires the means for hanging certain tools and cabinets, shelves or fire-safe containers for others. It needs good ventilation both for fire safety and to dry the equipment washed after use. It should have facilities for this washing. Its location should make the transportation of the heavier tools and supplies to and from work sites as easy as possible. Since housekeeping has a vital role in the preservation of the historic building and its furnishings, the restoration architect should make the best provisions he can for these functions.

Methods and Materials

The methods used for cleaning furnished historic rooms and the substances applied in the process should meet three tests. First they should help preserve the artifacts being cleaned, specifically avoiding potentially harmful operations or ingredients. Next they should leave the surfaces looking as they would have when the historic occupants cleaned them. Finally these techniques and materials should clean as efficiently and eco-

nomically as the foregoing considerations permit. Cleaning methods for present-day buildings have a different priority of requirements. They must first of all work quickly, effectively and as easily as possible, saving time and labor. Their long-term effects are of secondary importance because the building surfaces and furnishings they are intended to clean or polish have a limited life expectancy. These procedures have no occasion to match the visual results of methods abandoned years ago. Consequently it is more fortunate than intentional when convenient modern techniques and the products readily available from supermarkets or janitorial supply houses happen to prove entirely suitable for cleaning historic buildings and their furnishings. Labels and sales literature on cleaning and polishing supplies seldom reveal what they contain. This aggravates the difficulty of choosing safe and satisfactory ones. Some modern equipment and supplies, like the vacuum cleaner, do the job far better than anything a pre-20th century housekeeper had. Others are the same as, or quite similar to, what she used. Some involve preservation hazards. Until conservators have analyzed and tested them, cleaning methods and materials should be selected on the basis of their closely observed effects reinforced by scepticism about their advertised virtues. Exercising these precautions, consider the highly efficient techniques developed for cleaning public buildings only as a starting point for your adaptations. The needed application of scientific conservation to historic housekeeping, when it comes, will provide surer guidance.

Housekeeping supplies suggested in the cleaning procedures discussed below have been chosen with the criteria for historic furnishings care in mind, but often without benefit of the analysis and scientific testing they ought to receive. In making the choices the preservation of historic surfaces being cleaned has outweighed the ease or effectiveness of cleaning. Even so, apply the cleansing agents with sceptical caution. Always read carefully the directions and warnings on the containers before use. Gentle cleansers do not handicap the historic housekeeper. Regularly scheduled care of surfaces already in exhibitable condition makes harsh, heavy cleaning unnecessary as a rule. Most of the selected products should prove reasonably convenient to obtain. The principal ones include:

Abrasives

When cleaning or polishing requires steel wool, use the 000 grade. To polish steel get 600 grit, A weight emery paper. Hardware stores usually carry these. The desirable abrasive for polishing copper and brass consists of precipitated chalk in ammonia and ethyl alcohol. Presumably some commercial polishes such as Noxon or Brasso approximate this composition. They tend to overpolish, so apply them carefully. Avoid acid polishes intended for shining modern copper kitchenware. For pewter, if polishing becomes necessary, use a commercial mixture designed specifically to do it.

Goddard's pewter polish is one example. Fine jewelry stores and department stores should offer a selection of acceptable silver polishes including Goddard's, Gorham's, International Silver and 3M. Choose one with an anti-tarnish ingredient. Obtain whiting (powdered chalk) and rottenstone, both mild abrasives, from a hardware or paint store. Get rubber polishing "erasers" from jewelers' suppliers.

Detergents

In choosing among the many varieties and combinations of synthetic detergents conservators often avoid potential hazards by selecting ones that do not react chemically with other materials and are neither acidic nor alkaline. They use a nonionic neutral detergent such as Igepal CA-630 (a GAF Corporation product), Lissapol N or DuPont's Merpol SH. Lissapol has European distributors. Another kind of nonionic neutral detergent that is water soluble and conforms to U.S. Military Specifications MIL-D-16791E should provide a relatively safe and convenient general purpose cleaning agent for historic housekeeping, at least when used in the minimum concentrations recommended on the container. National Park Service museums may be able to obtain it from the Federal Supply Service (Item 7930-282-9699 in the *GSA Supply Catalog*) when in stock. Janitorial suppliers perhaps can furnish a commercial detergent that meets the same strict specifications. Ask for a liquid, nonionic, water soluble product composed at least 99% of a surface active agent of the alkyl aryl polyether alcohol (alkyl phenol ether or polyethylene glycol) type when the alkyl group is iso-octyl or iso-nonyl, that contains no builders, soaps or addition agents of any kind. This technical description may help the dealer identify or approximate your need. In many situations a neutral soap is preferable to synthetic detergents provided it can be used in soft water (distilled or deionized water, or filtered rural rainwater). Obtain a soap free of builders or additives, for example Ivory or a comparable type.

Protective coatings

Various transparent coatings over bright metals can delay the need for repolishing. Synthetic lacquers such as Krylon, Quelspray, Frigilene or Incralac applied by aerosol can or brush serve this purpose. Dealers in artists' supplies handle at least some of them. Microcrystalline waxes provide an even better barrier against corrosive agents. Objects which cannot conveniently be dipped in the molten wax, require its application in paste form. Making up a paste involves the risk of heating flammable solvents. It seems wiser to use a prepared microcrystalline wax paste such as the British Museum formula marketed by the Smithsonian shops and other dealers as Renaissance Wax. Easier to obtain, although not quite as effi-

cient as a metal coating, are hard, clear paste waxes of natural origin. These include Butcher's and Simoniz available in hardware stores and also used as protective coatings for furniture and wood floors. Any commercial stove polish consisting of powdered graphite in a suitable vehicle should protect the cast iron of stoves and fireplace fittings. British Museum leather dressing, marketed under that name by chemical companies and library suppliers, is a mixture formulated after careful research. It functions at least partly as a protective coating.

Solvents

Water is the solvent most used by historic housekeepers. Ammonia water—ordinary nonsudsing household ammonia—aids it in removing grease from glass. Perchlorethylene, a dry cleaning solvent, packaged with an inert powder in an aerosol container may act like a poultice when sprayed on a stain. Obtain it as a fabric spotter from dealers in cleaning supplies or as Goddard's Dry Clean spot remover. Stoddard solvent, widely used in dry cleaning, is a petroleum distillate. A local dry cleaning plant might supply the relatively small quantity an historic housekeeper would need. Chemical suppliers and paint stores also carry it. While turpentine substitute from the hardware or paint store provides the solvent for paste wax, water emulsion floor waxes require a liquid dewaxer to emulsify them. Get one recommended by the wax manufacturer.

Other supplies

Some paper cleaning tasks call for the use of powdered eraser, such as Opaline or Skum-X available from library suppliers or art shops. Library suppliers also market a leather protector comprising a solution of potassium lactate to buffer airborne acids and a fungicide to retard mold growth. Dealers in silverware carry a mixture of liquid chemicals for removing tarnish under such names as Silver Dip and Tarnex. Silver cleaned by this method needs a tarnish inhibitor. Available products include Silver Shield and Goddard's Tarnish Preventive Spray.

Floors

The care of modern floors involves sweeping, mopping, scrubbing, buffing, stripping and waxing depending on the kind and condition of floor and finish. These processes can often apply directly to the staff, storage and utility areas of the museum. Employ them also in the public use areas, modified as necessary for antique floors on which visitors walk. Adapt them for cleaning in the exhibited areas to the extent that they contribute to the preservation and historic appearance of the floor. Some of these

possible adaptations will be discussed following description of current procedures.

Floors are now swept with a treated dust mop. It gathers the loose dirt from the surface without raising dust. Sweep in a planned pattern that will save steps while moving the dust mop over every bit of exposed floor in the room. Start with the dust mop, radiator brush, dustpan, hearth broom and putty knife clean and ready at hand. Move light furniture out of the way carefully and turn back rugs a little. If the space to be swept is less than eight feet wide (c. 2.5 m), walk forward pushing the dust mop straight ahead. At the far end of the room turn, keeping the mop moving on the floor and the same edge forward, and follow a parallel path overlapping the first one slightly. Continue this pattern until the space is completely swept. Stop along the way only to use the radiator brush for pulling dust out of corners or other spots inaccessible to the mop, to sweep under furniture that could not be moved or to pry gum and similar substances loose with the putty knife. To avoid marring furniture with the mop handle reach halfway under from each side when practicable. In wider spaces swing the dust mop in an arc from side to side as you walk forward or backward, using the straight push only around the edges. Keep the same side of the mop forward by twisting the handle at the end of each arc, and the long axis of the mophead at a 45° angle to the direction of stroke. While using either pattern keep the mop flat on the floor. Lift it only to transfer accumulated dirt onto a dust pile, raising the mop a few inches and giving it a quick shake or two. If too much remains on the mophead, clean or rotate it. Use the hearth broom to gather the small dust piles into the dustpan for prompt disposal. When finished sweeping take the equipment back to the housekeeper's storeroom, clean it carefully and put it away. In sweeping marble or terrazzo floor be sure the treated mop has only a minimum of the oil emulsion in it. Excess oil would harm these porous surfaces.

Damp mopping removes light films of clinging dirt from all types of floors. This process requires a string mop, mop bucket and wringer. Fill the bucket half full of cold water. Take the equipment to the room being cleaned. Take along all the regular sweeping equipment because a floor should be swept thoroughly just before you mop it. After sweeping wet the string mop in the bucket. Wring it nearly dry. Then draw the mop along the floor close to the baseboard. Rinse the mop and wring it as before. Carry it to the far end of the room and mop the open floor with long, continuous, side to side strokes. To do this stand with feet apart and one a little ahead of the other. Step back as the mop passes close to the foot in front. Throughout the stroke keep the mop heel on the floor and the strands spread. At every fourth stroke lift the heel of the mop slightly as it comes in front of you and reverse the direction. This turns the opposite face of the mop to the floor. Rinse and wring the mop frequently. Change the water as soon as it becomes dirty. Be careful not to slap the strands against base-

boards, furniture or rugs. Use a push-pull stroke under furniture. Wipe the floor around the legs and in corners with the mop strings held in your hand. Rub scuff marks with the mop heel. When the floor is clean, return the equipment to the storeroom, wash the mop, shake out the strands and hang to dry. Then rinse and wipe the bucket and wringer.

Damp mopping with clear water may not suffice for floor areas in the direct path of visitor traffic. If experience proves the need for more cleaning action there, follow the same procedure but with a dilute detergent. Fill the mop bucket half full of warm water. Add the amount recommended on the label using, if possible, a nonionic neutral detergent conforming to U.S. Military Specifications MIL-D-16791E. Sweep the floor and then mop it as described above. The mop should be a little wetter, so wring it with slightly less pressure. Damp mopping modern floors with a mild and dilute detergent does not ordinarily require rinsing. For original or accurately reproduced historic floors this additional step does seem advisable. In this case go over the area again promptly using clear water from a second bucket. Keep the mop damp enough to pick up any residue of the detergent. Rinse and wring the mop often. Wipe over the floor finally with the mop wrung as dry as possible.

Wet mopping should be used only on hard surfaced floors such as marble, other stone, ceramic tile, terrazzo or cement. Its purpose is to clean off moderate films of dirt that would resist damp mopping. The job requires two string mops, three buckets and a wringer as well as the sweeping tools to prepare the floor for mopping. Fill one bucket with hot water. Add a nonionic neutral detergent to the recommended proportions. If this is unobtainable, select a detergent marketed for use on such floors. Use clear water to fill another bucket. Attach the wringer to the third, empty bucket. Have all the equipment ready. When the floor has been cleared and swept, dip a mop in the cleaning solution. Do not wring it out, but let the excess drip back into the bucket. Draw the saturated mop along the floor to mark off an area of about 9 × 12 feet (2.7 × 3.7 m). Dip the mop again and let it drain. Mop the marked out space with long swinging strokes like those used in damp mopping. Be especially careful not to spatter baseboards or furnishings. Mop over the wetted section again to agitate the cleanser. Scrub corners and especially soiled spots by hand with the mop strands or, if necessary, with a brush. Wring the mop dry. Go over the same area again to pick up the cleaning solution. Turn the mop over and over, wringing it frequently. Do not allow the detergent to lie on the floor longer than 10 minutes. Before this portion of the floor has time to dry, take the second mop, saturate it in the clear water letting the excess drain back. Mop the same area once more to rinse it thoroughly. Then use this mop to pick up the rinse water. Turn and wring the mop often as above. Finally mop the section as dry as possible with the mophead wrung hard. Return to the first mop and cleanser. Mark off an adjacent area of about the same size as

before. Follow the full cycle of washing, picking up, rinsing, picking up and drying. Continue until you have done the entire floor. Since a wet floor is slippery, leave warning signs in place until the surface has dried completely. Take all the equipment back to the storeroom, clean each item properly and put it away. In wet mopping observe two special precautions. Do not let the mop wet with cleanser stand on the floor while not in actual use. Such prolonged contact may damage the surface. Do not let the solution or rinse water get into electrical floor outlets. A resulting short circuit could cause injury or fire.

Scrubbing supplements wet mopping. It becomes necessary when the latter process fails to clean hard surfaced floors adequately. The operation employs an electric floor polisher fitted with scrubbing brushes. In addition it calls for all the equipment to sweep and wet mop the floor. Follow the procedures in the preceding paragraph from initial sweeping up to the point of agitating the cleaning solution. When the solution has been mopped onto a section of the floor, use the polishing machine as a scrubber. Lay the machine on its side and attach the brushes. Set it upright. Make sure the switch is turned off. Plug in the cord. Standing directly behind the polisher and gripping the handle, switch on the motor. Guide the machine back and forth over the wetted area in wide swinging arcs. For places the polisher cannot reach shut off the motor and scrub them with a hand brush. Having finished scrubbing set the machine aside, being sure the wet brushes do not rest on the floor. Then resume the mopping steps. Pick up the cleaning solution with a wrung out mop, remembering not to let the liquid remain on the floor for more than 10 minutes. Rinse the scrubbed area, pick up the rinse water and dry. Complete the first section before wetting the next. At the end of the job wash the scrubbing brushes thoroughly as well as the mops. Wipe the polisher and cord clean and dry. Coil the cord properly. Rinse and wipe the buckets and wringer. Clean the dust mop and dust pan. Store each item carefully.

Buffing helps to clean waxed floors and improves their appearance. It removes slightly imbedded dirt from the finish and restores its gloss. For lightly soiled floors buffing may take the place of damp mopping. When dirt has become moderately ground into the wax, buffing should follow damp mopping. In either case start by sweeping the floor thoroughly with the dust mop. If a floor needs only buffing, take all the regular sweeping equipment and the electric floor polisher to the room. The polisher will need buffing brushes or pads. Sweep up and remove loose dirt and any gum or similar substance carefully pried from the floor. Take the polishing machine to the far end of the room. Turn up the polishing head to attach the buffer. Check the switch to be sure it is off, then connect the cord to the electrical outlet. With the machine standing directly in front of you grasp the handle and turn on the switch. Guide the polisher from side to side stepping backward. Continue back and forth in parallel paths until you have buffed the entire

area of exposed floor. Be careful to prevent the machine from striking the baseboard or furnishings. As soon as the work is done, replace furnishings and return all equipment to the storeroom. Clean the buffing brushes or pads. Wipe the machine and cord and coil the latter. Clean the sweeping equipment. Then put each piece in its place.

In the second case, when a moderately dirty waxed floor requires damp mopping, follow the steps for this process as given above using clear, cold water. Rinse and wring the mop and change to fresh water frequently. After mopping let the floor become completely dry. Then buff it as just described. The mop, bucket and wringer will need cleaning afterwards along with the buffing brushes or pads, the polishing machine and the sweeping gear.

Stripping consists of removing completely old floor wax in preparation for fresh coats. All waxed floors require it from time to time. It becomes necessary when dirt has worked deeply into the wax, when the wax has deteriorated from exposure and wear, or when repeated applications have built up an objectionable thickness. The process involves spreading a liquid on the floor that will soften and dissolve or emulsify the wax and then removing the mixture of liquid and old wax before it damages the floor. Details vary with the kinds of floor and of wax finishes. In all cases sweep first. If the floor is wood, it probably has a solvent type paste wax coating. To strip it begin at a point farthest from the entrance. Wet a coarse cloth with turpentine, or preferably an odorless oil-paint thinner which is more stable. Rub hard with it over the floor within easy arm's reach. This should soften and pick up the old wax and dirt. Take a clean cloth and rub the same area dry. If any dirty spots remain, go over them with a little more turpentine on a pad of 000 steel wool. Then rub again with the dry cloth. Move to the adjacent area and continue the wetting and rubbing until the entire floor has been stripped clean. Change cloths as often as necessary. Observe precautions against two dangers throughout the process. Turpentine and its substitutes are moderately toxic when inhaled or absorbed through the skin. Therefore ventilate the room especially well while stripping and wear rubber gloves. Both turpentine and wax are flammable. So are paint thinners. Keep open flames and smokers away from the work area. Place a fire extinguisher for Class B fires at the entrance ready for emergency use. Do not let soiled cloths or the material stripped from the floor remain in the building. Store the supplies of turpentine and fresh wax outside the historic building, if possible, or in a cabinet approved for the safe storage of flammable liquids.

Linoleum floors and those surfaced with any of the non-ceramic tiles usually have a water emulsion wax finish. To strip these floors use a wax remover, an emulsifying liquid which may contain flammable and irritating substances. Follow the procedures for wet mopping or scrubbing. Fill the first bucket with hot water to which add the proportion of wax remover

specified on the label. In the case of concentrated solutions this may be one part dewaxer to 32 parts of water. Saturate the mop and drain the excess back into the mop pail. Mark out a 9 × 12 foot section (2.7 × 3.7 m) and wet it thoroughly with the mop. Then go over the area again with the mop freshly saturated agitating the liquid on the floor to loosen the old finish. If the floor is unusually dirty as well, agitate with scrubbing brushes attached to the electric floor polisher instead of the mop. With either method be especially careful not to spatter the baseboards or furnishings. Pick up the liquid and old wax promptly with the mop, wringing each mopful into the empty bucket. Do not let the mixture stay on the floor more than 10 minutes. If this treatment leaves any dirty spots, hand rub them lightly with 000 steel wool wet from the bucket of dilute dewaxer. Use a cloth to pick up the residue. Before the section of stripped floor dries, rinse it well with the second mop using sufficient changes of water. Then pick up the rinse water with the wrung out mop leaving the floor as dry as the mop will make it. If the wax remover is flammable and should not come in contact with your skin, take precautions to guard against fire in using, storing and disposing of it. Wear protective gloves when handling it. Wash the mops and scrubbing brushes used for stripping without delay. It will take warm water and detergent to clean the old wax out of them. Clean and store the other equipment promptly also.

Waxing concludes the list of processes customarily employed in the care of modern floors. It follows stripping as soon as the floor has dried, before dust again settles on the cleansed surfaces. It consists of paste-waxing or emulsion-waxing according to the type of floor. To wax a wood floor dampen a clean, soft cloth. Squeeze out any excess water. Fold the cloth into a convenient pad. Place a small amount of paste wax on it. Then wipe it over the floor to leave a thin, even coating. Begin at the far corner of the room. Add wax to the cloth when necessary and continue until the entire floor is lightly covered. Attach buffing brushes to the floor polishing machine and carry it to the far side of the room. Connect the cord and operate the machine as previously described. Guide it over the whole floor area. The brushes assure that the wax is evenly distributed. If the floor needs a higher gloss, put buffing pads on the polisher and go over the waxed surface again. Finally dust mop the room to pick up any fine particles of wax scattered by the brushes. You can vary either step of the waxing-buffing procedure to fit the amount of floor space. For a room too large to wax by hand spread the paste with the floor polisher. Put a tablespoonful of wax on the floor. Start the polishing machine and set the rotating brushes directly on the lump of paste. Move the polisher from side to side in the usual way. Put down more wax as required until you have spread it thinly over the whole area. Buff with pads on the polisher. In a small room you can buff the wax by hand as well as applying it and not need a polishing machine at all. First work over the freshly spread paste with a fiber brush

to make sure the coating is thin and even. Then rub the floor hard with a clean cloth pad. After waxing replace the furniture and wash without delay the brushes, pads and cloths used. This gets the wax out of the equipment before it hardens. Prompt cleanup also reduces the fire hazard. Store the supply of wax outside the building or in the approved cabinet for flammable liquids.

The solvent in paste wax permits reconditioning the finish on a wood floor numerous times before it needs stripping. When regular buffing fails to restore the desired luster even after damp mopping, wax the surface again lightly and buff it as described in the preceding paragraph. The solvent helps to clean the soiled finish and minimizes the build-up of thick, unsightly layers of wax.

The application of water emulsion wax to linoleum or non-ceramic tile floors requires different methods. The wax being in liquid state pour a sufficient amount into a mop bucket. Prepare a second bucket with clear rinse water. As soon as the stripped floor is completely dry, dip the long handled lamb's wool wax applicator into the wax. Press out the excess against the inside of the bucket. Draw the applicator along the floor about 4 inches (c. 100 mm) from the baseboard. Then with side to side, slightly overlapping strokes spread the wax over the rest of the floor. Dip and press out the applicator when more wax is needed. Rinse and wring out the lamb's wool pad if wax begins to accumulate on it. Let the wax remain on the floor until dry to the touch. This usually takes 20 to 30 minutes. Next use the polishing machine with buffing brushes to smooth the coating and give it a sheen. The brushes will extend the wax over the uncoated strip along the baseboard. Start buffing at the far side of the room. Follow previous instructions for keeping the polisher safely under control and moving it in wide strokes. If the floor sustains particularly heavy traffic, apply a second thin coat of wax after buffing the first. Spread it in the same way and let it dry well before using the polishing machine again. Dust mop the finished floor if buffing leaves a powdery residue. Discard any wax left in the bucket. Wash the wax applicator, bucket and buffing brushes thoroughly before the wax sets in them. Wipe the polisher and cord. Clean the dust mop and put away all equipment.

Water emulsion wax has no solvent action on previous coats. Successive layers applied to recondition a floor would build up to objectionable thickness. Before stripping becomes necessary, however, worn areas of finish can be patched to a limited extent. Clean the floor thoroughly. Spread fresh wax thinly over the worn portion. Buff it, using the polisher to blend the new finish as well as possible into the older wax surrounding it.

Acrylic emulsion floor finishes and those incorporating silicones work satisfactorily on the modern resilient floors for which the manufacturers formulate them. In general confine their use to such floors and follow the directions on the containers. These finishes often require special stripping

materials, as do some kinds of water emulsion wax finishes. Be sure to check the flammability and toxicity of both the finish and stripper used. Take the precautions indicated.

Adapting current methods of floor care to exhibited historic rooms requires some acquaintance with older practices. In North America before 1900 most buildings intended for human occupancy had plain board floors, often of pine. Ordinarily the boards had no applied finish. If untended and uncovered, they assumed a dull gray look. They readily absorbed grease and other stains from accidental spills. To keep such floors clean and bright demanded much time and hard work. In addition to the difficult job of extracting grease spots and stains promptly, the housekeeper who followed English tradition swept them, perhaps daily. The broom raised dry dust which settled on the furnishings. To prevent this she might fling handfuls of damp sand hard against the floor before sweeping. The rolling, bounding sand grains gathered at least some of the fine dust. Or she might scatter damp used tea-leaves, kept for the purpose, then sweep. Preferably about once a week the housekeeper would supplement sweeping with dry rubbing. She used dry sand, sometimes heated, on the floor, rubbing it hard with a long handled scrubbing brush, working always with the grain, never across the boards. Less often, but still frequently, she scrubbed the boards on hands and knees with sand and water. She used ample water, scrubbed hard lengthwise of the boards, then wiped it dry quickly because water tended to darken the wood. When the whole floor had dried, she might rub it again with clean dry cloths. During the 1800's soap came to replace sand in the scrubbing process. Such care conscientiously applied produced a bright, light colored floor in which the wood grain plainly showed. Perhaps relatively few rooms attained this condition consistently, but it was the goal.

Modern ways to achieve a similar appearance without an impractical investment of time and labor need more study and experimentation. Start by exposing the natural color of the floor boards. You can do this by scraping them carefully with a floor finisher's or carpenter's hand scraping tool. Remove only enough of the surface to reach clean wood. Do not try to cut down raised edges or level the irregularities caused by wear. Do not subject an original floor to this scraping more than once. To keep the floor looking reasonably bright try vacuuming it frequently enough to prevent an accumulation of dust and grit. Use the suction at full strength. Do not use a treated dust mop on the floor. When it becomes noticeably dull, mop it with clear water. Wet only the area within reach in front of you. Push and pull the mop back and forth along the boards, not across them. Rinse the mop often and change the water so you apply clean water with a clean mop. Dry the mopped area well with a wrung out mop before wetting the next section. Perhaps once a year you may need to scour the boards.

Not all floors in early American buildings lacked a finish. In the 1700's

some, probably well-to-do, homes had floor boards in one or more rooms stained to look like mahogany. To obtain this result by one recommended method the housekeeper swept the floor clean. Then she strewed selected herbs over it and rubbed them hard with a scrubbing brush. After the plant juices released from the crushed stems and leaves had colored the boards, she let the floor dry before sweeping up the remnants. Such a finish remained presentable for some time without the use of sand or water. Sweeping and perhaps occasional dry rubbing sufficed. A similar effect should come today from treating a clean board floor with brown mahogany water stain and dust mopping it regularly. Other finishes used to some extent, particularly in the 1800's, included paint, varnish and linseed oil. People painted kitchen floors more often than other rooms because bare boards there were especially hard to keep clean and available coverings were unsuitable. Paint also served to cover the narrow band of exposed floor between the rug and the walls. Varnishing provided another popular method of finishing this band and sometimes entire floors. It probably involved an annual application of varnish stain to a well cleaned floor. Similar finishes of paint or varnish stain can be put on clean board floors readily. Regular dust mopping and damp mopping should keep them in satisfactory condition. Linseed oil wiped periodically on a wood floor provided a finish that did not require scouring. An oiled floor swept regularly and at intervals sponged with water stayed clean enough. Adding a little milk or kerosene to the water gave the floor a slight sheen. Oiling a floor, however, turned it dark, so this finish found its principal use in buildings other than homes. A treated dust mop and occasional damp mopping should clean adequately an oiled floor on exhibition.

A waxed floor before about 1880 would have been rare if found at all. Therefore do not wax exhibited floors representing an earlier period unless this finish is unquestionably documented. Unavoidable heavy visitor traffic on an original wood floor might justify an exception because wax would protect the boards to some extent. In this case wax only the areas actually under foot. It would be better interpretation to let a reproduced floor wear out than to prolong its life by using anachronistic wax.

The small pieces of an old parquet floor may tend to splinter. Do not use a vacuum cleaner on it if this condition exists. Dust mop with extra care.

When marble or other stone floors required more than washing, oldtime housekeepers employed whiting or a similar mild abrasive. Modern sweeping, mopping and scrubbing techniques should produce comparable results. Waxing these floors would not, unless they represent 20th- or very late 19th-century occupancy.

Brick, packed earth and other less common floors do not have as well recorded cleaning practices. Common sense suggests that regular use of a vacuum cleaner should maintain a brick floor adequately if the bricks are well laid and closely set. Occasional sweeping of sand over bricks is also

very effective. Occasional scrubbing with clear water and a fiber brush may need to supplement it. Vacuuming with reduced suction and a light touch may also clean an earthen floor more safely than other means.

Wood floors, if they were well kept, cost a housekeeper much time and labor. She consequently sought practical ways to cover them. In England straw traditionally covered many floors during the winter. Rushes replaced the straw from Whitsunday till autumn. American housewives may have used these or other expedients, but such transitory materials require documentation before being used in exhibited rooms. By the late 1700's carpets and other manufactured floor coverings became available at prices many people could afford. The care of these furnishings assumed growing importance.

Floor Coverings

Carpet care in modern buildings involves four operations. Vacuum cleaning at regular intervals removes the loose dirt and grit that cause most wear. Areas that accumulate obvious dirt or litter between times need sweeping. Spot removal takes place promptly when some staining substance is spilled or tracked on the carpet. When a film of soiling adheres to the fibers, the carpet is shampooed. Apply these procedures to office carpets or rugs and to carpet runners along the tour route. The latter may need daily vacuuming. Once a week should suffice in staff areas. Make sure the dust bag, filter and attachments are clean. Carry the equipment to the room and set the canister in a central location. Attach the rug brush to the vacuum cleaner wand. Check that the cleaner switch is off, then plug in the cord. Hold the wand with both hands using one to move and the other to guide it. With the switch turned on propel the brush forward and backward at least twice over the area covered by the first stroke. Make the next series of strokes parallel to the first and overlapping a little. Continue in this fashion over the entire carpet. Lay the nap as you proceed by doing the final stroke of each series in the same direction. Turn off the machine, remove the rug brush and replace it with the crevice tool. Use this to extract thoroughly the dust and lint that settle between the edge of the carpet and the baseboard, a favorite breeding place for carpet beetles and clothes moths. When finished, return the vacuum cleaner to the storeroom. Empty and clean the dust bag. Clean the filter and attachments. Wipe off the machine and cord. Then coil the cord and put away all the equipment used.

The second procedure serves to clean small, heavily used portions of carpet that become unsightly or gritty under foot before the whole carpeted area needs vacuuming again. For this task use a non-electric carpet sweeper. It is handy, light, quiet and causes less wear than a broom. You can bring it quickly and gather up the worst of the dirt with a minimum of

disturbance. Roll the sweeper back and forth in several directions over the part that needs cleaning. Pick up by hand bits of litter, threads or lumps the sweeper fails to get. When putting the carpet sweeper away, empty the pan and clean the brushes so it will be ready for immediate use.

Stains left on a carpet overnight become more difficult to remove. As soon as possible after discovering a spot take measures to extract it. These comprise a third aspect of carpet care. If the spill is still wet, blot it carefully with absorbent paper or cloth. Work from the edges inward to avoid spreading it. Soak up all you can. In case the material has become sticky or pasty, use a putty knife to scrape up as much of it as you safely can. If it has dried into a crust, brush as much loose as will respond to a hand scrub brush. Gather the particles into a dustpan. The next step depends on whether the remaining spot is soluble in water or is greasy. For a water soluble stain use the nonionic neutral detergent recommended above. Mix a small amount to proper proportions in one pail. Have clear rinse water ready in another. Wet a clean cloth in the detergent solution and squeeze out the excess. With strokes that describe a circle around the spot, begin just outside the stained area and work toward the center dampening the discolored portion. Take a clean absorbent cloth to blot up the detergent and stain with the same pattern of strokes. Repeat the dampening and blotting until the spot has disappeared. Then rinse and dry the area with fresh cloths still using the circling, inward moving strokes. Finally arrange the pile strands so they conform with the rest of the carpet. To remove an oily or greasy stain wet a cloth pad with Stoddard solvent and apply it to the spot with the same motions as just described. Follow the solvent with the detergent solution and rinse water always working around and inward. Stoddard solvent is flammable. So keep smokers away. Dispose of the used cloths promptly outside the historic building. Store the container of solvent safely.

Museum carpets may suffer from dripping candles, discarded chewing gum or dropped cigarette ashes. To remove drops of candle wax scrape off what you can with a putty knife. Lay a clean blotter on the spot and place a warm flatiron on the blotter. Most of the remaining wax will melt and the blotter will absorb it. Treat what is left as a grease spot. To get gum out of a carpet freeze it with a little dry ice (solid carbon dioxide as used by ice cream salesmen). Use a putty knife to scrape loose the brittle mass. A greasy spot may remain to be removed with Stoddard solvent, detergent and rinsing. To render a small burned spot less conspicuous gently rub away the charred ends of the fibers with sandpaper.

A few carpet stains may resist these methods. If such spots become a problem, get a stain removal kit such as professional rug cleaners use. It will contain the necessary chemicals and instructions. When the problem consists of too many ordinary stains to remove by individual treatment a special non-electric carpet sweeper that also shampoos with "dry" foam

may take out most of them. Use this tool only on modern carpeting. Follow the directions on the sweeper and on the container of shampooing solution in careful detail.

Machine shampooing, the final cleaning technique suggested for the museum's modern carpets and rugs, attacks the dirt that clings to fibers. Carpets vacuumed faithfully and spot cleaned promptly should need shampooing no oftener than once a year. Consider hiring a commercial rug cleaner to do it or renting a machine for the occasion rather than buying and storing seldom used equipment. One type of shampooing machine discharges a cleaning solution onto the carpet. Rotating floor brushes beat this into a foam and scrub the carpet with it. A skillful operator can control the release of the liquid so the carpet does not get too wet. A second type has an additional beater inside that generates the foam before releasing it. Such a "dry" foam machine avoids the danger of wetting the carpet excessively. Either kind of machine calls for the supplemental use of a wet-dry model vacuum cleaner to pick up the spent suds. Some household floor polishing machines have shampooing attachments, usually for the "wet" foam process. The shampooing procedure starts with a thorough vacuuming of the carpet. Mix the cleaning solution exactly as directed on the container. Fill the machine reservoir and pour some additional solution into a pail. Use the latter with a hand brush to clean any parts of the carpet the machine cannot reach. Dry these areas with a clean absorbent cloth. Start the machine at one corner of the carpet. Keep the rotating brushes flat on the surface to be cleaned. Moving the machine in small circles work straight across the carpet. Return in a parallel slightly overlapping path. Stop after cleaning a few strips and use the wet-dry vacuum cleaner to pick up the dirt-filled foam. It should not remain on the carpet longer than four minutes. Push the vacuum brush forward in straight, parallel strokes so the nap will lie uniformly. Continue to shampoo and pick up alternately until the whole carpet is clean. Afterwards rinse out the reservoir, pail and vacuum tank. Clean all the brushes used. Wipe off the machines and cords.

The carpets and rugs in the historically furnished rooms require gentler, more specialized care. Unlike modern ones they cannot be replaced at will. As the first procedure, learned long ago from costly experience, protect them from direct sunlight. Close the blinds or draw the shade at each window during the hours the sun would shine through it onto an historic or reproduced carpet. Do this even though the windows have ultraviolet filters (see Protecting the Building and Furnishings, Chapter 12). Both measures are important.

Removal of loose dirt comprises the next housekeeping concern essential to the preservation of the exhibited carpets and rugs. The vacuum cleaner provides the safest means, but use it with extra care. Slow chemical changes coupled with wear have weakened the threads of old carpets. Strong suction could break fibers or tear loose those already broken. Fol-

low in general the vacuuming procedures described for modern carpets, but first adjust the control to reduce the pull (see Equipment, Chapter 11). Use the least amount of suction that will lift the dirt particles. If the carpet has a pile, move the vacuum only in the direction the pile lies, not against nor across it. Where the fabric has already frayed, lay a sheet of plastic window screening over it to hold damaged threads in place. Vacuum through the mesh. Bind the cut edges of the screen with tape to protect the carpet. Do not wait to vacuum old carpets until dust has settled thickly among the strands, but avoid vacuuming them oftener than they require it.

Clinging dirt inevitably collects on these carpets, but machine shampooing is too harsh for them. Have a textile conservator wash or dry-clean exhibited carpets. If you cannot call on the direct services of a trained conservator, carefully select a professional rug cleaner to do the job. Choose one, if possible, who has successfully cleaned historic rugs for other museums. Even so a textile conservator should specify the techniques and cleansers to use.

If something spills on one of these carpets, blot up the excess at once. Use the inward circling application of an absorbent pad to prevent further spreading. Dampen a clean cloth in water and with similar motions get out as much more as you can. Then notify the curator immediately. Old fibers and dyes may not react to stain removal techniques like modern carpets do. So consult a textile conservator or professional rug cleaner if time permits. Otherwise test the fastness of the colors before proceeding. Wet a cotton swab in the nonionic neutral detergent solution. Dampen a very small area of each color involved. Press a clean white blotter against the dampened spot. The blotter will pick up dye if it runs. Repeat the test with Stoddard solvent for a greasy stain. Unless some of the colors do run, you can use with relative safety the stain removal procedures previously described.

Another class of floor coverings includes rubber or plastic runners and entrance mats. They collect dirt by intention to keep it from the floor or carpets they protect. The frequent cleaning they therefore require involves two stages. Vacuum the runners and mats in place as often as they need it. Use the vacuum attachment that works best on their variously molded or fibrous surfaces. When they call for more thorough cleaning, vacuum them first. Then take them outside. Use a brush and hot detergent solution to scrub them. Rinse them amply with a garden hose. Be sure both top and bottom surfaces are clean and dry before putting them back in place. Also vacuum thoroughly the areas of floor or carpet they will cover. This is a good time to look for signs of accelerated wear.

Rooms correctly refurnished to show conditions of the 1800's and later 1700's may have other kinds of floor covering no longer commonly used. Modern cleaning technology has not taken these into account. Straw matting often replaced carpets in summer or covered floors the year round.

Matting gets as dirty as exhibited carpets do. It tends to turn yellow. Wetting harms it. Old time housekeepers swept matting with care and damp wiped it, usually with salt water, which you should not use as it might corrode metal objects nearby. The salt seemed to retard yellowing. For routine cleaning now use the vacuum cleaner. Select an attachment that will not abrade the reeds. Move the wand back and forth in the direction the reeds run, not across them. Observe the effect and control the amount of suction accordingly. When the matting looks soiled or dingy, vacuum it and then damp wipe it. Dip a clean cloth in clear warm water and squeeze out the excess. Rub the cloth over the matting lengthwise of the reeds. Change cloths and water as often as necessary. Dry the matting by wiping it with a fresh cloth. If clear water does not take out the dirt, use a solution of the nonionic neutral detergent applied in the same manner. Rinse with a cloth dampened in clear water and wipe dry. Finally wash out the cloths, rinse and wipe the pails, empty the vacuum dust bag and clean the attachment.

Another obsolete floor covering formerly common is oilcloth. A forerunner of linoleum, it adorned many hallways, some kitchens and occasionally other rooms. It consisted of burlap stretched and covered with many layers of oil paint applied to both sides. The upper surface often carried stencilled or block printed designs. The housekeeper swept floor cloths regularly. They required occasional washing, usually with clear water because the very alkaline soap available affected the paint. To brighten an oilcloth and give a slight gloss it was sponged with milk and rubbed dry. Most oilcloths in exhibited rooms are reproductions. Clean them by dust mopping, vacuuming and occasional damp mopping. Those subject to wear should receive a fresh coat of varnish when needed to protect the design. Clean them thoroughly first. Waxing them would give a false appearance. A little beeswax applied to the old ones made them dangerously slippery, so its use was avoided.

Walls and Ceilings

Some of the airborne dust and soot in any room comes to rest on walls and ceilings. A film of dirt accumulates almost unnoticed except where air currents above radiators or around duct openings concentrate the deposit. Walls also become dirty where people touch them or where objects being moved rub against them. Modern practice includes four wall cleaning measures. These comprise spot cleaning, dusting, washing and the cleaning of high wall or ceiling grilles. Most modern wall finishes permit the amount of washing involved. Historic wall coverings often require modified or different care. Old finishes may occur in public access and staff areas as well as in the exhibited rooms. Some of the restored walls in the latter may

be quite washable. Check with the restoration architect to determine the cleaning characteristics of all walls in the historic building.

Spot cleaning forms a regular part of daily room care. It removes from washable surfaces the smudges and marks left by hands and accidental bumps. Use a clean cloth or sponge dampened with water and a clean, dry wiping cloth. Rub the spot gently with the damp cloth or sponge to wipe away the dirt. Then dry the area with the second cloth. If water alone does not remove the spot, dampen another cloth with the nonionic neutral detergent solution and rub it again. Wipe off any detergent residue with the first cloth or sponge and follow with the dry cloth. If the spot now looks cleaner than the surrounding wall, use the first damp cloth or sponge to blend in the edges.

Many building managers have the walls and ceilings dusted with a clean, untreated dust mop. Others employ a vacuum cleaner for this purpose. Except when dealing with molded plaster ornamentation, for example, use the vacuum to dust walls in historic buildings because it collects the dirt more efficiently. Attach the wide brush designed for wall dusting. Start in a corner at the baseboard and move the brush upward. Touch the wall lightly and evenly with the brush hairs. Overlap successive strokes. Continue around the room. Keep the brush clean to avoid streaks. Lift cobwebs outward and upward so they do not smear. Change tools, if necessary, to clear heavier deposits from ledges, moldings and other horizontal surfaces beyond reach of daily dusting. Vacuum the ceiling with the same wide brush and with equal care. Dusting overhead is muscle straining work that calls for periods of rest or alternation with other tasks. When finished, clean the vacuum brushes used, empty and clean the dust bag. Wipe off the machine and cord.

Wall washing requires preparation. Move furniture to the center of the room. Take down whatever is hanging on the walls, window draperies and curtains as well as pictures and mirrors. Spread drop cloths. Have ladders ready. Mix a solution of the nonionic neutral detergent in one pail and provide clear water in another. Dust the walls with the vacuum cleaner. Then begin washing. Dip a clean sponge in the detergent and squeeze out the excess. Starting at the baseboard in one corner of the room wet a section of the wall about two feet wide and five feet high (.6 × 1.5 m) or a comparable area without rubbing. Then rub the wetted section with the sponge using straight strokes up and down or sidewise and enough pressure to take off the dirt. Rinse immediately with a fresh sponge squeezed out of the clear water. Dry the cleaned section with a wiping cloth. Continue around the lower half of the wall wetting, rubbing, rinsing and drying about 10 square feet (c. 1 m²) at a time. Overlap the preceding section a little with each new one. Wash the woodwork in the same manner as you come to it. Return to the starting point, set the step ladder in position and wash successive sections of the upper wall with the same technique. If any

detergent or water drips or runs onto a portion already cleaned, wipe it off at once with a clean damp cloth or sponge. Wash the ceiling following the same steps. Throughout the process keep the sponges well rinsed. Change the solution and rinse water and take a fresh drying cloth as often as necessary to clean the surfaces well. At the end fold the drop cloths neatly, put the furnishings carefully back in place, clean the vacuuming equipment, rinse and wipe the pails, wash the sponges and cloths and return all to proper storage.

If dark splotches of soot and dust settle above radiators or around the grilles covering air vents before the walls need a complete washing, clean them off as follows. Wet a sponge in water containing a little household ammonia (not the sudsing variety). Squeeze it well to prevent any dripping. Damp wipe the smudged area clean. Then dry it with a clean wiping cloth. Damp wipe accumulated dirt from all the grille surfaces within reach and dry them also.

Historic housekeepers must often maintain old wall finishes by painstaking methods. The exhibited walls in their care may have relatively fragile coverings of documentary importance or accurate reproductions as unwashable as the originals. Rather than subject especially valuable ones to spot cleaning, use protective measures to prevent visitors from touching them (see Protecting the Building and Furnishings, Chapter 12). Staff members who work beyond the barriers should exercise caution to avoid damaging these walls. When finger smudges and marks appear on old plaster or woodwork, clean them off carefully by damp wiping with a sponge dipped in very dilute ammonia water. Wipe the cleaned area dry with a cloth. This method should ordinarily work for walls and touchable ceilings that are unfinished, painted, varnished or wax polished. If the dirt persists on unfinished woodwork, scour the smudged area with a thin paste of whiting and water using a stiff brush. Then wipe off any residue of the abrasive with a damp cloth. Should a waxed surface require more thorough spot cleaning, use a cloth dampened with turpentine or the substitute paint thinner to remove the soiled wax and apply a thin coat of fresh paste wax to the cleaned spot. Dispose of the soiled cloths promptly. If modern proprietary finishes regardless of historical appearance have been used to polish exhibited walls, follow the manufacturer's cleaning instructions. Mural paintings on walls or ceilings of course require the attention of a paintings conservator for any sort of cleaning. When smudging or marking occurs on old wallpaper, roll powdered eraser gently over the surface as the cleaning agent (e.g., Opaline or Skum-X). Brush off and vacuum up the used powder. Damp wipe spots from washable reproduction wallpaper. Before attempting to clean smudges from wall coverings of silk, leather or other exceptional materials consult a conservator.

To dust most old walls and ceilings use the vacuum cleaner as described. Be extra careful to manipulate the brush gently. Reduce the suction where

it seems advisable. Vacuum fine fabric covered walls through plastic screening. Molded plaster, as in cornices and ceiling medallions, may require careful dusting by hand. Do not use the vacuum on mural paintings nor on any painted surface that shows the slightest flaking. At the first sign of paint loosening, inform the curator. In the case of a mural or of original paint the curator will call in a conservator. Otherwise he may refer the paint problem to the restoration architect.

When old walls finished with paint, varnish or wax require washing, do it cautiously with a mild solution of the nonionic neutral detergent. Follow the procedures for wetting, rubbing, rinsing and drying detailed above. Should woodwork without a finish require more intensive cleaning, scour it. Use soap and dry after scouring. If this involves a whole wall, do a section at a time following the pattern of ordinary wall washing. Do not attempt to wash some wall coverings. These include wall fabrics, old wallpaper and reproduced paper that is not guaranteed washable. Depend on regular dusting to keep them presentable for as long as possible. When further cleaning eventually becomes necessary, a conservator should supervise it. Whitewashed walls and ceilings, formerly common in many rooms besides the cellar, received fresh coats at least once a year, so they did not require washing. Most restoration architects imitate the effect of originally whitewashed surfaces with a more durable paint that can be washed with care.

The sooty accumulations above radiators or around air grilles sometimes occur on unwashable historic wall finishes or coverings. These situations require strict attention to the cleaning and replacement of air filters and any other measures that will reduce the rate of deposit. More frequent dusting may also help. Protective coverings may become necessary. A conservator should specify methods for cleaning the soiled areas considering both the nature and condition of the historic surface and the kinds of dirt deposited.

Windows

Modern window cleaning involves two stages, dusting and washing. Both differ little from past practices. Housekeepers wipe or vacuum the inside woodwork of windows and wipe the inside of the glass as part of daily dusting. They use an untreated dust cloth on the glass, dampening it if necessary to remove fingerprints. Window washing entails considerable risk of falling. As a safety measure building managers often have experts do this work under contract. Whoever washes the windows checks the condition of the ladders and the windows before trusting in their strength. The job requires suitable ladders, dusting equipment, a sponge, a squeegee or chamois, a pail of water containing a little nonsudsing household ammonia and pads to protect the floor and sill. It proceeds as follows. Take down curtains and drapes liable to be soiled during the operation. Exercise great

care to avoid damaging fragile textiles in the process (it may even be wiser to wash such curtained windows only twice a year). Clear any objects from the sill or adjacent floor. Dust thoroughly the window frame, sill, mullions and panes, inside and out. Get into a safe position to wash the outside of the glass. Dip the sponge in the cleaning solution and squeeze out the excess. Rub the wet sponge over the glass in straight, horizontal, overlapping strokes working from the top of the pane downward. Remove all the dirty water from the glass with a squeegee or chamois. Use the sponge to pick up excess water at the lower edge of the pane and to keep the squeegee blade clean. In using the squeegee wet the edge of the blade. Then draw it in straight, overlapping strokes either from top to bottom of the pane or from side to side with a continuous turning movement at each end of the horizontal strokes. If small panes make a squeegee awkward to manipulate, rub the wet glass with a chamois to pick up the dirt laden water. Repeat the washing process on the inside of the glass. Then inspect the window carefully, using the sponge and chamois to remove any streaks or spots that remain. For good results change the water frequently. After washing the windows rehang curtains and drapes, replace objects moved out of the way, rinse and wipe out the pail, wash sponges and chamois, clean the squeegee and return equipment to storage.

Earlier housekeepers often polished windowpanes after washing them. To do this they rubbed the glass with a clean, soft linen cloth or with chamois or crumpled newspaper. They avoided washing windows in direct sunlight because rapid drying tended to leave streaks.

To clean plastic ultraviolet filters mounted over windows see Case Exhibits, Chapter 15. Follow the manufacturer's instructions for cleaning filter films applied directly to the glass.

Window Shades and Venetian Blinds

These furnishings naturally collect dirt that seeps in around closed windows or blows through open ones. Shades and blinds therefore need cleaning regularly. Their continual exposure to strong light weakens the cloth of shades and the tapes of Venetian blinds. This limits the choice of cleaning methods. The sizing used in many window shades also makes it inadvisable to wash them. For shades two processes should combine to keep them reasonably clean. Dust them frequently to remove loose dirt. Damp wipe them before more persistent soiling becomes apparent to visitors. Do the dusting with a vacuum cleaner in most instances. Use an attachment with soft bristles. Employ straight, overlapping strokes. Reduce the suction if the fabric is old or weak. Vacuum both sides. If the shade is mounted on a spring roller, pull it down full length to dust the inside. Then raise it slowly while moving the brush back and forth along the roller to vacuum the outside. To damp wipe shades use a sponge or wiping cloth dipped in clear

water and squeezed nearly dry. Preferably take the shades down and lay them flat on a smooth surface one at a time. Wipe the upper side gently with straight, overlapping strokes to lift off adhered dirt. Rinse the sponge or cloth often and change the water before it becomes cloudy. Dry the cleaned surface with a fresh absorbent cloth. Then turn the shade over and repeat the process on the other side. Be sure both sides are quite dry before rewinding. If this fails to clean a shade satisfactorily, have a textile conservator test the sizing and any colors in order to recommend a safe cleaning solution. In dusting and damp wiping shades do not overlook the pull cord and ring. Grease from fingers on the latter may require the use of a little dry cleaning solvent in wiping it.

Modern Venetian blinds with metal slats present a familiar cleaning problem. Large establishments dust them by either of two methods and choose among three washing procedures. To dust a Venetian blind in accordance with these practices lower it full length and turn the slats to the closed position. Sweep the entire surface with a treated dust mop or with a vacuum cleaner. Begin at the top and work back and forth along the slats. Do not neglect the housing. After finishing one side tilt the slats in the opposite direction and repeat the process to dust the other side. Then adjust the slats open and brush the dust out of the tapes. Use a hand scrub brush dry or the vacuum. Furnished structure museums having modern style blinds in staff, storage or utility areas should probably dust them with a vacuum cleaner because it removes the dirt with less scattering. A long bristled dusting attachment works best for the slats and the upholstery tool for the tapes. Clean the dust mop or vacuum before putting it away.

Venetian blinds may be washed in place, taken down and washed by hand or machine washed. The first method applies particularly to blinds awkward to get down and reinstall. Hand washing fits most other situations. Only the necessity to clean many blinds warrants an investment in special machines. To wash a Venetian blind in place dust it thoroughly as described. Prepare one pail with the nonionic neutral detergent solution and another with clear water. Provide three clean wiping cloths and a step ladder of the proper height. Set the slats flat open. Dip the first cloth in the detergent solution and squeeze out the excess. Use it to wipe the top slat clean from end to end on both sides. Wet the second cloth in the clear water, squeeze it and rinse the cleaned slat. Wipe it dry with the third cloth. Continue this three-step process one slat at a time until the blind is finished. Keep the wet cloths well rinsed. Change the solution, rinse water and cloths as necessary to assure effective cleaning. Wipe any spills or spatters from the window and surrounding woodwork before cleaning and putting away the equipment.

To wash blinds by the second method take them to a suitable work space. If neglected until quite dirty, immerse them a few at a time in a solution of the nonionic neutral detergent. A bathtub can serve as a tank

for this purpose. Let them soak only long enough to loosen the dirt. Then hang each blind in turn fully open from a support of the proper height. Tilt the slats closed. Wash the exposed side with a scrub brush dipped in the detergent solution. Rinse with a hose. Reverse the slats and repeat the scrubbing and rinsing. Transfer the washed blinds to a drying area and let them hang open with the cords slack overnight or until completely dry. Mop the floor of the washing area and clean the equipment used. This mode of washing suits museum blinds that have no part in the historic scene.

Period Venetian blinds and exhibited reproductions of them usually have wooden slats and often have fancy tapes. Old tapes have surely weakened with time. Replacements are likely to be more delicate and costly than conventional ones. Dust these blinds carefully, but regularly to prevent rapid accumulation of dirt. Follow the procedure given for modern blinds, but take extra precautions with fragile tapes. Use reduced suction when it seems safer. Interpose plastic screening as further protection if needed. Dust especially weak or valuable tapes by hand with a lens brush.

Do not wash wood-slatted Venetian blinds on exhibition. Instead damp wipe them in place. If the paint on the slats is intact, adapt the three-step method described for washing modern blinds in place. Use a minimum of detergent in the solution and wring out both the washing and the rinsing cloths more completely. Wipe the slats gently. For slats with exposed wood avoid wetting. Use a powdered eraser pad with a trough below to catch the crumbs. Wiping the wood with potassium oleate in Stoddard solvent might also work. A textile conservator should examine old tapes before recommending safe ways to clean them. If reproduced tapes become soiled and have fast colors, dampen them with a cloth or sponge dipped in the detergent solution. Rinse in the same manner with clear water and absorb this with a fresh cloth. Should the dirt not respond, start again. Dampen the tape first with Stoddard solvent observing fire precautions. Then apply the detergent solution as before, rinse and dry.

Fireplaces

Keeping a fireplace clean involves more than the neat handling of fuel and the control or removal of ashes. It includes regular care of the hearth, mantel and fire irons. These need more frequent attention in a working fireplace than in one displayed without an actual fire. They should not be neglected even in a fireplace emptied for the summer. Modern cleaning methods do not fit all aspects of this task, particularly in regard to hearths. Different kinds of hearths require different cleaning procedures. The old practices may still be the best for maintaining the historic appearance of brick ones.

A brick hearth, according to housekeeping instructions in the 1830's–1860's, should have the bricks coated. Those near the fire should have received a wash of redding, a mixture of powdered red ochre in water or milk, applied with a paint brush. A conscientious housekeeper would have used the redding every day the fire burned, or at least often enough to maintain a freshly treated appearance. The bricks out in front of the fire were more likely painted with powdered graphite mixed in water, or preferably in a hot solution of soft soap which gave them a black gloss. This finish lasted somewhat longer. Redding and blacking made a fireplace look clean and well kept, although the extent to which housekeepers followed this practice is uncertain. The coatings were probably not applied often to the bricks of a kitchen fireplace. Here bricks not so treated should surely show evidence of being frequently washed.

Freestone hearths scrubbed daily with soap and water and occasionally scoured with sand remained quite clean, but tended to darken. Housekeepers restored the original color periodically by washing the hearth well, then rubbing it with a paste of powdered stone in water. They obtained the powder from a stone cutter, preferably one working the same kind of rock. When the paste dried, they swept up the excess. The hearth then looked almost new. The stones of a cooking fireplace cleaned more easily if rubbed from time to time with the whale oil used in lamps. Present day methods should keep a stone hearth comparably clean. If it is exhibited without an actual fire, dust it daily with a treated dust mop or vacuum cleaner. Damp mop the stones before they become dingy. In a working fireplace dust with equal care. Wet mop or scrub the stones with the usual detergent solution as often as necessary to remove marks caused by the fire or the activities around it. Rinse off the detergent residue and wipe dry. To extract grease spots from the stone apply Stoddard solvent in a poultice of fuller's earth or whiting. The evaporating solvent should draw the worst of the stain into the poultice powder to be brushed into a dustpan. Do not use a flammable solvent, of course, while any fire remains. Alternatives include using ammonia water in the poultice or on non-porous stone spraying dry cleaning powder on the spot from an aerosol can. The latter acts like a poultice but usually with perchlorethylene as the solvent. Follow the manufacturer's directions. Brush up or vacuum the powder remaining.

Early housekeepers apparently found marble hearths hard to keep clean. Various methods were advocated, some of which seem quite harsh. They included the application not only of strong soapsuds, but of abrasives and acids. Under museum conditions convenient modern procedures should do the job. Clean the marble in four stages as needed. Remove surface dust daily with a vacuum cleaner or an untreated dust cloth. At intervals determined by the rate of soiling damp wipe the marble with a sponge dipped in clear water that, as recommended by the Smithsonian Institution, has stood for 24 hours in a covered plastic bucket in contact with white marble chips

and dry it with a soft cloth. If wiping fails to take off all signs of dirt, wash the hearth with the nonionic neutral detergent solution using a hand scrub brush lightly. Rinse with clear water and a sponge or absorbent cloth. Wipe dry with a clean cloth. Examine the hearth each day for spots or stains. Apply spot removal techniques promptly. For water soluble stains brush with a lather of the detergent solution, rinse and wipe dry. A poultice of hydrogen peroxide and whiting may take out a more persistent spot. Treat oily ones with a poultice of ammonia water or Stoddard solvent and fuller's earth or whiting. If fuller's earth or whiting is not at hand, substitute pads of cotton batting. An aerosol spot remover may also work, as should commercial marble cleaners such as Goddard's or Vermarco.

Tile hearths should stay clean by daily dusting and occasional damp wiping. If they require more, wash them with the detergent solution and a sponge. Then rinse and dry.

Mantels present a variety of materials that require cleaning. Wood, marble, other stone, tile and brick occur most frequently in jambs. Mantelpieces are often wood or marble. The wood may be unfinished, painted or polished; the marble white or colored, plain or carved. Fine mantels attract attention, so proud housekeepers kept them well polished. Modern cleaning should reflect corresponding care. Dust all mantels daily. Use a vacuum cleaner or treated dust cloth on wood, tile, freestone and brick. Choose the vacuum or a soft, untreated cloth for marble. Take pains to get the dust out of carvings and moldings. If smoke from the fire leaves a deposit of soot, wipe it off a fine mantel promptly. Use ammonia water and a sponge, followed by a dry cloth. Note that ammonia darkens many fresh woods. Use it only if, after testing on an unobtrusive area, the wood does not darken and remain dark after the surface has dried. Wash the finished woodwork of mantels along with the adjacent walls. Use the same weak solution of detergent. Wet a portion at a time, rub it, rinse it with clear water and wipe it dry. An unfinished wood mantel shelf may need scouring, but not often. Damp wipe marble mantels more frequently than washing them. After sponging with clear water rub the marble dry with a soft cloth. Do not let excess water drip or run down the stone. When washing becomes necessary, apply the nonionic neutral detergent as a lather with a soft brush. Wash one relatively small area in this manner, rinse and dry it before proceeding to the next. Avoid drips. In addition to regular washing remove stains whenever discovered. Use techniques suggested above for marble hearths. If continual dusting, wiping and washing eventually dull the polished surface of the marble, have a conservator recommend treatment. It will probably involve careful rubbing with a mild abrasive. Damp wipe mantel tiles as they need it. Wipe them dry promptly. As with hearth tiles, wash them occasionally. When brick or freestone jambs become soiled, wash them with the detergent solution and hand scrub brush. Rinse and dry them. Some brick jambs can appropriately take the old treatment

of painting with red ochre mixed with milk or water.

Andirons, grates, fire backs, fenders and fire tools also demand continual attention. Iron rusts, brass tarnishes, soot and ashes soil the metalwork. Rust prevention comes first. Use stove blacking to keep cast iron andirons, grates or fire backs polished. Andirons and tools forged of wrought iron resist rust quite well. In the absence of a hearth fire and in especially humid situations give them added protection by applying a thin coat of micro-crystalline wax or hard paste wax. Check the tools frequently. If any rust appears, remove it with fine steel wool and wax the surface. Bright steel fenders and fine tools rust much more readily. Give them a high polish using 600 emery paper. Avoid making fingerprints. Work while the steel is warmed by an electric heater and in the absence of fumes from burning coal or kerosene. Then protect the polished surface with a thin layer of microcrystalline wax carefully rubbed on to cover the steel completely and melt it into a uniform thin film by means of an electric heat lamp. Brass fenders, andirons and tool handles also require polishing. Use a polish containing a mild abrasive and ammonia, for example, Noxon. For a flat surface brush on a little of this mixture, rub it over the brass with a flat stick of sugar pine wood and wipe the polished area clean. Continue until the whole piece is uniformly bright. To polish a round surface replace the stick with strands of soft cotton wrapping twine. Cut about eight strands of convenient length and tie them together at one end into a bundle. Loop this once around the brass piece. Having applied the polishing mixture to the brass, work the strands back and forth by pulling alternately from each end, or fasten the strands by the knotted end and work the piece back and forth along them. Then wipe clean. Each polishing, of course, cuts away some of the metal. This justifies a protective coating to delay tarnish formation. Some commercial brass polishes contain a corrosion inhibitor. Spray the brass thinly but evenly with a synthetic lacquer or rub on micro-crystalline or paste wax. The latter will dull the shine a little. Polishing fire irons and protecting them from corrosion meant daily hard work. Since the metal tended to corrode in the summer dampness of unused fireplaces, housekeepers commonly rubbed the metal fireplace fittings with something oily, wrapped them carefully and stored them in a dry attic each summer. In fireplaces being used follow also the old daily practice of cleaning soot and ashes off the shovel, tongs, grate or other metalwork.

Stoves

Cast iron cooking or heating stoves require cleaning and protection from rust. Housekeepers in the 1800's accomplished both purposes by blacking and polishing their stoves with powdered graphite. Instructions called for doing this every day. Before convenient stove polishes became available, the daily chore included mixing the graphite with a suitable liquid such as

egg white, spreading it over the stove and rubbing it with a stiff brush until it shone. Stove polish now comes ready to use and makes the job much easier. Apply it to all cast iron stoves. In many situations do it often enough to maintain a freshly polished look. Follow the directions on the container. As another aspect of cleanliness cook stoves used in demonstrations should have the tops washed after the preparation of each meal in keeping with 19th-century recommendations. Polished steel or brass embellishments on stoves need to be treated as described in the preceding paragraph.

Furniture

Economy and convenience determine the cleaning methods appropriate for modern furniture in staff offices and workrooms, storerooms and areas of public access. Dust wood, metal and composition surfaces with a treated dust cloth. Do it on schedule frequently. Much less often clean and polish the wood. For this purpose dust it. Then apply one of the current silicone cleaner-polisher products. Spray or wipe it on the wood, then wipe it off following the directions on the container. When metal or plastic surfaces become dirty, wash them with the nonionic neutral detergent solution. Dust them first. Dip a sponge in the solution. Squeeze out the excess and wipe over the surface to be cleaned. Rub enough to loosen dirt. After rinsing the sponge squeeze it and use it to pick up the dirt-filled liquid. With a fresh sponge and clear water rinse the washed surface. Dry it with the rinsing sponge or a clean cloth. If metal furniture has been waxed to deter rust, clean it by stripping the old wax. Use a cloth dampened with a petroleum distillate paint thinner, a chemically stable substitute for turpentine, to soften it. Then wipe off any remainder with a dry cloth. After cleaning apply a fresh coat of paste wax. Keep linoleum work surfaces clean by dusting, damp wiping and occasional rewaxing. Clean the upholstery by employing four procedures. While doing other dusting, clean out crevices with a whisk broom. Vacuum the upholstery on a regular schedule using the attachment designed for the purpose. Remove stains as they occur. If one of the aerosol spot removers (not to be applied to leather without special reason and precautions because it may remove necessary greasy substances) does not work, try the spotting techniques for carpets described above. When the upholstery becomes soiled, have a commercial cleaner shampoo it.

The furniture on exhibition requires cleaning by methods that will prolong its life and, if possible, preserve the appearance it had when the historic occupants used it. Cleaning operates primarily on the surfaces of furniture. It therefore serves both these objectives when it protects the historic finish without altering its color, texture or luster. The choice of methods depends on the kind of finish and its visual characteristics. Before

a housekeeper can safely undertake the care of historic furniture, the curator should identify and record the original and any overlying finishes. They are not only among the most valuable aspects of the objects, but provide the reference points for future care. A conservator can often help make the identifications. He should also remove any accumulated layers of dirt or products of deterioration and restore the surface to an historically accurate and exhibitable condition. If no qualified conservator is available, the curator may have a reliable furniture restorer under supervision apply nondestructive interim measures to make the piece presentable. Whatever the restorer does should not jeopardize later analysis or conservation. He should document his work completely. The housekeeper's responsibility begins when the furniture is ready for exhibition.

Cabinetmakers and chairmakers applied several kinds of finishes to furniture wood. Cleaning requirements for the wood surfaces differ accordingly. That is why the housekeeper needs to know what each finish is. All the finishes need dusting and measures to remove clinging dirt. Most call for polishing as well. With the exceptions noted below dust all types with a treated dust cloth. Change to a clean face or a fresh cloth frequently. Get the cloth into all the crevices of carved, molded or fretted ornaments. Immediately after dusting rub most polished finishes with a clean, soft, untreated cloth to brighten the polish. Do not use modern furniture polishes nor older abrasive ones. Neither serves the objectives of historic housekeeping. In damp wiping and washing use a minimum of water to wet sponges or cloths. As another general rule do not let furniture remain in direct sunlight. It can fade wood finishes severely. Close blinds or draw shades to prevent it. Treat the various finishes more specifically as follows:

Raw wood

Some work furniture and pieces made under frontier conditions have no coating over the generally smoothed surface of the wood. The furniture at the outset has the natural color of the wood. This changes gradually as whatever comes in contact with the porous surface tends to leave a residue. Dust this kind of furniture daily with an untreated cloth to avoid staining the wood with oil. Subsequent rubbing is unnecessary. Remove spots or stains that disfigure the article as they occur. Scrub the stained area with a little of the nonionic neutral detergent solution, rinse and dry. Under normal conditions damp wipe and dry the wood once in two years. Aim in doing this to keep the wood as nearly as possible in the condition of initial display by minimizing progressive discoloration from accumulating grime. Kitchen table tops and perhaps a few other special surfaces require a higher level of cleanliness. Scour them as needed. Early housekeepers used sand or wood ashes, water and a scrub brush. Substitute a modern scouring powder or soap.

Oil-finished wood

Linseed oil applied directly to the wood in several coats with much hard rubbing produced the finish on many pieces of furniture. The oil hardens, darkens and eventually shrinks a little. Dust this finish each day with a treated cloth. Rubbing after dusting should bring up some of the initial gloss. Once in two years as a rule wash the wood with a sponge dampened in the nonionic neutral detergent solution. Rinse with a second sponge and clear water. Wipe dry with a cloth. Then rub to polish. Use the detergent solution promptly to wash off stains. If this does not work, rub the stained area with a little turpentine substitute and a mild abrasive. Oldtime housekeepers used rottenstone. After about five years of regular cleaning the curator might have a fresh, thin coat of boiled linseed oil applied to the wood and rubbed to a fine gloss, making sure that "more is rubbed off than was put on." A light cleaning with the turpentine substitute would probably be safer.

Painted wood

Both common and high style furniture may have a painted finish. Sometimes a coat of clear varnish covers the paint. Whether exposed or varnished, dust the painted furniture with a treated cloth daily. Use a damp sponge or cloth to wipe off soiled spots or stains as soon as discovered. If water fails to remove the stain, try carefully a cloth moistened with Stoddard solvent. Usually a biennial damp wiping with a sponge or cloth and clear water should remove the dirt that resists the dust cloth. Wipe dry afterwards. If this does not suffice, wash the paint with a mild solution of the detergent, rinse and dry. Use a minimum of liquid in the process. Paint and varnish chip easily. Be especially careful not to hit furniture having these finishes during cleaning operations. Vacuum cleaners, dust mops, belt buckles and buttons too frequently damage wood finishes of all kinds through carelessness.

Varnished wood

A fine varnish finish consists of many layers of an oil varnish, each carefully flowed onto the wood and rubbed very smooth. Often the varnish has a surface coating of wax. If so, clean it as wax-finished wood. Otherwise dust it each day with a treated cloth. Then dry rub with a soft cloth to maintain the polish. Remove stains by prompt damp wiping, washing with detergent solution or rubbing with a cloth dampened in Stoddard solvent. If white spots occur, rub them with a little linseed oil. Should more drastic treatment be necessary for spot or stain removal, consult a conservator. For the biennial cleaning damp wipe and dry the wood, or if necessary, wash with detergent solution, rinse and dry. Then polish by dry rubbing with a soft cloth.

Waxed wood

Beeswax dissolved in turpentine provided a popular finish applied directly to wood or over varnish. It was often kept highly polished. Dust it daily with a treated cloth. Give it additional rubbing with a hard cloth if necessary to polish the wax. If damp wiping does not clean soiled or stained spots, wipe them with a very little paste wax on a cloth. Then rub to polish. At two-year intervals clean the surface with a cloth dampened in turpentine substitute. Wipe well. Then apply a fresh coat of hard paste wax. Use only a little wax. Spread it thinly. Rub it to a fine polish. Use a small brush to clean old wax out of carvings and crevices and to polish the fresh wax in these awkward spots.

French-polished wood

This finish used on some fine furniture consists of many thin layers of specially applied shellac. Dust it carefully with a treated cloth. Polish it lightly afterwards with a clean, soft cloth. Use the same spot cleaning methods as for varnish. Damp wipe to remove clinging dirt. Damaged French polish requires an expert to repair.

Gilded wood

Gold leaf forms the gilding on some furniture. This delicate finish may decorate only a small part or cover the whole surface as in fine mirror and picture frames. When a coating of varnish thoroughly covers the gold leaf, the appearance of the gold suffers, but its care involves less extreme caution. In this case clean it like other varnished surfaces. Be gentle in the process. Avoid using detergents. If the gold leaf is exposed, do not touch it. Dust it regularly by blowing the particles of dirt off with a rubber ear syringe or other suitable, mild air blast. Leave any further cleaning to a conservator. Housekeepers of the 1800's covered gold leaf frames with paper or cloth during the summer to keep fly specks off the gilding.

Finally, keep in mind that marquetry, other inlays and veneers are usually held in place by water-soluble glues. In damp wiping and washing such furniture use a minimum of water. Dry the work quickly and thoroughly.

Historic furniture in storage also needs attention, of course, regardless of its state of repair. It should have individual dust covers of unbleached muslin treated with fire retardant or of polyester or polyethylene plastic sheeting. The housekeeper cleans the protective covers, makes sure no condensation occurs beneath the plastic ones and watches for any signs of insect attack.

The glass components of furniture present fewer cleaning problems. Wipe mirrors, the outside of cabinet doors and clock glass, drawer pulls and other exposed glass daily with an untreated dust cloth. Dust loss on posed glass surfaces in the same ways, probably once a week. To remove the film of dirt that deposits on glass and the accidental finger marks damp wipe furniture glass about once a month. Use a sponge or chamois dampened either with clear water or with water containing a little nonsudsing household ammonia. Squeeze out all the excess water and manipulate the sponge or chamois carefully to clean the entire glass surface without wetting the surrounding woodwork. Wipe dry with equal care using a soft, lint-free cloth or chamois. Furniture glass exposed to touching by visitors will need to be damp wiped more frequently. Some furniture glass has painted decoration on its inner side. Do not touch the painted side. Let a conservator take care of it. Clean the exposed side with extra care and the least possible moisture on the sponge or chamois. Treat the glass covering framed pictures in the same way.

Marble tops of tables, bureaus, washstands and exhibited toilet fixtures soil easily and, if subject to use, stain readily. Keep them clean by daily dusting. Use a vacuum cleaner fitted with its dusting brush in preference to an untreated dust cloth. Perhaps once a month damp wipe the marble with a clean sponge. Dampen the sponge with clear water. If soot or other oily dirt is a problem, add a little nonsudsing household ammonia to the water. Rub the marble dry with a soft cloth. Wash it once a year. Use a lather of the nonionic neutral detergent. Do a small area. Then rinse and dry it before proceeding. If spots or stains occur, follow the methods suggested above for marble hearths.

Furniture hardware exposed to view is commonly brass. Keep it polished using the materials and methods described for fireplace fittings. In this case start by fitting a template of cardboard or stiff paper closely around the brass to protect the wood. Use masking tape or other self-adhesive tape to hold together the parts of the template, but do not apply the tape to the surface of the furniture. Lacquer the polished brass to avoid the wear of frequent polishing. Brass bedsteads and door hardware require similar treatment, but it may not be practical to use lacquer on some door brasses. Polish the steel keys of cabinets, desks and drawers with abrasive rubber. Then give them a protective coating of wax. Iron hinges and locks may rust. Use fine steel wool to remove the rust, being careful not to scratch adjacent wood. Wax the metal afterwards. Finely chased and gilded metal ornaments on furniture may be truly fire gilt. Treat them like gold leaf.

Leather desk tops and leather upholstery require cleaning and protection from direct sunlight. The latter is vital. Be faithful in closing window blinds or shades during the periods the sun would shine on the leather. Keep the leather well dusted. Use a treated dust cloth on flat areas, but work the dust out of crevices and rolled seams with a vacuum. When washing becomes

necessary, perhaps every four years, use saddle soap. Follow the directions on the container. After the leather has dried, wipe it with potassium lactate solution (see Miscellaneous Furnishings below). Then treat it with anhydrous lanolin in Stoddard solvent or with British Museum leather dressing well rubbed into the leather, then as much as possible removed with a clean cloth. Observe fire precautions while applying the dressing as well as in storage of the material and disposal of cloths. Between washings use the leather dressing about once a year.

Fabric upholstery provides different problems for the historic housekeeper. They parallel those encountered with exhibited carpets discussed above and fabric furnishings considered in the following section. As with carpets the older textiles have weakened while reproduced ones usually are expensive and hard to replace. Compared with carpets upholstery fabrics are more delicate and often more easily harmed. Since direct sunlight acts destructively on textile fibers and colors even faster than on leather and wood finishes, adjust shades or blinds without fail to exclude it during critical periods. The care of fabrics justifies keeping all the blinds closed except during visiting hours to reduce the total amount of light exposure. Dust upholstery regularly. Once a week seems desirable in average situations. Use a vacuum cleaner with a flat, brushless upholstery attachment. Be sure the attachment is clean. Reduce the suction by means of the control to allow for weakened fibers. Hold the plastic screen on the fabric and draw the dust out through it. Changing to the round dusting attachment with long bristles, which should also be clean, work the dust out of pleats, seams, tufting and fringes. To get dust out of deep pleats or from around buttons use a small brush in conjunction with the vacuum. A lens brush is too soft for this purpose. Try an artists' bristle brush, No. 14 broad, with bristles about 1½ inches long (c. 38 mm). If an old upholstery fabric requires further cleaning, a textile conservator should undertake it. Should a reproduced fabric become obviously soiled or stained, apply dry cleaning powder from an aerosol dispenser. Let it dry completely. Then vacuum up the powder, brushing the area carefully to free the particles.

Fabric Furnishings

Historic structure museums ordinarily contain a variety of textiles. These may include window curtains, window drapes, portieres, tapestries, bell pulls, bed hangings, coverlets, blankets, bed linens, towels, table linen, doilies and others in addition to the carpets, wall coverings and upholstery already discussed. Cotton, linen, silk, wool and synthetic fibers differ in their cleaning characteristics. So do the wide range of weaves and dyes. Age and condition greatly influence the choice of safe methods and the frequency with which cleaning should occur. A textile conservator should

therefore examine the fabrics, if possible, and prescribe the ways to keep them clean.

In general give first attention to protecting the textiles from sunlight. Operate window blinds or shades to keep the sun from shining directly on a fabric. Reduce the light at other times when interpretive needs permit. Historically many housekeepers took down and put away window curtains and drapes during the summer. Some furnished structure museums wisely follow this practice.

As the second consideration keep fabric furnishings dusted. Whether hanging or lying exposed they usually need dusting on a weekly schedule to prevent a build-up of dirt. If a textile is installed in a hanging position and is sufficiently strong in structure and condition, go over it carefully with the round drapery or dusting brush attachment on the vacuum cleaner. Wash the brush first to make sure the bristles are clean. Work in vertical strokes from the top down except as necessary to get the dust out of pleats, swags, trim and tiebacks. Vacuum both sides of the hanging. To dust a more fragile hanging take it down carefully and lay it flat on a clean surface. Use the flat, brushless upholstery attachment. Wipe it clean. Diminish the suction. Place the plastic screen over the fabric and vacuum through it. After dusting one side turn the fabric over carefully and do the other in the same way. Using the brushless attachment, the screen and controlled suction vacuum the textiles that normally lie on a bed, table or other surface. Turn them over and vacuum the back as well. Lay muslin or polyester dust covers over historic textiles in drawers, closets or elsewhere out of visitors' sight, but vacuum the covers regularly. Keep a hidden dust cover on top of the tester of a high post bed as oldtime housekeepers did.

Fabric furnishings should be washed or dry-cleaned periodically unless their condition precludes it. This prevents the accumulation of dirt that would hasten deterioration. Nevertheless, do not attempt to wash colored textiles, ones of historical importance or ones with weakened threads without the direct advice of a textile conservator. Those which can be washed safely, do by hand. The best procedure employs a temporary, shallow tank. The tank, devised from a large sheet of polyethylene held by a plywood bottom and board sides, should be big enough to hold the textile unfolded. Fill the tank with clear water. Use warm water for cotton or linen. Keep it at room temperature for silk or wool. Lay the fabric on a sheet of plastic screening the same size or slightly larger held rigid by a wood frame. Cover it with a second screen if necessary. Lifting it by the screen, lower it into the water with the screen still beneath it. Push the textile gently to the bottom repeatedly so the water moves back and forth through the cloth. This should flush out the particles of dirt. Lift the screen out of the tank carrying the textile supported on it. Empty the tank, wipe it clean and refill it. Immerse the screen and fabric again. Create the same gentle flow of water among the interwoven threads. Repeat the rinsing

cycle until the water remains clear. Remove the fabric this time, still supported by the screen, onto another polyethylene sheet laid flat on a suitable working surface. Absorb the excess water by blotting with clean towels. Smooth out all the wrinkles gently by hand. If necessary, use pins to block the fabric so the threads run straight and the edges true. Leave it to dry. An electric fan will speed the drying, but do not let it blow the cloth. Washed and dried in this manner the fabric should not need ironing. When ironing is imperative, do it gently with an iron moderately warm. Clear water should suffice to launder a textile merely exposed to room air for a year. If more cleansing power is required, add a little of the nonionic neutral detergent solution to the first bath. Rinse it out thoroughly in the subsequent changes.

An alternative procedure demanding less space and fewer hands employs a bathtub as the tank. It involves more risk because the fabric receives less support while weighted with moisture. Fill the tub nearly full with clear water, either warm or at room temperature depending on the kind of fiber. Fold the fabric as little as necessary to fit the tub. Lower it into the water. Holding it submerged gently fold and refold. These movements propel water through the cloth to dislodge the dirt. Drain the tub and refill it. Manipulate the folds again as the fabric becomes submerged. Repeat the rinsing until the water remains unclouded. Roll the fabric loosely while still under water. With hands beneath the roll to support it, lift it out and lay it on the flat sheet of polyethylene. Absorb excess water from the roll with towels. Then unroll and unfold the textile on the plastic sheet. Complete the blotting of excess water. Smooth the fabric as before and block if necessary. Leave it to dry, perhaps aided by a fan.

With a conservator's approval use the hand washing technique to clean colored textiles of suitable weight and strength in which all dyes are fast. Reserve dry cleaning for furnishings composed of two or more kinds of fabric which cannot be taken apart, some especially heavy materials and those with dyes or sizing not safe to wash. Have the work done by a carefully selected dry cleaning plant. Ask the operator to test the dyes and sizing with whatever solvent or combination of cleaning agents he proposes to use. Review the test report before authorizing him to proceed. See that the dry cleaning fluids he uses on the museum textile are completely fresh. He should also enclose and support it in a suitable protective bag during the cleaning process. Inspect the cleaned fabric critically and observe its condition through the ensuing year. These observations will determine any needed modification of procedures the next time. The National Institute of Dry Cleaning, Silver Spring, MD, has done museum quality cleaning of textiles, when necessary without the dangerous use of tumbling machinery.

Window curtains or drapes in staff rooms and public access areas usually consist of modern textiles, even if reproducing the appearance of old ones. Their location makes them more liable to catch fire and to endanger

human life if they do ignite. Unless they are fiberglass, they should contain a flame retardant. Washing or dry cleaning removes it, requiring its renewal each year. If these non-historic fabrics are laundered, transfer them from the last rinse into a solution of seven parts borax, three parts boric acid and 100 parts water. Be sure the solution saturates the cloth. Lift the fabric onto a flat sheet of polyethylene as described above for handwashing historic textiles. Omit the blotting step because as much as possible of the chemical retardant should remain in the cloth. Smooth out the wrinkles carefully because ironing the treated material risks discoloration. Then let it dry. Run a test strip of similar fabric through the same procedure. Try to ignite pieces of this strip at intervals during the year to make sure the chemicals remain effective until the next washing. If the modern curtains or drapes are dry-cleaned, request the cleaner to flame proof them and a test strip for you to check periodically.

Miscellaneous Furnishings

Historic housekeepers, like their predecessors, must spend much patient effort on the smaller, usually more numerous objects that comprise the intimate furnishings of a room. Handling these often fragile as well as valuable articles tests skill in addition to patience. For the sake of safety do not hurry such tasks. Remember to wear clean cotton gloves when touching metal objects. The following notes suggest cleaning methods for some of the common minor furnishings:

Books

To dust a book adequately use a vacuum cleaner with the long bristled dusting brush. Be sure the bristles are clean before starting. Hold the book in one hand. Pass the brush along the top, inner edge and bottom of the pages. Then lay down the vacuum and, unless the book has a fine leather binding, wipe the spine and covers with a clean dust cloth. While a treated cloth with only enough oil emulsion should not smear a book cover, it is safer to use an untreated one. Replace the book and take the next one. While dusting, make sure the books are not packed tightly on the shelf. Look for signs of mold, insect attack or damaged bindings. Report any to the curator. Dust the shelf behind the books.

Leather-bound books require special treatment. Since dust particles can scratch the leather, some experts prefer not to use a dust cloth on these bindings. Instead dust the spine and covers with the vacuum. Attach the flat, brushless tool and pass it over the leather surfaces without quite touching them. About once in two years take each leather-bound volume, except those in suede covers, and lay it on a clean surface. Slip a sheet of waxed paper or plastic inside the front and back covers to protect the

pages. Brush a thin coating of British Museum leather dressing or an-
hydrous lanolin in Stoddard solvent over the leather. Use the least possible
amount. Be careful to keep it from staining the endpapers that line the
covers and the cloth or paper on the covers of half and quarter bound
books. Rub the dressing in thoroughly with your fingers. Stand the book in
normal position with the covers slightly open for about two days to let the
dressing dry. Then polish the leather with a lint-free cloth and replace the
book on the shelf. Report any breaking hinges, powdery leather or other
deterioration to the curator. The solvent in the leather dressing is flam-
mable and mildly toxic. Keep smokers and other sources of ignition away
while the books are being dressed and dried. Ventilate the work space
adequately.

Every fourth year, unless exposure to acid air pollution makes more
frequent treatment desirable, wash the leather as follows before applying
the dressing. After dusting, wipe the spine and covers with a sponge slightly
dampened in a mild solution of the nonionic neutral detergent. Rinse them
with a clean sponge dampened similarly in clear water. Wipe very lightly
over any gilt tooling. When the leather has dried, wipe it again lightly with
a sponge dipped in a solution of potassium lactate. Library suppliers market
the solution in the correct strength and add a fungicide to retard mold
growth. The lactate buffers the leather against acids from the air that attack
leather. Again let the binding dry. Then apply a leather dressing as before.
Most other leather furnishings require periodic washing and dressing in the
same manner. For suede and leathers tanned or finished by less common
methods consult a conservator.

If a book lies open in a furnished room, the housekeeper should turn
several leaves to expose a fresh page each day as a routine part of the
dusting operation. This reduces damage to the paper caused by light.

Ceramic ware

Dust porcelain and most glazed or moderately vitrified pottery with an
untreated cloth unless trial proves that the treated cloth leaves no discern-
able film. Use a lens brush instead of a cloth to get dust off ceramic objects
having intricate molded decoration. To avoid smearing or scratching po-
rous unglazed ware brush the dust from it also. Wash most ceramic furnish-
ings annually under average conditions. For porcelain and glazed or other
nonporous pottery use warm water and the nonionic neutral detergent, but
water alone for gilded or overglaze painted pieces. Add mild soap if neces-
sary. Rinse well in clear, warm water. Let the pieces air dry or wipe them
carefully with a clean towel. Do not wash relatively soft, porous, wholly or
partially unglazed earthenware in the detergent solution. Dip it in clear
water at room temperature. Agitate the water gently to carry away loos-
ened dirt. Dry this ware by blotting or patting with a dry towel rather than

wiping. Check with the curator before attempting to wash American Indian or African pottery and any ware of which the clay or pigments might not withstand wetting.

Glassware

Use an untreated cloth to dust glass. Wash glassware about once a year with a solution of the nonionic neutral detergent in warm water. Omit the detergent if the glass is gilded or painted. Rinse thoroughly and wipe dry. Watch out for any pieces mended with a water-soluble cement. See also cleaning methods for the glass of lamps and other lighting equipment described below.

Kitchenware

Most historic kitchen utensils are made of iron, copper, brass, tin or wood. Many combine two or more of these materials. Earlier housekeepers understood the importance of cleanliness in the kitchen. They scoured at least the inside and lip of iron pots and pans used on the hearth, and the outside also of those used on stoves. To prevent food contamination from the corrosion products of brass and copper they cleaned utensils of these metals just before as well as after use. Tinware they cleaned thoroughly, but carefully to avoid wearing or scratching through the thin layer of tin. The iron core it protected would rust quickly. Steel knife blades required daily scouring on the knife board (a leather-covered utensil coated with abrasive). In the same spirit keep exhibited kitchenware looking as clean as its users would have. Wipe all the utensils with a treated cloth often enough to keep them free of visible dust. Wash the metal ones on an annual schedule. Use warm water and the nonionic neutral detergent. Rinse and dry thoroughly. Damp wipe wooden utensils and the wood parts of composite ones. If rust develops on any of the ironware, use fine steel wool or abrasive rubber to remove it. Polish rusted steel utensils with 600 emery paper. Then wet either the iron or steel with a corrosion-inhibiting liquid such as CRC 3–36 (available from dealers in shop supplies and some hardware stores). After standing for one day, wipe dry with changes of clean cloth and coat with an inconspicuous layer of microcrystalline wax or hard paste wax to retard further rusting. Remove the tarnish from copper and brass utensils with the mild abrasive and ammonia polish recommended above for use on fireplace fittings, but do not necessarily bring them to as high a gloss as ornamental brass. Apply a light coating of synthetic lacquer or wax to avoid the wear of frequent repolishing. Be particularly careful to clean off any of the green corrosion liable to appear in lip crevices and at handle attachments. A cook would not tolerate its presence. Treat tinware like copper, but rub gently to preserve the tin.

When "living history" participation or demonstrations involve kitchenware, use replicas as a matter of sound preservation policy.

Lights

Modern light fixtures require frequent cleaning. Dust accumulating on lamps, reflectors, filters or baffles quickly reduces their efficiency. Remove it weekly with a vacuum cleaner and dusting attachment. Wash the lamps, reflectors, baffles and housing four times a year. Use a sponge dipped in water containing a little nonsudsing household ammonia and squeezed to prevent dripping. Wipe dry with a clean cloth. Clean ultraviolet filters at the same time, but follow the direction in Case Exhibits, Chapter 15, because these parts are plastic.

Candle holders of all types and materials should be dusted regularly. Use a treated cloth for those of metal or wood, an untreated one for ceramic or glass. Glass pendants are an exception. Use a brush to dust them and work carefully to avoid knocking them against one another or dislodging them. They chip easily and the wires break or pull loose. The candles themselves also gather dust, especially at their tops. To get rid of it light each candle briefly once every two weeks. Guard against fire in the process. Notify the curator in advance and have a fire extinguisher at hand. Wash candle holders annually. Most candlesticks can be washed in a warm solution of the nonionic neutral detergent, rinsed well and wiped dry. Candelabra usually will come apart for washing. Damp wipe metal or composite chandeliers with a sponge. If you use a detergent solution, rinse them well by wiping again with a sponge and clear water. Dry them carefully. Again crystal chandeliers present a laborious exception. Their effectiveness depends on the sparkling cleanness of the faceted drops. Washing is essential, but requires you to unhook and take down each pendant piece. Lay these in precise order on a polyethylene sheet spread on the floor so you will know the exact position and sequence for reassembly. Then wash each pendant with ammonia water and polish it dry with a clean, lint-free cloth or chamois. When all are clean, carefully put them back together. Brass and silver candlesticks require polishing. Treat the brass as described above for fireplace fittings. For silver see the section on silverware below. Snuffers and extinguishers need polishing similarly. Use 600 emery paper to polish steel snuffers, which rust if not carefully maintained. Candle holders in use become caked with the wax or tallow that drips or runs. Careful housekeepers, now as in the past, clean off the drippings the next morning. Dip metal candlesticks in boiling water and wipe them clean immediately. Run warm water over glass ones to soften the wax or tallow and rub clean.

Oil lamps generally demanded more housekeeping attention than candles. Their safety, efficiency and appearance depended on frequent cleaning. The daily care of a kerosene lamp when in use, for example, should

include dusting the shade and body of the lamp, washing the chimney, trimming the wick, wiping the burner clean and clearing out all the air holes in it with a toothpick, filling the oil reservoir to within a half inch of the top (c. 12 mm), wiping the outside of the oil can, and finally washing or disposing of the oily cloths. In addition the reservoir should be emptied once a week and the cloudy oil at the bottom discarded. The shade may need washing at the same time. Earlier housekeepers were advised to empty the reservoir and oil can each month and wash them out with an alkali solution (pearlash water). All the alkali had to be gotten out before refilling. Dust lamp shades with an untreated cloth unless their fragility requires the lens brush. Most lamp bases can be dusted with a treated cloth. Use warm water and the nonionic neutral detergent to wash chimneys, glass shades and other glass parts. A bottle brush or dish swab helps clean the inside of chimneys. Trim the wick with scissors or by lifting off the charred ends with a dry cloth.

Pewter

Utensils of this variable alloy should appear well cared for and clean. Dust them daily with a treated cloth. Wash them about once a year in a denatured alcohol shellac solvent. Rinse them well afterwards and wipe dry. As the surface becomes dull, polish it lightly with a good quality commercial pewter polish. Do not try to bring old pewter to a high gloss. Pewter is relatively soft, so polishing tends to wear away any raised decoration. If gentle polishing does not produce the desired result, obtain the advice of a conservator. Treat Britanniaware like pewter.

Pictures and frames

Housekeepers should not, under any circumstances, attempt to dust or otherwise clean paintings and prints. Touching the surface of an oil painting can cause severe damage, even if not noticeable at the time. Works of art on paper also suffer if touched. Leave the care of these furnishings to a trained conservator. Frames and the glass covering pictures, on the other hand, permit cautious cleaning. Carved, molded and gilded frames require particular care. Do not dust them with a cloth. Blow the dust from carved and molded ones. A small ear syringe provides a suitably gentle blast. Be careful not to bring the tip of the syringe into actual contact with the frame. As far as possible direct the air stream to blow the dust away from the surface of the painting. For plain gilded frames use a lens brush. Dust simple ungilded frames with a treated cloth, but keep it off the picture surface or glass. In glazed frames dust the outside of the glass lightly with an untreated cloth, watching out for the frame in the process. Damp wipe the glass when necessary with a sponge dipped in ammonia water and

squeezed almost dry. Do not let the moisture get onto the frame or under the edge of it.

Silverware

The historic occupants in most instances esteemed the bright luster of their silverware. Keep it clean and well polished accordingly. Dust silver regularly with a treated cloth. Wash it at least annually, but use a mild soap instead of detergent. Any phosphate in the detergent might cause a stain. Silver tarnishes readily, so requires polishing. For small pieces use a commercial silver dip. It contains an acid, a sequestrant and a wetting agent and removes all the tarnish quickly, even out of fine depressions in the decoration. Immerse the article completely, remove it at once and rinse it thoroughly in clear water. Dry it and spray it with a commercial tarnish inhibitor. Rub larger pieces of tarnished silverware with a good quality commercial silver polish containing a tarnish inhibitor. Follow the directions on the container. Because each polishing removes a little more of the silver, apply a protective coating as well as the inhibitor to make the treatment last longer. Either spray the polished silverware with synthetic lacquer in a thin, even layer or rub on microcrystalline wax. Silverplate should receive the same housekeeping care.

BIBLIOGRAPHY

Up-to-date cleaning manuals generally are developed for internal use by organizations maintaining hospitals, hotels, office buildings and other large complexes. An example is:

Shields, William R. *Procedures for Building Cleaning Maintenance. Guide.* Clearwater. Environmental Management Association.

For miscellaneous furnishings in particular see such curatorial guides as:

Fall, Frieda Kay. *Art Objects, Their Care and Preservation: A Handbook for Museums and Collections.* LaJolla. Laurence McGilvery, 1973.

Guldbeck, Per E. *The Care of Historical Collections: A Conservation Handbook for the Nonspecialist.* Nashville. American Association for State and Local History, 1972.

American housekeepers of the 18th century who consulted books probably turned to ones published abroad. For insights into English practice see:

Glasse, Hannah. *The Servant's Directory, or Housekeeper's Companion.* London. 1760.

Whatman, Susanna. *The Housekeeping Book of Susanna Whatman, 1776–1800.* London. G. Bless, 1956.

Among the numerous 19th-century books written to help housewives in their domestic duties the following seem especially useful. Most appeared in many editions. The dates given are those of the earliest ones available in the Library of Congress:

Beecher, Catherine E. *A Treatise on Domestic Economy.* Boston. 1841.

Child, Mrs. Lydia Maria. *The American Frugal Housewife.* Boston. 1835.

Eaton, Mrs. Mary. *The Cook and Housekeeper's Complete and Universal Dictionary.* Bungay. 1823.

Holt, Mrs. Elizabeth F. *From Attic to Cellar or Housekeeping Made Easy.* Salem. 1892.

Leslie, Eliza. *Miss Leslie's Lady's House Book.* Philadelphia. 1863.

Scott, Mrs. M. L. *The Practical Housekeeper, and Young Woman's Friend.* Toledo. 1855.

Wigley, Mrs. W. W. *Lessons in Domestic Economy. Book II. The House.* London. n.d. (c. 1880).

Chapter 12 Protection

This chapter concerns the safety of museum objects and of people in the museum. Conditions inherent in a furnished historic structure complicate both these aspects of protection. The furnishings and the building itself are historic specimens. Preserving them is consequently a primary responsibility as it would be in any museum. Here, however, the curator cannot use display cases to shield them. The objects he must protect are unavoidably exposed to varied hazards. At the same time visitors and staff find themselves in a building not originally designed for use as a museum. They often encounter narrower passageways, steeper stairs or fewer exits than safety standards ordinarily require. Warning signs and safety aids appropriate in other situations would seriously intrude on the historic setting. Under these circumstances protection of both specimens and occupants demands careful planning and continuous concern.

Safe Practices in Housekeeping

The people who most endanger the furnishings and themselves are the staff members. They spend much more time in the museum than a visitor does and have more to do. They have a corresponding responsibility to avoid accidents. Does everyone who must lift a chair or move a cabinet know how to do it safely? How many good stepladders and helpers make it safe to take down the drapes for cleaning or to dust the chandeliers? What routes are least hazardous in carrying the ladders from room to room? Who is to see that no oily dust mop or cloth remains in the building overnight? These or similar questions are pertinent to most furnished historic structures. Multiplied to cover every aspect of maintenance and operation, they suggest the action needed. It differs in detail for each museum but consists of: analyzing the potential hazards, object by object and operation by operation; establishing procedures that minimize the chances of accident; providing the equipment needed to apply safe practices; training

all staff members in the safe ways to do their work; instilling and sustaining staff alertness to the dangers. Publications of the National Safety Council can be especially helpful in explaining how to prevent work accidents. Check carefully the application of the Occupational Safety and Health Act.

To safeguard the furnishings translate the analysis of hazards into such rules as these and abide by them faithfully:

1. Never move historic furniture by pushing or pulling it. Raise it off the floor. Lift chairs by the seat frame, not by arms or back. Take hold of other pieces only by solid parts of the frame, not by convenient projections.

2. Before moving furniture empty any drawers or compartments. Then fasten shut the doors and drawers, or take out the drawers and move them separately.

3. Remove marble or glass tops and carry them separately, on edge rather than flat.

4. Cover the furniture to be moved so hands or clothing do not rub against the upholstery and finish. Wearing clean cotton gloves gives added protection against harmful fingerprints.

5. If large or heavy pieces must be moved more than a few feet, use a padded dolly or flat-bed hand truck. The vehicle should be longer and wider than the object carried so no parts overhang. Maneuver it with great care to avoid striking other furniture, walls or door jambs. Remember that two or more pairs of hands are better than one when moving large pieces.

6. In moving antique curtains, draperies, bedspreads, rugs or other large textile specimens, even from room to room, roll each one carefully. Use a paperboard cylinder several inches in diameter and a little longer than the full width of the fabric. Stores selling carpets often have such tubes for the asking. Remove any curtain hooks or rings before rolling. Employ enough helping hands to keep the weight of the textile evenly distributed as it is lifted or lowered and smoothly rolled. Have two workers carry the roll, one at each end of the tube. If the specimen will remain on the roller for several days or longer, cover the face of the fabric with acid-free tissue paper as you roll it.

7. Carry a smaller textile specimen with both hands to avoid folding or straining it.

8. Pick up tableware, lamps, ornaments, books and other small items only one object at a time. Use both hands, one beneath the specimen and the other holding it by the side. Do not grasp it by the handle or rim. Wear clean cotton gloves, especially if your hands will touch metal.

9. To carry such an object out of the room, put it in a well padded container. A market basket makes a safe and convenient carrier if it has a soft lining sewn in place and covering the rim, and if the handle is firmly attached. When carrying two or more specimens in the container, separate them with additional padding.

10. Lift framed pictures or mirrors from the wall with one hand grasping the bottom of the frame and the other hand holding one side of the frame. Take hold of the frame where it is solid, not in areas of carved or molded ornament. Carefully avoid touching the face or back of a painting or breaking the sealed paper covering the back of a framed print. Do not try to move large or heavy ones alone.

11. While the picture or mirror is off the wall, remove the screw eyes and hanging wires. Rest the bottom of the frame on padded blocks or padding on the floor. Lean the specimen against the wall, face out. Be sure the pads will not slip on the floor. Cover the face of the object with a sheet of corrugated cardboard or other stiff material wider and taller than the frame. Others can lean against it, each with a similar protective cover, but no more than five should be stacked together.

12. Use a vacuum cleaner, carpet sweeper, floor polisher, dust mop or other housekeeping tool with enough care to avoid striking or rubbing it against any piece of historic furniture.

13. In all cleaning, waxing and polishing operations use only those materials and methods approved in advance by the curator or conservator as safe and beneficial to the structure and furnishings.

14. Do not smoke while handling specimens, so both hands are always free and the hazards of hot embers and ashes are avoided.

Consider another set of rules to protect the housekeeping staff from injury. These may include:

1. Before moving a piece of furniture think how to do it. If the piece is big or heavy, you may require help. Ask for it. Check the route for danger spots where you might slip, stumble or bump into something. Find out exactly where the furniture is to go. Select places along the way to set it down safely if arms or fingers need a rest.

2. Do not bend over to pick up the piece. Stand close to it with your feet well apart. Bend your knees until your hands can grip the frame properly. Then rise, letting your leg muscles rather than your back do most of the lifting. Carry the load close to your body and low enough, if possible, so you can see where to go. When turning move with your feet rather than twisting your body. Set the furniture down by bending your knees again rather than your back alone.

3. If two or more people help carry it, put one person in charge. Be sure each helper knows what to do. Keep in step.

4. For jobs that require a stepladder use one that is strongly made, in good condition and the right length. The bottom step should have metal braces and all steps should preferably be rodded or braced. The back legs should have horizontal rungs for bracing. The metal spreaders should provide rigid support when opened. The ladder should be no taller than neces-

sary to reach the work while standing on the second step from the top. Do not climb higher.

5. When moving a stepladder during a job be sure no tools or other objects have been left on it. Carry the ladder with the front end higher and check both ends at every turn.

6. Take similar precautions with a straight ladder. Select one that has a steel reinforcing rod beneath each rung and feet designed to prevent slipping. Inspect the side rails and rungs to be sure they are in good condition. Set the ladder at an angle so the bottom is out from the wall about ¼ of the ladder's length (45 inches out for a 15–foot ladder or 1.14m for a 4.5m one). Use both hands in climbing, so carry tools in a pouch or haul them up afterwards. Do not go higher than the second rung from the top. While working hold onto the ladder with one hand, do not reach too far and do not push or pull. Carry a ladder with the front end high and watch both ends for clearance.

7. Before plugging in an electrical housecleaning appliance check the cord, plug and switch. If the insulation is worn, any connection loose or any wire or part broken, have it repaired before using the appliance. Do not use electrical equipment when your hands or feet are wet. Modern appliances have a three-prong grounded plug and should be used with a three-hole power outlet. If an adapter is used, be careful to ground it to a cover plate screw.

8. Have the curator or conservator check each kind of insecticide, fungicide, cleaning solvent, wax, polish and other similar material you use so both of you are aware of its poisonous properties and its flammability. Then follow the special safety instructions for each.

For more complete lists of desirable precautions consult Robert P. Sugden, *Care and Handling of Art Objects*, New York, Metropolitan Museum of Art, 1946; Frieda Kay Fall, *Art Objects, Their Care and Preservation: A Handbook for Museums and Collectors*, La Jolla, Laurence McGilvery, 1973; and leaflets of the National Safety Council.

Protecting Visitors

When you invite the public into a museum, you assume a responsibility for the reasonable safety of your visitors. Your first concern in this regard is to avoid injuries. A furnished historic structure often requires an aggressive accident prevention program because it contains hazards not commonly found in other kinds of museums. In spite of such precautions the time will almost surely come when an accident happens. At that moment the staff must be ready to give effective help. The museum also may have to pay the costs of injury suffered by a visitor. You need to make sure that payment will not cripple the institution financially.

Avoiding Accidents

First identify the hazards. Your visitors will be in unfamiliar territory. The historic scene recreated around them will tend to draw their attention away from possible dangers. Study every step of the route they will follow through the grounds and building. Look for obstacles likely to trip someone or throw him off balance—unusually high steps, sudden changes in floor level or raised thresholds for example. Floors may be slippery, especially beneath wet shoes. A lintel may be too low for some people to pass under without stooping. A stairway, particularly if visitors descend it, is a danger point often made worse by dim light, narrow or worn treads and inadequate handrails. Furniture along the way may be topheavy, liable to tip over if someone leans against it or a child tries to climb on it. It may have projections sharp enough to snag clothing or cause bodily harm. In examining the route think of the different kinds of people who will use it. Not all your visitors will be healthy adults of average height and weight. Some will have impaired vision, arthritic joints, weak hearts or other common disabilities. A fairly large proportion of your visitors will be wearing bifocal or trifocal glasses. Consider them particularly. Many visitors will be children, so conduct your search at their eye levels too.

This initial study of the situation gives you a list of potential or apparent hazards. These need to be checked, if possible, against actual experience. Watch a variety of people follow the planned route. Observe how they fare in the presumed areas of danger. Note any additional obstacles their movements reveal. Continue to observe visitors and have attendants report incidents of stumbling, tripping or bumping as well as any real accidents. Such data will refine the list and keep it up-to-date. You may find that some apparently hazardous conditions cause little or no trouble while other less obvious ones involve more risk. The front doorstep of the Harper House at Harpers Ferry National Historical Park is deeply and unevenly worn. It is backed by an unusually high threshold. Thousands of visitors go in and out the doorway. They have experienced no observed difficulty with the irregular footing. On the other hand, the single step between the dooryard and the front porch looks innocent but occasionally trips people. The step is of convenient size, firm and level, but is an inch or two farther below the porch than one expects. As these two examples suggest, you need to evaluate the danger points before proceeding to the next phase of accident prevention.

Having spotted the conditions that actually endanger visitors, eliminate or mitigate the hazards. Here you must recall that you also are responsible for preserving the historical integrity of the structure and its furnishings as well as the interpretive quality of the whole. It would seldom be justifiable to alter the original fabric of the building or the historic placement of furniture. Neither would you want to introduce safety devices that clash

with the setting. You would not cut down old thresholds, raise lintels, replace worn floors or change floor levels, for example, unless no reasonably satisfactory alternative remained. Nor would you install yellow warning strips on the edge of steps, modern non-skid treads on original stairs, signs warning visitors to watch out or emergency exit signs. Many other possibilities may be more acceptable and at least as effective. A change in the visitor route may bypass a dangerous situation. A simple ramp, perhaps concealed by the floor covering, may greatly decrease the chance of someone falling over an obstruction. If floors are slippery under ordinary conditions, changing housekeeping practices such as the kind of wax and frequency of polishing in areas where visitors walk may suffice. When wet weather creates a slipping problem, provide an efficient doormat outside and absorbent rugs inside the entrance so people can clean and dry the soles of their shoes. Furniture that might topple can usually be anchored by inconspicuous hooks or braces without screwing into or otherwise vandalizing the piece. Positive safety can often find a place in the interpretive message. A word of warning at the proper moment in the guided tour leaflet or audio can do more than a sign and be far less intrusive. Other more subtle ways of helping visitors get through the museum without accident warrant trial. A little augmented light at one point, a change of color or texture in the floor covering at another, may be all that people need to take the extra bit of care required.

Stairways that visitors go down often constitute hazards calling for special attention. While you cannot change the original width of treads or height of risers, you can make the footing as secure as these conditions permit. You can keep the surface finish in good shape, nonslippery and free of any splinters or nails that might catch a heel. You can be sure stair carpets are securely fastened and without holes or threadbare areas. You can assure good lighting so people will easily see where to step. Original lighting appliances for a stairway frequently are inadequate under museum traffic conditions. Wiring the old fixtures for electricity is of questionable value and taste. So is the installation of additional electric fixtures in period style. Concealed spotlights or floodlights completely recessed and shining through small holes in the ceiling have solved the problem well in some instances. A luminous ceiling or a continuous light source hidden below a handrail might fit other circumstances. Whatever the methods, visitors should find sufficient light to see each step without being conscious of the source. Safe descent also requires the aid of handrails. These need to be sturdy, set at the right height and of a size that permits a firm grip. Some stairways need rails on both sides. If you install new handrails for safety, it is good practice to make them unobtrusively functional, frankly added rather than faked to seem original.

Some furnished structure museums lack original stairways capable of

safely handling as many visitors as have to descend them. At the Home of Franklin D. Roosevelt the National Park Service has erected a metal stairway extending from the second floor to the ground. The new stairs are entirely outside the walls of the house, but being on the back are completely hidden from view as you approach and enter the mansion. One carefully reconstructed historic house has a deliberately added stairway inside. This unhistoric feature is designed for safety. Since it is obviously although unobtrusively modern, visitors can understand that it does not represent part of the building as it originally existed. Stairways become critical factors also in cases of emergency evacuation (see Evacuation below).

Coping with Accidents

When it finally happens that a visitor is hurt or stricken, a well managed museum will be ready to respond. Regardless of the nature of the injury or illness—broken bone, sprained joint, concussion, heart attack, epileptic seizure, fainting or whatever, the nearest staff member will initiate a three-step procedure which has been planned and practiced. One person, perhaps whoever is responsible at the time for answering the phone, will immediately telephone for a doctor. Whoever makes the call will find at hand the proper phone number, based on advance arrangements with an individual doctor, a medical switchboard, an emergency dispatching service or a hospital, depending on local circumstances. While expert help is on the way, staff members will administer first aid, for which they all have received recent, standard training. As soon as the victim is receiving care, a designated employee will gather information for a detailed report of what happened. The report will describe the accident or seizure, tell exactly when and where it occurred, note the apparent injury or illness, state what was done for the person and record the names and addresses of witnesses who can vouch for the facts. A thorough, accurate report will help in preventing a recurrence, improving emergency procedures and settling questions of liability. If the museum has only one person on duty, this individual performs the three steps in sequence.

Paying for Accidents

For most museums this means carrying adequate liability insurance. Be sure the claim agent who will handle your cases has on file full information about what the museum has done and is doing to protect visitors from accidental injury. Get from him or her detailed instructions on the specific data needed concerning an accident. The agent may provide accident report forms as a guide. Park museums, since the government is self-insured,

should document all accidents to visitors with at least equal care in preparation for tort claim suits. Standard report forms designed to compile accident prevention data include the kinds of questions to be answered, but may allow space for only a summary narrative of what happened.

Protecting the Building and Furnishings

Most of Chapter 4, Caring for a Collection, applies with equal urgency to a furnished historic structure museum. The building and its contents comprise the collection. The same agents of deterioration threaten it: adverse climatic conditions, airborne pollutants, strong light and destructive organisms including ourselves. Basically the same methods are available to combat them. The same standards of protection govern, but the curator must try to achieve them with a minimum of alteration in the historic fabric of the structure and with the least visible intrusion. The restoration architect shares intimately in the solution of some of the problems these requirements create. He knows, for example, that cutting a pipe chase in an original brick wall, although hidden from sight, smacks as much of irresponsibility or even vandalism as installing electrical outlets in fine old paneling.

Environmental Protection

Most furnished historic structures require continual knowledgeable action to control relative humidity and temperature, harmful particles or gases in the air, the amount and kind of light falling on the furnishings, infestations of insects or other vermin and mildew. Problems of control for each of these factors will be considered in turn.

Too much or too little moisture in the air within a historic building in relation to the temperature can cause serious damage. So can wide, rapid fluctuations in the relative humidity. The historic furnishings will ordinarily last longer if the indoor climate maintains a steady (constant) relative humidity between 40% and 60% and a temperature between 60° and 75° F. (16°–24° C.) day and night the year round. Air-conditioning can provide the close control if designed and operated for protection rather than comfort. Such an installation requires equipment to cool, heat, humidify, dehumidify, filter and distribute the air. It also must provide measures to prevent harmful condensation that would occur if the conditioned air came into contact with cold walls or windows. When the building itself is a reconstruction, the machinery, ducts, grilles and insulation for optimum air-conditioning can be planned into it or added with relatively few technical obstacles. For an original structure, on the other hand, two critical questions must be answered first. Can the system be installed without significant

changes or losses in the fabric of the building that will erode its historical integrity? Can the museum afford the costs of continuous operation and maintenance without which air-conditioning cannot accomplish its purpose? Some original historic buildings have been air-conditioned successfully. Many must do without this protection. These must rely instead on the staff's vigilance and care in manipulating the limited controls available.

Vigilance in this case means monitoring the climate inside and correlating it with the weather conditions outdoors. Using instruments described under Climate Control in Chapter 4, maintain a continuing record of the relative humidity and temperature in the furnished rooms. Watching the instrument readings and weather forecasts, take positive action to hold the conditions indoors as close as possible to the safe ranges. In summer you can open or close windows and blinds as housewives have traditionally done to moderate changes in temperature and consequently in relative humidity within the building. You can augment ventilation with discreetly placed electric fans. This will decrease the chance for pockets of warm, damp, stagnant air to accumulate behind books on a shelf or in closets. Portable dehumidifiers can also be placed out of sight in the rooms. These appliances should have humidistats set to turn them on automatically when the relative humidity rises above 55%. Be sure to empty the accumulated water from the reservoirs before they overflow. In winter the central heating system should hold the indoor temperature well within the proper range. If the heating unit delivers air to the rooms through ducts, the system should incorporate a controlled humidifier so the incoming air has the proper amount of moisture in it. When some form of radiation in the rooms heats the air, use portable humidifying units. These should operate by evaporation and have humidistats to start them wherever the relative humidity falls below 45% or another selected setting. Unless you add moisture, the dry air of a centrally heated building can wreak havoc on some furniture even in a single night, although the damage usually occurs less dramatically. On the other hand, the building itself may suffer harm if the added moisture condenses on or in cold walls and windows. If walls are not adequately insulated and windows double-glazed, this may happen when the relative humidity of the inside air is well below 40%, and consequently too low for the health of furnishings. In such a dilemma steer a narrow course raising the relative humidity as near to the recommended range as the situation permits and watching closely for signs of damage to either furnishings or structure. In winter hold the indoor temperature as low as you safely can in order to keep the relative humidity high. Sometimes it is practicable to warm visitors only by radiant heat, leaving the furniture at almost outdoor temperatures when necessary to prevent loss of water from its substance. Some historic buildings have improved the situation under varying conditions by having automatically controlled humidifiers and dehumidifiers continuously activated, one or the other turning itself

on whenever the relative humidity goes beyond prescribed limits.

The airborne pollutants you see in furnished structure museums are the particles of dust and soot which find their way in and settle on the historic materials. If allowed to remain, they do more than make things look dusty or soiled. Such particles can become minute centers of chemical deterioration or augment abrasion with every movement. Their removal requires the cleaning procedures discussed in Chapter 11, but cleaning unavoidably increases the rate of wear and tear. So consider measures to minimize their entry and deposit. Under normal conditions you can establish some control by such commonplace methods as keeping a clean filter in the furnace and a clean and effective doormat at the entrance, being sure windows and doors fit and close tightly and cleaning all air grilles regularly. If the air outside carries a heavy load of dust or soot, you should explore other means. Your objective would be to seal out the unclean air except as drawn in through efficient filters, and this might not be practical short of full air-conditioning. In selecting filters do not use electrostatic precipitators. They remove the particles effectively, but on occasion generate ozone in the process which contributes to specimen deterioration.

Not all airborne pollutants are visible. Some are colorless, odorless gases. One common example is sulfur dioxide, frequently produced when coal, oil or other fossil fuels burn. When sulfur dioxide comes into contact with historic furnishings, some of it often changes to sulfuric acid. All the ingredients necessary for this chemical change are likely to be present in the air and the specimen. The acid does not evaporate readily, so tends to accumulate. Even in very small quantities it weakens cotton and linen, discolors leather and turns it powdery. The air in rooms may contain a higher concentration of sulfur dioxide and other gaseous pollutants than does the freely moving air outside. If you wait until the effects become evident, damage will already have occurred, so test the air in the furnished rooms. An indicator paper that changes color in the presence of sulfur dioxide may be exposed in the room, or your local air quality control agency may be willing to check samples (see also fig. 14). The enforcement of clean air regulations will lessen the dangers from these invisible pollutants, but your collection may need active protection in the meantime. If sulfur dioxide is present, treat leather bookbindings and other leather in the furnishings thoroughly and regularly as described in Methods and Materials, Chapter 11. Place valuable papers in acid-free buffered folders and interleave books with buffered paper. Clean cotton and linen textiles more frequently. Improve ventilation. Air-conditioning systems can give good protection from pollutant gases by washing the air with a mildly alkaline solution and using an activated charcoal filter properly maintained.

Daylight provides the principal source of illumination for most furnished historic structure museums. Accurate portrayal of the original setting ordinarily requires you to use it. Light is a form of energy. It can cause

chemical reactions harmful to some of the materials common in historic furnishings. It fades colors and weakens fibers in particular. The rate at which the chemical degeneration occurs depends on the amount of energy supplied. This in turn depends on the intensity of the light and the duration of exposure. Light from the sun is especially damaging because it is very bright and you cannot turn it off. So your furnishings tend to be exposed to strong light for long periods. Even on cloudy days the light coming in a window may be 10 or more times brighter than is good for the preservation of mildly light sensitive materials. It far exceeds the level recommended by conservators for such objects as watercolor paintings. Daylight also contains a high proportion of the ultraviolet wave lengths which pack more harmful energy than the visible ones. Obviously the use of daylight entails protective measures.

You can do at least four things to minimize the undesirable effect of daylight. Direct sunlight acts quickly to damage many curtains, drapes, upholstery fabrics, rugs, papers and wood finishes. To prevent this follow the sound and simple old practice of closing blinds or drawing shades at windows on which the sun is shining. When a window is in shadow again, reopen the blinds or shades. To give further protection from the intensity of daylight line the backs of window drapes and use slipcovers to shield fine upholstery fabrics, at least in the summer as the historic occupants may well have done. Unless you have strong evidence to the contrary, place the most vulnerable objects in the darker parts of a room. These would include watercolors and other works of art on paper, silks and open books. To reduce the length of exposure keep the blinds closed or shades drawn during whatever daylight hours the museum is not open to the public. To eliminate most of the ultraviolet radiation install ultraviolet absorbing filters over the inside of the windows. Start with the sunniest, but consider covering the others as well.

Sheets of specially formulated, $\frac{1}{4}$-inch (6.35mm) thick, clear, almost colorless plastic such as Plexiglas UF-3 make efficient, durable filters. You can mount a single large sheet in front of a window fastening it to the frame with inconspicuous mirror clips or other devices. You should be able to remove it easily for cleaning the filter and the window glass. This method of installation may work well for windows which visitors view from a distance, especially when hangings conceal the edges of the plastic. For windows close to visitors it may be better to cut the filter plastic to fit directly against the panes and hold it in place by an added fillet pinned to the moldings that hold the glass. Again, you will need to remove the filter for window cleaning. At least two other kinds of ultraviolet filters are available. Both incorporate ultraviolet absorbing substances in clear plastic. One uses thin plastic in the form of a roller shade. The other is applied to the surface of the glass as a varnish. In both these methods the thinness of the plastic layer reduces the amount of absorbent it can contain, and so

presumably shortens the effective life of the filter. Conservators recommend that the thin filters be replaced at least as often as the rooms need repainting. It would be good practice to have a conservator equipped with an ultraviolet monitoring instrument test the continued effectiveness of all filters every five years.

Furnished structure museums often use some form of artificial illumination to supplement daylight. One common method employs hidden electric lights directed toward the ceiling. Diffused in this manner the added light makes the furnishings easier to see on overcast days. If the fixtures are well chosen and properly placed, few visitors become aware of the addition. Use the supplemental lights only when really needed and check with a light meter to be sure the intensity at vulnerable objects does not exceed 15 footcandles (150 lux), or 5 footcandles (50 lux) for very light-sensitive items (see Climate Control, Chapter 4). Cover any fluorescent tubes with ultraviolet filters such as sleeves or sheets of Plexiglas UF-3. Another method of artificial lighting especially appropriate if a museum opens in the evening, uses period lamps. If these are candles, oil lamps or gaslights older than the incandescent mantle type, they will hardly be bright enough to cause photochemical damage. They increase fire hazards, of course, so must be closely supervised (see Protection from Fire below). They also produce enough soot to necessitate extra cleaning of ceilings, walls, ducts and air filters as well as often fragile furnishings. If the illuminating gas contains sulfurous impurities, it may release acidic combustion products.

The injurious insects most often found in historic structures are those that also infest our homes. So you may already know them by sight or by the destruction they cause (see Agents of Deterioration, Chapter 4). Sooner or later silverfish and cockroaches will almost surely attack your books, documents, prints, wallpaper or other historic furnishings composed of or containing paper. These pests eat the sizing, paste or glue, spoiling the paper or binding in the process. They may do similar damage to starched cloth. Carpet beetles and clothes moths, which feed especially on animal fibers, will likely invade rugs, woolen clothing and drapes. Expect them also in the hair stuffing of upholstery furniture and mattresses, in the feathers of feather beds and pillows and even among the bristles of brushes. The damage these insects cause can ruin objects for display in a short time. Termites and the several kinds of powder-post beetles too often severely damage not only the structural timbers and woodwork of a historic building but also the wood in its furniture. They feed on cellulose or starch in the wood. If termites encounter paper, cotton or linen in their tunneling, they will eat these sources of cellulose as well. When your historic structure museum represents a period before window and door screens were used, house flies will gain easy entry in summer. The principal harm will come from the specks you will need to clean from the furnishings and walls, unless you prepare or serve food in the museum. House flies can spread

disease when they get on food. All these destructive insects are hardy, wide spread and abundant. You need to guard against them actively.

To protect the building and its furnishings from insect damage take four countermeasures. These aim to: keep out the harmful species, deny them a favorable environment for breeding, detect their presence quickly, exterminate those that do get in. Because the threat of infestation is always imminent, the protective measures must remain in force.

Begin by trying to shut out the destructive insects. While their numbers, size and habits make complete success unlikely, you can minimize the occurrence of infestations. Furnishings acquired for an historic structure not infrequently contain eggs or active stages of these dangerous species. Avoid bringing the pests into the museum by first having each item of furnishing fumigated in a vacuum (see Organic Material, Chapter 3). This should kill all stages of the insects even hidden deep in wood borings, upholstery, stuffing or seams. If you cannot obtain vacuum fumigation, apply the best alternative methods you can. Have curtains, drapes, rugs, bedding, garments and other fabrics laundered or dry-cleaned under the supervision of a textile conservator. Thorough cleaning will probably eliminate any insects in them. Should expert cleaning be out of the question, take woolens outdoors on a sunny day. Brush them gently but thoroughly, turning pockets inside out and going over other concealed areas. Then let them hang in the sun for a few hours. The exposed wood of any furnishings should be inspected inch by inch. Whenever you find the round or oval hole made by a powder-post beetle larva, inject into it a recommended insecticide (see Organic Material, Chapter 3). Fumigate other furnishings following the instructions in Chapter 3. Such alternatives to vacuum fumigation will not reach the stuffing of upholstered furniture and mattresses or other filled bedding, nor the covered parts of wood. Knowing these to be potential sites of infestation, watch them particularly for signs of insect activity.

To keep termites out of the structure itself, first be sure that no wooden part of it comes into direct contact with the ground. Even a trellis might form a ready channel of invasion from soil to siding. Remove any wood lying on or in the soil near the foundation or beneath the building because its presence invites colonies to start. Fill cracks in foundation walls that might hide termite tunnels. Effective fillers include cement, coal-tar roofing pitch and rubberoid bituminous sealers, but you should have the restoration architect make the choice. Then have a reliable professional exterminator treat the soil along the outside and, if possible, the inside of foundation walls with an insecticide that will form a barrier against termites.

The second countermeasure to take consists essentially of good housekeeping. In an historic structure museum the furniture is seldom moved. No one sits on the chairs or sleeps in the beds. No one rummages through closets, drawers or book shelves. Such freedom from everyday use reduces

wear to a minimum, but it could allow any insect pests that may be present to feed and multiply undisturbed. Proper cleaning denies them this security. Use a vacuum cleaner frequently under and behind heavy furniture, along baseboard and floor cracks and in the other hard to reach spaces. Carpet beetles and clothes moths can breed in the rolls of dust and lint that readily collect there. Roaches and silverfish hide in such places by day. Vacuum carefully the folds, seams and crevices of upholstered furniture where insects might work unnoticed. Set up a schedule for remaking beds and for cleaning shelves, drawers, closets, cabinets and their contents. Since roaches and flies thrive on human food, enforce scrupulous cleanliness in kitchens where period cookery is demonstrated, in any room where staff members may lunch and for those rare special occasions when food and drink are served to guests. Conscientious cleaning provides the best overall defense against insect damage. You can practice it without sacrificing the important interpretive aspects of housekeeping if you keep both objectives clearly in mind (see the introduction to Chapter 11).

As your third protective action maintain a close watch for infestations. Organize your vigilance on three levels. Request all staff members consciously to look for insects or insect damage as they carry on their regular duties. Have them report what they observe. Require this continual search particularly of those who do the daily cleaning and of whoever makes the daily security inspection. Be sure everyone on the staff can recognize the harmful insects and the signs of their activity. At the next level make a thorough periodic search for evidence of infestation. Go over the building and furnishings in detail at least three or four times a year. Finally, because termites can do much damage with little or no visible evidence of it, call in a professional exterminator to check for them. How often you should do this depends on the vulnerability of the structure as determined by its location as well as the materials and methods of construction. Termites attack buildings in every state except Alaska. The milder the climate, the more frequent and destructive the attacks. If your museum is in the Gulf States or California, have it inspected each year.

In making your own inspection look for several kinds of evidence. Cockroaches are large enough to catch the eye readily (fig. 12a). They come out in the open at night, so you need to check for them then. When you suddenly turn on the light, you may see one or more roaches scurrying for cover. Also search their normal hiding places by day. These include the undersides or backs of drawers and shelves, the spaces under or behind sinks and built-in cupboards, the crevices of furniture, baseboard and wall cracks and openings around pipes or conduits. Look for their small, brown, leathery egg cases in these same locations (fig. 12b). You can spot silverfish when they move, although they are smaller and less conspicuous than roaches (fig. 10). They also hide during the day and should be looked for at night. In the daytime you may see them when you take books from a

shelf and leaf through them. Also look closely at the backs of pictures and among stored papers. Search their preferred hiding places. Cool, damp basement walls attract one kind, warm walls near furnaces or attics in summer another. Examine the surface and edges of any paper for signs of their feeding (fig. 11). The bristly larvae of carpet beetles and other dermestids are small but easily recognized once you have seen them (fig. 7). Search for them feeding on the pile of undisturbed rugs or beneath them or in woolens and other animal products. If you find spots where they have destroyed an area of fibers, intensify the search. Often the first evidence will be the cast skin of a larva, still bristly, left behind on the fabric or in the floor dust. When the beetles are at work in the hair stuffing of a chair or mattress, you may be fortunate enough to detect them by a fine, grayish powder sifting out through the bottom. A glimpse of an adult clothes moth in flight or on any furnishing material of animal origin will warn you of a likely infestation. Examine all woolen fabrics closely for the small, white tubes or webs of the feeding larvae (fig. 9b). Look especially in folds, seams and other sheltered points. Check for moth holes as evidence of their work since your previous inspection. Remember that they may also infest furnishings containing hair, feathers and bristles. Detect powder-post beetles by the fine, whitish powder you may tap from their holes or that may accumulate in little piles beneath the wood in which they are working. For termites your regular inspection should consist of a close examination of the foundation walls inside and out as well as any other part of the building that touches the ground. Look for the tubes a colony may build up the surface or in the cracks of a masonry or concrete wall or post to reach from soil to wood. Also watch for a scattering of small, transparent wings inside the rooms. Breeding adult termites discard them when they swarm. Whenever you discover evidence that any of these kinds of harmful insects are present, implement the fourth measure of protection without delay.

The fourth step consists of destroying the insects before they do further damage. It often involves the application of one or more insecticides. Most of these are poisons. They can harm you or your visitors if not used properly. Some have proven to be dangerous, long-lasting sources of environmental pollution. So employ insecticides with care and conscience, as well as in strict accordance with the Federal Insecticide, Fungicide and Rodenticide Act as amended (Public Law 92-516). The commercial formulations change, as do the regulations governing their sale and use. Therefore, do two things before using a pesticide. Consult a recent authoritative publication such as the latest edition of the U. S. Department of Agriculture's Home and Garden Bulletin No. 96, *Controlling Household Pests.* Read carefully and follow the instructions on the insecticide container and in any accompanying leaflets. You cannot lawfully use the insecticide in any other way. In addition, avoid applying these chemicals

directly to historic furnishings unless you have assurance from an expert conservator that it is safe to do so. This restraint complies with the general rule of specimen conservation to use only substances of which you know the composition and effects. With these precautions in mind consider the following methods.

To get rid of cockroaches, apply a persistent contact poison to surfaces over which the insects will crawl. Then use a fine insecticide spray directed into cracks and corners to flush the roaches from their hiding places. To treat the surface select an insecticide in liquid or cream consistency, recommended by the manufacturer for cockroach control and containing a poison approved for this purpose in the USDA Bulletin cited (the 1971 edition suggests diazinon, malathion or ronnel). Rather than spraying it, use a brush to paint it on the critical areas of floors, baseboards, pipes, shelves and other surfaces close to the probable hiding places. The petroleum distillates that form the base for many household insecticides may injure parquet, linoleum or asphalt tile floors. So use the material sparingly in these situations. For the fine spray use an aerosol containing pyrethrum. Should the historic structure be heavily infected with roaches, you may need to call in a professional exterminator. Have him specify in advance the content of the insecticides he will employ and check these with the USDA Bulletin. Also make clear your restrictions about applying insecticides directly to articles of historic furnishing without prior approval by a conservator. One of the safest and longest lasting materials he could use might be a silica aerogel.

To eradicate silverfish first fumigate any papers into which the pests have gotten (see Organic Material, Chapter 3). Then spread a contact poison on surfaces over which they will crawl. Choose an insecticide recommended and approved for use against silverfish (USDA Home and Garden Bulletin No. 96, 1971 edition suggests chlordane, lindane, malathion or ronnel). Brush it on book shelves behind the books, around the back edges of picture frames and on other surfaces adjacent to paper the insects may attack, but not on exposed parts of historic furniture unless a conservator approves. Use a fairly course spray to apply the insecticide to basement or attic walls where silverfish may be breeding. If the product contains petroleum distillates avoid spraying near any pilot light, other open flame or electrical equipment which might ignite the flammable mixture.

When you find evidence that either carpet beetles or clothes moths are at work, have the affected or suspected furnishings vacuum fumigated promptly (see Organic Material, Chapter 3). If this is impossible, have textiles washed or dry-cleaned in accordance with a conservator's instructions, or sun and brush them carefully. Consider at this time treating woolen fabrics, furs or other furnishings largely composed of animal fibers with a mothproofing chemical to deter reinfestation. If you mothproof, use

only materials and methods specifically approved by a conservator (see é.g. H. J. Plenderleith and A. E. A. Werner, *The Conservation of Antiquities and Works of Art: Treatment, Repair, and Restoration*, 2nd ed., London, Oxford University Press, 1971, pp. 114–115; but the products they recommend are not necessarily registered with the Environmental Protection Agency and available in the United States). For historic upholstered furniture or stuffed bedding no alternatives to vacuum fumigation are presently registered. Fumigate these furnishings as directed under Organic Material in Chapter 3. While you have removed the furnishings for treatment, brush or spray a persistent contact insecticide on surfaces in the room where the larvae might crawl. These include the edges of baseboards and moldings, floor cracks, closet walls and shelves, curtain or clothes rods and their attachments or other places where dust and lint tend to collect. Again select one of the insecticides recommended and approved for this specific purpose (USDA Home and Garden Bulletin No. 96, 1971 edition, lists chlordane, diazinon, lindane, malathion and ronnel in particular concentrations). If any item of furnishing vulnerable to these pests is stored out of sight, wrap it after treatment in a tightly sealed package which also contains an open weave cloth bag filled with paradichlorobenzene crystals. Use the crystals at the rate of one pound per 100 cubic feet (162 g per m³).

If powder-post beetles get into a piece of furniture or wooden implement, have it vacuum fumigated without delay. The alternatives are to paint the infected wood with an oil-base insecticide containing 2% chlordane or inject an insecticide containing lindane into the individual holes bored by the beetle larvae. When the wood has a finish, inject the product having EPA Registration No. 18910-2 into each hole using the pressurized container in which the insecticide comes. You can brush the chlordane mixture having EPA No. 876-100 liberally onto unfinished wood, but might find it safer to use the lindane injection method. If the larvae are in the timbers or woodwork of the structure, you can apply the same treatments to infected areas within reach.

Should termites attack the building, call in an expert exterminator. Have the restoration architect supervise any treatment or removal of original framing or woodwork. Furnishings into which termites have penetrated should be vacuum fumigated if possible.

Unless you regularly prepare or serve food in the museum, house flies should require no control beyond the use of fly swatters. If the flies become a real nuisance, spray the air in a room at closing time with one of the common household insecticides labeled specifically for use against flying insects. Follow the directions on the pressure can.

Insects are not the only dangerous animal pests. Mice, rats and in some situations other rodents including squirrels get into buildings to feed or nest. They can damage historic furnishings more rapidly than insects do (see Agents of Deterioration, Chapter 4). Guard against them by following

these simple procedures. First inspect the building for possible points of entry. Plug holes that would make it easy for these animals to get indoors. If any food attractive to them is kept in the building, store it in closed metal containers at night. Keep the grounds as well as the interior of the building clean in this respect. You cannot put out of reach all the furnishing materials that rodent teeth and claws might pull apart for nest building. So watch closely for evidence of this activity as well as for rodent droppings during every inspection (see suggestions above for detecting insect infestations). At the first sign of an infestation set snap traps. Locate them near walls along which the animals seem likely to run. Place the traps facing the wall so the intruders will pass close to the baited triggers. Bait the traps with peanut butter or other strongly attractive foods. If this does not clear up the invasion promptly, call in an exterminator. Because rats are hard to trap, you should consult the local health department or an exterminator as soon as you suspect their presence. In some instances keeping a cat may be the historic and effective way to combat invasions of mice, rats or squirrels.

Mildew attacks the furnishings in historic buildings wherever sufficiently warm, damp conditions exist. It grows destructively on paper, leather and cotton, linen, silk, wool or even rayon textiles. The mold can also flourish on interior walls, woodwork and paint. It not only weakens the materials on which it grows, but often leaves unsightly stains. Mildew is plainly visible under close inspection as thin, irregularly shaped, usually whitish patches on the surface of the object. You may also detect its musty odor. Look for it especially during humid spells in summer. Check poorly ventilated areas in particular. These include closets, bookcases, cabinets, the walls behind furniture or pictures and the space within picture frames. If you can keep the relative humidity below 70% in all such places, mildew will not become a problem. You can also inhibit mold growth by holding the temperature below 70° F. (21° C.). In the absence of an air-conditioning system capable of maintaining these conditions use room dehumidifiers and electric fans to eliminate likely pockets of damp air. When you do find mold on any article of furnishing, remove the object from the historic building so as not to spread the spores. If you can fumigate the specimen with thymol, do so (see Organic Material, Chapter 3). Should this be impractical, dry it either outdoors in the sun or with a flow of warm, dry air. You can generate the latter with an electric hair dryer or a combination of any heating device and an electric fan. As soon as the piece has been fumigated or dried, remove the mildew carefully with a soft brush and a vacuum cleaner. If a stain remains, consult a conservator before trying to remove it by washing, dry cleaning or bleaching. To protect vulnerable furnishings in poorly ventilated spaces from a recurrence of mold use paradichlorobenzene crystals as you would for clothes moths and carpet beetles (see Basic Steps, Chapter 4). Garments in closets or trunks and

books in closed bookcases can be treated in this way, for example. The chemical acts as a fungicide. When the mildew develops on walls or woodwork, these also need to be dried. Use heat and moving air, but proceed slowly enough to avoid cracking the plaster or warping and splitting the wood. Then wipe away the mold with a soft, dry cloth. If more is required to remove the growth or stain from historic surfaces, get the advice of a conservator. When the wall or woodwork is not original, you can try a cloth dampened with soap suds, with water containing a little washing soda or even with a fungicidal disinfectant containing quaternary ammonium compounds properly diluted such as janitors use. Then rinse the cleaned area using fresh cloths dampened with clear water. Finally dry it thoroughly as before.

Other kinds of fungus attack the wood in historic structures when environmental conditions permit it. These include species that cause soft rot, white rot, brown rot, dry rot and blue stain. To recognize these forms of deterioration and initiate their control consult William Merrill, "Wood Deterioration: Causes, Detection and Prevention," American Association for State and Local History Technical Leaflet 77, *History News*, 29:8 (August 1974).

Protection from Wear and Tear

People by their sheer number damage the furnished historic structures they visit. It is primarily a matter of mechanical friction. Surfaces that have withstood generations of normal use wear out under the heavy traffic visitors unavoidably create. Floors and floor coverings suffer most. Wall coverings and occasionally draperies also deteriorate faster in situations where many people brush against them. When the affected surfaces are original or actually date from the period being interpreted, protection sooner or later becomes necessary. The replacement cost of a reproduced carpet or wallpaper may sometimes justify protective measures as well, in spite of their intrusive effect.

While it is obvious that floors and floor coverings wear out because people walk on them, at least four factors affect the rate of wear. These are: the nature of the surface to be preserved, the number of feet treading it, the amount of dirt underfoot and the kinds of soles and heels on visitors' shoes. To determine the urgency of protection and the methods to use, consider each factor as it applies to the situation in your museum and the extent of your control over it. For example, a stone pavement resists wear longer than pine flooring and a Wilton carpet longer than an ingrain, but history rather than durability decides which you have to protect. You could not rationalize the installation of a flooring material or covering different from the original just because it would wear better. This factor is beyond your control. The second one is not entirely uncontrollable, but involves

difficult choices. The more people visit your museum, of course, the greater the wear on its floors. Is there a point at which the preservation of a floor justifies turning away people who want to visit? You may have authority to restrict the number admitted, but few museums have done so for this reason alone. If the need to protect especially vulnerable floor surfaces coincides with problems of safe floor loads, emergency evacuation or the quality of interpretive experience, limiting the number of visitors may be warranted. You can control the third factor to a greater extent. Grit and dust ground into a floor or carpet by visitors' feet accelerate abrasion. The more dirt tracked in and the longer it remains, the faster floor surfaces are damaged. Longer open hours tend to increase floor wear. Visitors coming late in the day do more harm that the same number earlier because they walk over floors that have become dirty in the meantime. The situation is liable to grow progressively worse if the cleaners have more dirt to remove and less time in which to do it. You can do things to minimize the amount of dirt on visitors' shoes as they enter and you can regulate cleaning schedules. The fourth factor involves the vagaries of fashions. The 1960's vogue of spike heels on women's shoes seriously damaged many historic floors. Any hard soles or heels cause more floor wear than soft ones. So be alert to the kinds your visitors are wearing as styles change. Some may require protective measures. Your analysis of these determinants of the rate of wear should help you choose among the protective methods that have been used, or develop better ones.

Floor protection commonly includes two sets of measures, both designed to reduce abrasion. One keeps the floors clean where visitors walk or stand. The other puts a layer of expendable material between the bottom of visitors' feet and the surface particularly liable to wear. Action on the first set should begin at the parking area. If this is clean underfoot, it minimized the transport of dirt indoors. A pavement of stone, brick, cement or blacktop would be preferable to gravel in this respect. Less intrusive and as effective might be a perforated cement surface largely hidden by grass growing up through the openings. If adherence to historical accuracy allows a choice in the kind of walkway leading to the historic building, one that leaves shoe soles cleanest would naturally be best. A brick path would tend to create less dirt than one of gravel. Tanbark would leave a less abrasive residue on shoes than would oyster shell. Well drained paths stay cleaner. Hard surfaced ones should be swept regularly. At the entrance a clean, effective doormat would invite visitors to wipe their feet as they come indoors. Inside, the floor along the tour route should be kept as free of grit as possible. If a thorough daily cleaning is adequate ordinarily, it may need to be supplemented during wet weather and on days of peak attendance (see Methods and Materials, Chapter 11 for floor cleaning techniques).

A protective layer can be interposed between floor and feet in either of two ways, by placing it on the floor or on visitors' feet. Some historic

buildings in Europe require visitors to remove their shoes, carry them in a bag provided and don soft slippers for the tour; or the museum issues large, shaggy cloth covers with elastic tape to slip on over shoes. A number of historic structure museums and other have counteracted the devastating damage of spike heels by providing plastic pads that fit onto the heel tips. The other approach is far more common, being simpler to manage although undesirably intrusive. The covering laid on the floor may extend along the entire tour route as a continuous strip. More often it provides a protective pathway across an historic carpet or old flooring which is easily damaged or irreplaceable, or covers the restricted area in front of room barriers where the concentration of visitors causes maximum wear. Whatever material comprises the protective floor covering should combine several attributes. It needs to absorb the wear without transmitting it to the underlying surface. It should therefore be reasonably thick and resilient. It should stay firmly in place as people walk on it so it will not rub against the protected surface continually. For reasons of economy it should be long wearing and easy to clean. For safety it should provide good traction. The problem is to find these virtues combined in a material that is also inconspicuous. While it should be clearly a nonhistoric addition to the furnishings so anyone noticing it would not be deceived, it should detract as little as possible from the historic impression. Manufacturers produce several kinds of runners and mats designed to protect modern floors and carpets in buildings subjected to heavy foot traffic. Available types include rubber, vinyl and carpet-faced. Rubber mats and runners of several thicknesses come in smooth, ribbed and textured surfaces and in a moderate range of colors. Vinyl ones offer a choice of ribbed and textured surfaces and may be translucent or colored. Carpet-faced ones usually have a nylon pile in plain or mixed colors and a vinyl back. These special purpose coverings afford a good selection in regard to resiliency, wear, cleaning characteristics and safety. Although they tend to appear uncompromisingly modern in an historic building, some may fit particular situations quite well. Strips of carpeting provide another kind of material for protecting historic floors or rugs. Coming in such a great variety of colors, patterns, structure and fibers, carpeting may blend more satisfactorily into many settings. A carpet runner, for example, can match the colors of a protected rug while differing enough in pattern to distinguish it from the original. Carpet manufacturers make some types designed to take hard wear and clean easily. Eighteenth- and nineteenth-century householders occasionally protected their valuable rugs by laying over them floor cloths of drugget, baize or painted canvas. Some furnished structure museums use canvas or similar woven fabrics where visitors walk over historic materials. Straw matting has also been used. Whatever protective material is chosen, be sure that its use does not accelerate wear through friction between it and the historic surface. If it is composed of or backed with rubber or a synthetic

plastic, have a conservator check to be sure no chemical emanation will damage the rug or floor beneath it. Some reprocessed rubber may be particularly suspect.

Historic wall coverings usually need protection only in limited areas where visitors tend to crowd into a small space. This situation occurs, for example, when a room barrier restricts viewers to the corner of a room. A frequent solution is to cover the endangered area of historic material with a rigid transparent sheet such as glass or a clear acrylic plastic (e.g. Plexiglas). The plastic weighs less so should be easier to install, but scratches more readily and requires more careful cleaning (see Case Exhibits, Chapter 15). If glass is used, it should be one of the safety types to lessen the serious risk of breakage. Mount either material out from the wall so air will circulate behind it. Otherwise condensation may damage the wall covering. The moving air should also carry away any harmful chemicals a synthetic plastic sheet might emit. To minimize the intrusive effect as well as the cost make the transparent shield no larger than necessary. Cover only the wall area actually requiring protection. It may need to be only shoulder high or up to eye level unless the historic surface especially invites touching. A flocked or embossed wall covering may call for shielding within arm's reach.

In similar situations visitors may crowd against, or be tempted to finger, historic window draperies or wall hangings. The fabric within reach then requires a protective covering. A sleeve or envelope of thin, transparent polyester film (e.g. Mylar) usually accomplishes the purpose, although not without detraction in appearance.

Historic chairs, benches or sofas along the tour route sometimes suffer damage if leg weary visitors sit on them. Experience indicates that the best protection occurs when an attendant at the outset explains to visitors where they may sit down to rest and why they should not sit on historic pieces. The old practice of stretching a cord or ribbon across the arms or from back crest to seat front does not make visitors feel welcome. Placing "Do Not Touch" signs on the seats effectively destroys the sense of experiencing history.

Protection from Visitor Abuse

A small proportion of visitors to furnished historic structure museums cause deliberate damage. In most cases they seem impelled to take or leave a souvenir of their visit. They surreptitiously pocket small objects or detachable fragments. Occasionally the urge is strong enough for them to lift a child over a barrier and send it across a room to snatch something. Less often they carve initials or indulge in other forms of graffito. Rarely a psychopathic individual wreaks wanton destruction. The people under consid-

eration here come in as ordinary visitors. They probably have no specific intention of stealing or vandalizing. You can distingush them from the majority only by witnessing their unacceptable actions. Unfortunately, these occur often enough to make protection essential. It involves, as a rule, surveillance, fastenings, barriers, alarms or combinations of these measures.

To protect the building and furnishings from abuse by visitors rely first on surveillance. Few incidents take place under the eyes of an alert attendant. Watchfulness prevents losses. Its main purpose is to deter a person who might act on impulse rather than to catch him in the act. So keep visitors under observation, but do it in a manner that leaves them practically unaware of it. In this kind of museum they need to get a pervading sense of historical reality. It would evaporate in the presence of people who were obviously guards. Therefore, employees engaged in other activities must do the watching. Receptionists, tour leaders, stationed interpreters, demonstrators and daytime cleaners should look for pilfering or petty vandalism as they carry on their primary duties. Successful surveillance under these limitations requires careful planning and adequate manpower. Every situation calls for its own solution. One museum allows only four visitors per well trained guide to assure full control. Another assigns two attendants to a tour group of 20–30 people, one leading the party while the other follows to make sure no one lags behind unobserved. Some museums station an attendant in each furnished room or on each floor to explain and answer questions, but also to watch. A costumed employee can clean, do needlework or carry on some other appropriate activity in an area that would be unsupervised without it.

The staff members who keep an eye on visitors along with their other duties must know what to do when someone does commit a misdemeanor in the museum. At that critical moment they must act instantly and correctly. Their legal authority in such a situation has strict limits. If, while they are summoning help, the culprit can replace the snitched souvenir unobserved, further action will embarrass the museum or worse. Work out practical procedures in detail with the local law enforcement agency. Tailor them to the individual employees, who will vary in their capacities for confrontation. Train and rehearse the staff in these important functions. Be sure they know how to observe without annoying, how and when to warn or reprimand, how to get assistance quickly. Then consider the other measures, which can only supplement the proximity of a staff member.

The exceptional visitor who attempts to steal some small object for a souvenir usually counts on snatching it quickly. If it is fastened down, he rarely will risk the time and commotion necessary to break it loose. Securing it in place therefore offers a measure of protection, especially for small items of furnishing which visitors can reach from normal viewing areas. Tempting things not infrequently have to be placed within reach. You cannot simply leave the candlestick off the mantelpiece or move the table

to another part of the room when it is contrary to the historical evidence to do so. The recreated environment ought to be as accurate and complete as possible. Yet to fasten an historic object securely and inconspicuously without defacing it or injuring whatever it is attached to demands considerable ingenuity. Making a hole in a specimen for a screw, nail or other attachment commits vandalism. Driving screws or nails into the historic fabric of the building for this purpose is almost as objectionable. Strong adhesives become very difficult to remove with damaging one or both of the joined surfaces, so are seldom acceptable fasteners. For some objects try looping a strong, almost transparent nylon monofilament, such as a fish line or leader, around or through the object and anchoring the other end of the line at a hidden point to something solid or heavy. A book might be so fastened to the pedestal of the table on top of which it lies, for example, or a pen to the hinge of the desk top. Try cutting and forming a sheet of transparent acrylic to clasp the base of a candlestick or ink well, extending the plastic fitting to the edge of the supporting surface and bending it down and under to clip the object rather firmly in place. Strap brass may also be fabricated to fit an object closely and then clamp to the support beneath its far edge. In favorable situations the brass becomes scarcely noticeable when painted to match the background. Specific circumstances will suggest other practical methods for attaching articles of inviting size displayed within visitors' grasp. Sometimes the value of the original object and the difficulty of fastening it securely may warrant substituting an expendable copy.

Room barriers comprise a second supplementary protective measure (fig. 47a–e). They keep most small objects out of reach by holding visitors back from selected parts of the furnished interior. In addition, they prevent wear and tear on furnishings and floors in the protected areas and help channel traffic to fit the interpretive plan. All barriers are intrusive, but some detract surprisingly little from the sense of history that visitors experience. The least objectionable ones seem to share three characteristics. They remain below the line of sight while visitors form their impressions of the furnished space beyond. People do not have to look through them except from a distance. They appear neat and attractive when noticed because they meet good standards in design, materials, workmanship, installation and maintenance. They provide a comfortable feeling of assurance about where it is proper to go in a museum, implying more strongly that visitors are welcome here than forbidden there. In practice room barriers range from hardly more than a suggestion of restraint to complete enclosures. They tend to grow more formidable when incidents of petty theft or vandalism have occurred, but this natural reaction seldom leads to the best solution. When barriers approach chest height, they seriously affect the historical atmosphere. If they fully enclose the opening, they destroy any likelihood of empathy between visitors and the historic occupants. Looking

a. Room barrier, Governor's Palace, Colonial Williamsburg. Light stanchions and cords, about knee high, effectively channel large groups through the room. Courtesy, Colonial Williamsburg Foundation.

b. Room barrier, Vanderbilt Mansion National Historic Site. Rope, stanchions and end hooks fit the elegance of the setting.

c. Room barrier, Sunnyside, Sleepy Hollow Restorations. A single bar hinged at one end and latched at the other stops visitors at the bedchamber door, but gives the staff quick access.

d. Room barrier, Sunnyside, Sleepy Hollow Restorations. Most visitors respect the simple stand with cross dowel at the doorway, but a staff member can easily set it aside.

Figure 47. Examples of successful room barriers.

Corner Details

Showing piano hinge location

C B

B A

3'–0" ±

B

6'–0" ±

C A

2'–6" ±

Open Position

3'–0" ±

Material:

3/4" BIRCH PLYWOOD
FINISHED IN 'WEATHERED
GREY OIL STAIN

A→ B

C

Folded Position

B

Kitchen Parlor

A

C

Room Plan

4"

3" Radius at all
inside corners

4"

Furniture glides under
all corners

Corner Detail

e. Enclosing a viewing area, General Meade's headquarters, Gettysburg National Military Park.

at a furnished room through a glass or plastic shield or a prison-like grille changes its interpretive character from an environment for life to an inefficient display of antiques. Good barriers, therefore, depend primarily on their psychological effect. They obstruct physical passage as little as circumstances permit. When the number or kinds of visitors and the insufficiency of attendants require substantial bars, these are only high enough and strong enough to force an intruder to climb over them. This much obstruction will stop all but a few determined pilferers. Other protective measures discussed in the next section help deal with such incursions. Good barriers also fit into the historic setting, not by trying to look like part of the original structure but by being unobtrusively functional. Wide differences in individual situations preclude standardization. Many varieties of barriers have proven successful when used in the right places. To design or select a suitable one calls for taste and judgment.

Some barriers mark one or both sides of the tour route passing through a room. Others form a viewing space within a room where several people at a time can stand as they look. Still others stop visitors at a doorway from which they can see the contents of the room. In any of these forms the barrier may be a rope or chain, a rod or a fence. Ropes used for this purpose vary from plush-covered ones 1½ inches (38mm) or more in diameter to quite slender cords. Velvet-sheathed cables, braided silk or rayon cords and ornamental chains connote wealth and luxury. In the many settings where these are inappropriate, plainer materials work better. A ⅜ inch (9.5 mm) nylon rope affords ample strength, for example. It can be wiped clean and, if dark colored, is relatively inconspicuous. A barrier rope ordinarily needs to have an open hook or snap hook spliced or otherwise neatly attached at each end to fasten into an eye on a stanchion or door frame. Merely tying the barrier to a doorknob or latch keeper as well as leaving the ends frayed or knotted debases the installation. Screwing eyes into historic woodwork for fastening the barrier implies a lack of respect for the structure. So stanchions often provide more acceptable as well as more adaptable supports. Although the heavy stanchions intended for crowd control in places of public assembly are efficient, they look out of place in many furnished interiors. Manufacturers supply lighter ones, and museums also make them to fit particular needs. Either ½ inch (12.7 mm) iron rods, which may be round or square, or 1½ inches (38 mm) wood posts provide satisfactory uprights. Bases can be of wood or iron, but require enough breadth and weight to resist tipping when visitors accidentally push against the rope. One 12 to 15 inches (305–381 mm) across and weighing at least 10 pounds (4.5 kg) should suffice in many situations. Lead poured into holes bored in the bottom of a wooden base can provide necessary ballast. When a rope barrier borders the route of a conducted tour, the stanchions may stand a foot or less in height (c. 300 mm). When circumstances make a higher barrier preferable, they average

three to three and one-half feet tall (.9–1 m). Stanchions usually stand not more than four feet apart (1.2 m).

Rod barriers use rigid bars of wood or metal in place of ropes or chains. Like the preceding type they mark the limits of permissible entry rather than creating an obstacle difficult to penetrate. A long rod held several inches above the floor on free standing supports can designate a tour route or a viewing area. A shorter one held horizontally by a single stanchion can close a passageway. A bar firmly anchored at each end and three to four feet (.9–1.2 m) above the floor can stop visitors at a door or wider room opening. In each case the rod and its support should reflect careful workmanship in construction and finish. They should respect the integrity of the original structure and the historic setting they help protect. Good sense suggests that a low wooden bar be rectangular in cross section with a sharp edge up so visitors will be less liable to rest their feet on it. Conversely, a higher, well anchored one should be comfortable to lean on and pleasant to touch.

Barriers in the form of a fence or railing often stand at the doorways of furnished rooms or enclose viewing areas just inside the doors. When they extend across a room these barriers become more conspicuous and seem justified only if visitors go through unattended or in groups too large for adequate surveillance. Most of the good fence barriers in use range from three to about four feet high (.9–1.2 m). A sneak thief should find it risky getting over a barrier higher than three feet while other people are likely to be nearby. At four feet most adult visitors can rest their forearms comfortably on the top rail as they scan the furnished scene. The top rail should be thin to minimize its visual intrusion, smooth to the touch without sharp edges and easy to keep clean. Both extruded metal and polished hardwood can meet these conditions, the best choice depending on the setting. If the bottom rail is raised a few inches above the floor, dust mop and vacuum cleaner can do their jobs easier. People, especially children, will step on this rail. So it should be strong enough to take the weight and have a durable finish that can be readily maintained. A hard paste wax on metal or wood may stand up better and renew easier than a paint finish in this circumstance. As in most railings the upright supports between the top and bottom members should be no more than 4–5 inches (c. 100–125 mm) apart for the protection of small children. Metal has one advantage over wood for these uprights because it can provide the required strength in smaller sizes and the thinner the upright, the less conspicuous. Quite a few young visitors cannot see over a four-foot railing. Rather than condemn them to look at the room through bars or plastic, some museums design barriers with a viewing space below the top rail (fig. 48). Some fence barriers can support themselves without attachment to the structure. More often they require fastening to the floor, door frame or wall. When this involves historic woodwork, consult the restoration architect to make sure

that damage to the fabric of the building, if permitted at all, is minimal. Staff members need to get into rooms protected by these barriers, perhaps quickly in an emergency. Consequently some railings include gates or are mounted on hinges. Gates must latch securely, and in extreme cases lock. The need for hinges and latches complicates both construction and anchoring. Figure 49 shows one National Park Service solution in which the barrier lifts to unlatch.

Figure 48. Room barrier, Arlington House, George Washington Memorial Parkway. Children can look through the space below the handrail or stand on the bottom rail to see over the top.

Detail A Full Scale

Detail B Full Scale

Grillwork Door Guard
Revised January 29,1969

Figure 49. Lift-off barrier permitting emergency access by staff.

The third supplement to surveillance consists of detection and alarm devices. These can guard valuable furnishings which must be left unwatched part of the time during open hours. If a visitor enters an area or attempts to remove an object protected by such devices, they summon help. Their usefulness thus depends on a responsible person receiving the signal and reacting promptly. The increasing variety of detection and alarm equipment provides an opportunity to choose the combination best suited to a particular situation. In selecting components or a complete system consider not only cost but also safety, reliability and ways in which the installation will affect the museum. For safety be sure that all parts of the system are listed by the Underwriters' Laboratories and that all wiring conforms to the National Electrical Code (NFPA 70, see also 70A, Dwelling Electrical Code). As to reliability all systems demand regular inspection and maintenance. Find out how frequently by consulting other museums that use the ones under consideration. The protective equipment can have several side effects on the museum. Visible devices tend to detract from the sense of history visitors should experience as they view the protected area. To hide them or wire them may entail damage to original woodwork or disturbing the historic placement of furnishings. Some types of alarm interrupt staff activities throughout the building. Others require a staff member to be stationed at the instrument which displays the signal.

With these factors in mind evaluate available equipment. Potentially useful detectors include pressure sensitive floor mats, capacitance units, microwave units, photoelectric devices, closed circuit television and miniature pressure switches among others (see Agents of Deterioration, Chapter 4). The size of a television camera and of the sending and receiving units of a photoelectric installation makes their concealment difficult in a furnished historic structure, although they are good detectors. In rooms with a floor covering thin pressure mats can be hidden beneath it at points where an intruder would have to step, but care is necessary to make sure that sharp eyed visitors cannot discern the mats under a light weight carpet or floor cloth. These mats work like the ones that open supermarket doors. The added weight closes an electrical contact embedded in the mat. This sets off an alarm. A capacitance unit consists of a small metal box (e.g. about $3\frac{3}{4} \times 2 \times 1$ inches or $95 \times 51 \times 25$ mm) mounted in the protected area and connected to a larger control box which can be elsewhere in the building. The unit generates a radio frequency field or "electronic fence" around an ungrounded metal object to which it is connected. A body or hand entering this invisible field alters the balanced circuit enough to trigger an alarm. The ungrounded metal may be foil behind, beneath or within protected furnishings. A microwave unit, although a few inches larger than the preceding one, can operate from a greater distance. It emits and receives a radio beam precisely focused to cover a limited area within a room. Any movement into the protected zone disrupts the pattern reflected

to the receiver and activates an alarm. Miniature switches guard individual items of furnishing such as an especially vulnerable chair, picture or candlestick. The object rests on the switch, its weight preventing the flow of electrical current. Any attempt to lift the object allows current to pass through the switch and reach the alarm mechanism. The fine wires leading to the switch can be quite inconspicuous in favorable circumstances, but the thickness of the switch, although only a fraction of an inch, may cause installation problems.

The alarm at the other end of the line in each case can also meet particular needs. Some situations may justify a clanging bell or blaring, gas powered horn audible even beyond the premises. Often a softer bell or buzzer located close to each protected area will effectively call a nearby attendant. Any type of detector can activate a taped warning message broadcast at the point of intrusion. The sound can be set just loud enough to alert the nearest attendant as well. If the museum has a continuously manned station, the alarm may take the form of a signal on a central control panel telling where the incident has occurred. While some museums have the staff capability to develop and install their own detection and alarm systems using off-the-shelf components, most will find it desirable to obtain proposals from two or more reputable protection specialists and confirm their choices on the basis of successful installation in similar institutions. Some leading firms in the field offer free consultant services worth investigating.

The attitude of the public toward the museum reinforces or works against the measures already discussed. An intangible but effective form of protection operates when people regard the historic building with its furnishings as a prime community asset, when they feel personal concern for it. A museum which not only cultivates but earns the respect and affection of its public minimizes problems of visitor abuse.

Protection from Burglary

A building filled with carefully selected antiques becomes a concentration of marketable goods liable to attract burglars. Furnished historic structure museums therefore need to maintain security at night, and whenever else they are closed as well as during open hours. Refer to the precautions noted in Chapter 4. They apply to the historic structure museum with similar urgency. Establish protection along these lines, but with full respect for historical integrity. Assign to one staff member clearcut responsibility for security. Observe the daily closing and inspection procedures with unremitting care. This should assure that every person has left the building, that all doors and windows have been locked and, upon reopening, that nothing has been taken. To these basic measures add as many of the following as the individual situation can justify. Altogether they form three

lines of defense. The first aims to prevent a would-be intruder approaching the building. High fences or outside detection and alarm systems would usually compromise the historic setting. Exterior lighting to illuminate the doors and windows through which a burglar would have to force his way acts similarly as a strong deterrent. Careful placement often can make the fixtures quite inconspicuous by day. When history rather than security determines the foundation planting, additional lights may reduce potential hiding places in the shrubbery. The second line of defense lies at the doors and windows themselves. Their locks should resist forcing, but the installation of modern ones can easily damage historic woodwork or appear obviously anachronistic to visitors. In this case consider ways to bolt, bar or brace the windows and most doors inconspicuously from the inside, leaving one service entrance to lock with the best modern security hardware. To protect the points of entry more fully equip them with magnetic contacts or other detection devices that send an alarm when someone opens a door or window. Install the devices, as they can be, in ways that will seldom catch a visitor's eye. Should a burglar gain entry through a door panel, window pane or otherwise without detection, the internal defense line provides a third means of foiling him. This may consist of a night guard, but furnished structure museums do not always employ one. As a replacement or supplement there is a choice of automatic systems that can detect and report the presence of an intruder. Some use ultrasonic waves, microwaves or infrared beams to sense his movements. Others react to his body heat or to whatever source of light he uses. Each of them can send a telephone signal to the home of a designated staff member, to the central station of a commercial security agency, or possibly to the local police. Probably to less advantage they can set off a loud alarm at the museum in the hope that the burglar will flee without taking anything while neighbors or passersby call the police. Sophisticated detection systems require regular, expert maintenance. Their sensitivity may result in false alarms. As already suggested, their value depends on the speed with which a capable, responsible person answers their summons. If they involve equipment that visitors will see, the adverse effect on the sense of history being evoked makes their installation questionable.

Protection from Fire

The record of destruction caused by fire in historic structures underlines the need for concern. If you take seriously the museum's obligation to preserve its collections, and its responsibility for the safety of staff and visitors, you will maintain an active fire protection program. A good way to start is to study the booklet, *Protecting our Heritage: A Discourse on Fire Protection and Prevention in Historic Buildings and Landmarks,* published

by the National Fire Protection Association in conjunction with the American Association for State and Local History. Other steps should follow logically.

In many cases the next step comprises an expert analysis of the problem. A well qualified team composed, for example, of the museum's architect and a fire protection engineer (located through the Society of Fire Protection Engineers, Boston, or your insurance company) examines the property and operations in detail. This intensive study searches out the conditions which might cause a fire and contribute to its spread. It checks the surroundings for possibilities of ignition from outside, the vulnerability of the site and building to lightning, the nature and condition of the heating and electrical installations, maintenance practices that might invite spontaneous heating or carelessness in handling and disposing of flammable supplies, interpretive activities involving heat or open flame, visitors' attitudes that might lead to arson, and other potential sources. Weighing these risks it explores practical ways to minimize the chance of fire originating from each. The investigation also notes the kinds and amounts of combustible material in and near the historic building that might feed a blaze, and studies how to reduce, relocate or isolate them. It spots conditions likely to accelerate the spread of smoke, heat or flame into and through the building, then determines what corrective changes would be feasible. It observes how a fire would be detected and reported, and considers the various available ways to increase the efficiency of these important functions. The inquiry extends to the resources on call for extinguishing fires: water supply, equipment, trained fire fighters and other factors. If these do not seem adequate, it examines ways to improve and supplement them. The safety of people in the museum in case of fire comes under close scrutiny. Given the existing conditions how many people could get through the corridors, down the stairs and out the exits in time? From such considerations the experts formulate evacuation procedures and evaluate the possible need to limit numbers of visitors or make structural modifications. Another point of special concern is the protection of the furnishings, particularly items of exceptional historic value, should fire occur. This enters every calculation of risk and remedial action. It may also call for special salvage provisions. The study results in a report which should include cost estimates and recommended priorities. (See also Appendix G.)

The experts' report goes to the governing board or whatever authority has ultimate responsibility for the museum's collections and policies. Whoever sets policy must make the hard decision as to how much loss from fire the museum could tolerate, what proportion of resources to devote to fire protection, and the sequence of actions needed to achieve adequate protection. Then the report provides guidance for the staff to initiate well considered measures to reduce hazards, upgrade protective equipment and organize a continuing program of fire protection.

The staff faces other difficult choices in making a furnished historic structure as safe from fire as possible within the policy limits adopted. Conventional fire safety practices often seem to conflict with the museum's obligation to preserve the historic appearance. From the first point of view portable fire extinguishers should hang conspicuously at critical locations for instant use by the nearest person; detection devices and sprinkler heads should be exposed on the ceilings to achieve their maximum effectiveness; lighted signs should mark exits; the added safety of structural changes to make walls more fire resistant or to run water lines for automatic sprinkler or standpipe systems should outweigh questions of historical integrity especially in hidden places. From the other standpoint such intrusions and alterations would seriously erode or even destroy the values both sides earnestly aim to preserve. Fortunately experience has demonstrated that when a fire protection expert and a curator both approach the problems with open minds and the patience to understand each other's reasoning, creative compromises can ensue. Museums with exemplary fire safety have in fact successfully concealed from general view portable fire extinguishers, hydrants, detection devices, sprinkler heads and other fire protection provisions and have avoided the use of exit signs. To balance any curtailment of efficiency in each case these museums have instituted and maintained specific compensating measures. They carry out more frequent and thorough inspections, upkeep and staff training. They control public use more closely. The way to reconcile the demands of fire safety with those of historic preservation and interpretation is to match each deviation from standard practice with steps to achieve a corresponding degree of protection by other, more acceptable means. These alternative steps usually entail greater responsibility for the staff and involve the unflagging maintenance of an intensive fire protection program.

The fire protection program for a furnished historic structure museum should follow the outline comprising Chapter 10, Organization and Supervision, in the National Fire Protection Association Publication No. 911, *Recommended Practice for the Protection of Museum Collections from Fire*. As with security one staff member should be charged with the day-to-day management of the program (see Agents of Deterioration, Chapter 4). Usually the same person acts as security and fire protection manager. This individual needs ready access to the museum director, or to the park superintendent in the case of a park museum, so any recommendations will receive prompt consideration and rules will be enforced. The fire protection manager's duties should include:

1. Daily inspection to sustain a high level of fire safety in housekeeping and grounds keeping, storage and disposal of combustible materials, selection and use of electrical appliances, observance of smoking regulations, maintenance of corridors and exits clear of obstructions, correction of

other fire hazards that may develop and protection of the original copy of the museum catalogue.

2. Periodic inspections and tests, at recommended intervals usually in collaboration with an appropriate technical specialist, of fire detection and alarm systems, portable fire extinguishers, fixed extinguishing systems, materials treated with flame retardants, heating plant and electrical installation.

3. Liaison with the local fire department, facilitating its thorough familiarity with the building and contents and its advance preparations for meeting an emergency in the museum.

4. Staff motivation and training in fire safety so each individual actively supports the program, knows what to do in case of fire and has become skilled in doing it; with supplementary training for those selected to monitor evacuation, operate fire extinguishers or carry out salvage operations.

5. Personal study to become increasingly knowledgeable in fire prevention and protection.

6. Leadership, when fire breaks out, to insure effective action in calling the fire department, clearing the building, utilizing the extinguishing equipment until the firemen arrive, supporting their efforts, preparing a prompt report of losses and beginning the salvage of historical materials.

No matter how small the museum staff someone should conscientiously perform as many of these duties as apply to your situation. The danger of fire tends to increase during periods of structural restoration, repair and installation, but never warrants neglect. The NFPA publication on protection of museum collections cited above contains additional helpful recommendations (see also Agents of Deterioration, Chapter 4).

Protection from Other Catastrophes

Furnished historic structures have no inherent virtues that protect them from tornadoes, hurricanes, floods, civil disturbances or war. The potential destructiveness of these occurrences is obvious. Equally clear are the lessons learned by museums that have survived such disasters. Hard experience has demonstrated that it pays to weigh the possibilities in advance, then plan and prepare accordingly.

Evaluate the risks realistically. Available data permit you to do so. If the museum site has ever flooded, this may well happen again in spite of intervening flood control measures. Study not only the water levels reached, but also the combination of factors that resulted in major overflows. Weather records show tornado zones and hurricane tracks, so you can appraise the degree of risk for the museum's locality. Early warning systems provide a few hours or days of grace in which to make final preparations. Community conditions that lead to riots and bomb incidents seldom develop without observable signs of unrest. Government can usually warn

its citizens of impending war. Take civil defense recommendations seriously.

Having considered the chances try to visualize what would happen in the kinds of emergency you think might arise. People in the museum may need a safe shelter. Broken windows or other damage to the building may require you to cover or move furnishings quickly. You may have to secure the premises from illegal entry or move the collection to a safer place. During the most critical period and for awhile afterward the museum will probably be without electricity or telephone service. Police, the fire department and other public agencies will be too busy or handicapped to offer normal support. The help and supplies you need to make emergency repairs or apply essential preservative treatment to damaged furnishings will be in urgent demand by other victims.

With the potential problems in mind plan what you can do to be ready. Then make whatever advance preparations seem justifiable. You can decide what space will offer the safest refuge for staff and visitors and make sure that its regular use will not preclude its occupancy when needed. You can procure the supplies or supplementary equipment which should be on hand. These may include materials to board up windows and doors or protective covers for exposed furnishings. Emergency lighting or communications equipment may be in order. Develop whatever standby arrangements seem advisable for transporting, storing, securing or salvaging the collections. To prepare for bomb threats, which may accompany civil unrest, instruct the staff members who might receive a warning call. The person who takes such a call should remain calm, obtain as much information as possible about the location and timing of the bomb, and note peculiarities of the caller's voice and manner. As soon as the caller hangs up, the police should be notified as well as the staff member responsible for security. The latter should initiate established procedure to evacuate the building and keep people out until the police have removed the bomb or become convinced the call was a hoax. For museums within imminent war zones well tested practice has comprised two principal steps. The staff has removed the museum's treasures swiftly but carefully to predetermined safe hiding places. Then staff members have followed the guidance of the civil defense authorities in protecting the building and its remaining contents.

The preservation of objects remains a basic function of museums. Responsibility for the safety of persons has an even broader base. Therefore you cannot avoid the obligation to practice protection in its manifold and changing aspects.

Evacuation

Some emergencies require that all visitors and staff get out of the museum quickly. This situation arises, for example, in case of fire or a bomb

threat. Only careful planning and practice can reasonably assure rapid evacuation. A staff member on duty must have the clearly assigned responsibility to notify all occupants and make sure that all have actually left the building. All staff members should know from participation in fire drills what route to follow and which exits to use. In addition the number of visitors allowed inside the building at any one time should be limited to its safe capacity. If more than that crowd in, some people would probably not escape should a crisis occur. To estimate how many visitors should be allowed in the building or any part of it at a time you need the reasoned judgment of a fire protection engineer. The latest edition of the National Fire Protection Association's *Life Safety Code* will also help identify the factors to be considered such as distances to exits, size of passageways and the nature of the structure.

BIBLIOGRAPHY

Safe Practices in Housekeeping

Fall, Frieda Kay. *Art Objects, Their Care and Preservation: A Handbook for Museums and Collectors.* LaJolla. Laurence McGilvery, 1973.

Keck, Caroline K. *A Handbook on the Care of Paintings.* New York. Watson-Guptill Publications for the American Association for State and Local History, 1965, pp. 4–5, 7.

National Safety Council. *Handbook of Accident Prevention.* 6th ed. Chicago. National Safety Council, 1972 (or latest edition).

Sugden, Robert P. *Care and Handling of Art Objects.* New York. Metropolitan Museum of Art, 1946.

Protecting Visitors

National Fire Protection Association. *Life Safety Code.* NFPA 101. Rev. ed. Boston. NFPA, 1970 (or latest edition).

National Safety Council. *op. cit.*

Protecting the Building and Furnishings

In addition to many of the references cited under Agents of Deterioration and Climate Control in the bibliography for Chapter 4 see:

Beazley, Elisabeth. *The Countryside on View: A Handbook on Countryside Centres, Field Museums, and Historic Buildings Open to the Public.* London. Constable and Company, Ltd., 1971, pp. 124–141.

FitzSimmons, Neal. "Emergency Measures and Museums," *Museum News,* 43:6 (February 1965), pp. 23–24.

Hatch, John Davis. "The Case Against the Heel," *Museum News,* 42:9 (May 1964), p. 29.

Hopkins, Kenneth. "Confrontation . . . and Community," *Museum News,* 48:3 (November 1969), pp. 11, 48.

———. "Is Confrontation in Your Future?" *Curator,* XIII:2 (1970), pp. 120–124.

Jenkins, Joseph F., ed. *Protecting Our Heritage: A Discourse on Fire Protection and Prevention in Historic Buildings and Landmarks.* Boston. National Fire Protection Association with assistance from American Association for State and Local History, 1970.

Keck, Caroline K. "On Conservation," *Museum News,* 50:9 (May 1972), p. 9.

Merrill, William. "Wood Deterioration: Causes, Detection & Prevention," American Association for State and Local History Technical Leaflet 77, *History News,* 29:8 (August 1974).

National Fire Protection Association. *National Electrical Code.* NFPA 70. Rev. ed. Boston. NFPA, 1974.

———. *Electrical Code for One and Two Family Dwellings.* NFPA 70A. Rev. ed. Boston. NFPA, 1972.

———. *Life Safety Code.* NFPA 101. Rev. ed. Boston. NFPA, 1973.

———. *Protection of Library Collections from Fire.* NFPA 910. Rev. ed. Boston. NFPA, 1970. Rev. ed. in prep.

———. *Protection of Museum Collections from Fire.* NFPA 911. Rev. ed. Boston. NFPA, 1974.

Noblecourt, André. *Protection of Cultural Property in the Event of Armed Conflict.* Museums and Monuments—VIII. Paris. UNESCO, 1958.

United States Department of Agriculture. *Subterranean Termites, Their Prevention and Control in Buildings.* Home and Garden Bulletin 64. Rev. ed. Washington. Government Printing Office, 1972.

———. *How to Prevent and Remove Mildew: Home Methods.* Home and Garden Bulletin 68. Rev. ed. Washington. Government Printing Office, 1971.

———. *Controlling Household Pests.* Home and Garden Bulletin 96. Rev. ed. Washington. Government Printing Office, 1971.

Chapter 13 Interpretation

An accurately restored and furnished building is an historical resource. It is preserved because it embodies and documents something important about the past. Therefore visitors come to see it. Merely looking at it, like watching Old Faithful erupt, enriches a visit. But as with a geyser, seeing it only taps the surface. The more a visitor understands about what he sees, the more he appreciates and enjoys it. Unaided, however, his aroused interest may be diverted by details and miss the primary significance. Fortunately, a furnished historic structure is also an interpretive medium. It displays real things arranged in context to communicate meaning. It uses the artifacts to transmit an experience of what is important about its past.

Nature of the Experience

Visitors to a furnished historic structure museum encounter an almost total environment preserved or recreated with the objective of completeness rather than simplification. Only the historic persons who once occupied the rooms are absent. Evidence of their activity, however, pervades the scene. The place looks lived in; under ideal conditions it feels as though the historic occupants might return at any moment. A visitor's first glimpse of a furnished room gives him a flood of sensory stimuli. After the initial, quick, general impression his attention begins to focus on individual objects. His senses linger with some, brush over others and miss some entirely. A mental picture of the room forms. Emotional responses become more specific. Noticing things that seem familiar or strange, esthetically pleasing or distasteful, suggestive of pleasant or unpleasant experience, he feels the room to be comfortable and inviting perhaps, or exciting, or saddening. At the same time he starts to think about the room and its contents. Questions come to mind. He associates what he sees with things remembered. Speculations and judgments take shape. This is the critical point. His thoughts may proceed, or be led, along either of two paths. If the room retains its unity, he should acquire a strong sense of the reality of the people and activities represented by this setting. He should gain a clearer conception of what the people were like and what took place here. His understanding, enriched by many details, associations and insights, should be nearer the

whole truth. His feeling of discovery and accomplishment, linked with a fresh desire to learn more and often reinforced by esthetic satisfactions, should add up to a thoroughly enjoyable and rewarding experience.

If, on the other hand, the furnishings or architectural details in themselves become the center of interest, the visitor begins to misuse the medium. Because the objects are arranged throughout the room to illustrate their environmental role, as individual pieces they get in each other's way, compete for attention and defy close inspection. The Kentucky rifle hangs on the frontier cabin wall to tell of lurking danger, of the need to hunt fresh meat, of the concerns and activities of its owner. When the visitor tries instead to study its distinctive features and workmanship, he cannot get close enough, the lighting is unsatisfactory and other things partially hide it or distract his attention. He not only risks frustration, but loses sight of the significant concepts the total setting is intended to express.

A second threat to a satisfactory experience in a furnished structure museum comes from intrusions. The sense of reality that the furnished space should convey is easily destroyed. The thoughts and feelings which make a room come alive get diverted whenever a visitor becomes conscious of something incongruous or anachronistic. He promptly loses part of the historical experience intended for him. Individuals vary in their sensitivity to distraction, but the best course is to eliminate as many intrusions as possible and minimize the adverse effect of those that must remain. Objectionable ones commonly encountered include:

—signs, especially those attached directly to the historic structure; donor plaques on rooms or furniture; "do not touch" signs; posted notices; conspicuous room labels

—fee collecting and sales equipment or activity inside the historic structure, especially near the entrance

—extraneous conversation among attendants

—exhibit cases or interpretive panels in a building primarily furnished, collections displayed in cupboards, closets or other parts of the furnished structure

—visible evidence of modern wiring and heating, often electric lights burning in period fixtures, but also switches, wall outlets, thermostats and air duct grilles

—exposed protective devices such as fire extinguishers, hose cabinets, fire and burglar detection and alarm systems, modern door locks, room barriers and protective floor coverings

—modern screen doors and window screens

—most artificial flowers, wax fruit, plaster models of meats or baked goods, stuffed household pets.

Unfortunately, when overcrowding or thoughtless behavior occur, visitors themselves may become intrusive.

What to Interpret

Each furnished historic structure museum has an interpretive mission. This is spelled out for it in the first section of the Furnishing Plan. Its task is to illustrate, in depth, certain historical ideas the truth and significance of which are grounded on solid research. The building, its setting and the furnishings unavoidably embody many ideas. The relatively few of these carefully chosen for active interpretation should fulfill three conditions. The ideas should be important in themselves or, in the case of a park, because they support a significant aspect of the park story, for this makes them worth communicating. They must permit the furnishings to be selected and arranged in full agreement with the historical evidence, for the integrity of the museum depends on this. They must also find expression by means of fully furnished rooms, for this is the nature of the medium. Alternatives to complete furnishing, discussed at the end of this chapter, create different interpretive means.

The ideas selected for interpretation comprise the central subject which the complex environmental setting should make more real, more understandable and more interesting. The kinds most often appropriate involve:

Persons

Some buildings serve best to help us understand an historic person. The structure, grounds and furnishings reflect his interests, activities, tastes, social position, economic status, family and friends. Concrete evidence about such facets of his life may not explain the acts which made him famous, but it can make the man and his contribution to history more vital. It provides data for considering him from many angles. Visitors can get a fuller and more accurate conception of him. At the same time the environment that surrounded him can often shed light on key points of his character or career. For example, all the things in and about Arlington House which illustrate Robert E. Lee's strong attachment to it can be interpreted to emphasize the heart-rending difficulty of his decision to go with the South. At Glenmont, Edison's library can recapture in some measure the tireless searching so characteristic of his achievements. Theodore Roosevelt's love of adventure becomes apparent in many of the furnishings at Sagamore Hill. Furnished buildings that interpret important individuals may illustrate only one period of their lives, a lifetime, as at the Home of Franklin D. Roosevelt, or even several generations as does the Adams home. Each presents opportunities available nowhere else for illustrating selected aspects of a career which the detailed setting can illuminate. Figure 50 illustrates one such museum.

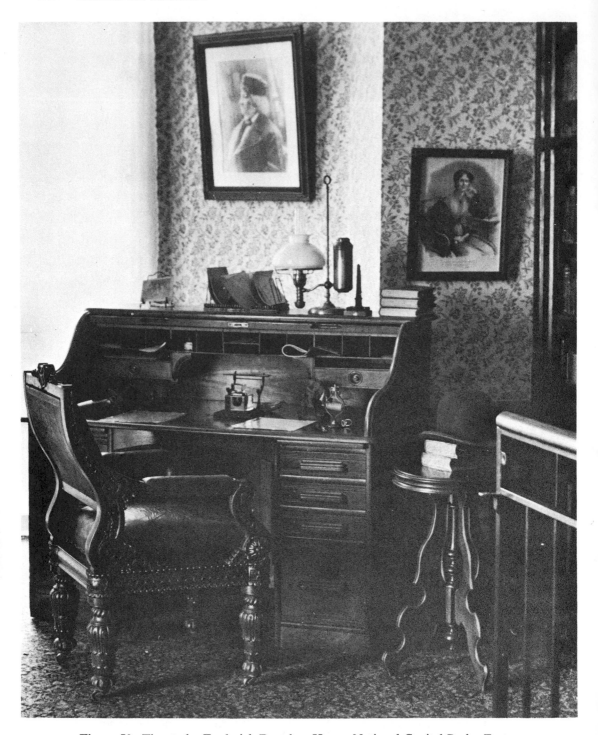

Figure 50. The study, Frederick Douglass Home, National Capital Parks–East.

Events

The significant association for some buildings is with an event. What took place there overshadows the participants. The ideas to interpret, accordingly, center on the action and its meaning. The furnished structure sets the scene, suggests the nature of the action and recreates to some extent the atmosphere of the occasion. With this help visitors not only get the emotional impact of standing at the actual spot, but can visualize what happened more vividly and in richer detail. This in turn should make the significance of the act more understandable. Visitors to Independence Hall can picture the delegates signing the Declaration and catch something of the spirit which must have filled the room. Interpretation can extend the experience to include the deliberation of the Continental Congress and the Constitutional Convention. The McLean House at Appomattox recreates the setting for the brief meeting of Grant and Lee on which the interpretation concentrates. The Moore House at Yorktown as noted above (see The Furnishing Plan, Chapter 10) presents a similar opportunity. Such buildings where the principal action involved only one room force a difficult decision. Does the exhibition of additional furnished rooms in each particular case enhance or dilute interpretation of the main theme? In some other instances the mood of the event demands primary consideration as in the House Where Lincoln Died and the little plantation office to which Stonewall Jackson was carried from the battlefield (fig. 51).

Figure 51. Room where Stonewall Jackson died, Jackson Shrine, Fredericksburg and Spotsylvania National Military Park.

Ways of Life

Other furnished structures illustrate concepts about everyday activities of the past. The persons who occupied the buildings represent categories of people. They stand for such groups as soldiers on garrison duty, the iron-workers at a charcoal furnace, storekeepers and their customers, home-steaders, lighthouse keepers or landed gentry of the Gilded Age. Buildings and furnishings combine to give a feeling approaching that of participation, a strong impression that this is what it was like to live as these people did. Often the installation also makes clear a technical operation, telling plainly that this is how they did it. Innumerable aspects of life and work might be illustrated by furnished structures, each filling in a bit of the mosaic of our history. Careful selection of what to present therefore becomes necessary. The choice should rest on activities of historical significance in most cases. Occasionally a group or activity of minor importance may merit the use of this medium because it contributes a needed element to the interpretation of a park, for example. In furnishing a building to show a way of life, base it on a known occupant if possible. This gives integrity and vitality to the setting. Lacking a known personality, a measure of vitality can come from a clearly visualized hypothetical occupant based on careful research, not on imagination. In either case, however, the significantly typical rather than the individual aspects of the scene should dominate the interpretation (fig. 52).

Architecture and the Decorative Arts

Preservationists have often restored a building because of its architec-tural merit and have furnished it in harmony with the style. The structure and its contents illustrate the artistic creativity and fine craftsmanship of a period. The purpose is to give esthetic pleasure, cultivate good taste and even foster connoisseurship. These commendable objectives seldom, if ever, control the development of furnished historic structure museums in the national parks. This is so first because buildings preserved in the parks are significant for historical rather than esthetic reasons. Second, if a build-ing is saved because it is architecturally important, interpretation should try to emphasize and explain its architecture. Refurnishing would conceal or draw attention away from the aspects of primary concern. In the same way, furnishings preserved for their individual artistic quality call for dif-ferent interpretation. See alternative methods at the end of the chapter. The Pope-Leighey House by Frank Lloyd Wright, a National Trust prop-erty, illustrates an exception that would prove the rule. A building designed by a famous architect and containing the furnishings he intended for it becomes an historic document to be interpreted as a whole.

Figure 52. Tavern converted to a field `hospital as restored at Manassas National Battlefield Park.

A furnished historic structure museum rarely interprets its point of emphasis to the complete exclusion of other aspects. For some visitors an installation primarily aimed to interpret a person or event will give insights into a way of life or provide esthetic enjoyment. Visitors are free agents bringing their individual interests and reacting to various stimuli. The task of the interpreter is to help them grasp the particularly significant ideas the furnished structure illustrates.

Interpretive Methods

The interpretation of a furnished historic structure involves three stages —preparation, the visit and follow-up. The actual visit, although clearly the most important element, does not constitute the entire experience or the sole interpretive opportunity. Each stage calls for the extra effort of intelligent experimentation. The unique aspects of every historic building should rule out stereotyped methods, as should the state of the interpretive art.

Preparation

Pre-visit interpretation aims first to induce a receptive attitude. It seeks to generate anticipation and curiosity, set an appropriate mood, channel thinking toward the principal meaning of the furnished structure and give people the essential facts needed in order to grasp this meaning. The interpreter's tools for accomplishing these objectives include publications, signs, the surroundings through which visitors approach the building and personal contacts. Two special situations call for additional tools.

The publication which park visitors ordinarily see in advance is the free information leaflet for the park. The format often allows only a sentence or two, or a captioned picture, about the furnished historic structure museum. These words and pictures that convey a first impression should be chosen carefully to express or suggest what is primarily significant about the historic building and its contents. The folder should avoid calling attention to subsidiary aspects. When a crucial meeting in the parlor is the real focus, for example, do not comment on the icehouse or the slave quarters, however interesting they may be. The text and illustrations which direct the visitor's thoughts toward the central theme can also begin to evoke feelings that will help him catch the essence of the place. So can the design of the folder, sometimes to a marked degree, by its visual suggestion of dignity, excitement or other appropriate attitude. It is not beyond the power of the brief reference to raise questions in the reader's mind and make the impending visit seem a desirable and perhaps exciting thing to do. The folder

can do these tasks well if the persons who write, edit and design it understand fully the interpretive purpose of the furnished structure and the intended functions of the leaflet in helping to attain it. On the other hand, the free folder does not seem to be the best means for giving visitors the background facts. Who, for example, were the Wicks and how did their house fit into the winter encampment of Washington's army at Morristown? The leaflet lacks space for such details unless the furnished building is the principal feature of the park. Even when the leaflet does provide the background story, it can seldom call the information actively to the visitor's attention at the time he most needs it.

Other publications which may prepare the prospective visitor well or poorly for his experience are tourist guidebooks and road maps. An alert curator, although he has no control over these commercial aids to travelers, can often influence what they say about the historic feature. If the references to the furnished structure museum create the right impression of its nature and purpose, these publications also contribute to the visitor's readiness.

Signs comprise a second set of preparatory tools. They interpret while they inform. Posters, and signs having a similar function, invite visitors to come. They tell people that an historic feature is available. Posters are designed to attract attention and arouse interest. The design can use color and pictorial elements to turn thoughts toward the dominant ideas of the furnished structure and help create the kind of mood desired. A poster's few words usually name the feature, perhaps tell where it is, and say no more.

Directional signs may lead visitors to the furnished structure. If so, these signs have considerable effect on the attitude of visitors when they arrive. Making it easy to find the way eliminates annoyances that weaken or spoil the interpretive experience of the actual visit. Directional signs should identify the destination and point the way clearly at a glance. They should be placed wherever visitors question the route. They should catch the eye unfailingly. It is ordinarily unwise to ask them to do more. Without additional content these signs can increase respect and anticipation for the historic building by the fine quality of their design, construction and maintenance. If the design incorporates a symbol suggesting an important aspect of the restored site, the visual impression will start some visitors thinking along the lines desired. Better no symbol, however, than one that interferes with showing the way.

When visitors reach the historic structure, they usually encounter one or more signs. These may serve several functions—to tell what the building is, to state its central theme, to fit it into a wider context, to identify sponsors and to give information on open hours and admission fees. Visitors come upon them at the moment when their minds should be shifting into high gear for the actual visit. Here the preparation for the visit attains its climax.

Every aspect of the signs at this point affects interpretation. Their appearance helps to set the tone for the visit. Overall quality is fully as important as with directional signs, but the need is greater here to keep in harmony with the setting. (Reflecting the period style of the furnished building is not the only way to do this.) Their placement is also critical. If they are mounted directly on the historic structure, they violate good practice in two ways. The building no longer looks as nearly as possible like it did at the time of its significance, and fastening the signs to it exposes a lack of concern or respect for the original fabric. Signs also intrude if they stand in the way of good views of the historic scene, either for the eye or the camera. Visitors should be able to look at and photograph the building in its setting without interference from signs (fig. 53).

What the signs say is even more crucial than how they appear and where they are placed. There is always a temptation to tell too much at this point. The preparatory signing should prime the visitor's imagination by providing it with the main ideas and key facts necessary for understanding what will be seen. The signs should stimulate his imagination to repeople the scene. What they tell him should make him ready to feel as though he were taking part, at least as an observer, in the activities implied by the furnishings. He should leave the signs in a questioning mood, actively searching for answers. Too complete an account or a full pictorial recreation of the scene robs him of the incentive and opportunity to discover and visualize for himself. The most timely message for this location is usually the central theme. The principal ideas the furnished structure is intended to illustrate should be close to the center of the visitor's attention as he begins his tour. A clear, brief, evocative statement in a well-designed and properly placed sign should receive a high percentage of effective use. The visitor's next most important need is often for the historical background which links the site to the broader picture. He should realize that the occupants of the Wick House at Morristown National Historical Park, for example, were involved with the impatient, hungry, cold army encamped around them. Sometimes one sign can do both of these jobs. If it would require more than about 25–50 words, however, a supplementary audio station or an additional sign should be considered. With the danger of over-signing in mind it is wise to subordinate or eliminate purely informational messages like hours and fees or sponsors' names at this point.

The visitor gathers sensory impressions as he approaches the historic site. What he sees, hears and smells along the way influences the mental set with which he begins the actual visit. If he drives to an 18th-century tidewater plantation through tobacco fields and pastures, he is more ready to understand and appreciate the rural life he finds interpreted at his destination. The sight of cannon drawn up on the Manassas battlefield waiting to fire prepares him to visit the nearby refurnished field hospital. Careful development of the approaches pays interpretive dividends. Sometimes it is

Figure 53. Entrance sign at the Todd House, Independence National Historical Park.

possible to recapture the general character of the original environment for the last quarter-mile or more of the way. At others a single vista glimpsed in passing can create the impression desired. Screening modern intrusions that break the spell is also important. Perhaps plantings can hide the neighboring factory or utility lines can go underground. The parking area makes one of the last strong impressions before the visitor starts his tour. Its location, treatment and screening affect interpretation and require careful thought from this standpoint. The possibilities of manipulating the approach to prepare the visitor's mind differ with each furnished structure. Good solutions contribute much to the visit.

The personal contacts that prepare people for the visit often take place at an entrance station or a visitor center information desk, during an orientation program or where the admission fee is collected. The contact in each case is likely to be brief and more informational than interpretive. In each, however, the person whom visitors encounter can do much to prepare for a pleasant and rewarding visit to the furnished structure. He or she can refer to the structure in terms of its significance and in a manner that will arouse interest. He can tell people to follow the tour signs to the Wick House and see how a farmer and his family adjusted to a starving, freezing army camped in their fields, for example. The collection of an admission fee in the historic structure intrudes seriously on the interpetive experience of the actual visit. In most parks, at least, this chore can be done more satisfactorily as part of a preparatory contact, perhaps at the visitor center information desk.

Two situations give the opportunity for more intensive preparation. When the furnished structure is the principal resource, a separate reception building may have this as its primary function. Most people stop at such a building to find out about the historic building before they visit it. Here audiovisual and exhibit methods can be used to prepare visitors more thoroughly in keeping with the significance of the site. An audiovisual presentation, for example, can do wonders to stir the feelings and point the thoughts. Like the *Story of a Patriot* at Colonial Williamsburg, it can prepare visitors unforgettably to grasp the meaning of the building and its furnishings. Or it can use the attributes of the AV medium to accomplish other results in preparation for the visit. Exhibits in the visitor center can use original objects to point out the relation of the people and events represented in the furnished structure to the mainstream of history, and to underline their reality. Both media can raise questions for visitors to answer in their tour, but should avoid encroaching on the visitor's chance to discover some things for himself.

The second situation calling for intensive preparation involves visits by organized groups. When a school class or other such group plans to visit the furnished structure, preparation should involve two steps. First, induce the teacher or leader to make a preliminary visit. This enables him to see

how the historic resource fits into what the class will be studying. The teacher also becomes familiar with the mechanics of the tour—where to park, the location of drinking fountains and restrooms, the timing. In discussing plans with the teacher, the curator finds out the nature of the class and its educational objective, the age and background of the children, whether the visit is an introduction to a new subject, part of an ongoing class project or the summarizing follow-up of previous work. Second, supply the teacher and class with a packet of preparatory material—the free information folder, a suitable bibliography, a vocabulary of unfamiliar terms they will encounter, perhaps postcards or other pictures to build anticipation and to relate the structure to historical people or events already studied, and any instructions about when and where to report or about other details of the visit. Some museums including Old Sturbridge Village have developed pre-visit resource kits to involve classes deeply in imaginative ways. A well prepared group gets maximum benefit from its trip.

The Visit

Interpretation during the actual visit may take several forms. A visitor may guide himself through the furnished building and grounds using a leaflet, labels or audio devices. One or more interpreters along the way may assist him with directions, explanations, demonstrations and answers to questions. A guide may conduct him on a tour. Each of these methods—self-guiding, attended stations and conducted tours—has its advantages. Each fits some circumstances better than others. The curator should therefore use them selectively. He can also combine them creatively. The objective in each case is to give the visitor understanding through an enjoyable experience rich in both sensory impressions and mental responses.

A self-guided tour with a leaflet has much to recommend it. It allows each visitor maximum freedom. He can proceed at his own pace as dictated by his interest and available time. The leaflet treats each visitor equally. It does not get tired as the day goes on. The visitor can carry it away to help him remember what he saw. To function well, however, a guide leaflet must have good quality in form and content and should be distributed properly. Regarding form, the leaflet should be suitable in size and shape. The visitor should find it easy to hold, easy to leaf through, easy to slip into pocket or purse. Both the 6 × 8½-inch (152 × 216 mm) and 4 × 9¼-inch (102 × 235 mm) sizes familiar in park publications have proven convenient in use. So has the 5-inch × 7-inch (127 × 178 mm) form of some guide booklets. The leaflet should be staple-bound if it requires more space than the four pages of a single fold sheet. A multifold format becomes too much trouble to use when the visitor must stand, move about and consult the text

intermittently. The leaflet should be attractive. Its typography, color and decoration should invite use. If they also bring to mind the ideas being interpreted, the design does double duty. The leaflet for a mansion can connote elegance or that for a fort strength. Design elements can suggest period, person or event as well. The major concern of form, however, should be legibility. The visitor should find the text easy to follow and pleasing to the eye. The content of the leaflet has two principal functions— to guide and to interpret. By using the leaflet the visitor should find his way surely to each room or other feature in turn. The text, perhaps aided by a map or diagram, should do this without making it necessary to post names or numbers at the rooms. Then it should help him imagine the original occupants using the furnishings in ways that relate to the central theme. It should sharpen his eyes for significant details. It should encourage him to make comparisons and speculate on how things were done or why. It should lead him to consider matters he will want to look up later. But it should strictly avoid diverting his attention to things peripheral to the main ideas. To prepare such a text requires interpretive insight and a good command of words. Fortunately, preliminary versions can be tried and refined in temporary form before committing it to print. Occasionally something a participant has said can make a room come alive and can be quoted in the leaflet. One additional consideration is important. Experience has demonstrated that the way in which visitors receive a guide leaflet strongly affects their use of it. When an attendant offers it with a friendly invitation to read it as they go along, people are much more likely to use it well. If it must be dispensed impersonally, a warmly worded label or audio message should tell visitors what they are getting and how to use it. References to it during the preparatory phase can also help. Leaflets merely handed out or picked up from a dispenser often are unread and discarded.

Guide leaflets have another use. Some visitors come with a legitimate interest in aspects of the structure or furnishings intentionally passed over in the interpretation of the main theme. If the specialist can buy a supplementary guide explaining the architectural details or the furnishings of particular interest to collectors, he finds his needs well served without loss to the main interpretive effort.

Self-guiding through labels offers some of the advantages of the leaflet and costs less. But it gives the visitor nothing he can carry away for future reference and introduces non-historic features into the carefully recreated environment. Also, only a few people can get close enough to a label to read it at the same time. This adds to traffic problems when visitors are numerous. Nevertheless, room labels when they are used, and any directional or warning signs if these are essential, should receive as much care in their design and wording as a guide leaflet requires. Legibility and attractiveness are as important as in the leaflet. So the typography should be excellent. The size of the letters becomes more critical because a visitor cannot

move a label to his best viewing distance as he can the leaflet. For this reason most room labels should use 30-point type in lines about 7½ inches (190 mm) long or 24-point with 6-inch (152 mm) lines. Two considerations control the mounting and placement of the labels and of any signs required. Do not attach them directly to the fabric of the building or place them on an article of furnishing. To do so would show a lack of concern and respect for the historic resource. Locate them where a visitor can see the room without having a label or sign in his field of vision. They should not intrude while he looks at the room. The dilemma of having to place a label where the visitor can use it conveniently but does not see it. in his view of the historic setting has several possible solutions. The label can be put on the room barrier, hanging just below the hand rail and hinged at the top so a visitor can lift it to a good reading angle. It can be mounted on brackets on the room side of the barrier, low and at the proper angle so a person standing at the barrier may look down and read it but will not see it as he looks up at the contents of the room. Similarly, the label can be on a wedge-shaped block placed on the floor just inside the barrier. Another possibility is to mount the label on a stanchion freestanding near the entrance so visitors may read it before stepping into the doorway to look. The location of the label helps to determine its color, shape and material. It may be printed and framed, silk-screened onto a hardboard plaque, made in metalphoto or produced by some other technique. It should be compatible with the setting and may suggest the central theme or the period. Whatever form the label takes, it must be brief to be unobtrusive. The text has the same work to do as that of a guide leaflet. The need for compression requires at least equal writing skill.

The third method of self-guiding uses audio equipment. The visitor carries a small, battery operated tape reproducer or record player, or earphones to plug into a jack at each visiting station or a radio receiver; or each station may have a message repeater he can activate and listen to through an attached earphone. He can look while he listens. The experience and its interpretation go on simultaneously. He can proceed at his own rate. (Audio systems using individual receivers and a short-range broadcasting loop that require listeners to move in a compact group at a predetermined rate do not fit the requirements of a furnished structure museum.) The great advantage of the audio technique lies in the opportunities it offers to deepen and enrich the interpretation. Its disadvantages are largely operational. Equipment and maintenance are fairly expensive. Most existing installations amortize part of the cost by renting the sets to visitors. Although fees are moderate, they come on top of the admission charge. Parks commonly find that only a small proportion of visitors will pay to use the audio devices. To avoid this wasteful and perhaps undemocratic situation, use of audio should be free to all visitors if possible. The mechanics of checking the equipment out and in, recharging it and cleaning

ear pieces before reuse require personnel and paraphernalia. These become far too intrusive if located in the historic structure. They belong at a reception point preceding the actual visit. Even with individual earphones some sound reaches other visitors. When a number of people are using the devices in the confined space of an historic building, the faint voices spilling from several instruments overlap and make it hard to concentrate. In spite of these difficulties the interpretive potential is enough to warrant full consideration of audio guiding. A visitor will usually tolerate more words when they are spoken than when he has to stand and read them. This gives the interpreter a better chance to communicate in depth. He can use voices to describe and explain, but also to recreate historic encounters. Grant and Lee might discuss the surrender terms in the McLean parlor, for example, if their original dialogue was reliably reported. In exceptional cases the voice of an historic participant can guide the visitor, as Eleanor Roosevelt's does in the unforgettable interpretation at Hyde Park. The medium invites the use of appropriate sounds—churning butter in the kitchen, a child practicing on the piano or violin and street noises from outside, for example. As with a guide leaflet, however, the script should concentrate on the central theme and should stimulate imagination and thought, not supplant them.

A friendly, knowledgeable person can help visitors understand and enjoy a furnished historic structure in ways beyond the reach of printed or recorded guides. He or she can observe individual needs or interests and actively mold his presentation to fit them. He can respond immediately and flexibly to visitor reactions or questions. To do his job well the live interpreter needs to know the central theme and appreciate its significance. His understanding of the main ideas which the furnished structure represents should grow in breadth and depth through continual directed study. He also should have a strong interest in the historic occupants and get to know them as intimately as sound scholarship permits. He needs a detailed knowledge of the activities they carried on in and about the building and how they used the furnishings. Stylistic knowledge of the structure and its contents is useful, but less important. At the same time the interpreter especially needs the ability and the desire to transmit his interest and knowledge to visitors. He should actively cultivate his skills of communication through study, experimentation, observing other interpreters and self-criticism. Since personal services poorly rendered do more harm than other media which can be more easily tuned out, the interpreter needs to guard against various faults. These include the set speech memorized and parroted, the too long and too detailed presentation that outlasts visitors' interest, the presentation played for laughs and dullness in manner or content. The good interpreter sets his goals in contagious enthusiasm tempered by taste and judgment, and in an equal division of his interest between the story he has to tell and the visitor whom he serves. This comprises a

demanding assignment calling for a person who is scholarly as well as effectively communicative.

A live interpreter may be assigned to contact visitors as they pass through a particular room or section of the building. As a stationed attendant he may interpret his area by several methods. He may give an informal talk, engage people in conversation, answer questions, use the queries to start a discussion or demonstrate some activity or technique appropriate to the room. Ordinarily he will use such methods in varying combinations tailored to the size of groups, ages and interests, time available and similar factors. All his methods should use the furnished space as a concrete, visual means of promoting interest in, and understanding of, the central theme. Since his station is only part of the tour, what he tells should fit into the whole. He should recall what visitors have already seen as it relates to his portion and should prepare them for what lies ahead, or summarize if this is the last stop. Whatever interpretive technique he uses should allow for questions and discussion. Demonstrations, because of their strong appeal, should be clearly pertinent to the main theme or of direct help in visualizing the historic occupancy. Furnished historic structures offer many opportunities to show how things were done and to let visitors take part. Some demonstrations can be almost continuous like preparing food in a kitchen, spinning or weaving. The attendant interrupts the work as necessary to talk with visitors. Other demonstrations may be occasional, for instance playing a musical instrument or a game. Some are seasonal, others may be brief ones worked into a talk or discussion. The attendant might use a penknife to cut a quill, for example, and let visitors try the pen as he talks about important writings of the historic occupants. Like the other methods, demonstrations require accurate and detailed knowledge.

A stationed attendant becomes to some degree a part of the setting. Consequently, he or she should be of the sex appropriate there—a man for duty in the guardroom at a fort or a woman in a domestic kitchen. For the same reason the interpreter assigned to a particular station may well be in costume. If so, his or her appearance should meet the same standards of accuracy as the furnishings. The costume should be correct in materials, cut and fit. A proper fit often requires the wearing of corresponding undergarments. Shoes, stockings and accessories should be equally accurate. Eyeglasses may have to be especially made. Wedding rings can be a problem. Hairdo and makeup should reflect the right time and place. Any anachronisms tend to detract not only from the authenticity of the scene but also from interpretive effectiveness. An attendant in costume takes on something of an actor's role. He plays the part of an observer of the historic activities, or even of a participant in them. This does not usually involve conscious acting, although he must get to feel at ease in the costume. In special circumstances, if he has the talent and training for it, he may literally act out a role with considerable interpretive impact. The Raleigh

Tavern baker at Colonial Williamsburg angrily appealing to his customers to help look for his truant apprentice affords an example. He uses a dramatic technique, drawing the visitors into it in this case, to give a vivid insight into the nature of master-apprentice relationships. Other situations surely offer comparable opportunities.

Instead of acting as stationed attendants at key points to serve visitors as they pass, interpreters may conduct people through the furnished structure. A conducted tour gives the guide more time in contact with each visitor. He has longer in which to communicate the ideas and attitudes that comprise the main theme. He has the opportunity to present a dramatic running account of people and events so the story unfolds with maximum clarity and interest. He can make each room in turn come alive as he stimulates the imagination of visitors while they look. He is able to answer questions on the spot and tie them into the storyline. He can adjust to individual differences and cater to individual needs. With these advantages a good guide can make a conducted tour the best way of seeing a furnished historic structure. To be good at it the interpreter must combine knowledge, skill and enthusiasm. Even these are not enough if the group is too large. A guide also has to minimize for visitors the annoyances of being regimented into a group of strangers, being permitted only so long to look and having to compete for vantage points in order to see and hear. To lead tours well an interpreter should develop his skills as a cordial host, greeting people warmly and putting them at ease. He should become adept as a marshal, organizing people into a coherent group and moving them under control from room to room. At each stop he needs to command attention for what he has to say. He must allow everyone the chance to look and react without letting others become restless. He must keep all his party with him in mind and body throughout the tour. If at the end visitors recall how nice the guide was rather than how interesting or important the theme, he has not been skillful enough.

Conducted tours that have proved successful at one site often include techniques which can be adapted for use elsewhere. In some of the best tours guides wear period costume. They employ this device to help visitors repeople the furnished rooms and feel closer to the past. It should be said, however, that good guides accomplish excellent results in modern civilian dress or uniform. Skill is the paramount factor, not what the guide wears. Another practice that has worked well is to start with a good introduction. The interpreter assembles his group away from other people where he can talk without distractions. He makes his visitors comfortable, letting them sit if possible. He sets an informal, conversational tone that will invite questions and comments. He arouses anticipation for what lies ahead, explains ground rules and tells how long the visit will require. Then he introduces them to the historic occupants they will be seeing in imagination, underlines what is significant about them and relates it to history that

is already familiar. Finally he tells the group where they are going next, how they will get there and what to look for as he shepherds them to the second stopping point. An effective technique for each of the tour stops consists of brief comments by the guide which induce his group to look at the furnishings with specific interests in mind, imagine the historic occupants using them and think about their broader meanings all more or less at the same time. The guide at Wayside in Concord (Minute Man National Historical Park), for example, speaks warmly of Mrs. Lathrop sitting there in the wicker rocking chair before the fireplace, rocking with her eyes closed and daydreaming the adventures of the children who will people her next book. Her thoughts, he recalls, were typical of Victorian New England in their bright optimism, strict morality and simple patriotism. He then encourages visitors to remember when they had read her books and to talk about it a little. Good tours also have a well-structured conclusion—a remark or two that will help drive home the main points of the experience and suggest follow-up, a chance for visitors to get final questions or comments off their chests, and a friendly farewell. The *sine qua non* of a satisfactory guided tour is, of course, a group small enough not to overcrowd the available viewing spaces. When numbers exceed this limit, use other interpretive methods.

School classes and other groups of children merit tour techniques adapted to their needs. They should not be subjected to the standard package. Their needs vary with age and cultural background, but particularly with what the children are studying in school or working on in their other group activities. The tour should provide a vital element in a learning program, not an isolated experience. For this to happen, the interpreter must find out what the visit can contribute to the group's educational project and plan the tour to do so. As discussed under preparation for the visit he needs to confer with the teacher or leader well in advance. The interpreter should take the initiative in assuring that the visit is mutually planned so the class comes prepared and leaves with a usable accomplishment. In planning the tour he should consider the potential resources represented by children among the historic occupants of the structure and their role in the historic activities. Working their life into the tour, if appropriate, would add authenticity and vitality. When the group arrives, every child should know that he has specific things to look for and pertinent questions to find answers for in the furnished rooms. Throughout the tour his eyes and mind should be productively busy. So should his hands. Children have a real need to touch things as part of the learning process. Fortunately, furnished historic structures offer many opportunities for children to participate in firsthand experiences. To write on a slate, snuff a candle, carry a pail of water from the well or stove wood from the shed merely suggest the possibilities an alert guide can develop. Some historical restorations have groups of children spend a day, a weekend or longer

living as the children of historic occupants did. Using accurately repro-
duced objects that can be replaced as these wear out, they sleep in oldtime
beds, eat traditional meals cooked at an open hearth, do chores, study old
school books and play old games. Another kind of educational activity
suited to a children's tour involves the use of work sheets. Each child fills
in the answers to questions requiring close observation and thought and
draws pictures of significant objects. The guide needs to have the materials
ready, of course. Conducting children's tours requires patience and under-
standing along with special skills. Two books by Molly Harrison (*Museum
Adventure*, London, University of London Press, 1950; *Learning Out of
School*, London, Educational Supply Association, Ltd., 1954) contain
helpful advice based on actual experience with methods that are imagina-
tive and aim at solid results.

Of all the means of interpretation that may operate during the visit, the
most important is the furnished structure itself. If it does not speak to the
visitor, supplementary methods will add relatively little. A room at first
sight should communicate a strong impression of the life it reflects. The
furniture tells what the room was used for and its arrangement shows how
it was used. The intimate grouping of objects makes people imagine the
action implied and sense the reality of the occupants. Numerous details,
carefully thought out for their effect, give visitors flashes of insight, stir
memories, spark discoveries. Any detectable sham such as plastic flowers,
wax fruit or plaster poultry may spoil the effect. Smell and touch confirm
that the ham is genuine. Heat and the odor of smoke from the hearth fire
attest its reality. Everything conveys the flavor of life, of the specific life, of
the room—the soot above the candles, the reeking clay pipe, the un-
finished game of cards, the book or handwork just laid aside, the mess
around the cuspidor or the profusion of bibelots in a patrician drawing
room. The room should truly reflect the standards of furnishing, decora-
tion, use and cleanliness of its own time and place, not of ours. It should
tell its story, skillfully aided by the live interpreter, leaflet, label or audio.

Follow-up

The interpreter has no control over visitors after they leave, but with
foresight he can add to their future enjoyment and understanding. He can
do this by helping them recall the experiences of their visit, to sustain and
expand the interests created and in the case of children to clinch what they
learned. Visitors should get the chance to carry away reminders of what
they saw and what it meant. Photographs they take during their visit will be
looked at on repeated occasions. The pictures will be shown and described

to friends. Each time they will bring to mind some aspect of the site or its story. If the snapshot or slide shows Junior holding that quill pen and behind him the cluttered table where the terms of surrender were drafted, he and his family will remember the significance of the Moore House. An alert staff, by creating opportunities or making suggestions, can help visitors get better and more meaningful photographs. The postcards, prints, picture books and other illustrative materials visitors can buy also aid recall. Purchasers will receive better value if the staff has chosen ones which call to mind the more significant features. Guide leaflets and information folders that visitors take home have a similar effect. Some people go away after their visit wanting to learn more. They are the interpreter's most successful product and his greatest opportunity. He can cultivate the interests he has aroused. He can encourage these people to read a good biography of the historic occupant, for example, and make it easy for them to find one. He can stock the sales counter with books and pamphlets carefully chosen to sustain the interests of different age groups. He can pick items that rate high in accuracy and readability. He can offer selected bibliographies and annotate them to stimulate, as well as guide, further reading. He can have at hand information leaflets for related historic sites and suggest visits to them. The volumes of the National Survey of Historic Sites and Buildings should be in evidence too. When the interpreter feels a real concern for making the visit a highlight of an ongoing educational process, he will find opportunities to help people dig deeper, broaden their understanding or follow specific leads.

For school classes, and to some extent for other groups of children, follow-up can be more direct. When the visit is properly integrated into a classroom project, the teacher will see to it. He will have the children apply the experience in various ways. They may prepare notebooks containing essays, stories or poems they have written and pictures or maps they have drawn. They may dramatize what they learned. What they produce may concentrate on the furnished structure and its themes, but preferably it will tie the story of the site into the larger concerns of the class projects. The interpreter can often help by suggesting during the tour ideas the children can develop in class, but he should consult the teacher beforehand. The museum can provide the class with an imaginative quiz sheet which the teacher can use to reinforce the learning experience. This has the double advantage of offering the interpreter some feedback to help appraise and improve the effectiveness of his visit techniques. The museum may also offer to lend the class slides, mounted pictures or specimens that can be handled to provide material for a follow-up discussion. It may also give the teacher references and reading lists. The familiar packet of thank-you letters contributes little. The interpreter, working with and through the teacher, can do much to make the visit a longer lasting part of the children's education.

Alternatives to Furnishing

A furnished historic structure museum is a complex and expensive interpretive device. Complete furnishing is not the only way to interpret an historic structure, nor always the best way. It depends on what the institution wants to accomplish by exhibiting it, and to some extent on limitations imposed by the structure. Alternatives are largely experimental as yet, and wide open for innovation. They will differ profoundly from typical refurnishing in one respect. The furnished historic structure aims to recreate an environment in all its rich detail. The alternatives simplify by selecting and emphasizing single aspects.

Hypothetical examples suggest some of the possibilities:

1. Stage setting. In the theater a few props carefully selected and artfully placed turn the stage into a forest or an elegant drawing room. Often the sharp realism of a focal grouping catches the essence of a scene and triggers the imagination of spectators to fill in the rest. Similar effects should be possible in an historic structure. Thomas Jefferson hammered out his draft for the Declaration of Independence in a Philadelphia rooming house. If the purpose is to focus attention on the framing of a document that embodied the political and social aspirations of an age, the room need not be furnished completely with its bed, dresser, tables, chairs, fireplace fittings, draperies and accessories. Instead, visitors might see only key objects in a darkened and largely empty room. Attention would concentrate on the single central setting—a Windsor chair drawn up to an appropriate table, on the table a replica of Jefferson's writing box open and bearing a partially finished manuscript, pen and ink ready for use, a lighted candle illuminating the page, a few reference books and discarded drafts lying about. Theatrical lighting would contribute all it could to enhance the effect. With the aid of audio, great phrases from the Declaration would echo through the minds of visitors as they looked.

2. Sound and light. This versatile and dramatic technique interprets historic structures from the outside, often with striking success. It requires only such furnishings as would be visible through the windows at a distance. Draperies and perhaps chandeliers would ordinarily be enough. The adaptation of sound and light for indoor use, as at Ford's Theatre, promises at least equally good results when the situation permits gathering an audience in full view of the scene of great events. The stirring narration augmented by lights and shadows that change and move in step with the story can carry visitors deeply into the experience. The extent of furnishing required for this kind of presentation will certainly vary, but the main reliance will be on stimulating the imagination to see things that are not there. Will sound and light also work for visitors moving through the rooms

of an historic structure when only a few people at a time can see? Perhaps the technique can effectively stand in for live interpreters in situations where details need to be pointed out and explained. Moving and pointing lights synchronized with a description, for example, might show how a mill worked without having to restore the machinery to full operating condition. Similar devices might explain the multiple functions a now-empty barn once served. Lights and sound might even add a feeling of life in stalls and pens. Consider a house having greater significance as an example of domestic architecture than as a setting for daily life or historic events. Laymen need help to understand the architectural lessons it illustrates. Might a tour of the unfurnished house prove rewarding if at each room a sequence of spotlights singled out structural features while an audio interpreted them? In place of a fully automatic program, the lights could be activated by visitor-operated push buttons. The switches could be cross-referenced to a guide booklet, and a booklet would offer the added advantage of explanatory sketches. Sound and light in any historic structure should be installed in ways that will not violate the original fabric of the building.

3. Symbolism. Objects sometimes have a symbolic value that is heightened when they are seen out of normal context. This attribute of objects should be useful to highlight particular aspects of historic interiors. If visitors looked into the dormitory of the Little Kinnakeet Coast Guard Station, for example, and saw instead of rows of cots and foot lockers an almost sculptural composition of dripping slickers, sou'westers and boots, would it help create a sense of the imminence of danger in the lives of the historic occupants? Would these symbols of storm turn the thoughts of visitors to shipwrecks and rescues? Could sand-encrusted shoes and a smoke-stained lantern make the dormitory seem a haven of comfort in contrast to the long, lonely beach patrol? Such symbols would hardly be self-explanatory, but might well reinforce words strongly.

4. Adaptive occupancy. The most frequently advocated alternative to furnishing an historic structure as a museum is to put it to present-day use. If an historic house is preserved primarily as an example of period architecture or as part of an historic scene, restoration of the exterior serves the main purpose. The interior can be adapted for current occupancy. Bona fide activity in and around the building gives it a genuine life that can be an interpretive asset. When the old house serves as a residence and, in fact, whenever the new use relates to the old, visitors are more likely to appreciate the historic role of the building. Adaptive use, however, is more often a method of saving buildings that would otherwise be lost than a way to interpret them.

Other ways to interpret special aspects of historic structures should be conceived and tried. The problem invites *avant-garde* solutions. At the same time the techniques of interpretation by complete furnishing warrant continual improvement.

BIBLIOGRAPHY

Alexander, Edward P. "Bringing History to Life: Philadelphia and Williamsburg," *Curator*, IV:1 (1961), pp. 58–68.

———. "Artistic and Historical Period Rooms," *Curator*, VII:4 (1964), pp. 263–281.

———. "A Fourth Dimension for History Museums," *Curator*, XI:4 (1968), pp. 263–289.

———. *The Interpretation Program of Colonial Williamsburg.* Williamsburg. Colonial Williamsburg Foundation, 1971.

Beazley, Elisabeth. *The Countryside on View: A Handbook on Countryside Centres, Field Museums, and Historic Buildings Open to the Public.* London. Constable & Company Ltd., 1971, pp. 116–134.

Benedict, Paul L. "Historic Site Interpretation: the Student Field Trip," American Association for State and Local History Technical Leaflet 19, *History News*, 26:3 (March 1971).

Black, Patricia F. *The Live-In at Old Economy.* Ambridge. Old Economy Village, 1972.

Coleman, Laurence Vail. *Historic House Museums.* Washington. American Association of Museums, 1933 (Repr. Detroit. Gale Research Co., 1972), pp. 87–95.

Colwell, Wayne. "Windows on the Past," *Museum News*, 50:10 (June 1972), pp. 36–38.

Fleming, E. McClung. "The Period Room as a Curatorial Publication," *Museum News*, 50:10 (June 1972), pp. 39–43.

Low, Shirley P. "Historic Site Interpretation: the Human Approach," American Association for State and Local History Technical Leaflet 32, *History News*, 20:11 (November 1965).

McCaskey, Thomas G. "Reaching Your Public: Turning Travelers into Visitors," American Association for State and Local History Technical Leaflet 29, *History News*, 20:6 (June 1965), rev. 1970.

Montgomery, Charles F. "The Historic House—a Definition," *Museum News*, 38:1 (September 1959), pp. 12–17.

Parr, Albert Eide. "Habitat Group and Period Room," *Curator*, VI:4 (1963), pp. 325–336.

Wall, Alexander J. "The Case for Popular Scholarship at Old Sturbridge Village," *Museum News*, 47:5 (January 1969), pp. 14–19.

Wall, Charles Cecil. "A Thing of the Spirit," *Museum News*, 46:6 (February 1968), pp. 13–19.

Part 4 Exhibit Maintenance and Replacement

Introduction

Whoever operates a museum carries out the day-to-day responsibilities involved in this assignment himself or supervises other staff members who share them with him. Parts 1 and 2 discuss his work on the collections. He also must concern himself with the care and use of the exhibits. Exhibits are tools of his trade. He therefore keeps them in as good working condition as possible to assure their maximum effectiveness. As a manager he also knows they represent a substantial capital investment. It is his duty to extend their useful life through proper care. The chapters which follow should help with routine maintenance, the problems of repair and the procedures for replacement of exhibits.

Chapter 11 discusses the cleaning of furnished historic structure museums in some detail. Other museums share some of the same maintenance problems. So some of the same considerations and methods apply. In the organization of the work the curator still has an important role, but the chief of maintenance or building superintendent usually plans and supervises it. He is responsible for the regular cleaning and repair of museum facilities. These include the exhibits. He may budget the maintenance funds and directs the employees who do the work. The maintenance staff performs the work within its capability. Maintenance funds pay for this and often for the more specialized repairs or rehabilitation that must be done by others. The curator, who must see that the exhibit rooms and study collection rooms function efficiently; therefore consults with the chief of maintenance to set standards, establish schedules and estimate costs. The curator then checks to make sure the methods used will not harm the contents of the museum and that accepted standards are met. When necessary, he and his staff supplement the work of the maintenance crew. The chief of maintenance needs to realize that cleaning the exhibit rooms, and particularly the exhibits, requires a gentle and sympathetic hand. He may find it best to hire someone especially for such housekeeping tasks, even if on a part-time basis. Both visitors and the museum benefit directly from good teamwork between curator and maintenance staff (see Organization, Chapter 11).

Chapter 14 Maintaining the Exhibit Room

Good housekeeping in the exhibit rooms pays dividends. It helps protect the specimens from agents of deterioration (see Chapter 4). It impresses visitors favorably, tending to create better friends and supporters for the museum. It adds to their enjoyment, which is part of the museum's underlying purpose. It acts psychologically to reduce littering and vandalism. The exhibit rooms probably rank next to the lobby and restrooms as areas in which the quality of housekeeping makes the strongest impression.

Chapter 15 considers the care of the exhibits. Maintenance of the room, aside from the exhibits themselves, involves cleaning, refinishing, keeping the room properly lighted and sustaining the desired atmosphere.

Cleaning

The choice of techniques and schedules for cleaning the exhibit room depends on several variable factors. Each museum must work out the best combination of practices to meet its needs. The kind of floor, wall finishes, volume of traffic and weather affect the decisions. One objective to keep in mind is that no visitor should be aware of dust or dirt in the room.

The techniques developed for cleaning public buildings described in Methods and Materials, Chapter 11, apply in general to rooms containing formal museum exhibits. Refer to these methods in relation to the following cleaning operations.

The floor ordinarily requires daily cleaning. Use a treated dust mop or vacuum cleaner as detailed in Chapter 11. Floors of stone, ceramic tile, composition tile, linoleum or cement need to be mopped frequently, perhaps once a week, but oftener in sloppy weather. Wood, composition tile and linoleum floors should be kept waxed and buffed, except those having acrylic or silicone polishes. For these newer coatings follow the manufacturer's instructions. Remember, however, that museum floors ought not to be highly reflective nor slippery. The accumulation of old wax must be removed with a safe solvent or emulsifier at least once a year. Avoid such

evident signs of poor workmanship in floor care as mop marks on base-boards and dark lines of dirty wax along cracks and edges.

All other surfaces where dust collects should be dusted daily with a vacuum or a clean, soft cloth. These include furniture, ledges, moldings and light fixtures. Use a treated cloth on non-porous surfaces that do not smear. Walls and other vertical surfaces should be brushed with a vacuum about twice a year or wiped more frequently with a clean, untreated dust mop. Hand marks and smudges on walls, doors, chair arms or other places should be removed without delay. Most finishes now in use will permit such spot removal first with a damp cloth and a little mild soap (e.g. Ivory) or nonionic detergent, then with a second damp cloth to wipe away the soap and finally with a dry cloth. Work gently avoiding scrubbing and an excess of water or soap. Dust drapes and Venetian blinds as part of the daily vacuum cleaning. The drapes will also need to be laundered or dry-cleaned perhaps as often as once a year. After cleaning be sure to renew the flame retardant (see Methods and Materials, Chapter 11). Venetian blinds should be taken down and washed annually. Any windows in the exhibit room should be washed regularly. To minimize these housekeeping chores, clean or replace filters in the air ducts on schedule.

Refinishing

In spite of regular cleaning the finish on walls and woodwork will deteriorate in time. The room should be repainted or otherwise refinished before the deterioration becomes obvious. Visitors are likely to notice shabbiness before someone who lives with the gradual changes every day, so try to observe the room as through a visitor's eyes. Be sure the new finish matches the original in color and texture because these relate to the design of the exhibits. If any change is necessary, consult the designer. Since it is often impossible to move the exhibits out of the way, the painters or other workmen need to apply the new finishes with special care. Drop cloths should be treated to retard fire.

Worn upholstery and faded drapes also require replacement before their condition becomes conspicuous. They are part of the overall design too, so should not be replaced by something different unless the designer concurs.

Lighting

In a properly designed exhibit room the general illumination and special lighting effects have an important part in the total scheme. Unplanned changes in the amount or quality of the light can physically damage the exhibits as well as decreasing their effectiveness. Maintenance consists of

keeping lamps lit at all times their illumination is intended, and of keeping them and their fittings clean.

Lamps, reflectors, lenses and louvers should be dusted frequently and washed as often as necessary to retain the full amount of reflection or transmission. The remains of insects attracted to the lights should be removed before they accumulate. After each cleaning make sure that reflectors, louvers and spot or flood lamps aim exactly where they did originally. Otherwise the lighting will not function as planned and visitors will encounter annoying glares.

As soon as an incandescent bulb burns out, put in a new one of precisely the same type and wattage. Replace burned out or flickering fluorescent tubes immediately, using the same color and wattage. It was probably chosen to minimize ultraviolet emission, so be sure to have a supply of this kind on hand. A fluorescent tube may need replacement before it burns out because its light output gradually diminishes. After a tube has burned during normal open hours daily for nine months, remove and destroy it. If it has an ultraviolet filter sleeve, transfer this to the new tube. The curator has responsibility to test the continued effectiveness of all ultraviolet filters or have them replaced periodically (see Climate Control, Chapter 4).

Atmosphere

The environment created in the exhibit room influences the amount of understanding and enjoyment visitors get from the exhibits. Keep the right setting. This entails maintenance of some other environmental factors in addition to those already discussed. Movable items of furniture should remain in the positions intended. If the decoration includes growing plants or cut flowers, these should be well tended and replaced as often as necessary. Artificial plants or flowers hardly provide an acceptable substitute. The temperature in the room should be controlled for both the preservation of the specimens and the comfort of visitors. The range should stay between 60° F. and 75° F. (16°–24° C.), and preferably not above 70° F. or 21° C. Relative humidity should be held as close as possible to 55%. In controlling temperature and humidity do not neglect air circulation. Air should remain fresh in spite of the many people who may be in the room.

Keeping the exhibit room in top condition will help in the more specialized job of maintaining the exhibits.

Chapter 15 Cleaning Exhibits

Dirt on an exhibit is especially conspicuous to visitors because it is unavoidably on display. Keeping exhibits clean is therefore a never-ending aspect of museum maintenance. The more successful the exhibit, the sooner it gets soiled by visitor use and the oftener it must be cleaned. The variety of materials composing an exhibit, the susceptibility of its elements to damage and the relatively high cost of their repair or replacement make cleaning a delicate and sometimes difficult task. In general, three sets of problems occur—those of case exhibits, open panels and exposed specimens. The first step in handling each is a close, daily inspection by the curator responsible. He must decide what needs to be done, how often and by what means.

Case Exhibits

Glass

Most exhibit cases in museums have glass fronts, tops and sometimes sides. The glass through which visitors look at the exhibit gets touched continually. The resulting greasy smears are disfiguring to the exhibit and annoying to subsequent visitors. They need to be washed off every day. The old reliable method is to use lukewarm water, adding a little household ammonia to cut the grease. Rub the glass vigorously with clean cloth or chamois well wrung out so the cleaning solution does not drip on other parts of the case. Then wipe it dry with a second clean cloth or chamois.

Numerous glass cleaners are on the market, but most are less satisfactory for museum use than the ammonia water. Those with an alcohol base tend to leave a film on the glass. So do the ones with a polishing component. The cleaners containing a mild abrasive leave a powder that accumulates in the edges of the frame. They also may dull the surface of the glass in time. Some spray-and-wipe glass cleaners employing quaternary ammonium compounds work well.

Daily washing will not suffice in many instances to keep case fronts in satisfactory condition. The museum attendant or a maintenance employee should walk through the exhibit room several times during the day wiping the more obvious smears from the glass with a dry cloth.

Visitors do not touch the inside of the glass, but a film does develop on it slowly. Look through the glass at an acute angle to see it. To remove it open the case and wash the inside of the glass with ammonia water or other proven glass cleaner. Do it at least once a year, and more often if the film becomes noticeable. The curator should supervise the opening of cases. The weight of a hinged plate glass case front as it swings open can spring the hinges or topple the case. This weight must be supported continuously. Cases with glass on all four sides may collapse if both ends are opened at the same time.

The top glass invariably gathers dust, even when it is covered. If the case is built into a wall, lumps of plaster and other detritus tend to collect on the glass. Dirt on the case top reduces the amount of light reaching the exhibit as well as being unsightly. Dust case tops frequently, preferably with a vacuum. Wash the top glass whenever the lamps and reflectors are cleaned. Be careful to wring out the cloth well so no water runs down into the case.

Plastic

Clear acrylic plastic replaces glass in many exhibit cases. It gets soiled and dusty like glass, but requires different cleaning methods. Being softer than glass it scratches more easily. Dust particles often leave scratches when wiped off with a cloth. Rubbing the surface of the plastic creates a static charge which attracts more dust. As the first step in cleaning, use a dampened soft, clean cloth to lift off the dust. Do not rub. Then go over the surface gently with one of the plastic cleaners containing both a cleaning solution and an antistatic component. Many brands are on the market. Avoid those which contain an abrasive unless the case front has already received fine scratches (e.g., from careless dusting). Ask the nearest distributor of plastics to recommend a safe cleaner for Plexiglas such as Kleenmaster Brillianize.

To remove scratches requires cutting away the surrounding plastic to the depth of the scratch. Careful hand rubbing with a cleaning and polishing liquid containing a fine abrasive will eliminate small ones. Choose a brand which conforms to Military Specifications MIL-C-18767B (ASG) or have the local plastics dealer recommend one. Deep scratches may need buffing with a power driven cloth wheel and #884 abrasive compound. This will leave a depression, but it will ordinarily be less conspicuous and more transparent than the scratched surface.

Metal Frames

Many exhibit cases have extruded aluminum frames. A few have brass, bronze, Monel metal or stainless steel. Visitors touch the metal as they do the glass. Airborne chemicals and dirt also affect the finish. It becomes dull and soiled. To prevent this and keep the frames in good condition, clean the metal regularly. Once a week should suffice under normally heavy museum attendance. For aluminum, brass and bronze use a non-abrasive metal cleaner. Park museums use whatever kind is stocked by the General Services Administration for cleaning the interior metalwork of public buildings. If extruded frames have gotten too discolored to respond to this treatment, rub them carefully with a damp cloth pad dripped in pumice. To clean stainless steel, Monel metal or anodized aluminum, wash it with the same ammonia and water solution used on glass.

Wooden Parts

Case bases are usually made of wood. So are the sides frequently, and sometimes the frames which hold the glass or Plexiglas. These parts of an exhibit case also get dirty from handling and other causes. If the wood is painted or covered with a vinyl wall fabric, wash it carefully as often as necessary. Use mild soap and water following the directions given below for cleaning exhibit panels. The same procedures should work whether the supporting material is solid wood, plywood or hardboard.

When the wood has an oil finish, do not wash it. Instead use a mixture containing equal parts of boiled linseed oil and turpentine. Dip a cloth in the oil and turpentine mixture and wipe it over the wood to be cleaned. Then rub the wood with a dry cloth. Ordinarily a cleaning every two weeks should prove adequate. Do it at the end of a day to allow the oil as much time to dry as possible before the museum reopens. If an objectionable film of oil builds up in time, use paint remover to cut it. Do not apply this treatment to historic furniture or any wood in other museum specimens.

Case Interiors

If a case is well built and properly assembled, the interior stays remarkably clean. Air moves in and out of a case to some extent, however, as temperature and air pressure change. The air entering the case carries some dust. Insects find their way even into apparently tight cases. Particles of dirt or other fragments fall from specimens or from cut edges in the case construction. The result is slow accumulation of dark specks and small pieces of foreign matter on the floor of the exhibit case. Such dirt is particularly conspicuous and unsightly. It should be watched for critically. As soon as any appears, open the case and use a soft clean brush to remove it.

Open Exhibit Panels

Many existing exhibits in park museums are open panels unprotected by cases. These units ordinarily have a background panel spray painted in colored lacquers. The panel is usually of tempered hardboard framed in wood, although older ones are of plywood. The lacquered surface bears silk-screened or handpainted illustrations and labels and the whole is covered in turn by a coat of clear lacquer. Mounted photographs and specimens are attached to the panel. The photographs have no protective coating. If a specimen is rugged enough to permit handling, it is merely fastened securely to the panel. When a specimen requires more protection, a cover of transparent plastic shields it. Being invitingly exposed, panel exhibits receive a full share of the dirt in the museum.

Background Panels

Dust the top edge of the panel, the lower sill of the frame and any other horizontal surfaces daily. Use a vacuum cleaner if possible.

Whenever the panel face shows dirt, wash the lacquered surface as follows. Dip a clean, soft cloth in lukewarm water. Rub it on a bar of mild soap (e.g., Ivory). Squeeze the cloth to work the soap well through it and get rid of excess water. Then wash the face of the panel itself with gentle, circular strokes. Carefully avoid getting soap or water on the specimens or photographs. Use a second clean cloth, dipped in clear water and wrung, to rinse off the soap. With a third cloth dry the panel.

Spot cleaning individual smears by this method may be tried, but usually shows where the cleaning stopped. It is generally wise to do the whole painted surface of the panel at one time. The frame and face of the panel might be cleaned separately if desirable.

Although the clear lacquer coat covers the labels and background illustrations, these features are raised above the general surface by the thickness of their paint. They therefore receive more wear during cleaning. They are the most expensive parts of the exhibit to replace. For this reason be sure the washing, rinsing and drying are done gently. Do not scrub. At the first sign of wear on the lettering get advice about renewing the clear lacquer coat. If the original lacquer is still in good condition, a fresh coat can sometimes be applied over it safely. Deteriorated lacquer usually must be removed with a solvent or abrasion before the panel is recoated. This requires a skilled hand.

Clean vinyl or melamine covered exhibit surfaces in the same way.

Photographs

Dust them frequently. Do not wash them. At the most, wipe them with a

slightly damp cloth and dry them without rubbing. Replace them if they become obviously dirty. Single smears can sometimes be removed by a solvent. Benzine (petroleum) (e.g., lighter fluid) serves this purpose but should be used with full precautions against fire.

In park museums photographic prints, both black and white and color, are not sprayed with clear lacquer because such protective coatings tend to pull the emulsion away from the paper causing the picture surface to crackle. Some museums use a transparent film applied with heat to cover exposed photographs that will be discarded when they become worn or faded.

Specimens

Objects mounted openly on the panels should be dusted carefully with a vacuum cleaner each day except as noted in the next section.

The clear plastic sheets and boxes covering specimens should be cleaned in the same manner as acrylic case fronts (see Case Exhibits above).

Exposed Specimens

Instructions for the day-to-day cleaning of specimens openly displayed in the museum can be generalized to only a limited extent. Each object calls for its own regimen to some degree. Therefore, apply the following directions with good judgment. The curator should supervise specimen cleaning and should ask a conservator's advice on specific problems.

Flags

Shake the dust off modern or reproduced flags as part of each day's cleaning. About once a week dust these flags with a vacuum cleaner or a soft brush. Take them outdoors for brushing, if possible, to avoid spreading dust in the exhibit room. Repeated touching or soot in the air can deposit more persistent dirt. To remove this have the flags dry-cleaned or laundered, perhaps annually. Older flags normally require much more careful handling. Even after expert restoration they need more protection than exposed display provides.

Furniture

Pieces of furniture on display should be dusted daily with a dry, soft cloth. Do not use furniture polish. Vacuum the upholstery regularly.

About once a year clean the wood of most specimens with a cloth dipped in turpentine substitute. This will remove the coating of wax on the

finish with its accumulated dirt. Then apply a fresh coat of wax. Use a hard paste wax such as neutral Simoniz or Butcher's. Fold a 12-inch (300 mm) piece of cloth into a pad. Place a spoonful of the wax within the folds. Apply a thin, even coating to the wood by rubbing with a circular motion. Polish with a fresh cloth.

For furniture which has an oil finish do not use turpentine and then wax, but wash the wood about every two years with a damp sponge and nonionic detergent solution. Rinse and dry it. Then rub it with a dry cloth.

Unfinished wood, such as tool handles for example, should be dusted regularly wth a dry cloth. Do not apply any cleaning solution. If the wood gives evidence of drying out by checking or cracking, correct the temperature and relative humidity promptly. A conservator may have to repair the damage to the specimen. See Furniture under Methods and Materials, Chapter 11.

Metal Objects

Wipe them with a clean, dry cloth to remove as much as possible of the corrosive fingerprints which result from touching by visitors. The best time to do it is at the end of the day so the prints do not remain on the specimens overnight. Should signs of corrosion appear, see Basic Steps, Chapter 4. The curator should remove the corrosion products carefully and renew the protective coating.

If the exposed specimens include metals which tarnish readily, the metal should be lacquered to avoid frequent treatment with abrasives. It is most likely to be brass. It may be cleaned by rubbing with a metal polish containing precipitated chalk or whiting in ammonia and incorporating a corrosion inhibitor if available, being careful not to get it on adjacent wood parts.

Models

Most models displayed without cases will need regular careful dusting. They often invite touching, so require additional cleaning periodically. Topographic models usually have a painted surface that may be washed. Use the method described above for exhibit panels, but dampen the cloth with only a minimum of water. Clean other models according to the materials and finishes involved.

Mounted Animals

In a few instances mounted birds and mammals are exhibited without a protective case. Do not attempt to clean them. Dusting or gentle brushing may disarrange the lay of fur or feathers which plays a big part in the

proper appearance of the specimen. As soon as the animals become soiled or dingy, return them to the taxidermist for cleaning.

Oil Paintings

Do not attempt to dust either the picture or the frame unless the frame is a plain molding. Gesso and gold leaf are very easily injured. A conservator will need to clean them periodically. Framed watercolors and prints are also best left to an expert. If the glass must be wiped off, use a minimum of moisture.

Stone

Geological specimens and stone carvings are often shown exposed. Dust them frequently with a vacuum or soft brush. Before they get too dirty, wash them with mild soap and warm water as described for open panels. A piece of marble sculpture should be washed with great care, a small area at a time, beginning at the top and making sure that no dirty water runs down. Be sure the water contains no trace of iron. Distilled or deionized water that has been stored for 24 hours in contact with clean white marble chips (Smithsonian recommendation) used in a glass container should be safe. Rinse the soap off thoroughly. For marks and smears on marble, consult a conservator.

When visitors touch an exhibit, they get it dirty. At the same time by touching they learn more about it. Children especially seem to have a real need to feel with their fingers as they look. This applies to labels as well as objects. For adults feeling the shape and texture of a specimen and perhaps testing its weight or balance also adds to understanding and appreciation of it. Therefore, the right solution is not to discourage people from touching the exhibits that can take it, but to clean them as often as necessary. Specimens too fragile or valuable to risk the dangers of public handling need to be installed in ways to provide adequate protection.

Chapter 16 Maintaining Outdoor Exhibits

It is a characteristic of park museums to extend beyond their walls. Some of their most important specimens are outside in the parks. These objects or the interpretive devices associated with them present maintenance problems shared by an increasing number of other museums having exhibits out-of-doors.

Cannon and Cannon Carriages

Artillery preserved in the parks consists of historical specimens, most of them on exhibition outdoors. They require proper care.

Tubes

Bronze guns under normal conditions of exposure acquire a hard green patina. This tends to protect the metal from further corrosion and should ordinarily be left intact. Chemically active pollutants in the air may cause additional corrosion in some situations, however. Rain usually washes harmful deposits off the upper surfaces, but they may collect in less exposed portions. If necessary, wash the cannon barrel using a neutral soap and a bristle brush. Should evidence of active corrosion develop, consult a conservator because specialized treatment may be needed.

When bronze guns were in service, they apparently were not polished bright but allowed to tarnish to a dull bronze color. If any cannon are to be displayed in this condition, do not attempt to remove the green patina with abrasives. Removal of this coating calls for expert chemical treatment. Maintaining the bronze at the right degree of tarnish then becomes a chore. Daily rubbing with a dry cloth should suffice. If the tarnish gets too dark, use bronze wool, not steel, grade medium or fine.

Iron cannon rust if unprotected. In service they were painted black and this practice should be continued. Repaint them as often as necessary to prevent air and water coming into direct contact with the metal. Inspect iron cannon tubes frequently for signs of rust. If rust spots appear, clean the rust

away with a wire brush and steel wool. Then prime the exposed metal with a red lead or damp-proof primer paint and follow with a second coat of black paint. Select good quality paints formulated for use on ironwork. While it is not the practice to paint the bore, rainwater can collect in the chamber and should be drained out if it does.

Cannon Carriages, Limbers and Caissons

Any original specimens of these vehicles with wood construction should be preserved indoors. The wooden parts probably will need specialized treatment to compensate for decay.

Many of the older replacement carriages as well as some siege and casemate ones were manufactured of iron and newer ones often have cast iron wheels and fittings. These must be kept painted and inspected regularly for signs of rust. Treat rust spots as described above and if necessary (usually in cast iron) use dewatering rust inhibitors such as CRC 3–36 before priming. Finish with black paint when the parts were originally iron, but paint the castings that simulate wood in the historically correct color as detailed below. Check to make sure that water does not collect inside the hollow castings of wheels or trails. Its presence would accelerate rusting in these hidden areas. Provide for drainage if necessary. Keep the wheels and the end of the trail away from direct contact with moisture in the ground. Cement blocks set under them almost flush with the ground surface and suitably colored serve this purpose. Rotate the wheels occasionally to equalize stress and strain.

Many replacement artillery vehicles include wooden members as in the originals. The wood must be kept painted to withstand the deteriorating effects of exposure. In service the wood was thoroughly primed and given two coats of oil paint of the proper color. It was then repainted as often as necessary to maintain the protective coating. Nowadays, prime any cracks that develop in the wood with boiled linseed oil, fill with glaziers' compound and repaint. Use high quality exterior oil paint of the following colors:

British, colonial to 1812		—lead gray
French, Valliere system		—red
	Gribeauval system	—blue
Spanish, to about 1750		—turpentine
	after about 1750	—blue
American, Revolutionary		—gray, red or blue according to origin and type, sometimes brown
	1780 to 1840	—light blue
	1840 on	—olive drab

The colors were mixed to formulas which varied somewhat from time to time and place to place so the exact shades must have varied. The lead gray was a light gray such as would be obtained by mixing 100 lbs. of white lead ground in oil, 1 lb. of lampblack and 6 gals. of linseed oil (40kg–400g–20 1). The red used was red lead. It gave a fairly dark color. The blue was obtained by mixing Prussian blue with white lead. Before 1780 it varied from light to almost a royal blue. After 1780 American gun carriages generally were light blue. Olive drab resulted from mixing 46 lbs. of French yellow ochre, 40 lbs. of boiled linseed oil, 5 lbs. of litharge, 2 lbs. of lampblack, 5 lbs. of turpentine and 2 lbs. of Japan varnish according to one formula (21kg–18kg–2.3kg–.9kg–2.3kg–.9kg). Satisfactory approximations of the historic colors can be obtained from paint dealers who mix white house paint with colors ground in oil to customers' specifications. For example, a local store mixed Pratt and Lambert paints as follows:

gray	—light base house paint with 1 oz. lampblack and $\frac{1}{12}$ oz. yellow ochre per quart (31.7 g-2.7 g-1 1).
blue (pre-1780)	—deep base house paint with $\frac{5}{8}$ oz. thalco blue, $\frac{5}{8}$ oz. lampblack, $1\frac{5}{8}$ oz. ultramarine blue and $1\frac{0}{48}$ oz. thalco green per quart (19.7 g-19.7 g-51 g-6.6 g-1 1).
blue (post 1780)	—light base house paint with $2\frac{6}{48}$ oz. lampblack, $\frac{5}{6}$ oz. ultramarine blue, $1\frac{0}{48}$ oz. thalco green and $1\frac{1}{2}$ oz. white per quart (17 g-26.2 g-6.6 g-47.3 g-1 1).
olive	—deep base house paint with 4 oz. lampblack, $3\frac{1}{2}$ oz. burnt umber, 3 oz. yellow ochre and $1\frac{1}{12}$ oz. Hansa yellow per quart (126 g-110.3 g-94.4 g-34.3 g-1 1). This mixture contains too much pigment to bind and adhere well.

To obtrain a red satisfactory in color but more glossy than preferred this store started with a red house paint, the pigment content of which was 40.8% ferric oxide, 5% molybdate orange, 21.6% titanium oxide and 32.6% magnesium silicate. The mixer added $2\frac{1}{2}$ oz. of white color in oil per quart of this paint (78.8 g–1 1).

With wood carriages it is even more important to keep wheels and trail ends away from direct contact with the ground and to rotate the wheels periodically.

To attach labels to gun tubes or carriages by drilling holes, using screws or nails or any other means that would deface or alter the specimen is a form of vandalism that should not be tolerated. Placing a label directly on a specimen in any event is poor museum practice.

Statues and Stone Monuments

Sculptured metal and stone are relatively durable materials. Exposed to weather or vandals, however, they require maintenance to control corrosion, repair breaks and remove surface dirt. Many parks have responsibility for the care of outdoor statues, commemorative plaques, gravestones and other examples of monumentation. Often metal sculpture is mounted on stone, so the materials must be treated in combination. Too frequently maintenance procedures must depend on experience unsupported by scientific knowledge because the problems have not been sufficiently studied.

Metal Sculptures

Bronze

Being by far the most common metal for outdoor sculpture, this material presents the most frequent problems. Bronze tends to change in color from deep brown to blackish and finally to pale green. These changes result largely from sulfur compounds, increasingly prevalent as pollutants in the air. The airborne chemicals corrode the surface of the bronze. A coating of dark sulfides develops. Slowly, often over many years, a light green patina composed principally of basic copper sulfate replaces it. This forms a protective layer between the metal and the air inhibiting further corrosion. Maintenance usually aims at promoting the natural development of the patina. During the often unsightly intermediate stages when the bronze is blotched or streaked with black and green, the patina seems to form best on the areas washed clean by rain. Accumulations of soot, bird droppings and other dirt not only add to the disfigurement but retard patination and may cause deeper corrosion. Regular cleaning therefore becomes the primary maintenance practice.

Clean outdoor bronze sculptures by washing. Scrub the metal with bristle brushes using warm water and a neutral soap. Then rinse it thoroughly, using a hose stream if possible. Some areas of encrusted dirt, perhaps mixed with thick corrosion products, may resist brushing. Use a wooden or copper scraper to loosen this grime. The underside of a figure or other parts sheltered from rain and runoff may need particular attention. Steam cleaning may be used instead of washing if the equipment is available. With either cleaning method protect the stone base from the runoff of dirty water. Usually plastic sheeting can be taped in place for this purpose.

Bronze that can be washed often enough probably needs no other treatment. Waxing the metal when it is clean, however, may permit an interval of 2 to 10 years between washings. The wax improves the appearance of the bronze and does not prevent formation of the green patina. Two thin

coats of a hard paste wax, such as neutral Simoniz, applied and polished by hand on a warm day give satisfactory results. Paraffin dissolved in carbon tetrachloride and sprayed on the statue, beeswax dissolved in turpentine or in a suitable petroleum distillate and sprayed or brushed on and a lanolin-paraffin mixture in Stoddard solvent have been used, but each has disadvantages.

When a statue has been waxed previously, brush and wipe it with Stoddard solvent to remove all remnants of the old wax before washing with water.

Inspect bronze sculpture at regular intervals between washings. Look especially for spots of active corrosion that may result from "bronze disease." Chloride pollution in the atmosphere can cause chemical reactions in the bronze which are not self-healing like the sulfate patina. Such spots should be scraped clean, given a protective coating of wax and watched for any recurrence. If they persist, have a conservator treat them.

Vandalism of statues usually takes the form of breaking off pieces (e.g., a sword, tassel or tail); scratching names; or smearing with paint or other colored material. Missing parts must ordinarily be remodeled by a sculptor, cast in bronze and reattached. Sometimes the new parts can be securely fastened by tapping and bolting. Bolt heads can be cut off and finished flush to the surrounding surface leaving only a small spot of brighter color. In other instances the replacements must be welded to the statue. The heat of welding tends to discolor the bronze for some distance around the mend. If scratches are too disfiguring to tolerate, they may be removed by abrading away the surrounding metal to the depth of the cut. Buffing may remove light markings, but deep scratches require filing and sanding first. Removal of scratches, of course, leaves a conspicuous area of bare metal. A coating of darkened wax would help conceal it temporarily. Paint or other color daubed or sprayed on the bronze should be cleaned off without delay. Use a paint remover composed of organic solvents, being particularly careful to keep it off the stone base.

Some bronze is gilded. The film of gold over the bronze is thin and relatively soft. The gold shows little tendency to tarnish and, if the coating is complete, protects the bronze from corrosion. Gilded statues get dirty, however. Wash them with ammonia water and rinse thoroughly, but do not use brushes and avoid hard rubbing. Proceed carefully watching for any abrading of the gold. If the result is unacceptably dull, rinse with dilute formic acid (wearing gloves) and then with clear water.

If neglected bronze sculpture has reached too unsightly a stage of corrosion and partial patination, a firm specializing in bronze treatment can be employed to remove the natural coatings and give the metal an artificial patina by chemical means. Look for such companies under Bronze in the yellow pages of telephone directories. The resulting finish seems to be less durable and to require more care than a naturally formed patina.

Aluminum

The parks contain a few statues cast of aluminum. Aluminum exposed to the weather acquires a dull tarnish which tends to protect the metal by slowing the rate of further corrosion. As with bronze, these sculptures should be washed periodically to remove corrosive deposits of dirt. Use a nonionic detergent because weathered aluminum is particularly sensitive to alkalis. Rinse thoroughly. Protect the stone base from dirty runoff. Do not wax the aluminum.

To repair after vandalism, see recommendations under Bronze above.

Lead

Some parks have architectural or garden ornaments of lead. This metal oxidizes when exposed to the weather. If the dull gray oxide coating forms a continuous layer, it protects the surface from further reaction with the air. The sculpture then requires no treatment, but should be washed periodically like bronze to remove accumulations of dirt. Polluted air, however, may oxidize the surface unevenly. Swelling incrustations of lead carbonate may form. Active corrosion usually calls for chemical treatment to remove the offending salts and seal the surface against them. If such problems develop, consult a conservator because treatment in the laboratory may be advisable.

When lead sculpture is vandalized, shallow scratches can be burnished out, deeper ones can be filled with solder and replacements for broken parts can be attached by soldering. Use organic solvent removers to clean off paint smears.

Iron and steel

Modern sculptors use iron and various kinds of steel among the materials for their creative work. Stainless steel should only require washing. The same may be true of the metal pretreated to develop a fine protective coating of rust. Many works in iron or steel, however, are painted. The original colors and textures comprise important aspects of the pieces. Presumably they will need to be repainted every few years to prevent rusting as the paint weathers. Follow the sculptor's specifications for the paint, color and method of application. When the artist cannot be consulted, clear with the recognized authority (e.g., the curator, the city architect or the local Fine Arts Commission) the details of treatment including removal of old paint and rust spots. Since experience with the weathering of iron and steel sculptures is limited, inspect them frequently.

Stone

When an architect or sculptor chooses stone for a monument, he can judge its appearance and test its workability, but in regard to durability he can only depend on its reputation. Whether he picks granite, marble, limestone, sandstone or some other kind, they are all composed of mineral particles bonded together. They vary greatly in chemical content, grain size, the nature and strength of cohesion between grains, porosity and other aspects. Variation occurs not only between the different kinds of rock, but also in the same kind from one quarry to the next and even in stone coming from different parts of a single quarry. Consequently, some stones stand up well to weathering while exposure causes others to crumble, flake or crack. Maintenance involves delaying or counteracting disintegration, repairing damage and preserving the desired appearance of the stone.

Stone deteriorates as a result of chemical and physical changes. Rainwater or dew, for example, may pick up acid from airborne gases, or from soot deposits, bird droppings or plants clinging to the rock. Acid reacts with some components of stone forming soluble salts which leach out leaving the affected portions weaker and more porous. This is the process which eventually converts granite to clay and sand. When water penetrates into stone, picks up soluble salts and then evaporates, the salts recrystallize. As they form, they may exert pressure enough to break the bonds between rock particles causing crumbling or flaking. Water alone, if it freezes in the pores of the stone, has a similar effect because it expands as it crystallizes.

For more than a century people have been trying to seal the surface or impregnate stone to keep out water or to reinforce weakened cohesion. What too frequently happens is that the outer layers of the stone affected by the treatment respond to daily and seasonal temperature changes by expanding and contracting a little differently than the underlying untreated portion. When this occurs, cracks may develop and the surface layers fall off in bigger flakes or chunks than before.

Better methods are being developed in conservation research laboratories. Until they have been tested in use, treat stone conservatively. Wash it frequently enough to prevent accumulations of foreign matter on the surface. Adjust the washing technique to the condition of the stone. Perhaps steam cleaning will do less harm to stone in excellent condition than leaving it dirty, but this is a relatively drastic treatment. Cemeteries use various strong chemical cleaners on gravestones. These include chlorinated lime, and mixtures of dilute acids and detergents. Such methods and other cure-alls should be considered too drastic for use on historic monuments. British authorities after much experimenting in cleaning old stone structures advocate using a gentle, long continued spray of water without detergents or brushing. A lawn sprinkler head playing on an area of stone for days or weeks has removed sooty incrustations up to 3 inches (76 mm) thick, for example. Historic stone buildings in France are being cleaned

with plain water and nylon brushes. As a rule, therefore, stone monuments should be cleaned using low water pressure, no soap or detergent and as little brushing or rubbing as the situation permits.

To remove paint from stone monuments use organic solvents applied with cotton swabs. Soak up the dissolved pigment with the cotton. Thick accumulations can be scraped carefully first to cut away the paint almost down to the stone. If the stone is not too porous, it should be possible to get all the pigment out with the solvents, but some staining from the paint vehicle may remain. Start with a mixture of equal parts of acetone and benzene (benzol). If stronger solvents are required, consult a conservator. For ink stains try chloramine-T (obtainable from chemical supply houses) made up fresh in a 2% aqueous solution. This is an oxidizing agent, so the stone should be rinsed thoroughly afterwards. The greenish stain that washes down from bronze statues or plaques appears to be harmless to the stone and should ordinarily be left alone except for the periodic washings.

On the basis of present knowledge, monumental stonework should be protected from the penetration of moisture only by: (1) providing good drainage so that no water stands on the stone or accumulates around the foundations, (2) keeping all joints well pointed or caulked and (3) inserting a waterproof barrier between the stone and the ground if one is not already in place. Special instances of advanced deterioration may call for further protection. In this case a conservator should be asked for advice.

The repair of stone sculptures and monuments calls for individual diagnosis and treatment. In some circumstances a stone that, because of weathering or accident, no longer performs its function can be removed and replaced with a new one. Sometimes the weathered portion of a stone can be cut away and new stone fitted in its place. In either case a perfect match is unlikely. The insert will look newer than the original work around it for a long time. Broken corners and carvings are more often patched with a plastic material molded to reproduce the original form. Stone of the same kind as the original is ground and mixed with cement or a synthetic resin to produce a similar texture and color. The work is usually done under contract by specialists who are still in the trade secret stage regarding the mixtures they use. As long as the patch is durable and a good match, concern centers on the method of attachment to the original stone. Will the joint cause further damage to the stone from water penetration or differential expansion and contraction? So far, past experience with the same product and methods supplies the best guide. Fortunately, responsible research continues on the care of stone.

Cast Aluminum Markers

Many parks use these markers for outdoor, on-site interpretation be-

cause they are exceptionally durable, resistant to vandalism and easily maintained. The marker consists of a cast aluminum plaque ½ inch (c. 13 mm) thick with lettering, outline maps and other illustrative details raised about ¹⁄₁₆ inch (1.5 mm) above the background surface. The manufacturers coat the plaque with a high grade automotive baked enamel. They then roll on the letter colors also using automotive enamels. The resulting surface is quite weather-resistant and needs no additional protection. Attempts to cover the markers tend to trap moisture which hastens the otherwise slow deterioration of the paint.

Metalphotos (photographs reproduced on aluminum by an anodizing process), often mounted in recessed frames as part of the marker, sometimes deteriorate sooner and are more vulnerable to vandalism. By having duplicates on hand the park can replace a metalphoto as soon as it becomes unsightly, merely by mounting a new print directly over the old one with epoxy adhesive.

Cleaning

Dust and soot collect on these outdoor interpretive devices, especially when the surface is not vertical. Rain runs off around the raised parts leaving streaks of dirt. To keep the markers satisfactorily clean, wash them as often as necessary. The enamel finish permits them to be washed like a car. Use plenty of water to flush away the dirt. Avoid rubbing because the dust acts on the enamel as an abrasive. Use a soap or detergent that is safe for car washing, but rinse it off thoroughly. Wipe dry with a clean, soft cloth or sponge.

Repainting

When the enamel becomes worn, dull, faded or disfigured by scratches or chipping, repaint the marker. Be sure to use the type and colors of enamel specified by the manufacturer.

First wash the marker as described above. Sand any scratches or chipped areas lightly with 180 grit sandpaper to cut away loose or rough edges of the paint film. Then clean the entire surface with a solvent to remove all grease. Use Stoddard solvent to lessen the fire hazard in this operation, but avoid over-exposure to the liquid or fumes. When the marker is clean and dry, cover any metalphoto inserts with heavy kraft paper and masking tape.

Next spray the entire face of the marker with the background color. If it is desirable to do the work with the marker in place and regular paint spraying equipment cannot be transported to the site, the paint distributor should be able to supply self-contained spray cans for the enamel.

After the overall spray coat has dried thoroughly, paint the raised portions of the casting. The most efficient and satisfactory method is to roll the

enamel on with a brayer. Dab a small amount of the specified enamel on a glass sheet or other smooth, flat surface. Roll the brayer back and forth through the paint until it is completely coated. Then roll it lightly over the letters and other raised surfaces. Do not attempt to apply enough paint to color the letters adequately in one coat because this will cause excess enamel to run down the letter edges. A thin coat should be applied, allowed to dry, then covered with another thin coat. If any raised details are too small or otherwise inconvenient for rolling, apply the enamel with a brush. When the second coat dries, remove the masking from the metalphotos. Experience indicates that a dense rubber or composition brayer should be used for the enamel. One marker manufacturer uses the #1 brayer, 2 × 2¾ inches long (51 × 70 mm), standard composition, with handle, produced by the Samuel Bingham's Son Manufacturing Company, 88 South 13th Street, Pittsburgh, Pennsylvania 15203.

Repair

If severe vandalism causes dents or holes in the aluminum, repair them with the metal mending epoxy compound used for body repairs on automobiles. After filing and sanding the patch flush and smooth, repaint the marker as described above.

BIBLIOGRAPHY

Boekwijt, W. O., and B. H. Vos. "Measuring Method for Determining Moisture Content and Moisture Distribution in Monuments," *Studies in Conservation*, 15:2 (May 1970), pp. 81–93.

Fink, Colin G. "The Care and Treatment of Outdoor Bronze Statues," *Technical Studies in the Field of the Fine Arts*, 2:1 (1933), p. 34.

Gettens, Rutherford J. "Composition of the Patina on a Modern Bronze Statue," *Technical Studies in the Field of the Fine Arts*, 2:1 (1933), pp. 31–33.

Greathouse, Glenn A., and Carl J. Wessel, eds. *Deterioration of Materials: Causes and Preventive Techniques*. National Research Council, Prevention of Deterioration Center. New York. Reinhold Publishing Co., 1954.

Hempel, Kenneth J. B. "Notes on the Conservation of Sculpture, Stone, Marble, and Terracotta," *Studies in Conservation*, 13:1 (February 1968), pp. 34–43.

————. "The Restoration of Two Marble Statues by Antonio Corradini," *Studies in Conservation*, 14:3 (August 1969), pp. 126–131.

IIC, ed. *Preprints of the Contributions to the New York Conference on Conservation of Stone and Wooden Objects, 7–13 June 1970*. London. International Institute for Conservation of Historic and Artistic Works, 1970, pp. 1–64, 71–76, 103–134.

Lewin, S. Z. "The Preservation of Natural Stone 1839–1965: An Annotated Bibliography," *Art and Archaeology Technical Abstracts*, 6:1 (1966), pp. 185–277.

————, and N. S. Baer. "Rationale of the Barium Hydroxide—Urea Treatment of Decayed Stone," *Studies in Conservation*, 19:1 (February 1974), pp. 24–35.

Organ, Robert M. "Aspects of Bronze Patina and its Treatment," *Studies in Conservation*, 8:1 (February 1963), pp. 1–9.

Pelikan, J. B. "The Use of Polyphosphate Complexes in the Conservation of Iron and Steel Objects," *Studies in Conservation*, 9:2 (May 1964), pp. 59–66.

————. "Conservation of Iron with Tannin," *Studies in Conservation*, 11:3 (August 1966), pp. 109–114.

Rawlins, F. I. G. "The Cleaning of Stonework," *Studies in Conservation*, III:1 (April 1957), pp. 1–23.

Stambolov, T. "Notes on the Removal of Iron Stains from Calcareous Stone," *Studies in Conservation*, 13:1 (February 1968), pp. 45–47.

Chapter 17 Rehabilitation, Repair, Revision and Replacement

Exhibits gradually deteriorate. Colors fade, paint cracks or wears thin, adhesives lose their grip. Before aging becomes obvious the exhibits should either be put back into good condition or replaced. This applies to parts as well as the whole. Not all elements in the displays age at the same rate, so some need rehabilitation or replacement before others. Accidents occur in museums. So does vandalism. Damaged exhibits should be repaired promptly or removed from sight. Changing conditions make some exhibits obsolete in content, form or location. They should be revised to remain functional or else replaced. A healthy chronic dissatisfaction on the curator's part leads to new insights and fresh ideas that call for changes in existing displays. Whatever the cause, staff members responsible for the care and use of the museum must take corrective action. They need good judgment and foresight to decide what rehabilitation or repair should be done and how much money to program for keeping the exhibits in proper condition.

Preventive Maintenance

The scrupulous cleaning described in Chapters 14 and 15 serves as an excellent form of preventive maintenance. So does adequate surveillance, preferably by a friendly interpreter rather than a guard. Equally important is keeping the right environmental conditions in the exhibit room and inside display cases. These include proper temperature, relative humidity, light intensity and a minimum of air pollution and ultraviolet radiation (see Agents of Deterioration, Chapter 4). It is up to the curatorial staff to replenish insecticides and fungicides in exhibit cases as often as necessary. Any exhibit case containing woolen cloth, fur, feathers or other specimens especially susceptible to attack by insects or mold should have the hidden container of paradichlorobenzene or dichlorvos refilled regularly. Exhibit

cases and mountings need to be kept in first class condition. It is surprising how often close inspection will reveal screws loose or missing, joints beginning to separate and small cracks or chips in the glass. Dust and insects can enter such openings, which also invite tampering. In spite of the best of care, however, exhibits sooner or later need more than routine maintenance.

Programming the Work

Setting Priorities

It often becomes necessary to choose among exhibits, each of which needs rehabilitation or replacement. The following guidelines should help in making the decisions. Apply them in turn:

1. Is the exhibit visibly deteriorating or inoperative? Seeing a rundown or damaged exhibit gives visitors a bad impression of the museum. It detracts from their enjoyment and may adversely affect their behavior. Such exhibits therefore demand first attention. The staff can take care of the situation in many instances. If a jolt or continued vibration moves a specimen out of position, put the object back promptly and carefully. If a photograph starts to pull loose from its mounting, reattach the corner or edge with a little adhesive (e.g., Elmer's glue). Hold it in place with a clamp while the glue sets, but put wax paper over the mend before clamping. Remove the clamp and paper in time to wash off any excess glue before it hardens. If a panel gets scratched, touch up the scar temporarily with colored pencils matching the background as closely as possible. Splinters can be fastened back on with, for example, Elmer's glue using the same precautions as with photographs. A broken switch on a visitor-actuated device can be replaced by a new one of the same kind. If a case glass cracks or chips, have a local glazier replace it. On the other hand, whenever the deterioration or damage involves labels, illustrations, background patterns or other art work, have a qualified artist make the repairs. When a specimen needs care, check with a conservator unless you are really qualified to treat it. If the problem involves malfunction of an audio device, projector or other electronic component, call in an AV maintenance specialist without delay. A standby unit should be available. National park museums do have replacements ready and immediately send faulty equipment to a repair depot. In any event, do not make a temporary *Out of Order* sign and scotch-tape or thumbtack it to the exhibit. This only compounds the unfavorable effect. Remove the switch and its label or cover them neatly. In applying this first guideline watch out for the effects of slow degeneration. Visitors may react to conditions that have developed too gradually for the staff to notice.

Photographs deteriorate more rapidly than most other exhibit elements. Color slides and transparencies may fade noticeably within a few months. Some color prints also fade quickly. Black and white ones wear out under repeated touching by visitors or the emulsion crackles. Plan to replace exhibit photographs as soon and as often as they need it, and program the money to do so.

2. Is the exhibit clearly ojectionable for other reasons? Sometimes unforeseen circumstances make it necessary to change an exhibit. The alteration may need to take precedence over instances of deterioration or damage. A case may turn out to have very annoying reflections in the glass, for example. If visitors cannot see the contents of the case without considerable effort, a corrective change should be scheduled. Occasionally some part of the exhibit structure constitutes an apparent hazard. Visitors trip over it, bump their heads or catch their clothing. Children rather than adults may be the ones endangered. Any temporary corrective measures should avoid damage to the exhibits or downgrading their appearance.

3. Does the exhibit contain factual inaccuracies? Museum exhibits owe much of their effectiveness to their well earned reputation for reliability. The effort to make and keep them accurate in all respects is well repaid. Errors sometimes creep into them during production. More often, further research alters or overturns a conclusion. The staff should report all errors in exhibits as soon as they are discovered. Because of the materials and techniques used in exhibit construction a qualified artist will usually need to make the correction. When the required changes cannot be made at once, the museum probably should install a neat temporary label pointing out the correction.

4. Does the exhibit fail to communicate? Each exhibit has, or should have, a clearly stated interpretive purpose. Refer to this and decide whether or not the exhibit transmits the facts or ideas or arouses the feelings intended. If it does not, it should be revised or replaced. Until the museum is in a position to measure the effectiveness of its exhibits, however, the guideline must be applied subjectively. Members of the staff can study the unit individually and compare their reactions. The behavior of visitors at the exhibit also can be observed for indirect but useful evidence. Do people stop to look at it? How long do they stay? How does this compare with the time apparently necessary to examine the specimens and read the labels? Does the exhibit generate comments or questions? In judging an exhibit on this basis, remember the wide variation among visitors and use as large a sample as circumstances permit. All exhibits will communicate some unintended things to some visitors, but watch particularly for signs of incorrect impressions being received.

5. Is the exhibit heavily used? When choices must be made among exhibits needing rehabilitation or replacement for one or more of the preceding reasons, the number of people likely to benefit from the change merits

consideration. Work is more urgent on an unsatisfactory exhibit placed where 10,000 visitors see it than on one which has only a few hundred viewers.

6. Is a museum revision planned? If the museum proposes redesign and replacement of existing exhibits, weigh the advisability of investing in interim rehabilitation. Some degree of aging or dissatisfaction may be tolerated during a normal waiting period. Some conditions, however, might need to be corrected in the meantime.

7. Is it a key exhibit? In even the most tightly coordinated series of exhibits some units stand out as focal points of meaning or interest. The effectiveness of the museum depends especially on them. Therefore, consider their rehabilitation or replacement ahead of less important ones.

8. Is the exhibit obsolete in technique or design? Well made and well cared for exhibits may remain in usable condition for many years. Visitors change meanwhile in tastes, interests and the background of education and experience they bring. When an exhibit speaks less clearly and attractively to a new generation, even though the display is accurate and in good repair, consider changing it. This situation usually involves the entire installation, so it is a costly operation. Sooner or later it becomes necessary.

Funding

Rehabilitation and replacement of exhibits involve both regular and special expenditures of museum funds. Applying the priority guidelines the curator can plan a well balanced program, estimate costs and justify the need for money. Keeping exhibits in good repair is a continuing need financed, in park museums, from the maintenance accounts. In forecasting the amount required for a year ahead, the curator should include reasonable provision for the emergency repair of exhibits suffering from accidents, vandalism or other unpredictable damage.

Funds appropriated for maintenance and rehabilitation may not be used in a park museum to increase the capital investment. The redesign and replacement of a whole series of exhibits constitute an effort to improve the overall quality of the installation. Work on this scale becomes a construction project. Park museums obtain money for preparing new exhibits from the appropriations earmarked for construction. An important and extensive revision may properly become a line item in the appropriation act, in which case budget makers and Congress can consider it on its individual merits.

Whenever an exhibit is rehabilitated or replaced, the museum wishes to improve it. Every chance to work on an exhibit offers an opportunity to make it more effective. The incidental redesigning and refining of displays should accompany rehabilitation and replacement as a matter of course. This does not ordinarily represent a significant increase in capital value when individual exhibits rather than entire installations are concerned. So

qualitative improvement characterizes maintenance funded work as well as construction projects.

Every aspect of a curator's work, from the acquisition of specimens to the replacement of existing exhibits, challenges him or her to improve the quality of its results.

Appendixes

A. Laws Affecting National Park Service Museum Operations

An Act To increase the public benefits from the National Park System by facilitating the management of museum properties relating thereto, and for other purposes, approved July 1, 1955 (69 Stat. 242)

Be it enacted by the Senate and House of Representatives of the United States of America in Congress assembled, That the purpose of this Act shall be to increase the public benefits from museums established within the individual areas administered by the Secretary of the Interior through the National Park Service as a means of informing the public concerning the areas and preserving valuable objects and relics relating thereto. The Secretary of the Interior, notwithstanding other provisions or limitations of law, may perform the following functions in such manner as he shall consider to be in the public interest:

(a) Accept donations and bequests of money or other personal property, and hold, use, expend, and administer the same for purposes of this Act;

(b) Purchase from such donations and bequests of money museum objects, museum collections, and other personal properties at prices he considers to be reasonable;

(c) Make exchanges by accepting museum objects, museum collections, and other personal properties, and by granting in exchange therefore museum property under the administrative jurisdiction of the Secretary which is no longer needed or which may be held in duplicate among the museum properties administered by the Secretary, such exchanges to be consummated on a basis which the Secretary considers to be equitable and in the public interest;

(d) Accept the loan of museum objects, museum collections, and other personal properties and pay transportation costs incidental thereto, such loans to be accepted upon terms and conditions which he shall consider necessary; and

(e) Loan to responsible public or private organizations, institutions, or agencies, without cost to the United States, such museum objects, museum collections, and other personal property as he shall consider advisable, such loans to be made upon terms and conditions which he shall consider necessary to protect the public interest in such properties (16 U.S.C. s 18f.)

Excerpt from *An Act To provide for the preservation of historic American sites, buildings, objects, and antiquities of national significance, and for other purposes, approved August 21, 1935 (49 Stat. 666)*

Be it enacted by the Senate and House of Representatives of the United States of America in Congress assembled, That it is hereby declared that it is a national policy to preserve for public use historic sites, buildings and objects of national significance for the inspiration and benefit of the people of the United States (16 U.S.C. sec. 461.)

Sec. 2. The Secretary of the Interior (hereinafter referred to as the Secretary), through the National Park Service, for the purpose of effectuating the policy expressed in section 1 hereof, shall have the following powers and perform the following duties and functions:

(f) Restore, reconstruct, rehabilitate, preserve, and maintain historic and prehistoric sites, buildings, objects, and properties of national historical or archaeological significance and where deemed desirable establish and maintain museums in connection therewith.

An Act For the preservation of American antiquities, approved June 8, 1906 (34 Stat. 225)

Be it enacted by the Senate and House of Representatives of the United States of America in Congress assembled, That any person who shall appropriate, excavate, injure, or destroy any historic or prehistoric ruin or monument, or any object of antiquity, situated on lands owned or controlled by the Government of the United States, without the permission of the Secretary of the department of the Government having jurisdiction over the lands on which said antiquities are situated, shall, upon conviction be fined in a sum of not more than five hundred dollars or be imprisoned for a period of not more than ninety days, or shall suffer both fine and imprisonment, in the discretion of the court. (U.S.C., title 16, sec. 433.)

Sec. 2. That the President of the United States is hereby authorized, in his discretion, to declare by public proclamation historic landmarks, historic and prehistoric structures, and other objects of historic or scientific interest that are situated upon the lands owned or controlled by the Government of the United States to be national monuments, and may reserve as a part thereof parcels of land, the limits of which in all cases shall be confined to the smallest area compatible with the proper care and management of the objects to be protected: Provided, That when such objects are situated upon a tract covered by a bona fide unperfected claim or held in private ownership, the tracts, or so much thereof as may be necessary for the proper care and management of the object, may be relinquished to the Government, and the Secretary of the Interior is hereby authorized to

accept the relinquishment of such tracts in behalf of the Government of the United States. (U.S.C., title 16, sec. 431.)

Sec. 3. That permits for the examination of ruins, the excavation of archaeological sites, and the gathering of objects of antiquity upon the lands under their respective jurisdictions may be granted by the Secretaries of the Interior, Agriculture, and War to institutions which they may deem properly qualified to conduct such examination, excavation, and gathering, subject to such rules and regulations as they may prescribe: Provided, That the examinations, excavations, and gatherings are undertaken for the benefit of reputable museums, universities, colleges, or other recognized scientific or educational institutions, with a view to increasing the knowledge of such objects, and that the gatherings shall be made for permanent preservation in public museums. (U.S.C., title 16, sec. 432.)

Sec. 4. That the Secretaries of the departments aforesaid shall make and publish from time to time uniform rules and regulations for the purpose of carrying out the provisions of this act. (U.S.C., title 16, sec. 432.)

Uniform Rules and Regulations

Prescribed by the Secretaries of the Interior, Agriculture and War to Carry Out the Provisions of the "Act for the Preservation of American Antiquities," approved June 8, 1906 (34 Stat. 225)

1. Jurisdiction over ruins, archaeological sites, historic and prehistoric monuments and structures, objects of antiquity, historic landmarks, and other objects of historic or scientific interest, shall be exercised under the act by the respective Departments as follows:

By the Secretary of Agriculture over lands within the exterior limits of forest reserves, by the Secretary of War over lands within the exterior limits of military reservations, by the Secretary of the Interior over all other lands owned or controlled by the Government of the United States, provided the Secretaries of War and Agriculture may by agreement cooperate with the Secretary of the Interior in the supervision of such monuments and objects covered by the act of June 8, 1906, as may be located on lands near or adjacent to forest reserves and military reservations, respectively.

2. No permit for the removal of any ancient monument or structure which can be permanently preserved under the control of the United States in situ, and remain an object of interest, shall be granted.

3. Permits for the examination of ruins, the excavation of archaeological sites, and the gathering of objects of antiquity will be granted, by the respective Secretaries having jurisdiction, to reputable museums, universities, colleges, or other recognized scientific or educational institutions, or to their duly authorized agents.

4. No exclusive permits shall be granted for a larger area than the applicant can reasonably be expected to explore fully and systematically within the time limit named in the permit.

5. Each application for a permit should be filed with the Secretary having jurisdiction, and must be accompanied by a definite outline of the proposed work, indicating the name of the institution making the request, the date proposed for beginning the field work, the length of time proposed to be devoted to it, and the person who will have immediate charge of the work. The application must also contain an exact statement of the character of the work, whether examination, excavation, or gathering, and the public museum in which the collections made under the permit are to be permanently preserved. The application must be accompanied by a sketch plan or description of the particular site or area to be examined, excavated, or searched, so definite that it can be located on the map with reasonable accuracy.

6. No permit will be granted for a period of more than three years, but if the work has been diligently prosecuted under the permit, the time may be extended for proper cause upon application.

7. Failure to begin work under a permit within six months after it is granted, or failure to diligently prosecute such work after it has been begun, shall make the permit void without any order or proceeding by the Secretary having jurisdiction.

8. Applications for permits shall be referred to the Smithsonian Institution for recommendation.

9. Every permit shall be in writing and copies shall be transmitted to the Smithsonian Institution and the field officer in charge of the land involved. The permittee will be furnished with a copy of these rules and regulations.

10. At the close of each season's field work the permittee shall report in duplicate to the Smithsonian Institution, in such form as its secretary may prescribe, and shall prepare in duplicate a catalogue of the collections and of the photographs made during the season, indicating therein such material, if any, as may be available for exchange.

11. Institutions and persons receiving permits for excavation shall, after the completion of the work, restore the lands upon which they have worked to their customary condition, to the satisfaction of the field officer in charge.

12. All permits shall be terminable at the discretion of the Secretary having jurisdiction.

13. The field officer in charge of land owned or controlled by the Government of the United States shall, from time to time, inquire and report as

to the existence, on or near such lands, of ruins and archaeological sites, historic or prehistoric ruins or monuments, objects of antiquity, historic landmarks, historic or prehistoric structures, and other objects of historic or scientific interest.

14. The field officer in charge may at all times examine the permit of any person or institution claiming privileges granted in accordance with the act and these rules and regulations, and may fully examine all work done under such permit.

15. All persons duly authorized by the Secretaries of Agriculture, War, and Interior may apprehend or cause to be arrested, as provided in the act of February 6, 1905 (33 Stat. 700) any person or persons who appropriate, excavate, injure, or destroy any historic or prehistoric ruin or monument, or any object of antiquity on lands under the supervision of the Secretaries of Agriculture, War, and Interior, respectively.

16. Any object of antiquity taken, or collection made, on lands owned or controlled by the United States, without a permit, as prescribed by the act and these rules and regulations, or there taken or made, contrary to the terms of the permit, or contrary to the act and these rules and regulations, may be seized wherever found and at any time, by the proper field officer or by any person duly authorized by the Secretary having jurisdiction, and disposed of as the Secretary shall determine, by deposit in the proper national depository or otherwise.

17. Every collection made under the authority of the act and of these rules and regulations shall be preserved in the public museum designated in the permit and shall be accessible to the public. No such collection shall be removed from such public museum without the written authority of the Secretary of the Smithsonian Institution, and then only to another public museum, where it shall be accessible to the public; and when any public museum, which is a depository of any collection made under the provisions of the act and these rules and regulations, shall cease to exist, every such collection in such public museum shall thereupon revert to the national collections and be placed in the proper national depository.

Protection of Endangered and Threatened Species

The Endangered Species Act of 1973 (87 Stat. 884) contains the following prohibitions:

Sec. 9. (a) General.—(1) Except as provided in sections 6(g)(2) and

10 of this Act, with respect to any endangered species of fish or wildlife listed pursuant to section 4 of this Act it is unlawful for any person subject to the jurisdiction of the United States to—

(A) import any such species into, or export any such species from the United States;

(B) take any such species within the United States or the territorial sea of the United States;

(C) take any such species upon the high seas;

(D) possess, sell, deliver, carry, transport, or ship, by any means whatsoever, any such species taken in violation of subparagraphs (B) and (C);

(E) deliver, receive, carry, transport, or ship in interstate or foreign commerce, by any means whatsoever and in the course of a commercial activity, any such species;

(F) sell or offer for sale in interstate or foreign commerce any such species; or

(G) violate any regulation pertaining to such species or to any threatened species of fish or wildlife listed pursuant to section 4 of this Act and promulgated by the Secretary pursuant to authority provided by this Act.

(2) Except as provided in sections 6(g)(2) and 10 of this Act, with respect to any endangered species of plants listed pursuant to section 4 of this Act, it is unlawful for any person subject to the jurisdiction of the United States to—

(A) import any such species into, or export any such species from, the United States;

(B) deliver, receive, carry, transport, or ship in interstate or foreign commerce, by any means whatsoever and in the course of a commercial activity, any such species;

(C) sell or offer for sale in interstate or foreign commerce any such species; or

(D) violate any regulation pertaining to such species or to any threatened species of plants listed pursuant to section 4 of this Act and promulgated by the Secretary pursuant to authority provided by this Act.

Sec. 10. (a) Permits—The Secretary may permit, under such terms and conditions as he may prescribe, any act otherwise prohibited by section 9 of this Act for scientific purposes or to enhance the propagation or survival of the affected species.

The following excerpt from Part 11, Title 50, Code of Federal Regulations applies certain provisions of 54 Stat. 250 as amended by 73 Stat. 143 and 76 Stat. 1246:

11.1 *Eagles protected.*

The taking, possession, or transportation of the bald eagle (*Haliaeetus leucocephalus*), commonly know as the American eagle, or the golden eagle (*Aquila chrysaetos*), or their parts, nests, or eggs is prohibited, except as permitted in this part. No bald eagle or golden eagle, or their parts, nests, or eggs may be purchased, sold, traded, or bartered, or offered for sale, trade, or barter in the United States or in any place subject to its jurisdiction.

11.2 *Permits to take for scientific or exhibition purposes.*

Whenever the Secretary determines that it is compatible with the preservation of the bald eagle or the golden eagle to take, possess, or transport such birds or their parts, nests, or eggs for the scientific or exhibition purposes of public museums, scientific societies, or zoological parks, a permit may be issued for such purposes.

B. Scope of Collections Statements

Lincoln Museum, National Capital Parks—West

The Lincoln Museum contains about 4,894 specimens, all of them related in some degree to Abraham Lincoln. Within this theme the museum has had a broad and rather uncritical accession policy. Consequently the collection has a miscellaneous character and an extreme range of quality. A number of the objects have outstanding interest and importance. Others would share this significance if their direct association with Lincoln could be verified. Many of the specimens, however, have historical or interpretive value largely because they illustrate how people have responded to Lincoln's life and death. Osborn H. Oldroyd, whose collection provides about half the museum's holdings, gathered nearly any kind of object he could find which claimed some connection with Lincoln, bore his name or image, or related to places and events in his life. Oldroyd's collection, purchased by Act of Congress in 1926, came into National Park Service custody in 1933 and formed the nucleus for the Lincoln Museum. The Service continued to collect Lincolniana within the same wide scope, mainly through acceptance of specimens offered as gifts. Such unchanneled growth endangers the value of the collection. To assure that in the future each acquisition will fill a recognized, justifiable need, the museum requires clearly defined purposes and precise guidelines for its collection.

The Lincoln Museum collection serves three legitimate purposes:

1. To preserve objects which give people a truer understanding and deeper appreciation of Abraham Lincoln in the presidency and in those other specific aspects of his life interpreted through exhibits.

2. To strengthen and enrich the exhibits of the museum and the House Where Lincoln Died.

3. To provide resources for *limited* studies of Lincoln, particularly in the presidency, and to document the conclusions.

In developing and refining the collection, the basic guideline is as follows: Objects acquired for the Lincoln Museum shall relate directly to Abraham Lincoln during his presidency from the campaign of 1860 until his death except as specifically noted below:

1. Specimens selected to improve or enrich exhibits in the museum on other aspects of Lincoln's life.

2. Specimens importantly related to the assassination and trial of the conspirators.

3. Objects that were part of or used in Ford's Theatre, August 27, 1863–April 14, 1865.

4. Furnishings that were in the House Where Lincoln Died on April 14–15, 1865 or objects specified in the Furnishing Plan to represent the original furnishings of exhibited rooms.

5. Specimens necessary to round out existing series of objects in the collection which are potentially significant resources for study.

The primary concern of the collection shall be Lincoln from the presidential campaign of 1860 until his death.

This basic guideline shall be applied to specific parts of the collection as follows:

1. Personal Possessions
 a. Collect objects satisfactorily authenticated as having belonged to or been used by Lincoln or members of his family during the campaign of 1860 or his presidency.
 b. Transfer Lincoln possessions associated with his earlier years to museums at the sites where they were originally used unless such museums lack adequate facilities for their continued preservation. If the objects are on exhibition, retain them until suitable replacements can be acquired, when they can be transferred to appropriate sites.
 c. Collect objects properly authenticated as having belonged to or been used by employees of Ford's Theatre or members of the cast playing on April 14, 1865 provided that these objects contribute or support knowledge of the mechanics and operation of the theatre or the events of that night.
 d. Collect objects authenticated as owned or used by the assassin and conspirators and related to the event.
 e. Collect objects satisfactorily verified as having belonged to occupants of the House Where Lincoln Died and been in the house on April 14–15, 1865.

2. Architecture and Furnishings
 a. Collect furnishings, stage property, equipment, fixtures and significant fragments of architectural detail or of furnishing fabrics authenticated as used in Ford's Theatre or the Star Saloon, August 27, 1863–April 14, 1865.
 b. Collect furnishings and significant fragments of furnishings and finishes authenticated as used in the House Where Lincoln Died, April 14–15, 1865.

3. Lincoln Iconography
 a. Paintings
 (1) Collect portraits of Lincoln or members of his family painted 1860–1880, consulting with the National Portrait Gallery to avoid competitive collecting and to assure significance, but do not acquire paintings depicting Lincoln or his family prior to 1860 unless specifically needed for an exhibit.
 (2) Collect group portraits or historical scenes (painted 1860–1880) which include Lincoln as president or as candidate for the presidency, including funeral ceremonies.
 (3) Collect portraits of Lincoln executed after 1880 only if required for a specific exhibit.
 (4) Through proper channels, dispose of non-exhibitable Lincoln paintings showing him prior to 1860 or painted after 1880.
 b. Sculpture
 (1) Collect original works of sculpture or casts made under the sculptor's supervision depicting Lincoln as presidential candidate or president and executed 1860–1880, consulting with the National Portrait Gallery.
 (2) Do not acquire sculpture showing Lincoln before 1860 or done after 1880 unless called for in an exhibit.
 (3) Do not acquire mass-produced copies of busts, statuettes or bas-relief plaques depicting Lincoln unless required to fill recognized gaps in an existing series important for study purposes.
 (4) Through proper channels, dispose of sculptural representations of Lincoln showing him prior to 1860, or executed after 1880, provided they are not on exhibition or required as part of significant study series.
 c. Prints
 (1) Collect one each of etchings, engravings, lithographs, woodcuts and similar graphic art works, 1860–1880, portraying Lincoln or members of his family during his presidency. Successive states and variations of the same subject should be included, but mass-produced copies should not be held in duplicate.
 (2) Collect one each of prints showing groups or events, including funeral cermonies, of 1860–1865 which include Lincoln and which were produced 1860–1880, including states and variations.
 (3) Collect political cartoons depicting Lincoln and concerning his presidential campaigns or presidency.
 (4) Consider iconographic items removed from books, magazines

and newspapers as reference material in the library collection, not as museum specimens.

 d. Photographs

 (1) Collect only photographs of Lincoln or members of his family taken 1860–1865 and not reproduced in Charles Hamilton and Loyd Ostendorf, *Lincoln in Photographs*, *An Album of Every Known Pose*, University of Oklahoma Press, 1963.

 (2) Through proper channels, dispose of Lincoln photographs taken prior to 1860 unless being used in exhibits.

4. Other Iconography

 a. Collect contemporary paintings, drawings, prints or photographs, but not clippings, showing the assassin and conspirators, employees of Ford's Theatre 1863–1865, members of the cast of *Our American Cousin* as performed on April 14, 1865, and significant occupants of the theatre or the House Where Lincoln Died on April 14–15, 1865.

 b. Collect contemporary paintings, drawings, prints or photographs, but not clippings, showing the exterior or interior of Ford's Theater, the Star Saloon, and the House Where Lincoln Died as they appeared in 1865.

5. Coins, Medals and Badges

 a. Collect only specimens of coins, paper currency and mercantile tokens bearing Lincoln's portrait which are necessary to fill recognized gaps in potentially significant study series.

 b. Collect campaign badges, medals and related insignia for both presidential campaigns, 1860 and 1864, and for all parties involved as needed for display or to build up comprehensive study series.

 c. Collect mourning badges only as needed to round out existing study series.

 d. Collect only such Lincoln memorial medals as are required to fill known gaps in potentially important study series.

6. Documents

 a. Collect political posters, broadsides, election tickets and related material associated with the presidential campaigns of 1860 and 1864.

 b. Collect printed documents that clearly represent Lincoln's important acts and opinions as presidential candidate and president.

 c. Do not collect Lincoln manuscripts, plays or similar material unless required for exhibition.

 d. Collect printed matter issued by or used in Ford's Theatre, August 1863–April 1865.

e. Collect sheet music only as required to fill recognized gaps in series illustrating Lincoln campaigns, Lincoln memorial compositions and music used in Ford's Theatre.
f. Collect original posters, broadsides and notices related to the assassination.
g. Collect documents printed in connection with Lincoln funeral ceremonies only as needed to round out existing series.
h. Collect newspapers only if they are original copies, 1860–1865, containing important news involving Lincoln and *are not* duplicated in other Washington repositories.

7. Miscellaneous
 a. *Do not* collect additional objects associated with Lincoln funeral ceremonies except as indicated in 5(c) and 6(g) above.
 b. *Do not* collect objects associated with other Lincoln sites unless needed for an exhibit and then only with the concurrence of site authorities.

Acadia National Park (draft)

We need to know what kinds of animals and plants inhabit the park and the principal inanimate factors of their environment. This information is essential for learning about and keeping track of the ecological processes going on in the park. Proper management and interpretation require such knowledge. The management need at Acadia is underlined by experience. The park has already had to cope with a disastrous forest fire and a critical overpopulation of deer. In both cases the staff could have done a better, more efficient management job if the details of the local ecology had been more fully recorded in advance. From the interpretive standpoint Acadia has traditionally attracted visitors interested in natural history. It has catalyzed similar interests in other visitors. Growing public concern for the environment now demands that we use the park more effectively to create ecological understandings.

Much of the information to meet these needs can only come from specimens collected and authoritatively identified. This means that Acadia should have a basic reference collection inventorying its natural resources. The insular character of the park calls for some paralleling of material. Special ecological problems may require additional collecting of a limited nature, but the resulting specimens can usually go to a museum outside the park for continued preservation. Parts of the reference series not needed at

hand for answering staff or visitor questions can also be preserved outside the park if suitable museums are available. The University of Maine can care for some material from the park. The growing State Museum in Augusta may develop staffing and facilities to handle other parts of our collection.

The scope of the natural history collection needed for park operations at Acadia is defined as follows:

Mammals Each species of mammal occuring on Mount Desert Island shall be represented in the collection by a limited series of specimens, viz. one good study skin and skull of an adult male, of an adult female, of an immature individual if the young show significant differences from the adults, and of the minimum number of forms needed to show important seasonal changes and transitional stages of pelage; one complete skeleton usually obtained from an accidental kill, and one set of casts showing tracks of fore and hind feet. Corresponding series shall represent any additional species found on the Schoodic Peninsula, Isle Au Haut or Baker Island. To establish what species inhabit Isle Au Haut and Baker Island the collection shall include the skin and skull of one adult of every species taken on each island. The marine mammals of the adjacent waters shall be represented by the full series for seals and single skeletons for cetaceans. Supplementary specimens illustrating the impact of mammals on their environment, e.g., stomach contents and examples of damage to plants, should be included in the collection when significant or the subject of visitors' questions.

Birds Each species of bird occurring in the park or on adjacent waters shall be similarly represented by one good study skin and skull of an adult male, of an adult female, of an immature bird if it differs markedly from the adults in appearance and is found at this stage in the park, and of the minimum number of adults needed to illustrate other seasonal plumages seen in the park; and one complete skeleton (preferably from an accidental kill). Supplementary specimens such as one set of track casts of shore feeding species, one example each of conspicuous nests, and stomach contents or pellets significant in ecological studies may be included as needed.

Reptiles and Amphibians Each species of snake, turtle, urodele and salamander found in the park or adjacent waters shall be represented in the collection by one adult specimen, preserved in alcohol, from each of the four major park units where it occurs (Mount Desert Island, Schoodic Peninsula, Isle Au Haut, Baker Island). One adult of the opposite sex may be added to the series when both sexes are not already represented. For amphibians the collection shall include one specimen of each distinctive larval stage or developmental form.

Fishes Each species of fish inhabiting the fresh waters of the park and the tidal or marine areas fished by park visitors shall be represented by one adult specimen preserved in alcohol. Additional specimens illustrating significant sexual differences or needed for reference use at other stations in the park may be included.

Insects Each conspicuous species and form likely to arouse visitor interest because of its appearance, sound, bite or sting (e.g., larger Orthoptera, Odonata, Hemiptera—Homoptera, Coleoptera, Lepidoptera and Hymenoptera, and selected Diptera) shall be represented by at least one properly mounted adult specimen, but by no more than will occupy the smallest appropriate size of pinning tray. Conspicuous larvae shall be included on the same grounds. Each species of importance in park management (e.g., parasites and others potentially requiring control measures) shall be similarly represented. Each additional insect family occurring in the park shall be illustrated by at least one adult specimen, but no more than will fill the smallest appropriate size of pinning tray. The additional specimens may be of the same or different species within the family.

Other Invertebrates One adult specimen of each conspicuous invertebrate species of the park's tidal zone shall be collected and preserved. A minimal number of additional specimens shall represent important sexual or color differences. Similarly one adult specimen shall serve to identify each species of conspicuous marine invertebrate likely to wash ashore from deeper waters and each principal species of terrestrial or fresh water mollusk and crustacean in the park. Single adult specimens shall suffice to inventory each of the other families of macroscopic invertebrates found in the park. Plankton animals will not be kept in the collection.

Plants Each species of seed plant growing in the park shall be represented by an herbarium specimen, including fruit as well as flowers whenever possible, collected from each of the four main units where it occurs (Mount Desert Island, Schoodic Peninsula, Isle Au Haut and Baker Island). Specimens illustrating important variations in form or color and identifiable hybrids shall be included. Each species of fern, moss, clubmoss, liverwort, lichen and conspicuous fungus found in the park shall be represented by one characteristic specimen. Each species of marine algae growing on the shores of the park shall be similarly represented, but phytoplankton will not ordinarily be retained in the collection.

Geological Collections The reference collection shall contain one characteristic hand specimen of each rock type and formation exposed in the park, and one or more thin sections of each if needed for critical study. More than one hand specimen shall be included when variations in the

composition or structure of any type or formation require it. A good specimen of each of the few fossils occurring in the park shall be in the collection. Individual specimens which illustrate particularly well glacial, igneous or tectonic events or processes in the geologic history of the park may also be included. So may one good crystalline specimen of each mineral entering into the composition of park rocks, even if the specimens come from elsewhere. To supplement the reference collection additional hand specimens for use in interpretive activities may be assembled.

The history of Acadia also involves specimens which the park has an obligation to preserve and which contribute to the interpretation and wise administration of the park. Two limiting factors restrict the scope of historical collecting at Acadia. History is a secondary resource here which should not be overemphasized. It is typical of wider areas rather than being unique in its significance. Accordingly, the collection should conform to defined park needs as follows:

Indians The park will not actively acquire specimens concerning the prehistoric or historic Indians except as called for in approved exhibit plans or as excavated in approved archeological research projects. Indian specimens not currently on exhibition or under active study shall be deposited in the Abbe Museum, the University of Maine or the State Museum.

French Colonial Existing material in the Sawtelle Collection will be supplemented only by specimens required for an approved exhibit or recovered through archeological investigations within the park (e.g., the Saint Sauveur site) or in immediately adjacent waters. Exceptions should be considered, however, if opportunities arise to acquire original material associated with Champlain, Cadillac or the Saint Sauveur settlement and its destruction.

New England Frontier The collection shall concentrate on those major local industries which support the interpretive emphasis of the park on aspects of the sea and its influence on Acadia. It shall contain as far as possible one only of each kind of artifact illustrating the material culture of the commercial boat building and fishing activities of the 18th–20th-century inhabitants of Mount Desert, Isle Au Haut and Baker Island. This will include objects associated with the Banks fishing, fish drying and packing; the menhaden fishing; and lobsters. Boat building tools, plans, models, paintings, drawings, prints, photographs and documentary evidence will be collected rather than the boats themselves unless the latter are specified in approved interpretive plans. Material presently in the Sawtelle Collection on island agriculture, community and domestic life and items associated with individual settlers will be supplemented only as required for approved exhibits or research projects.

Summer Resort and Park The collection shall include only those speci-
mens needed to give visitors an appreciation of the character of the sum-
mer colony that developed on Mount Desert and the role of summer
residents in creating the park. Collecting in this subject area should be
minimal until a research project can establish a want list.

Glacier National Park

(from Interpretive Prospectus, 1967)

Study Collections The scope of the study collections will include the
following representative forms:

1. The present plant, vertebrate and invertebrate life of the Park.
2. The rocks and minerals of the Park.
3. Archeological and ethnological material with local provenience.
4. Objects associated with the history, settlement, administration and
 operation of the Park.
5. A file of negatives, photographs and books associated with the Park.

Materials for these collections should be selectively chosen so that dupli-
cation of objects will be kept to a minimum since the basic purpose of the
collections is to provide resources for research, reference and exhibits.

Working space and storage facilities, albeit small, have been provided in
the basement of the Administration Building. Inspection and treatment of
all specimens are regularly scheduled. Researchers, both private and Fed-
erally sponsored, are encouraged to use these collections, and they are
readily available to any bona fide student.

Series collections will not be maintained because extensive collections of
both the fauna and flora of the Park are maintained at both The University
of Montana at Missoula, and Montana State University at Bozeman.

To comply with the stated purpose and scope of the study collection the
following guidelines should be followed whenever possible. This does not
preclude the replacing of present specimens with better examples as the
opportunity or need arises. Also, no specimen should be accepted unless all
the necessary information regarding the collector, place of collection and
pertinent measurements and data are available and recorded.

Guidelines for obtaining and retaining specimens:

1. Herbarium:
 a. Minimum, 1 specimen from east and 1 specimen from west of the Continental Divide.
 b. Life history states, i.e., flower, fruiting; for shrubs and trees winter conditions should be included.
 c. Maximum should not exceed 5.
2. Vertebrates:
 a. Minimum, 1 specimen from east and 1 specimen from west of the Continental Divide.
 b. If sexes differ appreciably in size and/or color, a male and female should be included. An immature specimen should be included only if it varies in color, not size, from the adult.
 c. Seasonal variations of resident animals should be represented by one specimen in winter plumage or pelage.
 d. Maximum should not exceed 6.
 e. In the case of larger vertebrates, e.g., bear, deer or mountain lion, a maximum of two skulls, male and female, and one pelt shall be preserved in the study collection.
3. Invertebrates:
 a. Minimum, 1 specimen from east and 1 specimen from west of Continental Divide.
 b. If sexes differ appreciably in size and/or color, a male and female should be included; adult forms only should be collected.
 c. Maximum should not exceed 4.
4. Geologic Specimens:
 a. *Formations*—Representative samples of each recognized geologic formation in the Park, not to exceed 3 specimens of each formation.
 b. *Fossils*—Samples of various biologic and geologic fossils, e.g., algae, mud cracks and ripple marks, not to exceed 3 of each species or type. An exception should be made if the fossil form is in danger of being destroyed if left in place.
 c. *Other features*—Representative samples of glacial features, etc., e.g., glacial striations and polish, not to exceed 3 of each phenomenon.
 d. *Minerals*—Maximum should not exceed 2 of each mineral occurring in the Park.
5. History:
 a. *Administration and settlement:* The scope of the study collection should be very limited as to the history of the administration and operation of the Park. Specimens relating to early settlement and establishment of the Park are most important; those relating to normal operation and administration should receive little, if any, attention. There is value in retaining objects associated with early

townsites and commercial ventures in the region, e.g., Altyn Town-
site and Cracker Mill.

b. *Archeology and ethnology:* Standard archeologic practices shall be
 followed in retaining specimens in the study collection. In general
 this means that all specimens will be retained until studied, after
 which a qualified archeologist shall determine whether all specimens
 shall be retained in the study collection.

C. Collection Inventory

Tuzigoot National Monument

I. Summary

The collections number approximately 2,000 items; 450 are stored at the Southwest Archeological Center, the remainder at the Monument. The collections are of value for (1) display and interpretation, (2) study of the A.D. 1100–1450 Sinagua, and (3) a source for comparative studies. The weakness of the collection is that it represents only one site and one period.

II. Area Value

Tuzigoot preserves the remains of a scientifically excavated hill-top Sinagua village occupied between A.D. 1100–1400.

III. Collections

 A. *NPS Museum Records*—1,994 (as of Nov. 1962)
 Cataloguing is current and complete and the catalogue duplicated for those items stored at SWAC.
 1. *Tuzigoot*—1,520 items.
 The major portion, 1,365 items is from the 1933–34 excavations. The collection is large, varied, and of excellent quality, valuable for display, study, interpretation and comparison. Well documented, published artifacts of the A.D. 1100 to 1400 Sinagua.
 2. *Tuzigoot Extension*—107 items.
 Excavated materials, bone, stone, shell and clay.
 3. *Hatalacva*—63 items.
 An excavated site, primarily bone, stone, clay and shell.
 4. *Hidden House and Sycamore Canyon*—106 items.
 These collections are primarily from sheltered sites, contain 58 perishable items and 10 split-twig figurines.
 5. *Miscellaneous Verde Valley Locations*—78 items.
 These include some good display pottery.
 6. *Provenience Undetermined*—120 items.
 Catalogued but undocumented materials including 52 perishable items possibly from Sycamore Canyon.

B. *Collections at Other Institutions*
Some display quality items are on loan at the Smoki Museum and the State Archives in Phoenix.

C. *Materials Lacking*
Tuzigoot is a completely excavated one period site. The collections have the usual "open site" weakness in organic materials; materials from an earlier period are lacking.

IV. Projected Development

No archeological projects are planned.

V. Evaluation

Except for a lack of perishable materials the collections are excellent for the site; they are also of high display value.

They are of high importance as a definitive Sinagua site collection.

D. Condition Standards for Antique Firearms

Factory New All original parts; 100% original finish; in perfect condition in every respect, inside and out.

Excellent All original parts; over 80% original finish; sharp lettering, numerals and design on metal and wood; unmarred wood; fine bore.

Fine All original parts; over 30% original finish; sharp lettering, numerals and design on metal and wood; minor marks in wood; good bore.

Very Good All original parts; none to 30% original finish; original metal surfaces smooth with all edges sharp; clear lettering, numerals and design on metal; wood slightly scratched or bruised; bore disregarded for collectors firearms.

Good Some minor replacement parts; metal smoothly rusted or lightly pitted in places, cleaned or reblued; principal lettering, numerals and design on metal legible; wood refinished, scratched, bruised or minor cracks repaired; in good working order.

Fair Some major parts replaced; minor replacement parts may be required; metal rusted, may be lightly pitted all over, vigorously cleaned or reblued; rounded edges of metal and wood; principal lettering, numerals and design on metal partly obliterated; wood scratched, bruised, cracked or repaired where broken; in fair working order or can be easily repaired and placed in working order.

Poor Major and minor parts replaced; major replacement parts required and extensive restoration needed; metal deeply pitted; principal lettering, numerals and design obliterated, wood badly scratched, bruised, cracked or broken; mechanically inoperative; generally undesirable as a collectors firearm.

(These standards have been developed by the National Rifle Association. See the general requirements on advertising "The Arms Chest," *The American Rifleman*, also *Gun Collectors Handbook*, Washington. National Rifle Association, 1959.)

E. Examples of Good Practice in Catalogue Descriptions of Museum Specimens

1. Mammal

Object. *Microtus pennsylvanicus,* meadow vole, study skin and skull.

Locality. Harpers Ferry NHP, Jefferson County, WV.

Description. Mature male, total length 180 mm, tail 55 mm, hind foot 22 mm, ear 14 mm, weight 99.2 g; skull data: condylobasal length 25 mm, zygomatic breadth 18 mm; dentition worn; ½ lower jaw lost in cleaning.

Condition: Infected with bot fly (*Cuterebra* sp.) in inguinal region, left ear badly scarred, shedline across rump (see sketch); for stomach contents see catalogue folder.

Collected Oct. 6, 1957 on Bolivar Heights between loop at end of footpath and pasture fence, elevation 612 feet, snap trap in runway in bluegrass (*Poa pratensis*), field no. 326.

2. Rock

Object. Sandstone, Navajo Formation.

Locality. Near Courthouse Towers, Grand Co., UT.

Description. Well sorted, well rounded, frosted quartz grains, .75–1 mm; carbonate cement; color white.

Hand specimen chipped to 127 mm × 76 mm × 25 mm.

Collected at Site #76 marked on park geologic base map (USGS 7½ quadrangle, Courthouse Towers), 30′ (9m) above contact with underlying Kayenta Formation. Field No. 137.

3. Ethnological Specimen

Object. Shirt, war.

Locality. South Dakota.

Description. Painted buckskin with quills, beads, cloth, scalp locks. Sewn with sinew and thread. Ca. 1850–1875.

Decoration: Upper part of shirt painted blue; lower part painted yellow and fringed. The neck is bound in red trade cloth as are the fringed cuffs. Bands of red and yellow quillwork bordered by blue and yellow lazy stitched beads are on sleeves; the same decoration moves from the chest over the shoulders to the back. The V at the neck has twelve thin rows of

red quillwork, a border of blue and yellow beads, and fringe. Attached to the sleeve, chest, and back quilled panels are scalp locks wrapped with red quills at their base.

Body: 78 × 53, sleeve 60 cm.

History: ex coll. David T. Vernon. Dockstader notes, "Fine example of such work." I agree completely; an excellent piece.

4. Textile

Object. Coverlet, double woven Jacquard.

Locality. United States, probably Indiana or Ohio.

Description. Woven on a power operated Jacquard loom. Typical pattern and materials—blue wool and white cotton. Pattern: 8 large medallions, 6 smaller rosettes, foliage lattice between medallions with pairs of long-tailed birds; a three-leafed plant is prominent. Border has single medallions in corners, linear arrangement of rosettes and medallions and small geometric patterns. Two selvage edges and two edges with small rolled hem, hand stitched. Made c. 1850–1860. Yarns:

cotton warps	S twist	3 ply	20 per inch
cotton wefts	S twist	3 ply	20 per inch
wool warps	S twist	2 ply	20 per inch
wool wefts	S twist	2 ply	20 per inch

Sewing thread used to hem—S twist, 2 ply linen.

Some light stains, especially one overlapping the outer edge of one of the large medallions near the center and one in a border medallion near the center of the opposite hemmed edge.

8′ × 6′ 11″ (the woven width of fabric) (2.44 × 2.11 m). Border 9⅛″ on selvage edges (229 mm), 9¾″ on hemmed edges (248 mm).

Condition is good, fibers strong, no tears or holes. Light stains as noted. Donor's family maintains coverlet was handwoven in Scotland. It is too wide to have been handwoven and there are extremely few examples of coverlets woven in Britain. Specimen might well have been woven by a Scottish immigrant in Indiana or Ohio where the donor's family resided prior to the Civil War.

Coverlet washed, fumigated and hem repaired Harpers Ferry Center, July 1974.

5. Furniture

Object. Armchair.

Locality. Philadelphia, PA.

Description. Walnut Queen Anne Chippendale open armchair with slip seat, circa 1745–1755. Broad serpentine crest rail with plain volute termi-

nals; solid vase-shaped splat; raking stiles chamfered into octagon below trapezoidal seat frame; side rails tenoned through rear legs; reverse serpentine arm rest terminating in scrolled knuckles, reverse C arm supports; side rails screwed into arm supports; front rail double reverse S-curves; ogee knee bracket; side rails shaped; plain cabriole front legs; slipper feet. Finish wax over brushed shellac. Trapezoidal pine slip seat frame, modern muslin webbing, tacks and all-hair filling, covered with brown leather. Small knot shows on inside of front seat rail 3″ (76 mm) from left end.

Measurements: h. 40%₁₆″ (1.03 m), w. knuckle to knuckle 30½″ (775 mm), depth 18¼″ (464 mm), length at seat 16¹⁵⁄₁₆″ (430 mm), width at seat 16⅛″ (407 mm).

Condition: very good. Rear corner blocks replaced.

Reference: John T. Kirk, *American Chairs, Queen Anne and Chippendale,* 1972, p. 6.

6. Firearm

Object. U.S. Model 1842 musket, rifled version.

Locality. Harpers Ferry, WV.

Description. Follows the 1842 pattern, but is rifled as 14,300 of the M1842's were between 1856 and 1859. This one has 7 grooves, unusual. Long range rear sight is an old replacement, calibrated from 100 to 800 yards. Top of barrel has a notch where a nonmilitary sight was once placed. Hammer screw is a new replacement. Ramrod is an old replacement.

Marks: stamped on lock plate behind hammer in three lines— HARPERS/FERRY/1854, on lock in front of hammer—U. S. below eagle, on barrel tang—1855, on left of breech—eagle head proofmark and U P, on face of breech—P O I J 9, on butt plate tang—U S, deeply on side plate side of stock the inspector's initials—N U.

Measurements: .69 cal. (17.5 mm), total length 57.75″ (1.466 m), barrel length 42″ (1.067 m), stock length 55″ (1.397 m), lock plate length 6.25″ (159 mm), lock plate width 1.28″ (32.5 mm), trigger guard length 9.625″ (245 mm).

Condition: Good, approaching very good. Metal parts including bore show little wear, rifling clear and sharp. Stock has some storage bruises and a small sliver of wood missing around rear of ramrod channel.

7. Painting

Object. Oil painting, "Bishop White's Study," by John Sartain.

Locality. Philadelphia, PA.

Description. Oil on linen canvas depicting the study of Bishop White's house on Walnut Street as it appeared to the artist, John Sartain, in late

summer 1836. Fireplace and reading chair to left, book presses on each side of bedroom doorway in center background, book shelves and chairs on right. Canton straw matting on floor. In original goldleaf frame, see Cat. No. 8130. Marked in paint on back of canvas, "J. Sartain pinx. 1836."

Measurements: h. 18″ (458 mm), w. 21¼″ (540 mm). Frame h. 25½″ (661 mm), w. 31½″ (800 mm), d. ½″ (13 mm).

Condition: Good. Restored by W. J. Nitkiewicz, 1968. Prior to restoration support was very weak, slack and buckled; small puncture in support with small losses of ground and paint slightly right of center of cabinets at right; extensive losses of ground and paint along lower edge with marked cleavage of ground and paint in same area; net crackle of ground and paint general; surface film moderately discolored. See treatment report in catalogue file.

History: Painting commissioned by Elizabeth White Bronson, granddaughter of Bishop White, to preserve the appearance of his study at the time of his death in July 1836. A mezzotint, also by John Sartain, after this painting was published in Bird Wilson's *Memoir of Bishop White*, Philadelphia, PA, 1839. See catalogue file for intervening ownership.

8. Document

Object. Account book.

Locality. Harpers Ferry, WV.

Description. Half imitation leather and marble paper bound containing c. 146 leaves with blue horizontal ruling and red columnar lines. Entries beginning from the front record daily medical visits and prescriptions with occasional receipts of cash or produce from October 1874 through March 1882, pages numbered 6178–6275, then not numbered. Entries beginning from the back record daily household expenditures and receipts from May 12, 1876 to January 20, 1884, followed by a half page of scattered entries from March 13, 1884 to August 17, 1885. Several blank pages separate the two sections, but within them 2 leaves contain later records concerning the doctor's estate including an affidavit of Annie P. Marmion dated July 1905 and notations of debts paid May 5, 1913. Pencil marked 290 on inside of front cover and on pages headed by entries for October 31, 1877, January 26, 1883, and February 20, 1883; pencil marked 291 on inside of back cover and on leaf 58. 15½″ h × 6⁵⁄₁₆″ w (392 × 161 mm). Both covers loose and spine completely missing; front cover has buckram missing except for remnant of upper front corner, cover paper badly worn over most of surface and missing from lower ⅙th, lower corners of board deteriorated; back cover has buckram strip along back edge and some at front corners and a loose tab at back bottom corner, cover paper worn, particularly along front, top and bottom edges; front lining paper wrinkled, several loose pages and signatures.

Dr. Nicholas Marmion's day book.

F. Furnishings Research

The historian who prepares Part I of an Historic Furnishings Report needs to search many sources for relevant information. As a first step he establishes the identity of the people associated with the structure in its time of historic significance. These may include the members of the family in residence, for example, and their relatives, friends and associates. Then he determines as fully and accurately as possible the material objects which surrounded them in the structure. One line of investigation seeks the actual furnishings that have survived and may well involve a systematic tracing of the dispersal of the family's worldly goods. Another aspect of the search concerns specific references to furnishings by people who saw them or used them there at the time. The third approach hunts clues to the furnishings that may be inferred from records of occupation, activities, interests and tastes. Experience has demonstrated the importance of using such sources as the following:

Letters

The correspondence of the family, friends and visitors often contains references to specific items of furnishings as well as shedding light on activities that must have required certain tools, instruments or other equipment. Letters also reveal the cultural milieu which affected the original choice of furnishings. While such letters may be in the possession of descendants, look for them also in public and private manuscript collections.

Diaries, scrapbooks and account books

Material of this sort kept by the family in residence, relatives, friends and visitors is most helpful. Look for it in the hands of descendants particularly.

Wills, inventories, papers of administration and other estate records

Although copies may be found in family papers, these important sources are usually in the appropriate courthouse. The historian needs to understand the past and present legal procedures for settling estates in order to explore the records intelligently. The processes and terminologies vary from state to state. Remember that jurisdictional boundaries have changed

also. Sometimes the old records move to the new court, but often they remain behind. Such changes have happened four or five times in the history of some estates. Even when the right courthouse is known, the papers may be hard to find. So few people consult old wills and inventories that they are seldom kept readily at hand. The clerks have little time or occasion to become familiar with them, although sometimes one will become too possessive. Park Service workers have found these files in the cellars and attics of courthouses or city halls, under years of dust and in questionable order. To obtain access to them the historian may need to win the cooperation of the person immediately responsible for their care. Prior knowledge that the records exist and polite determination may be necessary to ferret out their present location and gain permission to examine them. Do not let the initial reaction that the records no longer exist, or were destroyed or stolen during the Civil War terminate the search. For example, papers on the estates of residents of the Saratoga battlefield "did not exist," but thanks to patient persistence were found in the courthouse basement along with a magnificent collection of 17th- and 18th-century documents. In 10 years of searching the records of five Virginia counties, which appear to be incomplete, all the papers sought were eventually found except for those of one person. Even stolen records probably still can be located since several people usually can provide leads. Some states have centralized the old records in well managed archives which simplifies the task. On the other hand, the settlement of estates may extend over many years with long intervals of inactivity so it is easy to overlook useful material even when the papers are accessible. If the particular papers cannot be found, use those for other estates of people having similar economic, cultural and social backgrounds and living nearby at the same period.

Tax records

Sometimes these contain much valuable information. In late 18th-century Philadelphia, for example, carriages and silver were specifically taxable so were listed and described.

Miscellaneous legal papers

Civil suits, bankruptcy and other actions may result in court records that contain needed information. A prosecution for debt established the occupation of the resident of the Stone House in Georgetown in 1804, for example. Each jurisdiction may differ slightly in regard to these records, so a survey of documents available for the period in question should be made to determine the location of possible information. Indexes to civil court cases may prove helpful.

Federal census records

They may give occupation, age and other relevant data. The 1860 census showed that the occupant of the Stone House at Manassas was considered a farmer rather than an innkeeper.

License records

These will apply in some cases, although their value varies with period and jurisdiction.

School records

When some of the occupants were of school age, these records indicate and sometimes specify possessions they would have had.

Church records

Dates of baptism, marriage and death may add important information. Church records may identify friends who served as witnesses or godparents and so open new leads. These sources may also record a person's occupation, sometimes his travels, and at least suggest household objects associated with his religion.

Cemetery records

These may help with vital statistics.

Military records

Both personal service records and war claims may provide needed information in some cases.

Fire insurance policies

In some instances these indicate content or use of particular rooms and placement of furniture.

Records of Craftsmen and Tradesmen

These often reflect the purchase of objects used in furnishing a building. The Lees purchased silver for Arlington at Kirk's in Baltimore and furniture from Green's in Alexandria. Mrs. Madison's account at her grocer's shows what bottles were in her kitchen.

City directories

They indicate occupation, names of neighbors and of tradesmen whose records may prove helpful.

Newspapers

The papers recount activities at or near the historic structure. If the occupant was prominent, much more information may appear in the contemporary papers. Articles describing Mr. Custis' celebration of St. Patrick's Day listed his violin, titles of music in his library and his green coat—all furnishings of Arlington. He wrote a newspaper account of his talks with Lafayette which revealed information about his Washington collection. Later newspapers assist greatly in tracing the dispersal of furnishings in succeeding generations.

Magazines

The periodicals to which the occupants subscribed may indicate interests that were reflected in the furnishings. Magazine articles about the building or its occupants sometimes are valuable.

Catalogues of furniture collections and antique sales

These may trace the ownership of individual pieces as well as giving descriptive and comparative data helpful in selecting furnishings.

Paintings, prints and photographs

Any contemporary pictures of the structure may provide key data. Views of other buildings comparable in time, place and function offer good supporting information. Look for these in public or private collections.

Furnishings

The items of furnishing identified as original often indicate additional objects not otherwise identified. One piece may establish a set of china or silver pattern, for example. Period houses and furnishing collections in museums comprise physical documents worth consulting for comparative purposes.

Site evidence

A close study of the structure by the architect, archeologist and curator may give invaluable evidence of the original furnishings and their place-ment. Look especially at the layers of paint on the original walls, holes and lines in the walls, marks on the floor, hardware or marks where it has been removed or altered, sherds and other objects found in the walls or basement or on the grounds, especially in old wells, privies and dumps.

G. Fire Safety Self-Inspection Form for Museums

The individual charged with day-to-day fire protection in the museum should find this checklist helpful. Fit it to the local situation. Then use it to guide regular, thorough inspections that will indicate how well the fire safety program is operating. *Do not* let the use of this form replace periodic inspections by a professional fire protection expert, nor the regular inspection and testing of fire detection and extinguishing installations by specialists in their maintenance.

The Libraries, Museums and Historic Buildings Committee of the National Fire Protection Association is developing a self-inspection form which should supersede this one when the NFPA issues it. For information on its status contact the National Fire Protection Association, 470 Atlantic Avenue, Boston, MA 02210, Attention: Committee on Libraries, Museums and Historic Buildings.

Fire Safety Self-Inspection Form

General Conditions

1. Construction:
 fire resistive ____, non-combustible ____, combustible ____.

2. Size:
floor area	_____
number of connecting buildings or wings	_____
number of entrances	_____
number of emergency exits	_____
number of employees	_____
number of visitors per day, average	_____
maximum	_____.

3. Exposures:

	Serious	Moderate	Light	None
north	___	___	___	___
east	___	___	___	___
south	___	___	___	___
west	___	___	___	___.

4. Water Supply:
 municipal system ____, reservoir/pond ____, storage tanks ____
 capacity _____
 size of water mains _____
 distance from hydrants _____, _____.

5. Fire Service:
 professional ____, volunteer ____, museum brigade ____
 time required for fire service to reach museum _____.

6. Fire Protection:

	Yes	No	Partial	Corrected
standpipe system	____	____	____	
sprinkler system	____	____	____	
automatic detection system	____	____	____	
inert gas extinguishing system	____	____	____	
interior fire alarm system	____	____	____	
direct alarm to fire service	____	____	____	
clocked guard service	____	____	____	
fire walls and self-closing fire doors protecting horizontal openings between building units	____	____	____	____
fire walls and self-closing fire doors separating furnace room from rest of museum	____	____	____	____
fire walls and self-closing fire doors separating hazardous operations from exhibit and collection storage areas	____	____	____	____
fire resistive enclosures protecting stairways and other vertical openings	____	____	____	____
exit doors opening outward	____	____	____	____
locked exit doors equipped with panic hardware	____	____	____	____.

(Note any changes in character of buildings, occupancy, water supply or hydrants, accessibility or other general conditions affecting fire safety since the previous inspection.)

General Inspection

		Yes	No	Corrected
1. Roof:				
	is roof covering non-combustible	___	___	___
	are scuppers and drains unobstructed	___	___	___
	are lightning arrestors in good condition	___	___	___
	are skylights protected by screens	___	___	___
	is access to fire escapes unobstructed	___	___	___
	do fire escape stairs appear to be in good condition	___	___	___
	are fire escape stairs unobstructed	___	___	___
	are standpipe and sprinkler roof tanks and supports in good condition	___	___	___
	are standpipe and sprinkler control valves in proper position	___	___	___

2. All Floors (inspect from top floor to basement):

	Yes	No	Corrected
are self-closing fire doors unob-structed and properly equipped with closing devices	___	___	___
are fire exits and directional signs properly illuminated	___	___	___
is emergency lighting system operable	___	___	___
are corridors and stairways unobstructed	___	___	___
are openings to fire escape stairs unlocked and unobstructed	___	___	___
are sprinklers unobstructed	___	___	___
are standpipe hose outlets properly marked and unobstructed	___	___	___
are sprinkler control valves properly labeled and unobstructed	___	___	___
are recorded weekly inspections made of all sprinkler control valves to make certain they are open	___	___	___
are dry pipe valves (for sprinklers in areas exposed to freezing) in service, with air pressure normal	___	___	___
are all fire-detection and fire-suppression systems in service and tested regularly	___	___	___
are sufficient fire extinguishers present	___	___	___

are extinguishers of the proper type
(see NFPA 10. *Portable Fire
Extinguishers*) ____ ____ ____
are extinguishers properly hung and
labeled ____ ____ ____
are extinguishers properly charged and
tagged with inspection tags ____ ____ ____
is housekeeping properly maintained ____ ____ ____
are cleaning supplies safely stored ____ ____ ____
are all trash receptacles emptied at
least daily ____ ____ ____
are supply closets and slop sink areas
clean and orderly ____ ____ ____.

3. Ground Floor:
do entrance and exit doors provide
unobstructed egress ____ ____ ____.

4. Basement:
is rubbish removed from the building
daily ____ ____ ____
is rubbish removed from the premises on
a regular schedule ____ ____ ____
are stocks of flammable liquids stored
away from the building ____ ____ ____.

Special Area Inspection

1. Exhibit Areas:
are exhibit housings, fittings and other
accessories non-combustible or fire
retardant treated ____ ____ ____
does exhibit wiring conform to the
Electrical Code ____ ____ ____
do all electrical components have
U/L labeling ____ ____ ____
have exhibit installations kept exit routes
unobstructed and visible ____ ____ ____
is proper salvage equipment ready
for use ____ ____ ____

2. Collection Storage Areas:

is appropriate fire extinguishing equip-
ment at hand and unobstructed ____ ____ ____

are dust covers fire retardant treated ____ ____ ____

is proper salvage equipment ready
for use ____ ____ ____

does fire service have access to areas ____ ____ ____

are catalogue and accession records
in a safe or vault of the proper
fire rating ____ ____ ____.

3. Laboratories:

are flammable solvents and other
chemicals properly labeled and stored
in small quantities in ventilated
safety storage cabinets ____ ____ ____

are flammable liquids dispensed from
safety cans ____ ____ ____

are self-closing safety waste disposal
receptacles available at work
stations ____ ____ ____

are laboratory wastes disposed of daily
with appropriate special precautions ____ ____ ____

are spray coating facilities adequately
and safely ventilated ____ ____ ____

is electrical equipment in the spray
area explosion-proof ____ ____ ____

does the spray area have automatic
fire extinguishing equipment ____ ____ ____

is laboratory electrical equipment
U/L approved ____ ____ ____

do electrical appliances have warning
lights ____ ____ ____

are appliances unplugged when not
in use ____ ____ ____

are exit routes unobstructed ____ ____ ____

are employees aware of special hazards
and trained in necessary precautions ____ ____ ____

is entry limited to authorized persons ____ ____ ____.

4. Shops and Packing/Unpacking Areas:

are paints, thinners and other flammable
liquids properly stored in reasonable
quantities in ventilated safety
cabinets ____ ____ ____

are thinners and solvents dispensed
 from safety cans ____ ____ ____

are self-closing waste receptacles
 used for oily rags and other
 wastes liable to spontaneous
 heating ____ ____ ____

are flammable packing materials
 stored in self-closing safety
 containers ____ ____ ____

are power tools and machines
 properly grounded ____ ____ ____

do woodworking machines have proper
 dust collectors ____ ____ ____

do paint spraying facilities comply
 with local codes ____ ____ ____

does welding equipment meet local
 codes ____ ____ ____

are power tools unplugged when not
 in use ____ ____ ____

 are exit routes unobstructed ____ ____ ____.

5. Auditoriums and Classrooms:
 is safe capacity posted ____ ____ ____
 is occupancy restricted to safe capacity ____ ____ ____
 do furnishing and wall coverings
 comply with fire safety standards ____ ____ ____
 are exits unobstructed, unlocked and
 properly illuminated ____ ____ ____
 are aisles unobstructed ____ ____ ____
 does projection room meet local codes ____ ____ ____.

6. Restaurant or Tearoom:
 is capacity posted ____ ____ ____
 is occupancy limited to safe
 seating capacity ____ ____ ____
 are exit routes unobstructed and
 properly illuminated ____ ____ ____
 are ranges, hoods and exhaust ducts
 clean ____ ____ ____
 do exhaust ducts terminate in a
 safe area ____ ____ ____
 are grease ducts and deep fryers
 equipped with automatic fire
 detectors and extinguishing system ____ ____ ____.

Exterior Inspection

1. Evacuation:
 have all exits, emergency exits
 and fire escapes unobstructed
 passage to safe areas _____ _____ _____.

2. Environment:
 are grounds clear of accumulations
 of flammable material _____ _____ _____
 have neighboring occupancies minimized
 exterior fire hazards _____ _____ _____
 is fire service access clear _____ _____ _____
 are standpipe and sprinkler systems
 siamese connections unobstructed
 and operable _____ _____ _____
 are hydrants unobstructed _____ _____ _____.

Personnel Inspection

1. Training:
 do all staff members know how to
 transmit a fire alarm _____ _____ _____
 do all staff members know their assigned
 duty in evacuating the museum _____ _____ _____
 do all staff members know how and when
 to use portable fire extinguishers _____ _____ _____
 do all staff members know their
 responsibilities in fire prevention _____ _____ _____.

2. Organization:
 is the fire protection manager
 or his designated alternate on duty ____ ____ ____
 does he have an adequate training
 program in operation for himself
 and the staff ____ ____ ____
 is the written fire emergency plan up
 to date and properly distributed ____ ____ ____
 does the fire protection manager
 get adequate support from the
 director and trustees ____ ____ ____
 has the fire service planned or
 trained for protecting the museum
 since the previous inspection ____ ____ ____.

Inspection conducted by: _____. Date: _____.
 title: _____.

Report reviewed by: _____. Date: _____.
 title: _____.

Corrective actions completed: _____. Date: _____.
 Fire Protection Manager

H. Bibliography of Park and Countryside Museums

Alberts, Edwin C. "Exhibit for Tourists, Or Compromising Our Compromises," *Clearing House for Western Museums*, I:3 (Winter 1961), pp. 1–7.

Aldridge, Don. "Landmark Visitor Centre, Carrbridge, Inverness," *Museums Journal*, 71:1 (June 1971), pp. 3–6.

———. *Guide to Countryside Interpretation*. Part One. Principles of Countryside Interpretation and Interpretive Planning. Edinburgh. Her Majesty's Stationery Office for Countryside Commission for Scotland—Countryside Commission, 1975.

Allan, Douglas A. "Site Museums in Scotland," *Museum*, VIII:2 (1955), pp. 107–112.

Anon. "Museums in National Parks," National Park Supplement to *Planning and Civic Comment*, 2:4 (October–December 1936), pp. 27–29.

Appleman, Roy Edgar. "An Historical Interpretive Center," *Museum News*, XX:13 (January 1, 1943), pp. 10–12.

Aveleyra Arroyo de Anda, Luis. "The Site Museum of Tepexpan," *Museum*, XV:1 (1962), pp. 22–33.

Beazley, Elisabeth. *Designed for Recreation*. London. Faber and Faber, 1969, pp. 39–48.

———. *The Countryside on View: A Handbook on Countryside Centres, Field Museums, and Historic Buildings Open to the Public*. London. Constable & Company Ltd, 1971.

Bryant, Harold C., *et al. Reports with Recommendations from the Committee on Study of Educational Problems in National Parks, January 9, 1929 and November 27, 1929*. n. pub., n. d.

———, and Wallace W. Atwood, Jr. *Research and Education in the National Parks*. Washington. Government Printing Office, 1932, pp. 18–36.

Bumpus, Herman Carey. "Relation of Museums to the Out-of-Doors," and "Museums in National Parks," *Papers and Reports Read at the 21st Annual Meeting of the American Association of Museums*, Publications of the AAM, New Series 1, 1926, pp. 7–15, 37–40.

———. "Museum Work in National Parks," *Museum News*, VII:14 (January 15, 1930), pp. 6–8.

———. "Objectives of Museum Work in National and State Parks," *Museum News*, XV:4 (June 15, 1937), p. 7.

Burns, Ned J. *Field Manual for Museums*. Washington. Government Printing Office, 1941.

———. "Park Museums and Public Morale," *Museum News*, XIX:10 (November 15, 1941), pp. 11–12.

———. "Audio-visual Aids in National Park Service Museums," *Museum News*, 25:14 (January 15, 1948), pp. 6–8.

———. "Modern Trends in the Natural History Museums of the United States of America," *Museum*, VI:3 (1953), pp. 164–169(167).

Carr, William H. *Signs Along the Trail*. New School Service Series 2. New York. American Museum of Natural History, 1927.

————. *Blazing Nature's Trail*. New School Service Series 3. New York. American Museum of Natural History, 1929.

————. *Trailside Conversations*. New School Service Series 4. New York. American Museum of Natural History, 1930.

————. *Trailside Actions and Reactions*. School Service Series 5. New York. American Museum of Natural History, 1931.

————. *Trailside Family*. School Service Series 7. New York. American Museum of Natural History, 1932.

————. "Palisades Interstate Park Museums as Agents in Field Education," *Museum News*, XIII:7 (October 15, 1935), pp. 7–8.

————. *Ten Years of Nature Trailing*. School Service Series 11. New York. American Museum of Natural History, 1937.

————. *The Desert Speaks*. Educational Series 1. Tucson. Arizona-Sonora Desert Museum, 1956.

————. *Tunnel in the Desert*. Educational Series 2. Tucson. Arizona-Sonora Desert Museum, 1957.

Chhabra, B. Ch. "Site Museums of India," *Museum*, IX:1 (1956), pp. 42–45.

Coleman, Laurence Vail. *Contributions of Museums to Outdoor Recreation*. Washington. National Conference on Outdoor Recreation, 1928, pp. 23–31.

————. *The Museum in America: A Critical Study*. Washington. American Association of Museums, 1939, pp. 55–58, 78, 136–140, 154–156, 567–572 (reprinted Washington. Museum Publications, 1970).

Deane, C. Douglas. "A Field Museum and Nature Trail in Northern Ireland," *Museums Journal*, 65:2 (September 1965), pp. 97–99.

Disher, Kenneth B. "The Future of Museums in National Parks," *Museum News*, XV:4 (June 15, 1937), pp. 7–8.

————, *et al.* "Three Basic Questions in Park Museum Planning," *Museum News*, XVI:4 (June 15, 1938), pp. 11–12.

Downes, George G. "Death Valley: A Living Museum," *Museum News*, 43:6 (February 1965), pp. 25–30.

Everhart, William C. *The National Park Service*. New York. Praeger Publishers, 1972, pp. 63–72.

Gilbert, Rose Bennett. "A New Look for Liberty," *Museum News*, 43:6 (February 1965), pp. 11–16.

Good, Albert H. "The Future of Museums in State Parks," *Museum News*, XIV:13 (January 1, 1937), pp. 7–8.

————. *Park and Recreation Structures*. Part II. Recreational and Cultural Facilities. Washington. Government Printing Office, 1938, pp. 169–184.

Gould, Charles N. "Starting a Museum in the Proposed National Park," *Museum News*, XVI:15 (February 1, 1939), p. 11.

Greenwood, Andrew. "Country Cousins—The Future Pattern of Rural Museums," *Museum Assistants' Group Transactions*. No. 6 (April 1968), pp. 17–19.

Hall, Ansel D. "Educational Activities in National Parks," *First Pan Pacific Conference on Education, Rehabilitation, Reclamation and Recreation. Report of the Proceedings*. Washington. Government Printing Office, 1927, pp. 397–413.

Hamilton, Dwight L. "Dinosaur National Monument—A Unique In-Place Museum," *Museum News*, 39:6 (March 1961), pp. 20–23.

Hamlin, Chauncey J. "Studying Nature in Place," *First Pan Pacific Conference*

on *Education, Rehabilitation, Reclamation and Recreation. Report of the Proceedings.* Washington. Government Printing Office, 1927, pp. 435–438.

Harrington, J. C. "Interpreting Jamestown to the Visitor," *Museum News,* 24:11 (December 1, 1946), pp. 7–8.

Hatt, Robert T. "Educational Programmes of Natural History Museums in the United States," *Museum,* V:1 (1952), pp. 11–16 (13).

Heald, Weldon F. "Urbanization of the National Parks," *National Parks Magazine,* 35:160 (January 1961), pp. 7–9.

Hudson, J. Paul. "Historic Houses Administered by the National Park Service," *Museum News,* 27:9 (November, 1949), pp. 7–8.

Ise, John. *Our National Park Policy: A Critical History.* Baltimore. Johns Hopkins Press for Resources for the Future, Inc., 1961, pp. 200–202, 552.

Johnson, Sally Ann. "A New Look at Fort Laramie," *Museum News,* 40:9 (May 1962), pp. 11–15.

Kelly, A. R. "The Need of a Museum of Southeastern Archaeology," *Museum News,* XVI:15 (February 1, 1939), pp. 9–10.

Kent, Alan E., and Horace J. Sheely, Jr. "Museum in a Gun Emplacement," *Museum News,* 39:9 (June 1961), pp. 36–39.

Krepela, Rick. "To Tell the Story . . . Interpretation on a Nation-Wide Scale," *Museum News,* 48:7 (March 1970), pp. 42–45.

Leavitt, Thomas W. "The Need for Critical Standards in History Museum Exhibits: A Case in Point," *Curator,* X:2 (1967), pp. 91–94.

Lewis, Ralph H. "The Vicksburg National Military Park Museum," *Museum News,* XIV:19 (April 1, 1937), pp. 7–8.

———. "A Survey of National Park Service Museums," *Museum News,* XIX:17 (October 1, 1941), pp. 10–12.

———. "Designing an Exhibit of American Democracy in a National Park," *Museum News,* XXI:14 (January 15, 1944), pp. 7–8.

———. "Park Museums—State and Local," *Museum News,* 23:10 (November 15, 1945), pp. 7–12; 23:11 (December 1, 1945), pp. 7–12.

———. "Park Museums as Community Centers," *Fundamental and Adult Education,* V:2 (April 1953), pp. 85–87.

———. "Ned J. Burns: Educator, Naturalist, and Museum Expert," *Proceedings of the Staten Island Institute of Arts and Sciences,* XVI:2 (Fall 1954), pp. 61–74.

———. "Site Museums and National Parks," *Curator,* II:2 (1959), pp. 172–185.

———. "Museum Training in the National Park Service," *Curator,* VI:1 (1963), pp. 7–13.

———. "Selecting Exhibit Themes for Park Museums," *Park Practice Guideline,* Interpretation, 14–1 (7/63), pp. 69–73.

———. "Visible Storage," *Park Practice Guideline,* Interpretation, 23–1 (2/67), pp. 99–101.

———. "Museums in National Parks," *Museum Assistants' Group Transactions.* No. 6 (April 1968), pp. 12–16.

———. "Environmental Education and Research in Yellowstone National Park," *Museum,* XXV:1/2 (1973), pp. 85–88.

———. and Rogers W. Young. "The Zenger Memorial," *American Heritage,* n.s., 5:1 (Fall 1953), pp. 24–25, 63.

Mather, Stephen T. *Report of the Director of the National Park Service.* Washington. Government Printing Office, 1920, p. 59.

Merriam, John C. "Inspiration and Education in National Parks," *National Parks Bulletin* 53 (July 1927), pp. 3–5.

Orth, John. "Trailside Museum and Nature Trails at Bear Mountain," *Museum News*, 27:19 (April 1, 1950), pp. 6–8.

Pane, Roberto, ed. "Museums of the Monument," *Museum*, III:1 (1950), pp. 62–64.

Pennyfather, Keith. *Guide to Countryside Interpretation*. Part Two. Interpretive Media and Facilities. Edinburgh. Her Majesty's Stationery Office for Countryside Commission—Countryside Commission for Scotland, 1975.

Peterson, Roger T. *Small Nature Museums*. Nature Study for Schools Series, Part XV. New York. National Association of Audubon Societies, 1938.

Presnall, C. C. "New Trailside Museum in Yosemite," *Museum News*, X:6 (September 15, 1932), pp. 6–7.

Riviere, Georges Henri. "A New Introductory Approach at the Chateau de Compiegne," *Museum*, 1:3/4 (1948), pp. 175–176, 216–217.

Robinson, Harry B. *Guide to the Custer Battlefield Museum*. Repr. *Montana Magazine of History*, July 1952, pp. 1–48.

Russell, Carl P. "The Museum in the Yosemite National Park, California," *Museum*, IV:2 (1951), pp. 87–90.

Shankland, Robert. *Steve Mather of the National Parks*. 2nd ed. New York. Alfred A. Knopf, 1954, pp. 259–261.

Shaw, Betty. "Interpreting Our Outdoor Heritage," *Museum News*, 44:10 (June 1966), pp. 24–28.

Simoneaux, N. E. "Museums and State Parks," *Museum News*, XVI:11 (December 1, 1938), pp. 7–8.

Spalding, Branch. "Museum Policy and Display at Fredericksburg and Spotsylvania National Military Park Museum," *Museum News*, XVI:12 (December 15, 1938), pp. 7–8.

Stansfield, G. "Museums and the Countryside," *Museums Journal*, 67:3 (December 1967), pp. 212–218.

———, ed. "Conference on Countryside Centres," *Museums Journal*, 69:2 (September 1969), pp. 63–73.

Stucker, Gilbert F. "Dinosaur Monument and the People: A Study in Interpretation," *Curator*, VI:2 (1963), pp. 131–142.

Tilden, Freeman. *Interpreting Our Heritage: Principles and Practices for Visitor Services in Parks, Museums and Historic Places*. Rev. ed. Chapel Hill. University of North Carolina Press, 1967.

Tsuruta, Soichiro. "The National Park for Nature Study, Tokyo," *Museum*, X:1 (1957), pp. 31–33.

Wallin, Harold E. "Educational Opportunities in Trailside Museums," *Museum News*, 27:1 (May 1, 1949), pp. 7–8.

Yeager, Dorr G. "The Educational Program of the National Park Service," *Museum News*, XVII:11 (December 1, 1939), pp. 11–12.

Index

Abrasives, 220–221; aluminum oxide paper, 65; bronze wool, 335; emery paper, 65, 220, 244, 255, 256; jewelers' rubber polisher, 65, 221, 249, 255; #884 compound, 329; powdered eraser, 222, 237, 241; precipitated chalk, 66, 220, 333; pumice, 330; rottenstone, 221, 247; sandpaper, 232, 343; steel wool, 65, 220, 226, 227, 244, 249, 255, 335, 336; whiting, 66, 221, 230, 237, 333; wire brushes, 336

Accession, definition of, 143

Accession book, 145, 154, 162; contents of, 27, 136, 143–144, 146–147, 148, 149, 152, 199; permanent materials for, 143, 150; time of entry in, 143, 161, 199

Accession file, 143, 144–145; contents of, 22, 27, 30, 137, 144–145, 148, 161

Accession folder. *See* Accession file

Accession number, 143, 145–146, 152; undesirability of an open, 161

Accession records: function of, 34, 142–143; installing a new system of, 149; retention of incoming correspondence in, 144–145; separation of, from catalogue, 142, 152

Accidents, 260–267

Acetate, ethyl, as a killing agent, 50

Acetic acid, in a killing and preserving fluid, 50, 51

Acetone: as a drying agent, 65; as a solvent, 66, 158, 162, 342

Air-conditioning, 87–88, 91, 98, 267–268, 269, 277. *See also* Relative humidity: control of

Air pollution: control of, 70, 91, 269, 346; effects of, 70, 204, 254, 269; measurement of, 70, 87, 269; protection of specimens from, 70, 83, 194, 269; sources of, 70, 83, 271

Alarm devices, 80, 291. *See also* Security: detection and alarm equipment

Alcohol, ethyl: as a dehydrating agent, 51; dilution table for, 54–55; as a killing agent, 50, 52, 53, 54; as a preservative, 49, 50, 51, 52, 53, 54, 64; as a solvent, 158, 162; testing, 54

Alcohol-glycerin-acetic acid, as a killing and preserving fluid, 50, 51

Alcohol, isopropyl, as a preservative, 55

Algae, preservation of, 45

Alum: use of, on fish specimens, 48; use of, on study skins, 46

Aluminum, cleaning of, 330, 340, 343

Aluminum oxide, 65

American Association of Museums, 2, 26

American Institute for Conservation of Historic and Artistic Works, 63

Ammonia, household: use of, in cleaning glass, 222, 238, 249, 256, 257, 328, 329; use of, in cleaning metals, 330, 339; use of, in cleaning stone, 242, 243, 249; use of, in removing soot, 237

Amphibians: classification of, 167; preparation of, for study, 49; storage of, 98

Andirons, care of, 244

Animals: collection of accidentally killed, 20; rare, 20

Annelids, preparation of, for study, 53

Ants, preparation of, for study, 50

Applicator, wax, 219, 228

Aquarium cement, for sealing specimen jars, 64

Arachnids, preparation of, for study, 52

Archeological specimens: classification of, 169–170; culling of, 12–13, 105, 161; "field collection status" for, 12, 105, 161; identification of, 56; marking of, in central repositories, 161; special accessioning and cataloguing procedures for, 12, 160–161; storage of, 12, 93

Architectural specimens, classification of, 174